# Drawing from Life

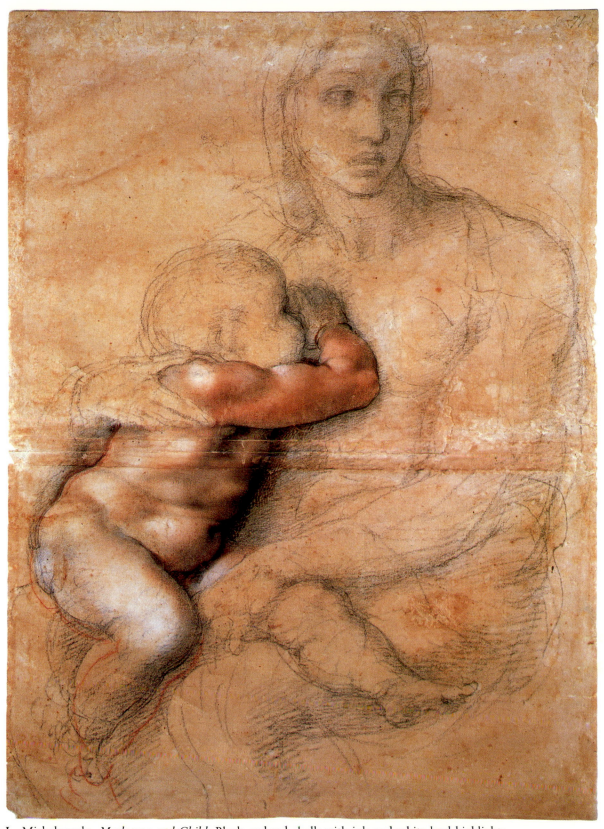

I  Michelangelo. *Madonna and Child*. Black and red chalk with ink and white lead highlights. Museo della Casa Buonarroti, Florence, Italy (Fototeca Casa Buonarroti).

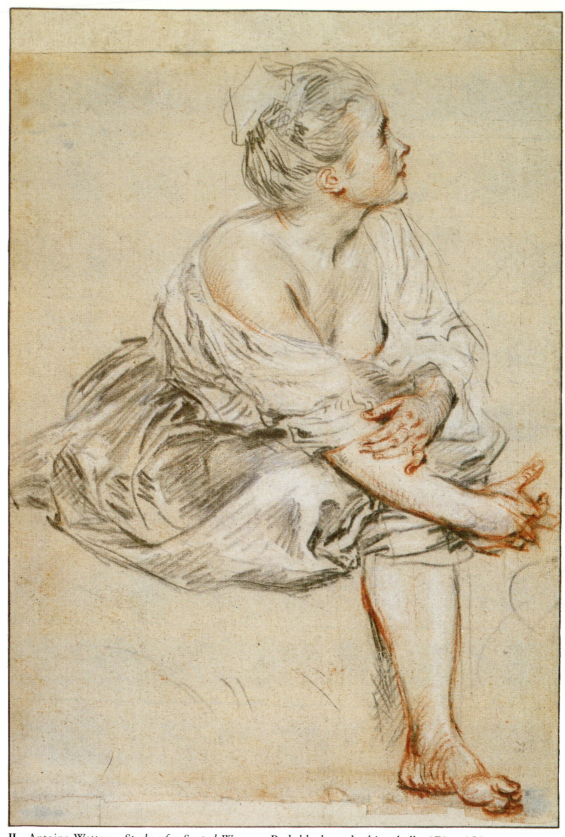

II   Antoine Watteau. *Study of a Seated Woman*. Red, black, and white chalk, 171 x 154 cm.
© 1990 Pierpont Morgan Library, New York. I, 278A

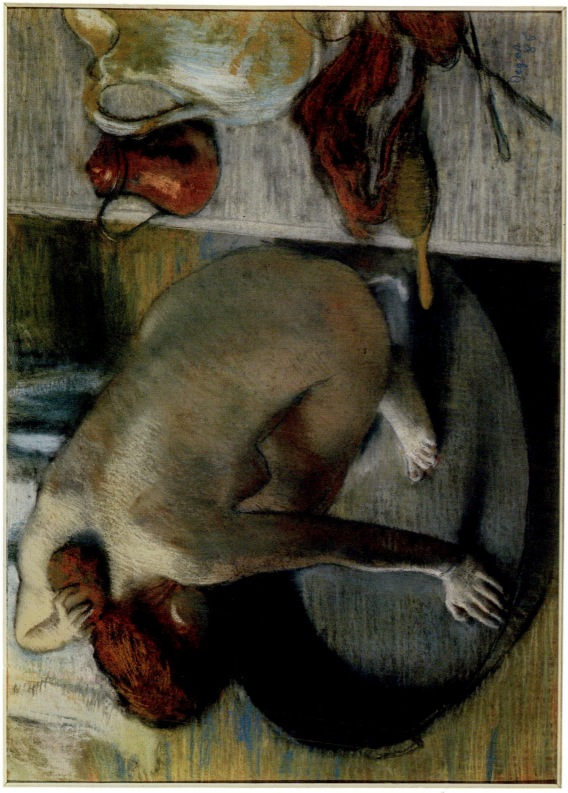

III  Edgar Degas. *The Tub.* 1885. Pastel, 27 1/2 x 27 1/2". Cliché des Musées Nationaux, Paris. © Photo R.M.N.

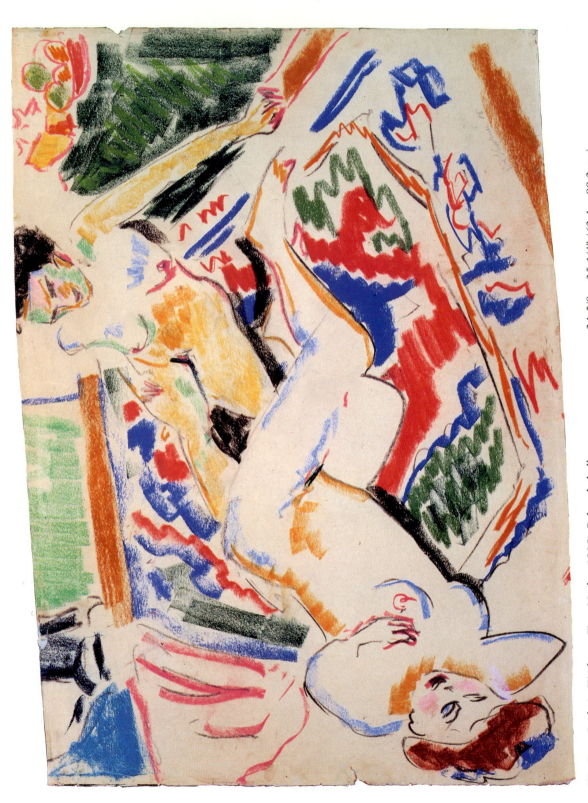

IV  Ernst Ludwig Kirchner. *Two Nudes.* 1905. Colored chalk on cream wove paper, 24 5/8 x 35 1/4" (62.4 x 89.2 cm).
Art Institute of Chicago, Chicago. Albert Kunstadter Family Fund, 1963.557.

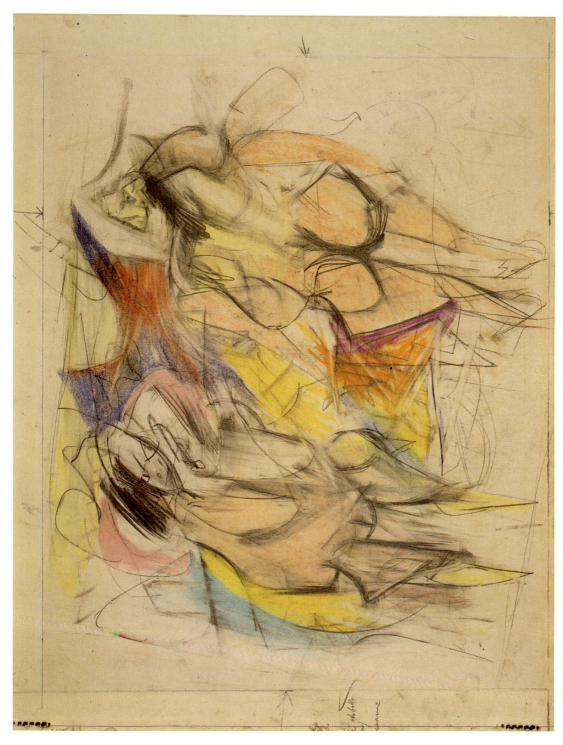

V  Willem de Kooning. *Two Women III.* 1952. Pastel and graphite on paper. Allen Memorial Art Museum, Friends of Art Fund, 1957, 57.11, Oberlin College, Oberlin, Ohio.

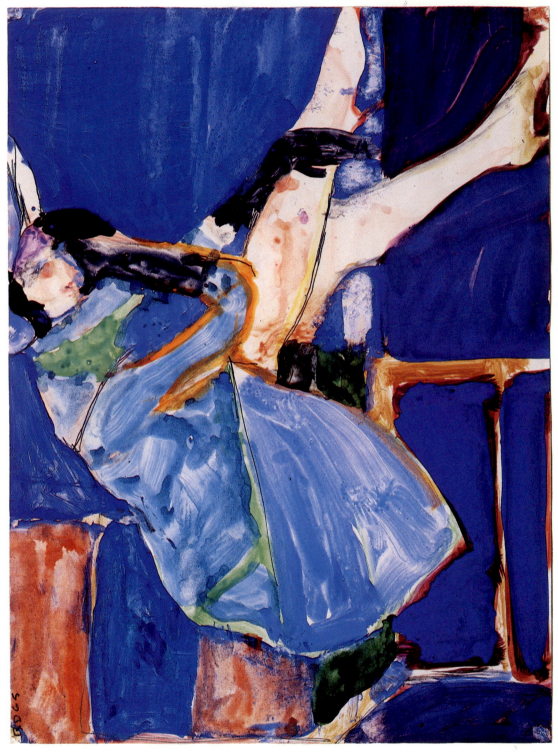

VI Richard Diebenkorn. *Seated Woman, Legs Crossed.* 1965. Watercolor, gouache, and ink, 12 1/4 x 17". The Fine Arts Museums of San Francisco, Achenbach Foundation for Graphic Arts, bequest of Beatrice Judd Ryan.

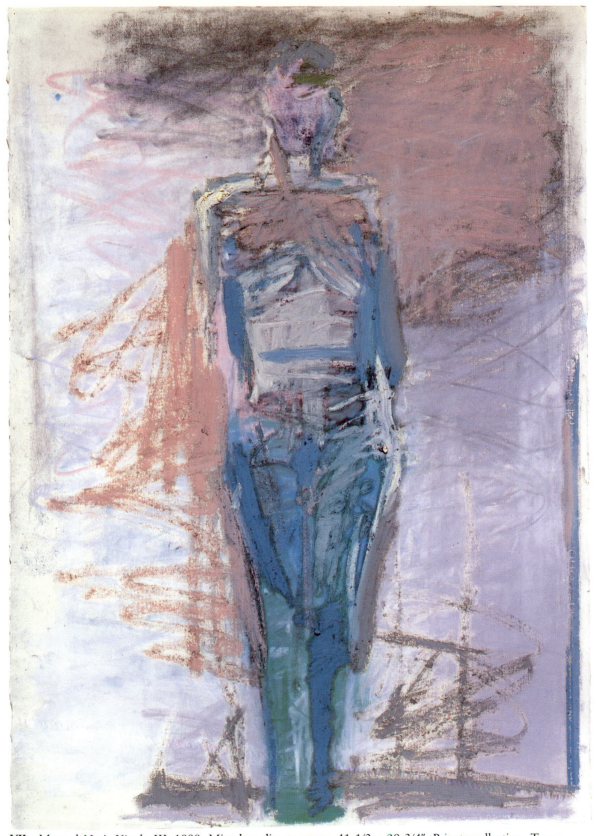

**VII**  Manuel Neri. *Vicola III.* 1988. Mixed media on paper, 41 1/2 x 29 3/4″. Private collection, Texas. Photo courtesy John Berggruen Gallery, San Francisco. Photo by M. Lee Fatherree.

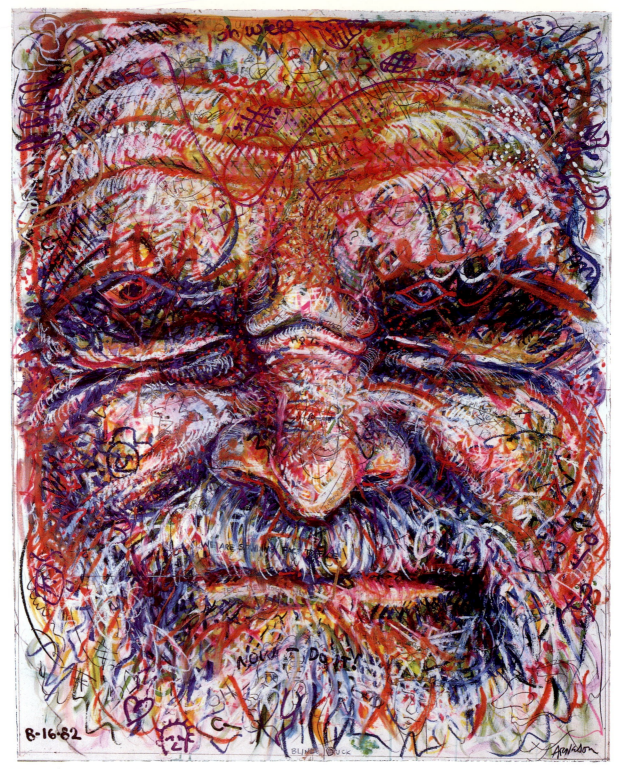

**VIII**  Robert Arneson. *Blink Duck*. 1982. Acrylic, oil stick on paper, 53 x 42″.
Frumkin/Adams Gallery, New York.

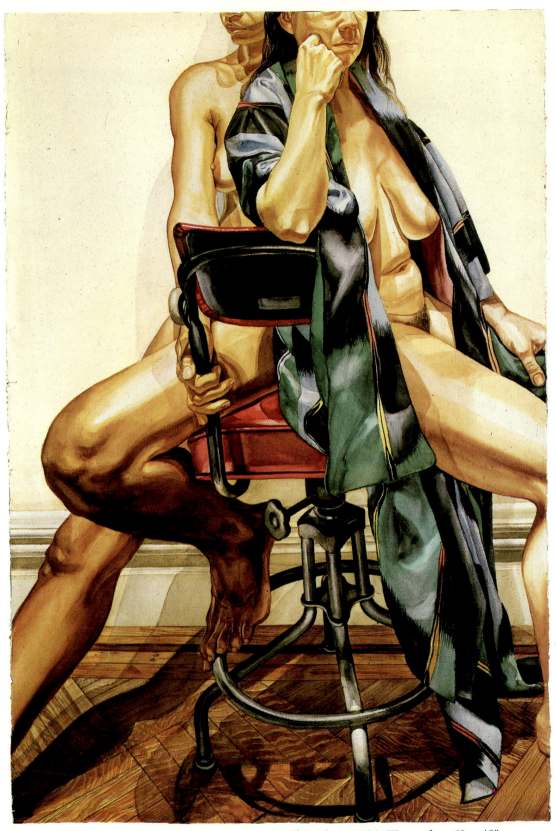

**IX** Philip Pearlstein. *Two Models on Red Swivel Office Chair*. 1984. Watercolor, 60 x 40″.
Private collection. Courtesy of Hirschl & Adler Modern, New York.

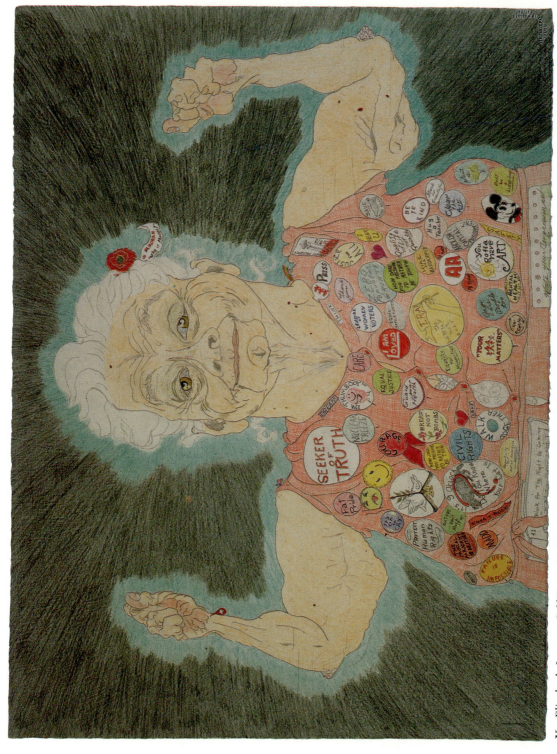

X Elizabeth Layton. *Self-Portrait: Her Strength is in Her Principles.* 1982. Colored pencil and crayon on paper, 30 x 22″. From the collection of Don Lambert, Topeka, Kansas.

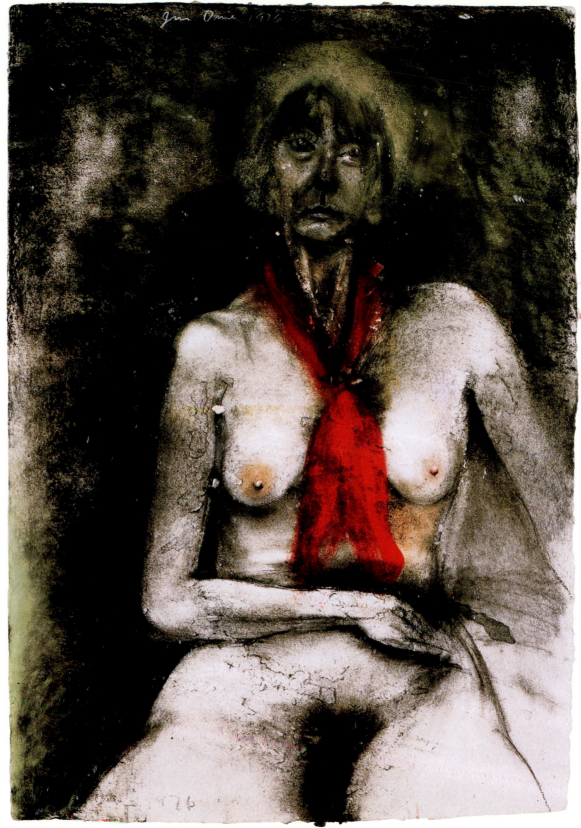

**XI**  Jim Dine. *The Red Scarf*. 1978. Pastel, charcoal, and mixed media on paper, 45 1/2 x 21 1/2".
Photo courtesy of The Pace Gallery, New York.

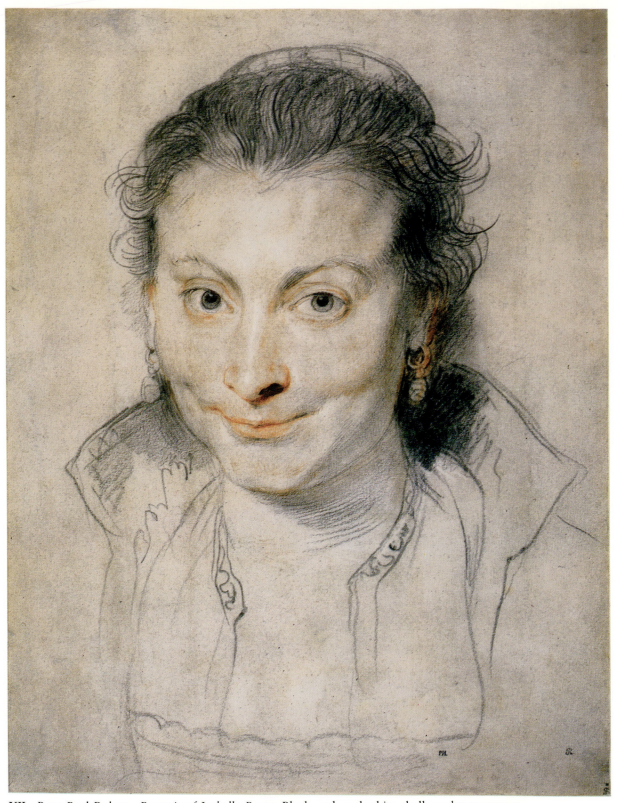

**XII** Peter Paul Rubens. *Portrait of Isabella Brant*. Black, red, and white chalk on brown paper, 38.1 x 29.5 cm. Reproduced by courtesy of the trustees of the British Museum, London.

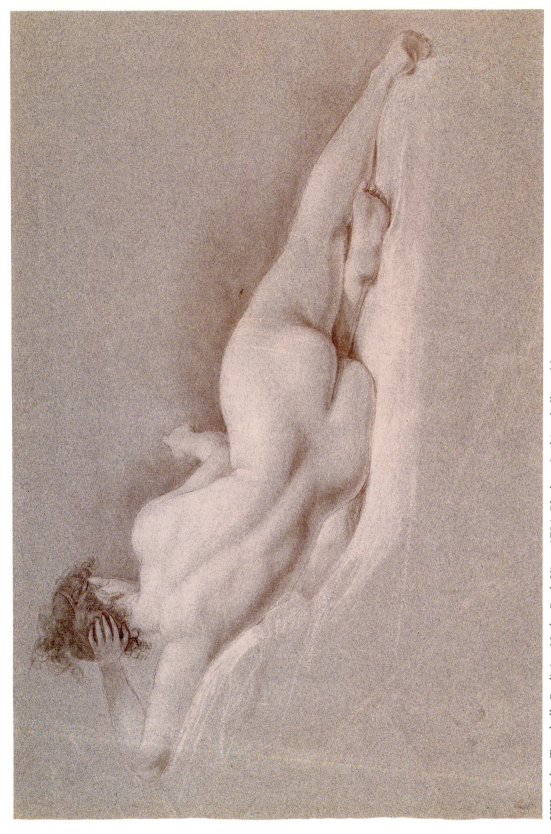

XIII   John Trumbull. *Reclining Nude: Back View*. 1784. Black and white chalk on blue paper, 14 x 22 1/2".
© Yale University Art Gallery, Yale Station.

# Drawing from Life

**Clint Brown**
Oregon State University

**Cheryl McLean**
President, CALYX Books

**Harcourt Brace Jovanovich College Publishers**

Fort Worth  Philadelphia  San Diego  New York  Orlando  Austin  San Antonio
Toronto  Montreal  London  Sydney  Tokyo

Publisher   *Ted Buchholz*
Acquisitions Editor   *Janet Wilhite*
Developmental Editor   *Barbara J. C. Rosenberg*
Project Editor   *Catherine Townsend*
Production Manager   *Kathleen Ferguson*
Manager of Art & Design   *Guy Jacobs*
Cover Design   *Amber Brown*
Compositor   *York Graphic Services*
Cover Art   *Vincent van Gogh*. Study with Three Hands. *1885. Black crayon,*
*8 x 13". Vincent van Gogh Foundation/Van Goghmuseum,*
*Amsterdam.*

**Library of Congress Cataloging-in-Publication Data**
Brown, Clint.
   Drawing from life / Clint Brown, Cheryl McLean.
      p.   cm.
   Includes bibliographical references and index.
   ISBN 0-03-028934-3
   1. Anatomy, Artistic.   2. Drawing—Technique.   I. McLean, Cheryl,
1957–      .  II. Title.
NC760.B86   1992                                             91-29647
743′.4—dc20                                                  CIP

ISBN: 0-03-028934-3

Requests for permission to make copies of any part of the work should be mailed to: Copyrights and Permissions Department, Harcourt Brace Jovanovich, Publishers, Orlando, FL 32887.

*Address for Editorial Correspondence* Harcourt Brace Jovanovich, Publishers, 301 Commerce Street, Suite 3700, Fort Worth, TX 76102

*Address for Orders* Harcourt Brace Jovanovich, Publishers, 6277 Sea Harbor Drive, Orlando, FL 32887
1-800-782-4479, or 1-800-433-0001 (in Florida)

PRINTED IN THE UNITED STATES OF AMERICA

2 3 4 5   048   9 8 7 6 5 4 3 2 1

# Preface

Without a doubt, the most valuable resources for life drawing is the human form, the life model. However, as anyone who has ever taken or taught a life drawing class knows, the mere inclusion of this important and often costly resource limits the time an instructor can or is willing to spend in discussing and demonstrating drawing techniques or in studying important historical and contemporary examples. These activities are usually excluded or limited to those short periods during the model's break.

The primary objective of this text is to provide the all-important supplementary information that enhances the studio practice and thereby contributes to the student's successes. This text offers much more than a course syllabus or a series of drawing exercises. It is designed to augment the studio experience so that the student comes to the drawing sessions with prior knowledge and a greater appreciation for the history, vocabulary, and techniques of life drawing. It is designed to complement and reinforce the information that drawing instructors provide and to encourage follow-up reading to carry skills and information from one drawing session to the next.

*Drawing from Life* approaches learning to draw the figure in a way that parallels the creative process, tracing a series of evolutionary steps that begins with sketchy notations followed by analysis, clarification, embellishment, evaluation, and refinement. The text is arranged to follow a similar progression, beginning with the ways an artist visually notes the underlying form and structure of the body, adding layers of technical and conceptual refinement, and concluding with an overview of the prevailing philosophical concerns of contemporary artists.

The first section established a basic vocabulary and defines the concepts necessary for classroom dialogue. Chapter 2 starts students off with quick gestural and schematic sketches and explores the wealth of information these quick drawings can convey. Chapter 3 introduces the study of human proportions and provides accessible explanations of sight measuring techniques and drawing the figure in perspective. Chapters 4 and 5 are devoted exclusively to the further study of line and value, the two primary tools through which drawings communicate.

The extensive anatomy section focuses on how the skeletal and muscular systems work together to determine the body's underlying structure and outward appearance. The chapters progress from the larger, more easily comprehensible form of the torso to the intricacies of the limbs, hands, and feet, and concludes with the study of the head and face. Accompanying the fine anatomical illustrations are many drawings by the masters that demonstrate the aesthetic and expressive applications of the artist's understanding of anatomy.

Section 3 focuses on the significance of the figure in contemporary art. Together, chapters 9 and 10 point out the role the human figure can play as both a compositional and an expressive device and how figure drawings can go beyond the level of figure studies. The text concludes by suggesting guidelines for evaluating both one's own work and that of others.

We believe the reader will find this text an enduring reference book, full of useful information, presented in a positive, supportive framework, introducing critical ideas without pedantic strictures in straightforward language that explains without daunting. We have tried, when relevant, to place the subject matter within its historical context so that students may obtain a deeper appreciation of the tradition of life drawing. You will also find a great many quotations by well-known artists who offer both informative and inspiring insight into the process of drawing.

We also believe you will find the layout of this book adaptable, lending itself easily to semester- or quarter-length sessions, or for a full year's sequential study. The instructors determine how much emphasis and studio time they wish to dedicate to basic techniques, anatomy, and composition and expression. The anatomy section, for example, could be presented as a topic for studio work or treated as an area for independent study. The third section lends itself particularly well to

expansion because of its focus on contemporary issues and experimentation.

The illustrations included in the text provide a sort of portable museum of figure drawing, examples valuable for any student but especially for those who have not yet developed the habit of visiting museums to study art or those for whom museums and galleries are not readily available. The drawings and sketches of the old masters, which constitute the bulk of the text, inspire a careful study of the human form and provide the student with a standard for quality. The broad array of drawings by contemporary artists; especially those in section 3, provide a stimulating wellspring for the students' own creative expression as they prepare to be artists in the twenty-first century.

Of the nearly four hundred illustrations in the text, all but a few are reproductions of actual drawings rather than prints, diagrams, photographs, or paintings. You will also discover that they are stylistically diverse, revealing a broad spectrum of possibilities. We have made a determined effort to include drawings by women and artists of color so that the artistic visions as well as stylistic approaches might be as varied as possible and more closely represent the figurative work being practiced today.

At the conclusion of each chapter, an "In the Studio" section provides exercises that suggest ways the student may apply concepts and develop skills related to the discussions and illustrations in the preceding chapter. Undoubtedly, individual instructors will want to modify and add to these exercises, tailoring them according to their own experience and to better meet the needs of their own students. The illustrations accompanying these exercises represent a variety of approaches and come from colleges and universities across the country. These drawings serve another purpose as well. Studying the works of masters like Leonardo or Michelangelo or Raphael can be intimidating to beginning drawing students. By presenting the works of their peers, we hope to help students feel more comfortable with their own initial efforts,

gaining confidence in their abilities as they proceed.

We want to express our appreciation and thanks to a number of individuals who have contributed to this project. We are extremely grateful to the many artists, students, private individuals, museums, and galleries who have provided the illustrations reproduced in this text. Our thanks, too, to the many students who read the material, performed the drawing exercises, and provided valuable feedback.

We would like to thank the following reviewers for their insightful critiques, which helped us direct our thinking and mold the text through its several drafts: Beverly Rusoff, Syracuse University, Syracuse, New York; Tim Morris; Richard W. Hlad, Tarrant County Junior College, Hurst, Texas; Harold Zisla, Indiana University, South Bend, Indiana; Steve Lotz; Robert K. Gronendyke, Sonoma State University, Rohnert Park, California; Richard Long, University of Wisconsin, Madison; Vince Falsetta, University of North Texas, Denton, Texas; Jerry Schutte, Arizona State University, Tempe, Arizona; Patrick Dullanty, Cosumnes River College, Sacramento, California; Stuart Baron, Boston University, Boston, Massachusetts; Bob Brawley, University of Kansas, Lawrence, Kansas; Thomas Gregg, Southwest Missouri State, Springfield, Missouri; Rita Lambros, Concordia College, Moorehead, Minnesota; and Wayne Horvath, Saddleback College, Mission Viejo, California.

We would also like to extend our special thanks to those individuals at Holt, Rinehart and Winston for their assistance, support, and encouragement: Janet Wilhite, Acquisitions Editor; Barbara J. C. Rosenberg, Developmental Editor; Cathy Townsend, Project Editor; Kevin White, Permissions Editor; Kathleen Ferguson, Production Manager; Guy Jacobs, Manager of Art and Design; and Mary Pat Donlon, Marketing Manager.

C.B
C.M

# Contents

# Drawing from Life

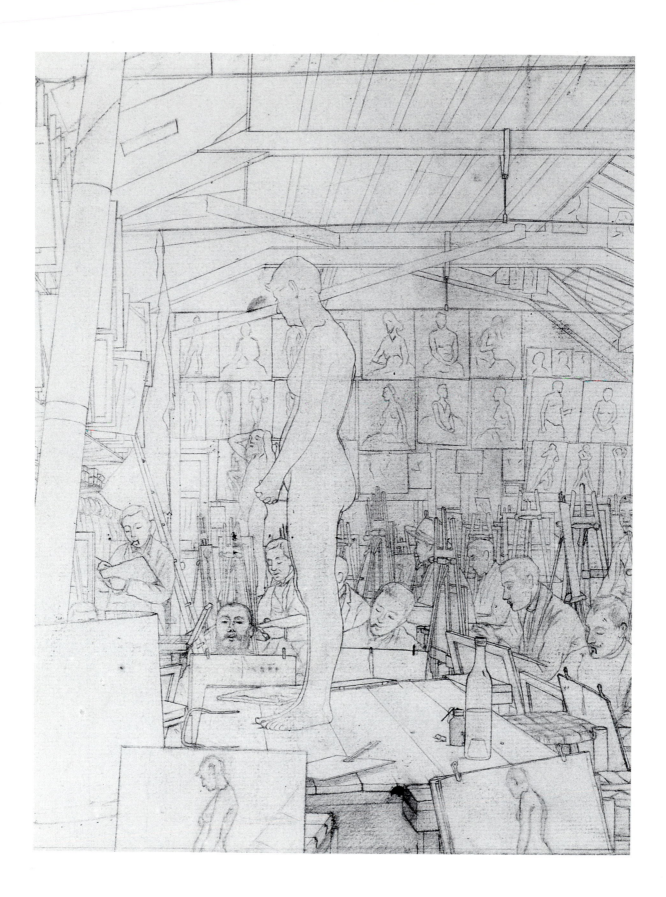

# SECTION ONE
## Getting Started

*A man paints [or draws] with his brains and not with his hands.*
—*Michelangelo Buonarroti*

*Drawing from Life* refers not only to the time-honored tradition of drawing from the life model but also to the notion that all artists, whether novice or professional, draw from within themselves and from their own life experiences in expressing their creativity. Drawing is a highly complex form of activity that engages the whole body—physically, psychologically, and intellectually. As humans, we are united on a fundamental level with all other members of our species. When drawing another human being, we symbolically reach out and bring that person near, and in the process, we instill a part of ourselves in the image we create. The drawing itself is never just a reflection of the subject: it is biographical and, therefore, for the artist, it becomes autobiographical.

The image of the human figure has, across cultures and throughout history, served as a potent visual metaphor through which artists have not only expressed themselves but something of the world in which they lived.

It was the Greeks who first used the nude body as both the subject and the form of their art. Kenneth Clark, in his treatise *The Nude: A Study in Ideal Form,* describes the nude as "an art form invented by the Greeks in the fifth century, just as opera is an art form invented in seventeenth-century Italy. . . . the nude is not the subject of art, but a form of art."[1]

The nude as an art form stretches across the centuries, linking artists of this age with the great masters of the past. Contemporary artist Isabel

Bishop represents this timeless subject in a style and tradition with its roots in the early Renaissance, Figure I.1. The artists of the Renaissance, spurred by a desire for greater realism, began an intense study of the human body. A renewed interest in classical art, with its prevalent use of the nude, encouraged the more progressive artists of the Renaissance to make studies from life models. From then on, such study has been considered an essential part of artistic training for all visual artists.

In 1563, Cosimo de' Medici, Florentine ruler, banker, and patron of the arts, officially founded the first art academy in Europe, the Accademia del Disegno, which offered students an opportunity to study anatomy and draw from life models. Similar academies emerged in other centers throughout Europe, and one of the most influential was the Académie Royale in Paris, founded by a decree

**I.1**
Isabel Bishop. *Nude Bending.* 1949. Ink and ink wash, 5 3/4 x 5 1/2″. Midtown Payson Galleries, New York.

**I.2**
Jefferson D. Chalfant. *Bouguerau's Atelier at the Julien Academy, Paris (Detail).* c. 1891. Pencil, 440 x 360 mm. The Fine Arts Museums of San Francisco. Gift of Mr and Mrs. John D. Rockefeller III, 1979.7.26.

from Louis XIV in 1648. The Académie Royale, for a long time, claimed a monopoly on the study from life in France, and models were forbidden to pose outside the Académie except in the studios of its members.

Female models were not allowed to pose nude at the Académie Royale until about 1780; and the École des Beaux-Arts, founded in Paris in 1795, forbade female models until 1863. However, it wasn't just female models who were barred from these prestigious academies; women artists were also excluded until near the end of the nineteenth century. The fact that women were virtually denied the opportunity to directly study the nude figure at a time when the nude was such a prevalent subject in Western European art explains to some degree the small number of nudes by women prior to the twentieth century. Jefferson Chalfant's 1891 drawing (Figure I.2) of a Paris life-drawing

studio reveals an environment not too different from those of today, except that in modern studio classes more than half of the students would likely be women.

The curriculum of the academies, moreover, was tightly regimented and restrictive by today's standards. The students were required to prove their worth by adhering to certain levels of academic professionalism in life drawing before being admitted to the painting studio. Notice the stamp to the left of the figure, which reads "Admitted to life/Admitted to painting," on an examination drawing by Abraham Walkowitz, Figure I.3.

Pablo Picasso drew his traditional study of the human form, Figure I.4, at the age of fifteen, when he was studying art in Barcelona. This early training served as a foundation for the innovative and exploratory work of his later career. "There is no abstract art," Picasso once said. "You must always

**I.3**
Abraham Walkowitz. *Life Study*. 1895–1905.
Charcoal on paper, 23 5/8 x 16 1/2″ (60.1 x 41.91 cm).
Whitney Museum of American Art, New York.
Gift of the artist, by exchange, Collection
of Whitney Museum of American Art;
Geoffrey Clements Photography.

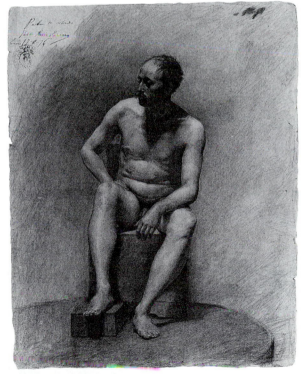

**I.4**
Pablo Picasso. *Charcoal and crayon drawing*.
1896. Charcoal and crayon, 60 x 47.4 cm.
Museo Picasso, Barcelona.
Gift of the artist, 1970. MPB 110.874.

start with something."[2] In fact, Picasso frequently worked from life models, and the human figure remained the most inspirational subject throughout his long career.

In the life-drawing studio, aspiring artists expand their understanding of the human form and hone their drafting skills, learning to render what they see accurately and with sensitivity to the subject. With this greater understanding and skill, the figurative artist explores his or her own paths of creative self-expression.

Although most artists view life drawing as an essential part of their formal education, for a long time it was highly suspect, considered by school administrators and the general public as an activity where nudity was sanctioned and morality questioned. Thomas Eakins was actually dismissed from his post at the Pennsylvania Academy of Fine Art in 1886 because his insistence that all students draw from the nude was thought to endanger the morals of the female students. It took decades and several hard-fought battles to get life-drawing classes introduced into the curricula at many of the schools where it is now taken for granted. The outcome, however, has been greater diversity in the study and representation of the human form.

Today, life drawing has more truly come to represent "drawing from life"—both in the traditional sense of drawing from the life model in the studio and from all of life's experiences. For example, Larry Rivers's quick sketch, Figure I.5, was inspired not by a living model, but by a photograph, which appeared in *Life* magazine, of the last Civil War veteran lying in state. The photograph was a symbol that marked the end of an era in American history. Rivers was moved by its significance, and he completed several large paintings commemorating the event. All of life's experiences, even those shared through history or mass media, are legitimate sources of inspiration for the artist who draws the figure. The term *drawing from life,* in the context of this book, centers on drawing directly from the nude, which we feel is critical, but also includes drawing from the artist's broader experiences, where, as Edgar Degas once said, "a transformation is effected during which the imagination collaborates with the memory."[3]

I.5
Larry Rivers.
*The Last Civil War Veteran-Dead, 1961.*
1961. Pencil, black crayon,
and paper collage heightened with white
gouache on spiral sketchpad sheet,
9 15/16 x 8" (25.2 x 20.3 cm).
Baltimore Museum of Art, Baltimore.
Thomas E. Benesch Memorial Collection,
BMA 1961.261.

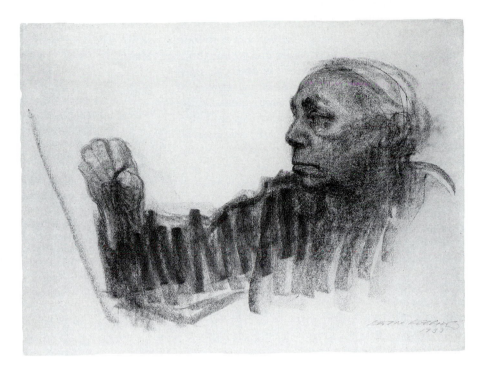

**I.6**
Käthe Kollwitz.
*Self-Portrait with
a Pencil.* 1933. Charcoal
on brown laid paper,
.477 x .635 m
(18 3/4 x 25″).
National Gallery of Art,
Washington.
Rosenwald Collection,
B-7713.

## The Mind's Eye

In recent years, researchers from various disciplines have sought clues as to how the mind processes and retains information. They have discovered that different regions of the brain control different mental processes;[4] but it is our contention that drawing is such a complex activity that it engages the whole person, involving intricate mental processes that at times demand analytic reasoning as well as intuitive responses. As psychology professor Howard Hoffman concludes in his book *Vision and the Art of Drawing,* "Our eyes may look, but it is our brain, and ultimately our whole brain, that sees."[5]

Käthe Kollwitz's self-portrait, Figure I.6, involves the artist's total being—physically as well as psychologically. You can see the connections between the eye and the mind and the drawing hand. You can sense her concentration as well as the physical energy of her action. In order for Kollwitz to create this self-portrait, she had to employ analytical processes that are generally attributed to the left hemisphere of the brain, and she had to respond intuitively to the visual spatial relationships, a process generally associated with the right side of the brain.

Drawing is spatial and sequential, but can also be spontaneous and intuitive as well as precise and analytical. It involves you subjectively as well as objectively. Ultimately, your mental attitude has far more to do with your development as an artist than does the organization of the human brain. Motivation, fortitude, pride in your work, and concern for quality all contribute to the success of your drawings. It is also important to learn to think as an artist. When drawing from life, this means learning to think in terms of the body's gesture, movement, mass, contours, volume, structure, proportion, anatomy—all of which are translated onto the drawing surface through a manipulation of line and value in a composition of the artist's design. Viewing the model in these terms allows the artist to maintain a professional detachment, which employs a mental attitude often difficult for the nonartist to comprehend.

## Learning to Draw

One does not learn how to draw simply by having someone describe the process or explain how it is done. As with learning to play a musical instrument, learning to draw requires an investment of time for practice. For a music student, it is also an essential part of education to hear the music of others. In like manner, a drawing student can benefit greatly by carefully observing the drawings of

skillful artists. As you look, see with the eyes of an artist, not those of a casual observer. Learn to look beneath the surface and consider everything about how the drawing was made. How does the artist use line, apply value? How does the choice of paper and media affect the drawing? How did the artist begin? What were the first strokes, and how did the drawing progress from there? Ask yourself about the compositional and expressive elements of the drawing. Reading about drawing is also helpful, revealing significant points that may otherwise go unnoticed.

Through your study of master drawings, your reading, your instructor's insights, and most especially through your diligent practice, you will begin to develop a sense of what constitutes qual- ity in a drawing, you will hone your own drawing skills, and you will expand your potential as an artist.

## Endnotes

[1] Kenneth Clark, *The Nude: A Study in Ideal Form* (Garden City, NY: Doubleday Anchor Books, 1956), 25.

[2] Pablo Picasso, interview in *Cahiers d'Art*, 1935; quoted in Ian Crofton, *A Dictionary of Art Quotations* (New York: Schirmer Books, 1988), 1.

[3] Edgar Degas, quoted in P. A. Lemoisne, *Degas et son Oeuvre* (Paris: Paul Brame et C. M. de Hauke, 1946), 100.

[4] Roger Sperry was awarded a Nobel Prize in 1977 for his analysis of the function of the hemispheres of the brain.

[5] Howard S. Hoffman, *Vision and the Art of Drawing* (Englewood Cliffs, NJ: Prentice-Hall, 1989), 144.

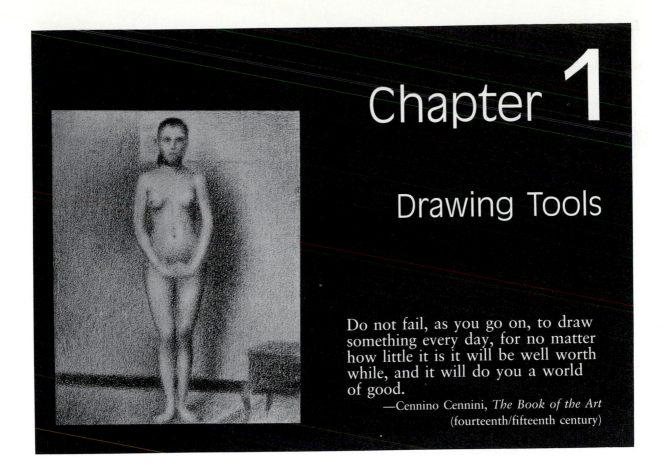

# Chapter 1

# Drawing Tools

Do not fail, as you go on, to draw something every day, for no matter how little it is it will be well worth while, and it will do you a world of good.

—Cennino Cennini, *The Book of the Art*
(fourteenth/fifteenth century)

An artist, like any professional, must develop a thorough knowledge of the tools of the profession and a proficiency in using them. The more you know about the capabilities of the tools of your craft, the more effectively you will use them to express your ideas. When drawing, the visual artist actually employs two different sets of tools: physical and conceptual. The physical are tools the artist can hold, tools that make perceivable marks on tangible surfaces. These are the raw materials of drawing: charcoal, pencils, paper. The other set of tools comprises the visual elements—the conceptual components of a drawing—such as line and value, texture and form. These are the artist's tools of communication. Different tools convey different impressions, each giving the figure you draw a distinct characteristic or personality. Chances are, you have received an introduction to both of these sets of tools in other drawing or design courses. The discussion in this chapter is intended to reexamine the conceptual tools as they apply to the specific task of drawing the human figure.

## Visual Elements as Conceptual Drawing Tools

Line, value, form, space, texture, pattern, and color are tools through which the visual artist communicates. The artist creates these tools, often referred to as the visual elements or the elements of design, by applying drawing media to the drawing surface. The arrangement and manipulation of these optically perceivable elements give a drawing its aesthetic and descriptive qualities. Whereas the physical, mark-making tools are tangible, passive instruments held in the artist's hands, these conceptual tools are expressive, active agents grasped by the intellect. These are the fundamental elements of the visual artist's language, used to formulate pictorial symbols to evoke impressions of the subject it is to represent.

Although every drawing of the figure is an abstraction (in that it is a symbolic representation, not a real person), a drawing can present us with a highly personalized and revealing description that communicates across cultures as a nonverbal lan-

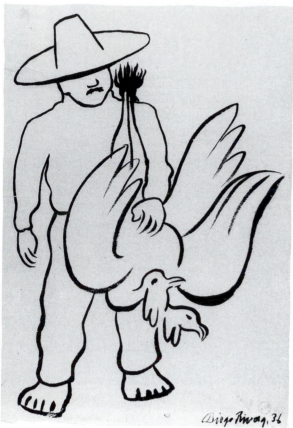

**1.1**
Diego Rivera. *Peasant Carrying Two Chickens.*
1936. Brush and Chinese ink on Japan paper,
15 1/2 x 10 7/8". The Chrysler Museum, Norfolk,
Virginia, 50.48.23.

munication is possible, in part, because the human mind is a willing participant and will complete—round out, you might say—an image with only the slightest provocation. The representational artist has learned to manipulate the visual elements for the express purpose of suggesting three-dimensional form.

In drawing, line and value are by far the artist's two most used and useful tools, for they can create textures, patterns, and the illusion of volume and space. Line allows the artist to abbreviate, to extract the essence of a subject with speed and efficiency. Value embellishes and more convincingly mimics what we actually see. The characteristics of line and value are not exclusive. Indeed, even a simple line, as in Rivera's drawing, is only distinguishable because of the value contrast between it and the surface on which it is inscribed. Although the visual elements are never presented in total isolation and are separable only on a theoretical level, it is useful to consider the special character and communicative power of each in its own sphere.

guage. Unlike a written or spoken language, which requires translation from one tongue to another, a drawing can hold and transmit information universally because its symbolism is based on the common way we see. Diego Rivera, in Figure 1.1, generalizes his subject with broad outline to create an archetypal image of the Mexican peasant, one that people all around the world can understand even if they have never traveled to Mexico. His drawing illustrates the universal, nongrammatical syntax of drawing.

Communication, whether oral or visual, depends on our human capacity for perceiving and understanding symbols. The word "dog" is not, in and of itself, a four-footed creature with teeth and wagging tail. The drawing of a dog, too, is merely a visual symbol. Both the word and the drawing communicate; they provoke, within the listener or viewer, a responding comprehension. This com-

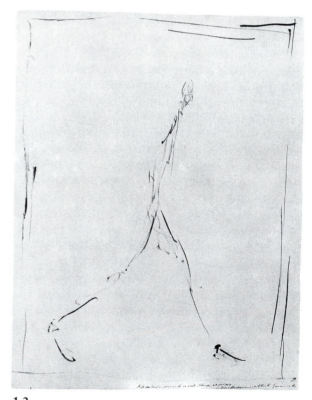

**1.2**
Alberto Giacometti. *Walking Man.* 1950.
Oil on cream paper, 26 3/4 x 20".
© 1990 ARS N.Y./ADAGP.

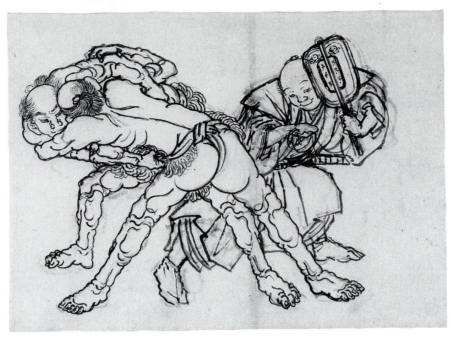

**1.3**
Hokusai. *Wrestlers*. Black ink over red, 12 1/2 x 16 3/8".
Reproduced by Courtesy of the Trustees of the British Museum, London.

## LINE

The power of line lies in its versatility, the myriad ways in which the artist can express personal views or characterize the human figure. In twentieth-century artist Alberto Giacometti's drawing, *Walking Man*, Figure 1.2, the line itself is a metaphor for the body of the man. Giacometti's line abbreviates the form and concept of a man in motion, recognizing the power line has to imply so much beyond itself. In a more complete narrative, the Oriental master Hokusai uses a brisk, chisel-like line to suggest the tension and action of combative wrestlers, Figure 1.3. Honoré Daumier lavishly applies line to build up volumes through a kind of sketchy layering, Figure 1.4. His lines are loaded with energy. Rather than give a clear sense of the body's contour, these lines collectively create an impression of the body as an undulating mass. Each line adds a bit more momentum and synergy to the overall impression of the drawing.

Whereas Daumier's lines are flamboyant and amply applied, David Hockney's use of line in his portrait of Sir John Gielgud, Figure 1.5, is more controlled and precise. It speaks softly and, like its subject, is much more reserved. The lines do not draw attention to themselves but quietly conform

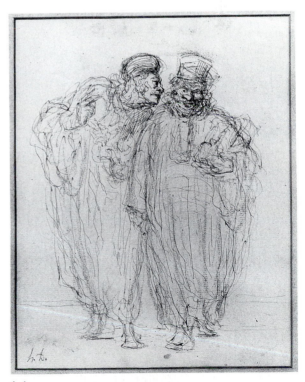

**1.4**
Honoré Daumier. *A Confidence*.
Black and red ink on charcoal, 23 x 18.5 cm.
Victoria and Albert Museum, London, (CA1 127).

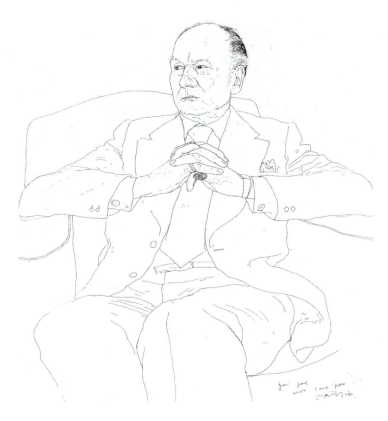

**1.5**
David Hockney. *Sir John Gielgud.*
Ink on paper, 17 x 14″.
The Fine Arts Museums of San Francisco,
Achenbach Foundation for
Graphic Arts purchase.

to the edges of the forms they represent. Lines render the facial features and suggest the folds of the clothing without use of shading or value.

## VALUE

Value refers to the tonal range of light and dark, from the brightest white to the darkest black, and all shades of gray in between. When drawing the human figure, value can be as expressive as line. Manuel Neri's mixed-media drawing, *Torano No. 2*, Figure 1.6, uses value to build up the body's form into an opaque, dense mass. We can begin to see the dramatic and expressive power of value. Devoid of details or movement, Neri's figure appears as a nongendered, anonymous being, distinguishable from its foglike surroundings only in

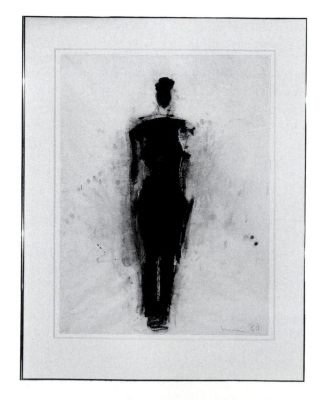

**1.6**
Manuel Neri. *Torano No. 2.* 1980.
Ink, charcoal, and pastel on paper, 39 1/4 x 29 3/4″.
Private collection, Washington. Photograph courtesy of John Berggruen Gallery, San Francisco.

**1.7**
J. Alden Weir. *Standing Male Nude, Viewed from Rear.* 1874. Charcoal on paper, 24 x 18 3/4″. Provo, Utah. Courtesy of Brigham Young University Museum of Fine Arts. All rights reserved.

**1.8**
Georges Seurat. *Study for "Les Poseuses."* c. 1887. Charcoal, 30 x 22.5 cm (9 1/2 x 11 7/8″). New York. The Metropolitan Museum of Art, Robert Lehman Collection (1975.1,704).

terms of value. Yet it has the imposing density of a radioactive monolith, emitting its own energy field, which, in turn, activates its surroundings.

Some artists would argue that value is more truthful than line because it more closely depicts what the eye actually sees. With value, the artist can duplicate the pattern and tonal gradations of light as reflected from the surface of the subject and create a powerfully convincing illustration of the three-dimensional figure.

*Standing Male Nude,* Figure 1.7, was drawn by the nineteenth-century American artist J. Alden Weir while he was a student at the École des Beaux-Arts in Paris. It demonstrates how effectively value can describe the body as a three-dimensional, anatomical form. In this drawing, charcoal records all of the subtle shifts in value that reveal the musculature within the body's contours and beneath its skin. The primary function of value is to convey visual information related to the play of light and to Weir's knowledge of anatomy.

Georges Seurat also studied at the École in Paris at this time. Although his student drawings clearly demonstrated his innate ability as an academician, he was soon influenced by scientific theories related to the nature of light and the invention of photography. His drawing, *Study for "Les Poseuses,"* Figure 1.8, shows how some of these influences manifested themselves in his later drawings. Here, Seurat uses value to the total exclusion of line. The result is a drawing that approximates the effect of a photographic image printed on textured paper.

## FORM AND SPACE

Form relates to the three-dimensional distribution of an object's volume. Space is the three-dimensional area around and between forms. It can be limited to the size of an enclosed box or room, or it may project to the stars in the universe.

Both form and space are fundamental to our existence in the real, three-dimensional world.

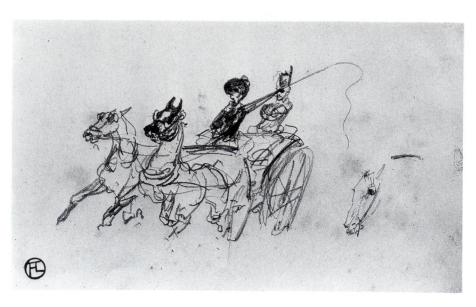

**1.9**
Henri de Toulouse-
Lautrec.
*Toulouse-Lautrec
Sketchbook: La Comtesse
Noire.* 1880.
Graphite on ivory
wove paper, 6 3/8 x 10″
(16 x 25.6 cm).
Rober Alexander Waller
Collection, 1949:80
leaf 4 recto.
© 1990 The Art Institute
of Chicago.

They are experienced on a physical level as we move through our surroundings. They can be experienced even in total darkness. In the plastic arts, such as sculpture and architecture, form and space can actually be created and aesthetically arranged. With drawing, however, form and space are experienced visually, as created illusions. This is not necessarily a limitation of drawing, for the artist is free to conjure forms that allude to our experience or spaces that stretch our imagination.

Henri de Toulouse-Lautrec's drawing of a horse and carriage, Figure 1.9, for example, brings to life the clatter of horse hooves and carriage wheels on cobblestones and the crack of a whip. We can feel the rapid advance of the horses and sense their muscular power and attitude of pride as they prance. From the simplest of visual clues, we gather a myriad of impressions about forms moving through space and also find ourselves transported to another time and place.

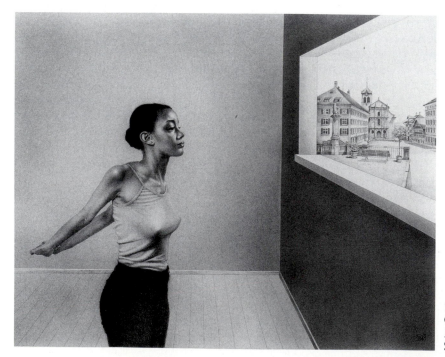

**1.10**
George Staempfli. *Looking
Back.* 1983. Pencil, 40 x 50 cm.
Staempfli Gallery, New York.

In a more detailed description, the suggestion of three-dimensional space pulls us into George Staempfli's drawing, Figure 1.10, and makes us forget that the surface of the paper exists. The modeling of the figure in a three-quarter view, with her arms stretched back—the perspective of an interior with the lines of the floorboards rising rapidly toward the horizon, the cityscape beyond—all lead us progressively deeper beneath the physical surface of the drawing paper into a world both alluring and mysterious.

## TEXTURE

Texture in the visual arts refers to the surface quality that can be experienced either as a tactile or, more frequently, as a purely visual sensation. Texture adds a great deal of information and richness to a drawing. In monochrome drawings (in a single color or medium), texture can distinguish one area from another and describe, in the absence of color, a multitude of visual sensations. It can capture the unique aura of an object by imitating its surface appearance, or it can transform an otherwise dull or nondescript area in a drawing into an opulent surface of the artist's invention. Texture can be defined in three ways: *physical texture*, *invented texture*, and *illusionistic texture*.

*Physical texture* actually exists in three dimensions: you can feel it with your hands. In a drawing, physical texture is usually limited and determined by the choice of drawing instruments and paper. Although the artist physically experiences the texture of the paper and media, the viewer experiences physical texture primarily as a visual quality of the drawing after the drawing is completed. In *Study for "Les Poseuses,"* Figure 1.8, Seurat chose a particularly rough-textured paper, the effects of which we can see in the grainy background. It is an example of how the physical texture of the drawing surface often becomes a visually observable element in a drawing.

*Invented texture* is created for its own sake as a purely optical phenomenon in order to add richness or expressiveness to the drawing, with little or no regard to the accuracy of the illusion. Rather than being referential, invented texture is primarily an aesthetic device. Invented texture often amplifies the manual application of the media and provides a record of the artist's physical action during the drawing process.

What distinguishes one texture area from another are variations in the application of the media to the drawing surface. The textures in Vincent van Gogh's portrait of his postman, Figure 1.11, result from shifts in the size and direction of the marks made during the drawing process. Within each area—coat, hat, beard, and wall—van Gogh changes the character of his strokes, giving each object a distinct textural quality. The diversity helps him differentiate the separate forms and materials in the drawing. Notice, however, that van Gogh uses texture to distinguish shapes rather than create an accurate illusion of how the surfaces would appear or feel. In this way, he invents textures as substitutes for color.

*Illusionistic texture* is created when the artist uses one material to represent the appearance and surface quality of other materials, as, for example, when an artist uses a graphite pencil to create the illusion of wrinkled skin, silky hair, coarse fabric, or grainy wood. With illusionistic texture, the artist's goal is to make the viewer forget about the

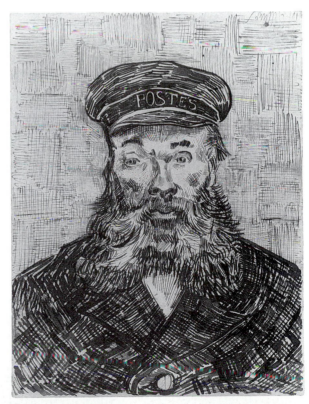

**1.11**
Vincent van Gogh. *Portrait of Joseph Poulin.* 1888. Reed and quill pens and brown ink over black chalk, 12 5/8 x 9 5/8″ (32 x 24.4 cm). The J. Paul Getty Museum, Malibu, California.

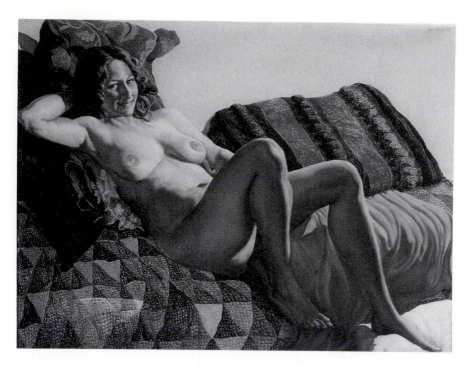

**1.12**
Jack Beal. *Patty*. 1985.
Pastel on paper,
48 x 60″.
Courtesy Frumkin Adams
Gallery, New York.
Photo by eeva-inkeri.

actual material substance of the drawing—graphite or charcoal on paper—and instead think of the represented material. The artist also minimizes the physical process by which the drawing is made. Jack Beal's realistic portrait, *Patty*, Figure 1.12, reveals a range of textures, from smooth flesh to the nubby fabric in both the blanket beneath the figure and the pillow to her right. The soft drapery of the blanket beneath the pillow provides a contrast, as does the flowery fabric behind the model's head. Beal applies his pigment not only to distinguish shapes and objects but also to

**1.13**
Simon Dinnerstein.
*Marie Bilderl*. 1971.
Charcoal,
conté crayon, 41 1/2 x 49 1/2″.
Minnesota Museum of Art,
St. Paul. Photograph courtesy
of the Staempfli Gallery,
New York. Photograph by
Peter A. Juley & Son.

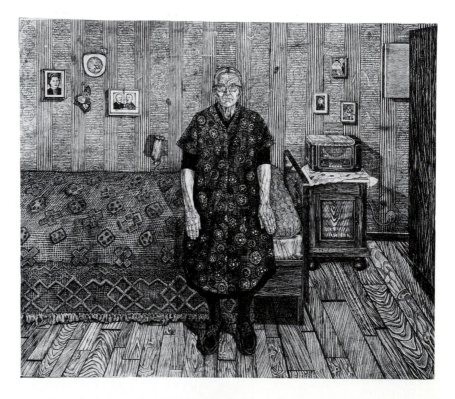

suggest the tactile surfaces of real objects. The viewer remains unaware of the strokes of the pencil, the marks themselves, as a record of the drawing process.

Simon Dinnerstein employs a vast repertoire of marks to create a richly textured environment in his charcoal drawing of *Marie Bilderl*, Figure 1.13. Each surface takes on a distinctive quality even though each is drawn with the same medium. Dinnerstein's eye seems to magnify the textural details, for he draws them with a crispness that makes them more vivid on paper than they are in reality. Although his subject stands passively in her modestly furnished room, Dinnerstein's rich texture brings out the character of his subject and reveals an unexpected textural opulence within a stark, rather stoic environment.

## PATTERN

Pattern refers to the sequential arrangement of values and textures over a broad area. In addition to their use of texture, artists Beal and Dinnerstein, in Figures 1.12 and 1.13, also describe rhythmic pattern sequences. In Beal's drawing, the fall of light determines the patterns of value on the smooth texture of the body, while the figure is surrounded by the more texturally rich patterns of the fabric. Dinnerstein's interior drawing is filled with pattern sequences. Whether you look at the old woman's dress, her bedspread, the wall, or the floor, you are confronted with pattern in a manner that conveys the homespun quality of a patchwork quilt. Pattern, like texture, is determined in part by the viewing distance. For example, when viewed from far away, the wood grain in the floor appears to be texture; but when viewed at close range, the pattern created by the relationship of the individual boards becomes more apparent. Pattern also refers to the mosaic quality of a picture. As opposed to poetry or music, which both involve a progression through time, a drawing is a progression through space and is "read" all at once as an optical pattern on the retina. The layperson may be consciously aware only of what the pattern areas represent, but on an abstract level, pattern can greatly enhance the aesthetic enjoyment of a drawing through its rhythmic sequences.

## COLOR

Color is a special consideration in drawing because its presence begins to break down the distinction between drawing and painting. Although one might argue that this is an arbitrary distinction to begin with, traditionally the role of color in drawing has been a limited one. Certainly the absence of color cannot be said to diminish the quality of a drawing. Perhaps more important than trying to distinguish between drawing and painting is recognizing that color adds to the expense and complexity of making drawings, two factors that can be restrictive to the beginning artist's progress. For these reasons, most drawing instructors reserve color media for advanced students. Color is far too important an element of visual communication, however, for it to be omitted altogether from a discussion of drawing tools.

Color can add to the descriptive and expressive power of a drawing. A traditional drawing technique involving a limited range of color is the use of natural chalks on toned paper. (See Color Plates I, II, XII, and XIII.) Although the color range is, for the most part, limited to blends of reddish-browns or white and black, it is possible to develop warm flesh tones and the illusion of a much broader palette.

In *The Tub*, Color Plate III, we see that for Edgar Degas, only the use of a pastel stick rather than a brush to apply the pigment distinguishes this drawing from his paintings. From this unconventional pose we sense that we are seeing the subject, unaware of the artist's presence, as she attends to her daily ritual of bathing. We can see Degas's awareness that color is the content of light and how light can turn a seemingly mundane activity into one rich with visual splendor. Degas attempts to capture the flickering quality of light, the surface of every object functioning as a catalyst that transforms white light into a spectrum of reflected colors.

In comparison with Degas's use of color for description, Ernst Ludwig Kirchner's use of color in Color Plate IV is free and imaginative. He applies orange, green, blue, and lavender to the surface of the nude figures, and the purity of color in combination with the energetic, zigzag strokes electrifies a drawing in which the figures themselves are rather sedate. Kirchner's expressive color reflects a flamboyant style and conforms only slightly to nature.

Elizabeth Layton's self-portrait, Color Plate X, provides an energetic example of colored pencil application. The intensity of color may not be as vibrant as with pastels or other color media, but

Layton uses the thin-lined pencils to advantage in creating an aura of power and self-reliance around her subject.

If dry color media blur the line between drawing and painting, the use of liquid color media can completely wash the line out. Yet artists have used transparent watercolors as sketching tools for centuries. Philip Pearlstein's Color Plate IX uses a full palette and demonstrates the degree of realism that can be achieved with transparent watercolor. Like Degas, Pearlstein carefully observes the pattern of light, and he uses the figure primarily as a compositional device. Transparent watercolor requires that the light ground show through to create light value areas, and multiple layers of wash define opaque regions.

Richard Diebenkorn, Color Plate VI, uses gouache, a watercolor paint to which an opaquener has been added, which allows him to work with brighter, more saturated areas of color. In comparison to Pearlstein's, Diebenkorn's use of color is both flatter and more vibrant.

*Mixed media* is a term used to describe a work of art that incorporates a combination of media. It is not a particularly new phenomenon. Artists such as Leonardo da Vinci and Raphael would not hesitate to combine media or work over the top of one medium with another. Over the centuries, artists have brought together all kinds of combinations of drawing materials to fulfill their expressive needs, which, for whatever reason, could not be met with a single drawing tool.

From a series called the Nazi Drawings, Mauricio Lasansky uses graphite pencil and turpentine in combination with watercolor washes the color of dried blood to express the horrors of war and the Holocaust of the concentration camp (Figure 1.14). He applies both the graphite and the wash in an angular, almost vicious manner, and each makes a statement that the other drawing tool alone would be inadequate to convey. He has added newspaper clippings to the surface to lend an impersonal quality that makes its own statement, serving as a stark foil to the soulful marks made by the artist's own hand. Lasansky had this to say about his choice of drawing materials: "I tried to keep not only the vision of the Nazi Drawings simple and direct but also the materials I used in making them." [1]

Jim Dine's drawing, Color Plate XI, also uses a limited quantity of color, in combination with charcoal, but it has a dramatic effect, intensifying the image and adding an expressive dimension, a heightened reality. Color, for Dine, is an image-

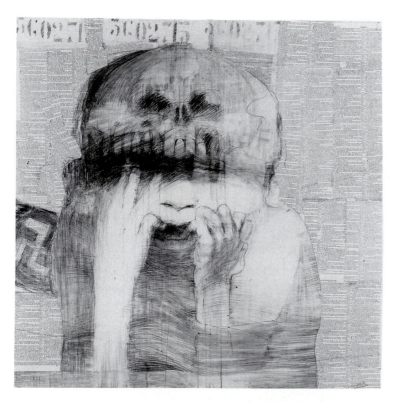

**1.14**
Mauricio Lasansky. *Nazi Drawing No. 27.* Graphite, watercolor, turpentine wash, newspaper, 46 x 46". Lasansky Corporation Gallery, Iowa City. Collection of the Richard Levitt Foundation. Photograph courtesy of the artist.

intensifying tool, not a descriptive or derivative one. Similarly, Neri uses acrylic in complement with pastel and charcoal, Color Plate VII, and Willem de Kooning uses oil paint with charcoal on paper, Color Plate V. Robert Arneson's large mixed-media drawing builds up the image of himself as a wild man from out of his multicolored attack of the drawing surface, Color Plate VIII.

## Summary

You can use just about any medium alone or in combination with others as the tools with which to fashion your drawings. The distinction between drawing and painting can be ambiguous, yet most artists would probably agree that having a clear definition is not at all important. What matters more is having whatever means are necessary to express ideas as directly and as clearly as possible. Drawing, like all visual art disciplines, is primarily concerned with ideas. Perhaps what makes drawing distinctive is that it functions at the most fundamental level of the creative process, where ideas are often still formulating and the conclusions still unknown.

Endnotes

[1] Mauricio Lasansky, *The Nazi Drawings* (Iowa City: The Lasansky Foundation, 1966).

# Chapter 2

# A Sketch to Build On

Out of the artist's impetuous mood
they are hastily thrown off . . . .
only to test the spirit of that which
occurs to him, and for this reason
we call them sketches.

—*Giorgio Vasari*
Vasari on Technique

## The Drawing Process

The significance of drawing as a genesis for creative expression in all of the visual arts has long been widely recognized. Through drawing, the artists' thoughts and ideas take form, their vague hunches and nebulous feelings are fashioned into something tangible and concrete. The sketch records a visual idea at its inception, before it is fully conceived or embellished. The impetuousness Vasari refers to is evident in a sheet by one of his contemporaries, Polidoro da Caravaggio, who crowds the page with his sketchy notations (Figure 2.1).

What is the difference between a drawing and a sketch? To sketch implies quickly conjuring or expressing in rough form the essentials of an idea or subject, without a great deal of refinement. Drawing, by definition, surely includes sketching, but sketching is limited to a particularly early stage of drawing when ideas are still indistinct, just beginning to take shape.

Drawing is an evolutionary process that includes beginning, formulating, defining, and refin-

ing stages. These stages and their sequence are rarely apparent in a highly finished work. When we admire such drawings, we are often enchanted with details and surface treatment. In fact, we have developed a hierarchy of worth, which we often apply to drawings based on their degree of refinement. In some ways, this reflects a natural appreciation for the artist's time commitment to a particular drawing. Most artists value their laborious works more than their quick, rough sketches. Often exploratory sketches are made for the artist's eyes only, executed to test an idea, to probe the unknown, to make notations for future reference. Seldom are they intended for exhibition or distribution. Historians have discovered that Michelangelo Buonarroti actually destroyed many of his rough sketches and working drawings, preferring the world not know how arduously he had labored in the development of some of his ideas.

Today it is widely understood that even the intellectual creativity of a genius involves a process of exploring options, researching ideas, and accepting and rejecting possible solutions. In addition to being impetuous, an artist's sketch can also

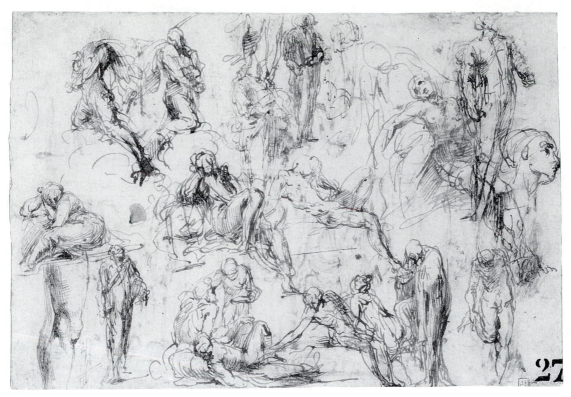

**2.1**
Polidoro da Caravaggio. *Studies for an Altarpiece with the Virgin Enthroned, Attended by Four Saints.*
Pen and brown ink wash, 20.2 x 29.8 cm. Metropolitan Museum of Art, New York.
Bequest of Walter C. Baker, 1971 (1972.118.270r).

form the impetus for creative development. The concept for Picasso's monumental painting, *Guernica,* originated with a small, almost indiscernible sketch, Figure 2.2. Although many more drawings followed before his final composition was determined, this first sketch formed the impetus of that evolutionary thought process. As Picasso himself said, "The picture is not thought out and determined beforehand, rather while it is being made it follows the mobility of thought."[1]

**2.2**
Pablo Picasso. *Sketch for Guernica.*
The Prado, Madrid, Spain.
© 1991 ARS, NY/SPADEM.

In the same way that a sketch can initiate ideas to be developed in other media, it also serves as a foundation for the evolution of the drawing. For someone involved in making drawings, understanding this evolutionary process is essential.

## The Old Masters

In the drawings of the great masters, one can often find beneath the surface traces of an underlying sketch that originally served as the drawing's structural foundation, over which sequential layers of refinement were added. This is especially true where parts of the drawing were left unfinished or where, in the search to establish the drawing's composition, the artist abandoned one pose in favor of another. The remnants of these preliminary underdrawings, where the artist has had a change of mind, are known as *pentimenti*. These ghostly fragments of the drawing's sketchy beginning are especially common in older drawings, made before the advent of erasers.

Leonardo's drawing, Figure 2.3, provides an exceptional opportunity to study its evolutionary process, from the loosely derived sketch to the highly detailed rendering of the drapery. From top to bottom, we can see how he developed the drawing by adding layer upon layer of refinement. The pentimenti faintly visible in the upper half of the drawing show how he began in silverpoint to sketch the head, changing his mind several times as he sought the appropriate gesture. In the middle of the drawing, we see some drapery that evolved from a quick sketch, with charcoal enhancing the faint silverpoint lines. At the bottom, Leonardo added white highlight, working it over and into the charcoal drawing. When we look at the delineation of these three-dimensional folds, we no longer think about its sketchy beginning. For the student of drawing, the value of Leonardo's study is its lesson on the role of the preliminary sketch in the *drawing process*.

A sketch expresses a visual concept still in a state of flux between its inception and its clarification. The visual clues it presents are therefore sometimes ambiguous, the body's form more loosely implied, often with repeated lines and changing contours that express the artist's search, rather than a firmly conceived solution. Michelangelo's drawing of *The Virgin and Child*, Figure 2.4, presents an example of a visual concept in this state of flux. The black chalk is applied in a loose, sketchy manner that captures a fleeting gesture of tenderness between mother and child. Several aspects of the drawing suggest that it is a composite of several overlapping gestures. You can see the faint image, the *pentimenti*, of another head of the mother, lightly drawn, in which she is kissing the child. The many lines suggest a bending of the woman's legs and back. During the drawing process, Michelangelo explores the pose and gesture of the body, clarifying and finally resolving his ideas about the form and composition. They take shape as he sketches.

As elegant and refined as Raphael's paintings inevitably are, his preliminary sketches, the seeds from which these masterpieces grew, are in many ways equally fascinating. Consider Raphael's

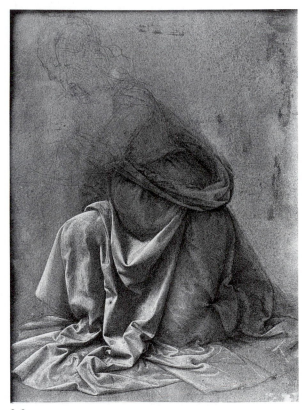

**2.3**
Leonardo da Vinci. *Study of the Drapery of a Woman*. Silverpoint, charcoal, brown wash with white lead, 10 1/16 x 7 3/4" (257 x 190 mm). Gabinetto Nationale Delle Stampe. Roma, Instituto Nazionale per la Graphica, Collezione Corsini.

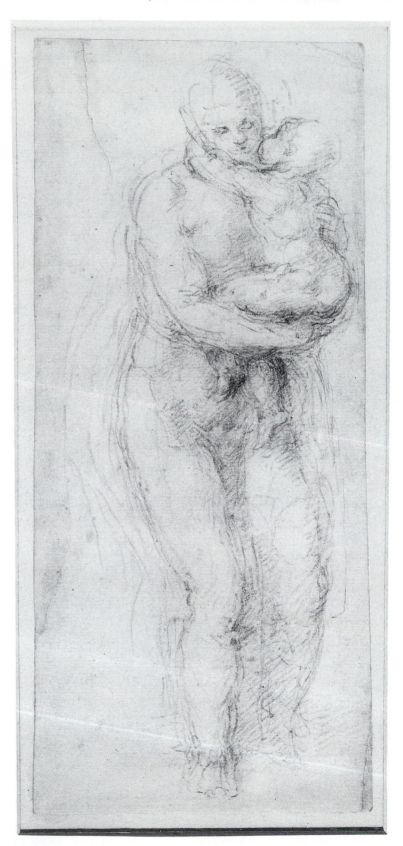

**2.4**
Michelangelo. *The Virgin and Child.*
Black chalk, 10 1/2 x 4 3/4″.
Reproduced by courtesy
of the Trustees of the British Museum,
London.

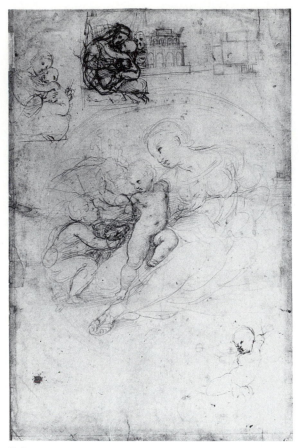

**2.5**
Raphael. *Study for the Alba Madonna.*
Red chalk, partly worked over in pen.
Musee des Beaux Arts de Lille, France.

*Study for the Alba Madonna,* Figure 2.5, and the finished painting, Figure 2.6. In the painting, he retains the figure's unmistakable fluidity and grace, as they were first expressed in his sketch. Just as the central composition in Figure 2.5 appears to evolve from a square composition (in the upper portion of the drawing) into a roundel, Raphael's figures also evolve from gestural interpretation, first drawn with a soft red chalk, into more solidly conceived forms worked over with the more distinct lines of pen and ink. Notice how the position of the Madonna's outer arm and hand is so briefly stated with just a few strokes, whereas her head and the Christ child are fashioned more completely.

So often, aspiring artists are enamored with the details and technical facility displayed in a highly polished drawing, and for some very obvious reasons, they are eager to draw with such skill. Yet because of this, they often focus their attention on the details and begin their drawings by attempting a surface rendering of one small part of their subject—the eyes or the nose—without having a grasp of the body's overall configuration. Just as an automobile or house has a frame beneath its polish or façade, a highly developed drawing is

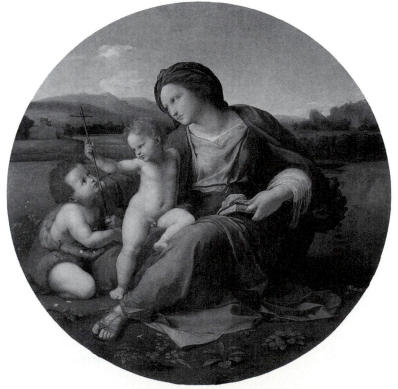

**2.6**
Raphael. *The Alba Madonna.* c. 1510.
Oil on wood transferred to canvas,
37 1/4″ diam. (.945 m).
National Gallery of Art, Washington.
Andrew W. Mellon Collection.

built on an underlying foundation. If we could peel back the layers to look underneath the finished surface, we would inevitably find the beginning, the essence of the figure's pose as a gesture or schematic sketch. Someone who appreciates a well-designed car or house does not need to know how to build one. Likewise, you don't need to know how to draw to be a connoisseur of drawings. But to make your own drawings, you, as an artist, have to be willing to work from the ground up. The ground, in this case, is the sketch—a means both of recording your initial impressions and of laying the foundation for a potential masterpiece.

In the early sketching stages of both Leonardo's and Raphael's drawings, there exists a gestural quality that expresses the impetuous haste that Vasari refers to in his definition of sketching, as in Peter Paul Rubens's impressions of *Dancing Peasants*, Figure 2.7. Initially drawn in chalk as a quick indication of the rhythmic bending and turning action of the dancers, these rather intuitive inscriptions were then strengthened and clarified with ink. The result is a description of movement and action as well as a suggestion of form. When read in sequence, one dancing couple to the next, Rubens's gestural sketch also suggests the sound of the music and the flow of the dance.

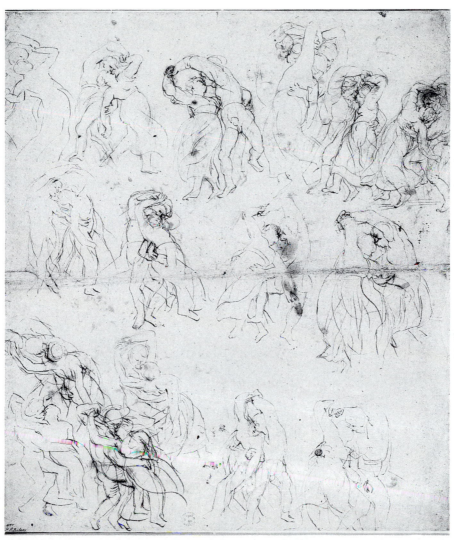

2.7
Peter Paul Rubens. *Dancing Peasants*. Black and red chalk reworked with ink, 502 x 582 cm. Reproduced by courtesy of the Trustees of the British Museum, London.

**2.8**
J. S. Sargent. *Sketch of a Spanish Dancer,
El Jaleo Sketchbook.* 1879. Pencil on paper,
11 1/2 x 9″. Isabella Stewart Gardner Museum,
Boston.

**2.9**
Albert Marquet. *Man Strolling.*
Brush and ink on paper, 18 x 9.8 cm.
Metropolitan Museum of Art,
New York. Robert Lehman Collection.

**2.10**
Rembrandt. *Two Studies of a Baby
with a Bottle.* Brown ink, 100 x 124 mm.
Staatliche Graphische Sammlung, Munich.

**2.11**
John Sloan. *Sketch*. 1912. Crayon,
6 1/4 x 4 3/4″. Delaware Art Museum,
Wilmington. Gift of Helen Farr Sloan.

## The Gesture Sketch

Gestural sketches, quick sketches, or action drawings—whatever term you give them—are all concerned with expressing the dynamics of the body's life forces and capturing the movement or the action implied in the presentation of its form. These drawings can respond to the body's kinetic energy—the physical force of actual movement—as with Rubens's Figure 2.7 or J. S. Sargent's gesture drawing of a flamenco dancer, Figure 2.8. A gesture drawing can also respond to the implied force of the body's weight and mass or to the simple suggestion of movement contained within a pose, as in Albert Marquet's *Man Strolling,* Figure 2.9. Every pose, even the most restive and relaxed, presents us with a gesture, as demonstrated in Rembrandt's study of a sleeping baby, Figure 2.10. With a few simple, curved lines, Rembrandt

wraps this child, defining its bundled form, and communicates a sense of its contentment. Typical of gesture drawings at their best, Rembrandt's sketch conveys a wealth of information and empathy through an economy of effort.

This distillation of form and gesture is also inherent in John Sloan's sketch, Figure 2.11, but the broader strokes add value to give a hint of the woman's attire and to convey a sense of formality. In the tradition of the gesture sketch, Sloan follows the form of the figure with his hand as he draws, capturing the essence of her attitude and the suggestion of her movement.

### GESTURE VERSUS OUTLINE

Although they appear simple, gesture drawings require a special attitude. Part of their difficulty comes from our fixation on details and outlines as

well as our desire to create what we think of as an "accurate" description. These preoccupations not only slow the drawing process, they are also premature. Probably the most difficult obstacle to overcome is our tendency to see the body in terms of isolated units, as a series of parts rather than as a whole entity. An initial overview is essential, enabling the artist to see the body's large relationships, thereby creating a stronger foundation and cohesiveness for the finished work. Gesture drawings respond quickly and intuitively to the impetus of a pose as a whole and describe how the figure's energy and action move through the interior of the form.

The difference between a gesture drawing and a more deliberate outlining of the figure is apparent in a comparison of two drawings of an identical subject by Gaston Lachaise, Figures 2.12 and 2.13. It was Lachaise's practice to first attempt to capture the dynamics of a pose with a gesture drawing, Figure 2.12, before inscribing forms with a more meticulous outline, Figure 2.13. The outline drawings are in many ways more refined expressions of his subject and arrived at with greater deliberation: a solitary outline circumscribes the body by flowing around the outer edge of the form. In contrast, the gesture drawing, with lines rushing all over the body, breaks away from the outer edges and suggests the action of the form more than its precise shape. Although the precise contour of the form in the gesture drawing, Figure 2.12, is fairly ambiguous, the energetic quality of the line seems to equate more truthfully with the flamboyant movement of the pose.

## THE FIGURE'S GESTURE, THE ARTIST'S HAND

In large measure, gesture drawing is a tactile event as well as a visual one: the artist *feels* the movement of the figure and the way the body's

**2.12**
Gaston Lachaise. *Seated Female Nude with Uplifted Leg.* c. 1930–34. Pen with blue-black ink and brown ink over pencil, 24 3/16 x 19″ (61.4 x 48.3 cm). Baltimore Museum of Art, Baltimore. Friends of Art Fund, BMA 1966.28.

**2.13**
Gaston Lachaise. *Seated Woman with Foot Raised.* c. 1933–35. Pencil, 24 1/8 x 19″. Museum of Modern Art, New York. Gift of Edward M. M. Warburg.

mass displaces the space around it as the artist's hand moves over the surface of the drawing paper. This rhythmic, flowing movement of the hand gave much of ancient Oriental art its distinctive quality. In Figure 2.14, a preliminary sketch by the master Ichiyūsai Kuniyoshi, we see that although the movements that created this drawing were fleeting, the ink that records the action gives it a permanence. Kuniyoshi's gestural line sweeps over the page as a record of movement, tracing the body seemingly unchecked by any inhibiting desire to present a detailed representation, which would inevitably halt or diminish the spontaneous fluidity of line.

Similarly, Raphael's drawing of a woman, Figure 2.15, records the graceful progress of Raphael's fluent lines. The multiple layers of line seem to suggest not only the movement of the body but, once again, the artist's search for the most expressive sense of the form and its movement, derived "out of the artist's impetuous mood . . . to test the spirit," as Vasari wrote.

Gesture drawing also conveys a sense of spirit. In Daumier's drawing of a frightened woman, Figure 2.16, we feel the artist's haste as much as we perceive the movement of his subject. The almost

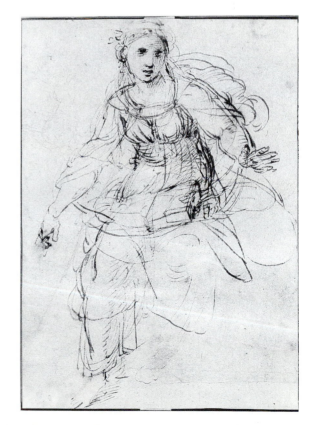

**2.14**
Kuniyoshi. *Sketch for Kakemono-e of Tokiwa Gozen.*
Ink on paper, 9 7/8 x 22 7/16".
Collection, Rijksmuseum voor Volkenkunde,
Leiden, The Netherlands.

**2.15**
Raphael. *Allegorical Figure of Theology.*
Pen and ink. Ashmolean Museum, Oxford, England.

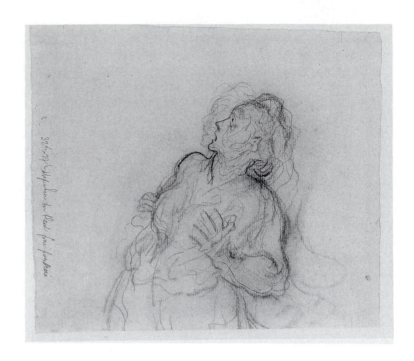

**2.16**
Honoré Daumier. *Fright.* Charcoal
heightened with crayon on
ivory laid paper, 20.3 x 23.4 cm.
Art Institute of Chicago, Chicago.
Gift of Robert Allerton, 1923.944.
Photograph © The Art Institute
of Chicago. All rights reserved.

feverish pitch of the drawing's execution portrays
in many ways a more accurate description of the
emotional content than a controlled and detailed
rendering could offer. Notice the multiple posi-
tions of the head, which suggest that she is recoil-
ing in fright. As is often the case with gesture
drawing, the artist's eye is busy looking at the sub-
ject rather than at the surface of the drawing. The
hand moves blindly over the surface in what is
often referred to as *blind gesture* drawing.

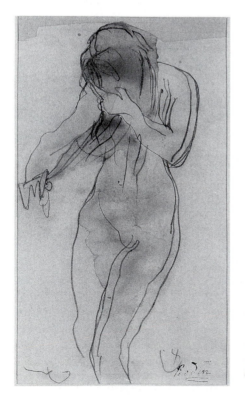

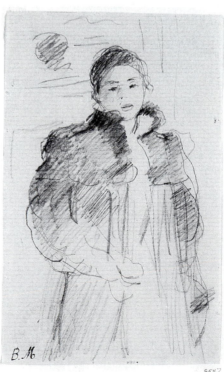

**2.17**
Auguste Rodin. *Study
of Nude.* c. 1895–96.
Watercolor wash and
pencil on graph paper,
8 3/16 x 4 3/4".
Yale University
Art Gallery,
The Jules E. Matbaum
Collection of
Rodin Drawings;
Gift of his daughter,
Mrs. Jefferson Dickson.

**2.18**
Berthe Morisot. *Study
for "Girl in a Green
Coat".* Pencil on paper,
17.5 x 10.2 cm.
Metropolitan Museum
of Art, New York.

Auguste Rodin's drawing, Figure 2.17, displays many of the same tactile tracings of the body in blind gesture fashion. Rodin would make rapid sketches of his models, encouraging them to move about the studio. Describing his process, he once said, "What is this drawing? Not once in describing the shape of that mass did I shift my eyes from the model. Why? Because I wanted to be sure that nothing evaded my grasp of it. . . . My objective is to test to what extent my hands already feel what my eyes see."[2] Notice the multiple interpretations of the edge and the way he simply suggests the woman's hand with his own erratic hand movements. Rodin's line quickly captures the direction and energy of an action; value just as quickly suggests the body's fullness and density, clearly distinguishing the form from its surroundings.

Berthe Morisot's drawing, Figure 2.18, exhibits a similar quality, with pencil implying the contour with a fine line and the density of the heavy overcoat with quickly scrubbed-in values. In addition to giving the form greater opacity, these rapidly sketched value areas function as abbreviated substitutions for color.

## The Schematic Sketch

A schematic sketch, although still executed rapidly, is more concerned with the body's structure than its gesture. Schematic lines are transcribed with more abrupt, "staccato" strokes than are typical of the gesture sketch. Schematic lines reflect a sequential chain of rapid calculations rather than the pattern the eye follows as it scans the figure. Within a schematic sketch, line plots the configuration of the pose and attempts to summarize in a diagram the spatial arrangement of the figure's planes and angles.

Alexander Bogomazov's sketch, Figure 2.19, breaks the figure into a connecting series of geometric planes. The figure appears essentially as an architectonic construct, and in many ways, a quick schematic sketch is an attempt to diagram with lines the body's underlying geometric relationships.

A sketch of this kind usually begins by blocking in the largest shapes and volumes, followed by progressively smaller, less significant forms. Jacques Villon's drawing, Figure 2.20, uses value to schematically break down the planes of the body while defining its gesture.

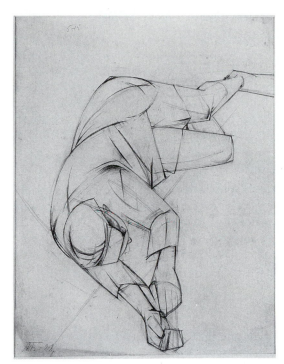

**2.19**
Alexander Bogomazov. *Figure Study I*. c. 1926–28. Pencil on paper, 16 x 12″. Arkansas Arts Center Foundation Collection. Anonymous Loan, 1986. EL4.1.1986.

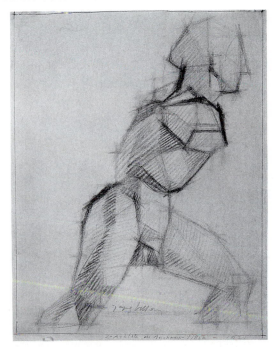

**2.20**
Jacques Villon. *L'Athlète de Duchamp (Torso of a Young Athlete)*. c. 1856–58. Black lead pencil with blue and red pencils, 10 3/8 x 8 1/8″. Museum of Fine Arts, Boston. George P. Gardner Fund.

## Volume, Mass, and Space

In addition to expressing the dynamics of the body's gesture and plotting its structural configuration, a sketch can convey more specifically the figure's volume, mass, and the spatial plane in which it exists. For in addition to moving through space, the body also fills it dimensionally with the density of its matter.

### VOLUME

Artists most often use line and value in combination to describe the figure in terms of its three-dimensional volume as well as the relationships of forms within a spatial plane. The convex curvature of a gestural line implies the fullness of the body's contour, its volume, while value imparts its solidity of matter.

Edward Hopper's line and value study, Figure 2.21, began as a gestural expression of the body's contours. Then, by laying his chalk on its side, he added value to create broad tonal areas, suggesting both the play of shadows over the body and the volume of its form. Although Hopper uses a dry drawing medium, its application is broad and painterly. His effort focuses on defining the general configuration of the form with line and establishing its physical density with the opacity of value.

In a similar manner, Degas's Figure 2.22 combines line and value to establish his figure's physical, three-dimensional presence. The rounding of the forms suggests the figure's volume, the displacement of space. It appears as if Degas built the substance of his figure out of a multitude of overlapping lines, making changes and adjusting con-

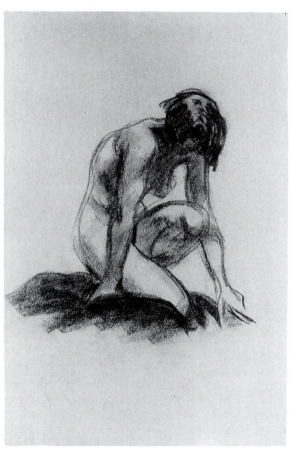

**2.21**
Edward Hooper. *Kneeling Nude.* c. 1923–24. Sanguine on paper, 17 15/16 x 11 1/2″ (45.6 x 29.2 cm). Whitney Museum of Art, New York. Josephine N. Hooper Bequest, 70.548.

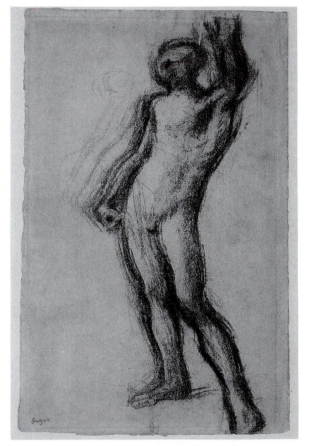

**2.22**
Edgar Degas. *Nude Man Standing with Left Hand Raised.* c. 1900. Charcoal, 17 11/16 x 8 9/16″. Cleveland Museum of Art, Cleveland. Gift of Ralph M. Coe, Twenty-Fifth Anniversary Gift, 1941.

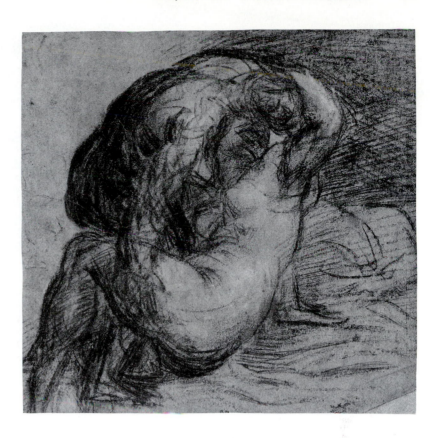

**2.23**
Titian. *Mythological Couple
In an Embrace*. Black chalk
and charcoal on blue-gray paper,
252 x 260 mm. Fitzwilliam
Museum, Cambridge, England.

tours as he proceeded. In some areas, the thickly overlaid lines now read as part of the background, which brings the lighter areas of the figure forward. At the same time, broad value areas round out volumes over parts of the body, pushing darker forms back into space.

## MASS

Mass relates to the density of the molecular structure within a given volume. The human body is made up of billions of molecules that are dense and compact in comparison to the atmosphere around us. What we see as the surface or edge of the figure is not really a line but the extremity of the body's mass. To more fully comprehend a body's mass, imagine the space it would occupy if you were to put your arms around it (*volume*). If it were standing on a scale, you would then have an indication of its *weight*. Now, if you were to put your arms around the body and lift it, you would experience its *mass*. *Mass*, then, is the combination of the body's *weight* and its *volume* as it relates to the force of its potential or kinetic energy.

Titian's *Mythological Couple Embracing,* Figure 2.23, creates a sense of both volume and weight with the robust and flamboyant use of line, swirling around the figures, expressing the extremity of the form and suggesting the subjects' movement. The lines defining the edges of the lower figure's hips, thigh, and torso, and the embracing arms of the upper figure, delineate the figures' volume. The use of value—broad areas of tone—gives density to the entire surface of the drawing, but especially to the two figures. Titian's sketch simultaneously expresses the elements of volume and weight, giving us a persuasive illusion of the body's mass as a kinetic force.

## SPACE

Space is characterized by the volumetric dimensions of height, width, and depth. *Pictorial space* refers to the illusion of these dimensions, especially of depth, in a drawing or painting. *Spatial plane* refers to the position of a form in space. For the human figure, it also refers to the spatial relationships of body parts and their directional bend or slant. Value provides a quick and efficient way to indicate the different spatial planes in your sketches. Darker values seem to recede in space because, as a general rule, planes farther away

appear darker. When forms overlap, the form in the foreground usually blocks the light from the one underneath.

In Jacopo Pontormo's sketch of two veiled women (Figure 2.24), he suggests the volume of the women's forms and establishes different spatial planes with his use of value. We sense the fullness of the nearer figure, particularly in the thigh, arm, and abdomen, because of the way the light value of the drawing surface is allowed to show through, making these forms appear to advance. Pontormo's chisel-like marks sculpt the surface of the leg and torso. The darker value between the figures places the second woman on a different spatial plane.

Volume, mass, and space all contribute to the solidity of Raphael's drawing of Madonna and child, Figure 2.25. Raphael first used a flamboyant gestural line to express volume. The line seemingly wraps around the figures like so much string and initiates Raphael's description of volume. Value

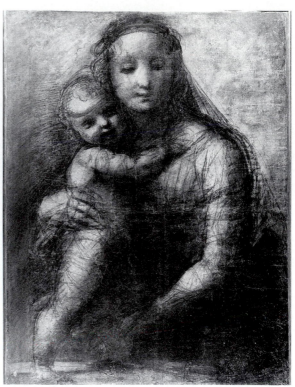

**2.25**
Raphael. *Cartoon for MacKintosh Madonna.*
Reproduced courtesy of the trustees
of the British Museum, London.

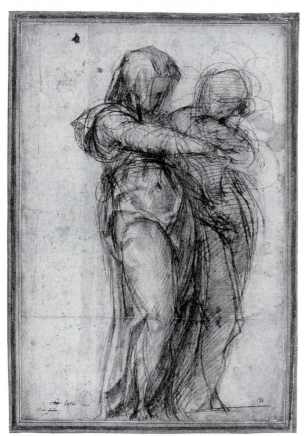

**2.24**
Jacopo Pontormo. *Two Veiled Women.* Red chalk,
15 1/2 x 10 1/8″. Staatliche Graphische Sammlung,
Munich.

then adds density and a voluminousness that makes the figures appear to emerge from their surroundings. Notice how the lighter areas appear closer and the darker values recede. This drawing also functioned as a *cartoon*, a full-scale study for a painting to be transferred to canvas by rubbing chalk onto the back and going over the main lines with a stylus. This sketch also effectively illustrates how a drawing that begins with thin gestural lines can develop into a study with substantial presence, determined in part by its composition—the way the visual elements are arranged within the two-dimensional frame of the drawing. Raphael's drawing is as much a compositional study as it is a figure study.

## The Compositional Sketch: Figure-Frame Relationship

Equally important to an artist's ability to capture the model's pose is the way in which the drawing itself is composed. A drawing is defined

in part by the space in which it exists. Some artists call this the *figure-ground relationship,* referring to the figure against its background. Other artists prefer to think of this relationship as *positive-negative form,* or *yin-yang.* Whatever the term, there is a universal recognition that the subject of the drawing is defined not only by the space it occupies but also by the surrounding space. Therefore, you need to interpret the dynamics of the internal forms of the body with sensitivity to how the pose relates to the picture plane in which it is going to exist. As an actor on a stage remains conscious of the perimeters within which to perform, so the artist must be aware of the boundaries of the drawing surface.

A figure can be completely contained within the space of the page, affecting the composition primarily by its position in reference to the borders, or the frame can encroach on the configuration of the body and even crop parts of it so that the composition is determined by the interaction of the body with the frame's physical edge. With any single pose, there exists a multitude of compositional possibilities, and even though the figure remains stationary, the artist can literally rearrange the surrounding space and change the visual perceptions. Depending on how the body is framed, it may appear to be distant or near. It may seem part of a larger environment or provide the composition's total structural elements. The following sketches, each using a very similar subject, demonstrate how differently each artist builds the form of the figure and defines the composition.

The first is a compositional study by Rembrandt for one of his engravings, *The Jewish Bride,* Figure 2.26. Beginning with a diluted mixture of ink, Rembrandt first defines the essence of his subject's face and body with thin line. Then, using both pen and fingers, he disperses the ink to create value areas suggesting the play of light and shadow on the walls. The generous use of the full concentration of his ink suggests the lavishness of the bridal wardrobe. Compositionally, Rembrandt maintains a distance from his subject, allowing a radiance that seems to emanate from her to fill the room. Although Rembrandt's subject physically

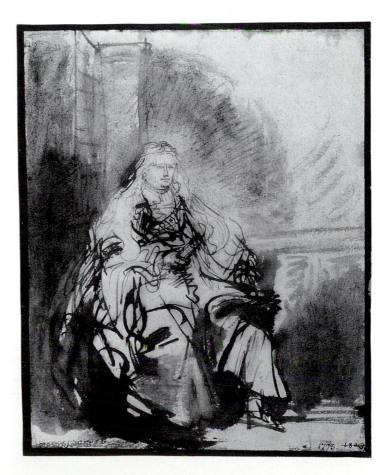

**2.26**
Rembrandt van Rijn. *Study for the Great Jewish Bride.* 1798. Pen and ink, 241 x 193 mm. National Museum of Sweden, Stockholm. Photo by Statens Konstmuseer.

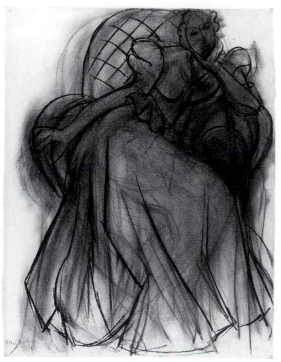

**2.27**
Henri Matisse. *A Seated Woman, Wearing
Taffeta Dress*. 1938. Charcoal, 66.3 x 50.5 cm.
Reproduced by courtesy of the Trustees
of the British Museum, London.

**2.28**
Richard Diebenkorn. *Seated Woman*. 1966.
Charcoal, 23 1/2 x 19″.
By permission of the artist.
Photo by Douglas M. Parker Studio.

fills only a portion of the composition, we sense
that the remaining space is not empty but filled
with an aura that balances the physical body and
adds an essential ingredient to the composition as
a whole.

In comparison, notice how Henri Matisse has
conceived his drawing of a seated woman to fill
the actual size and shape of his paper, Figure 2.27.
This did not come about by accident; for, as Ma-
tisse has stated, "If I take a sheet of paper of a
given size, my drawing will have a necessary rela-
tionship to its format."[3] Here, Matisse first uses
soft charcoal distributed as value to suggest the
figure's configuration; then he works over this
shadowy image with an application of line.

Richard Diebenkorn uses this technique in the
sketch of a seated woman, Figure 2.28. Dieben-
korn not only admired Matisse but shared his feel-
ings about the importance of the figure as a com-
positional element. Their drawings share a
gestural and exploratory quality, and the pen-
timenti reveal how the drawings underwent
changes. Compositionally, Matisse uses his line to

direct our eye around and through the contained
space of his paper, whereas Diebenkorn zooms in
and crops off parts of the figure so that lines will
intersect with and be tied to the edge, effectively
dividing the interior space of his drawing.

Edward Hopper would often prepare a number
of exploratory sketches before beginning a paint-
ing. At times, he focused on the effects of light; at
others, he was concerned with exploring composi-
tional variations. Notice in Figure 2.29 how he
quickly manipulates the compositional elements—
the figure, the window, and the distribution of
sunshine and shadow. He also uses an outline to
define his picture frame as a reference to the pro-
portions of a painted canvas. In a follow-up study,
Figure 2.30, he slows his sketching considerably,
though he is still very relationship-minded, con-
cerned more with the general structural elements
of his composition than with the details of the
forms.

Sensitivity to gesture-frame relationships helps
in determining the composition, or internal rela-
tionships, of the forms in your drawing. Each pose

**2.29**
Edward Hopper. *Drawings for painting "Morning Sun".* 1952.
Conté on paper,
11 x 8 1/2″ (27.94 x 21.59 cm).
Collection of Whitney Museum of American Art, New York. Josephine N. Hopper Bequest (770.243). Geoffrey Clements Photography.

**2.30**
Edward Hopper.
*Study for "Morning Sun".* 1952.
Conté on paper,
12 x 19″ (30.48 x 48.26 cm).
Collection of Whitney Museum
of American Art,
New York.
Josephine N. Hopper Bequest (70.244).

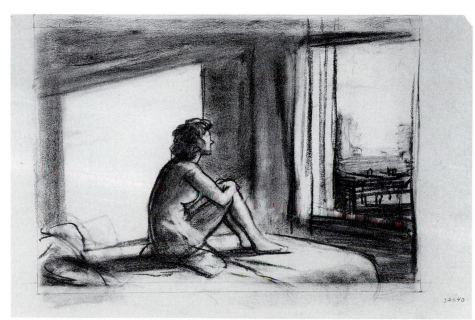

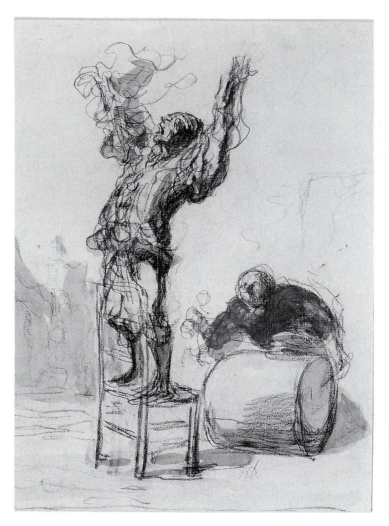

**2.31**
Honoré Daumier. *A Clown.*
Charcoal and watercolor wash,
14 3/8 x 10″.
Metropolitan Museum of Art, New York.
Rogers Fund, 1927. (27.152.2).

contains compositional elements, such as the curve of the spine, the gesture of the limbs, the position or attitude of the head, the slant of the hips or shoulders. In a drawing, however, these elements do not exist in isolation. They always exist in relationship to the picture plane. How you frame the figure will play as significant a role in determining the dynamics of your drawing as the model's body gesture. The gesture and mass of the body not only move through and fill the space, but also divide and activate the surrounding space.

In Daumier's *A Clown* (Figure 2.31), the figure standing on a chair boldly thrusts himself into the void of the upper half of the drawing. With arms waving overhead, he stirs and activates the space around him. This, in turn, gives us a sense of excitement and a visual equivalent for the sound we might hear from the clown's open mouth and from the lower figure, who is beating on a drum. The drum beater in the background is kept low so that we can fully appreciate the forward figure's upward stretching motion. By placing your hand or a piece of paper over part of the drawing, you can see how the overall effect would be reduced if the upper border were brought down to a point just above the clown's head. The stretching gesture would be thwarted and the clown's sense of excitement would, to a large extent, be lost.

## The Expressive Content of a Sketch

Every drawing has its own demeanor, emanating on some level an attitude; but for some artists, the expression of an emotional attitude is central

**2.32**
Käthe Kollwitz. *Self-Portrait.* 1934.
Charcoal, 25 1/4 x 19″.
Frumkin/Adams Gallery, New York.

to their purpose and is transmitted through all of their works, even their rapid sketches. For these artists, expression is the essence of drawing. Gesture drawing, in particular, allows artists to express ideas and visual impressions without taking time to analyze them, recording a fleeting impulse before it escapes and is lost. Each gesture, every attitude, visually transmits a message that fellow human beings are capable of perceiving and empathizing with. This is in part what makes drawing from life such an engaging and appealing challenge.

Although a sketch may be executed rapidly and economically, it can be both poetic and profound. Kollwitz's drawing, Figure 2.32, shows how effectively a sketch can expose the human spirit as well as suggest its form. In Rembrandt's drawing, Figure 2.33, we see two women aiding a child just learning to walk. We not only see and feel their action—the child leaning forward, slightly off-balance; one woman bending far forward and stepping toward us, the other gesturing—we also sense their mood, the attitude of tender caring on the part of the two women, their desire to teach and encourage the child. We can almost hear their words of encouragement. Within the economy of these few strokes, Rembrandt has recorded his own compassion and love for humanity.

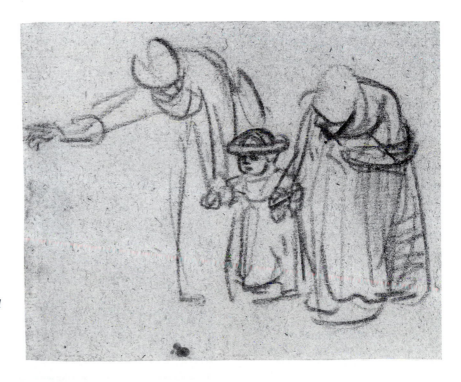

**2.33**
Rembrandt van Rijn.
*Two Women Helping a Child to Walk.* Black chalk.
Reproduced by courtesy of the Trustees of the British Museum, London.

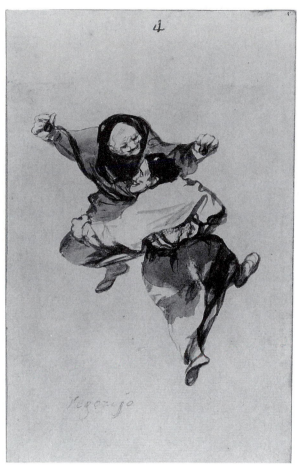

**2.34**
Francisco de Goya y Lucientes. *Regozijo (Mirth), Sketch from the 1815 album.* c. 1815. Gray and black wash on paper. Courtesy of The Hispanic Society of America, New York.

Francisco de Goya y Lucientes often used his art work as a caustic and bitter indictment of the follies of humankind, but Figure 2.34 presents a lighthearted expression of mirth. The enthusiastic gesture of these two characters is, in itself, amusing, but part of the expressiveness Goya conveys is in the way these rather hefty figures seem to defy gravity by dancing in midair. Goya applies ink as line and value to suggest movement and physical appearance, but his use of the negative space within this composition is also an important expressive factor. This apparent void surrounding the figures provides an expansive atmosphere, which we feel as surely as the dancers' enthusiasm.

## Summary

Serious artists have used quick sketches and gesture or action drawings for a long time and for a variety of reasons. Sketches can hold a wealth of information and are often full of life. Of course, artists like Goya, Rembrandt, or Michelangelo had years of experience drawing and studying the human body, and this surely contributed to their ability to distill the complexity of the figure's gesture and physical presentation to its essential graphic elements. Changes are common, even for the old masters, and a sketch is often only a beginning, the start of an investigation, a visual note to be amplified and developed further, as you can see with Andrea del Sarto's sketch, Figure 2.35. For all these reasons, many teachers feel the best place to begin drawing from life is with quick sketching

**2.35**
Andrea del Sarto. *Studies of a Child with a Cat.* Red chalk. Reproduced by courtesy of the Trustees of the British Museum, London.

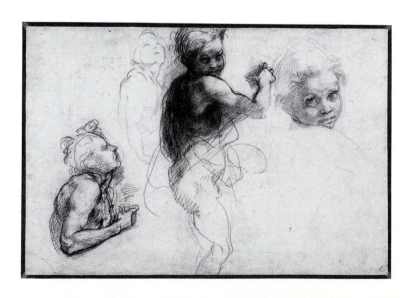

exercises. It is therefore common practice to dedicate several class sessions at the beginning of a drawing class and the first 15 to 30 minutes of each session thereafter to the practice of quick sketching. This is the warm-up period, but remember that while a sketch may record the genesis of an idea or serve as the foundation for a more comprehensive work, in many cases the sketch needs no further embellishment to provide an aesthetically rich experience.

# In the Studio

## Dominant Action Drawing

**Pose** - 15 seconds each (for 5 to 10 minutes)
**Media** - Conté, charcoal, or graphite on newsprint

The intent of this exercise is to state quickly and efficiently what you feel are the essential elements of the pose. To do this, use a bold line or lay a short piece of conté, charcoal, or graphite stick flat on the paper to make a broad value band through the core of the body. Do not attempt to draw the contour or edges of the body. Instead, try to see the movement through the center, or core, of the body. This exercise will help you get a feeling for the movement and gesture of the pose and record, in seconds, its key compositional element, as well as develop greater cooperation between eye and hand. As your eye scans the figure and moves with the body's gesture, let your hand move accordingly. Start with what you consider to be the dominant or key elements to the pose. Repeat and restate these large and essential movements as your eye moves repeatedly over them, as in Figure 2.36.

## Blind Contour Drawing

**Pose** - 1 minute each (for 5 to 10 minutes)
**Media** - Conté, charcoal, or graphite on newsprint
(one drawing per side of sheet)

This exercise, like the last, develops the coordination between your eye and your drawing hand. Position yourself so that you can see the model without seeing your drawing paper. Place your drawing tool on the paper; then, without looking at the paper or lifting your hand, attempt to trace the configuration of the pose and the various parts of the body. If your eye crosses over the body at the knee, for example, allow your line to follow. In this drawing, your hand's movements will be much more deliberate, rather than gestural. Your line should follow the edges of forms, attempt-

**2.36**
Steven Quigley. *Student drawing, Oregon State University. Dominant gesture sketch.* Black conté.

ing to circumscribe and contain the shape of the body. Expect the results to be distorted, as in Figure 2.37.

## Value Gesture Drawing

**Pose** - 1 minute each (for 5 to 10 minutes)
**Media** - Conté, charcoal, or graphite on newsprint
(may be done with ink or watercolor washes)

Use your drawing stick, approximately 1 inch long, held lengthwise against the paper to create a

**2.37**
Janiene Schaffer. *Student drawing,*
*Pratt Institute.*
*Blind outline drawing.* Charcoal.

## Gesture Drawing Using Combination of Line and Value

**Pose** - 2 minutes each (for 10 to 15 minutes)
**Media** - Conté, charcoal, or graphite on newsprint (may also be done with ink or watercolor washes)

In this exercise, you will be using both line and value in the same drawing as complementary elements. First, do several drawings that attempt to suggest the mass and gesture of the overall pose. Then redraw the same pose with line over the top of your value drawing. Avoid simply outlining your value drawing; let your line drawing be a new response to the model's gesture. After you have completed several drawings, reverse the steps, starting with line and following with a value drawing. Each element should complement and amplify the statement made by the other, as Figures 2.39 and 2.40 show.

broad value area. The idea is to deposit your pigment in wide, grainy areas, as in Figure 2.38, where the student uses black conté on its edge. See if you can draw the figure without using line. At first, work lightly, trying to get the configuration of the entire pose recorded early. You might think of the grainy texture of the drawing medium as representing the dense molecular structure of the body in an atmospheric space. As your eyes rescan the pose, make alterations as needed by expanding or darkening the form to express its gesture and mass. If you find yourself focusing on smaller aspects, rather than on the whole, try squinting at the model in order to slightly blur the edges and details.

**2.38**
Cynthia Limber. *Student drawing,*
*Oregon State University. Value gesture.* Charcoal.

**2.39**
Jeanne Heam. *Student drawing,*
*University of North Carolina, Chapel Hill. Gesture*
*drawing with line and value.* Ink and paraffin wax.

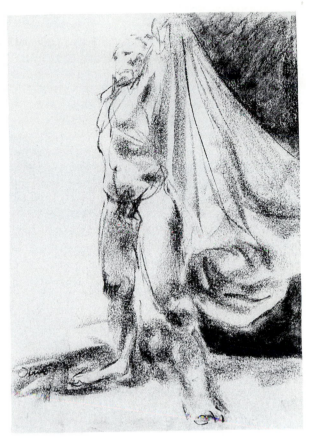

**2.40**
Michael D. Olive. *Student drawing,*
*University of Wisconsin, Milwaukee.*
*Gesture drawing with line and value.* Charcoal.

### Sketching Volume with Circumscribing Line

**Pose** - 2 minutes
**Media** - Conté, charcoal, or graphite on newsprint

The goal of this exercise is to build a sense of volume and mass through an accumulation of lines that appear to be circumscribing (wrapping around) the body's form. Begin by quickly suggesting the overall action and key components of the inner pose, as with dominant action drawing. Then describe the full breadth and depth of the body with gestural lines that cross over and around the contour of the body. Imagine that you are actually drawing on the model and that your line is wrapping physically around the body like string, as in Figure 2.41.

### Schematic Sketches

**Pose** - 2 minutes each (for 20 to 30 minutes)
**Media** - Conté, charcoal, or graphite on newsprint

A schematic sketch attempts to plot the configuration of the pose in a more diagrammatic fashion than was used for gesture drawing. These sketches describe the structure of the pose in terms of geometric forms or straight lines. The idea is to quickly analyze the body's shape and the shapes of its component parts in terms of their underlying geometric structure. This way of sketching the model's pose will have a more rigid, architectural feeling than gesture sketching. Begin by plotting the configuration of the very largest shapes and progress to the smaller forms. Use line and value to break up the larger shapes into multifaceted planes, as in Figure 2.42.

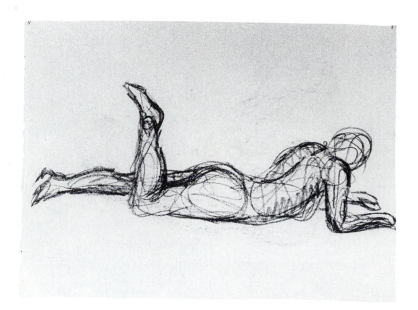

**2.41**
Cynthia Limber. *Student drawing,
Oregon State University. Continuous
line contour sketch.* Charcoal.

### Compositional Sketching: Figure-Frame Relationship

**Pose** - 5 minutes each (for 30 minutes)
**Media** - Conté, charcoal, or graphite on newsprint

The purpose of this exercise is to help you see more clearly the interrelationships between the body's configuration and the picture plane of your paper. Draw six to eight small rectangles (approximately 5" x 7") on a piece of large drawing paper. Then, drawing from the model, create a new sketch within each small rectangular picture plane. Attempt to see the pose as a compositional component in relationship to the frame and the space around the figure. Draw quickly, varying the format between horizontal and vertical. Consider how the dynamics of the composition may change by placing the figure in a different part of the picture plane or by cropping a part of the pose. Figure 2.43 shows the student's awareness of the frame in planning how the figure should repose within its borders.

### Extended Sketch

**Pose** - 5 to 15 minutes
**Media** - Conté, charcoal, graphite, or ink pen and
brush on newsprint

The extended gesture drawing begins with the same concerns you dealt with in the previous exercises. It requires that you respond quickly and in-

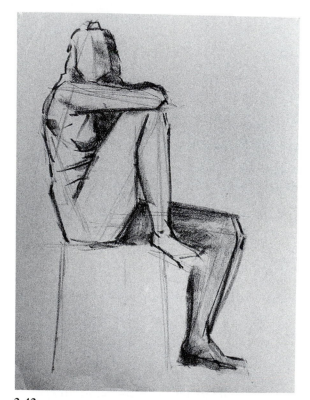

**2.42**
Steven Quigley. *Student drawing,
Oregon State University. Schematic sketch.*
Black conté on newsprint.

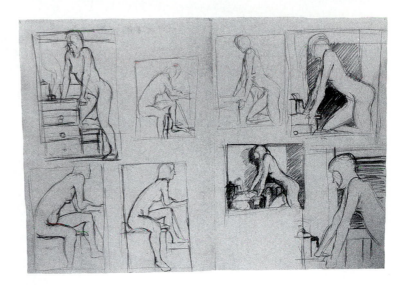

**2.43**
Tomas L. Wahlberg. *Student drawing,*
Oregon State University.
Compositional sketches. Charcoal.

**2.44**
Marek Reavis. *Student drawing, University of Washington. Extended gesture drawing developing figure-frame relationship.* Ink and brush.

tuitively to transcribe your feelings about the body's gesture and mass, and that you consider how the figure relates to the rectangular picture plane. In fact, as you begin your drawing, there should be little difference from how you would begin a 1- or 2-minute gesture drawing. What distinguishes an extended gesture drawing is not how it begins but, rather, how it develops. Over the extended period of time, your drawing should

evolve into an expanded statement about the figure over the abbreviated gestural statement, as in Figure 2.44. The longer drawings attempt to establish and expand on a number of elements: the dominant forces of a particular pose; the relationship of the model's movement to our eye and hand movements; a feeling for volume, weight and mass; and an awareness of the important relationship between gesture and frame.

### Independent Study:

1. Take a sketchbook out to draw people as they go about their daily activity: working, playing ball, shopping, walking. Draw quickly, filling each page with many small drawings. Concentrate more on sketching their activity than on their personal appearance. 2. Drawing larger (one figure per page), attempt to record in your sketchbook the activity of people you have observed in seconds, before they move; then use your memory to see what details you can add about the individuals whose actions you have recorded.

### Endnotes

[1] Pablo Picasso, quoted in "Conversation with Picasso" by Christian Zervo, in Brewster Ghiselin, ed., *The Creative Process: A Symposium* (Berkeley: University of California Press, 1952), 57.

[2] Auguste Rodin, *Personal Reminiscence of Auguste Rodin* by Ludovici, 1926. Quoted in Ian Crofton, *A Dictionary of Art Quotations* (New York: Schirmer Books, 1988), 165.

[3] Henri Matisse, "Notes d'un peintre," 1908, quoted in Jack D. Flam, *Matisse on Art* (London: Phaidon Press, 1973), 38.

# Proportions, Perception, and Perspective

A good figure cannot be made without industry and care. . . . And in devising such figures great attention should be paid to human proportions.

—*Albrecht Dürer*

While gesture drawing and sketching emphasize intuition and a spontaneous response to the figure's action, much of drawing involves cognitive mental processes and a more systematic approach. We analyze, compare, describe, classify, synthesize, and evaluate, as well as respond to the figure with empathy. Because drawing is a cerebral endeavor as well as an intuitive one, this chapter emphasizes a more deliberate and objective manner of drawing the human figure than discussed in the previous chapter. The complexity of the human body requires that we also study it in more depth than a quick sketch permits. It stands to reason that the more we know about the human figure, the more effectively we can use the figure as a vehicle for our own artistic expression. Masters like Leonardo, Michelangelo, and Albrecht Dürer made their drawings of the human figure a serious intellectual endeavor. Although they executed countless quick sketches, their approach to drawing at other times was contemplative and investigative, going far beyond the scope of simple sketching. For them, drawing was often a tool for

gathering information and recording the details of their discovery. During the Renaissance, artists were particularly interested in discovering a universal standard for human proportions along with a method by which they could accurately portray the figure as a three-dimensional object in space.

## The Search for a Standard of Proportions

The study of the relationship of one part of the body to another is the study of human proportions. Leonardo's famous drawing of a man within a circle and square, referred to as the *Canon of Proportion* or the *Vitruvian Man* (Figure 3.1), has become an archetypal symbol of the Renaissance blending of art and science. Leonardo spent years attempting to resolve a fundamental question: Are there divine or ideal proportions for the human body that can be defined mathematically and that will harmonize with geometry? Although the concepts expressed in this drawing actually originated with Vitruvius, a Roman architect who believed

beauty in nature is based on mathematical relationships, Leonardo was a meticulous observer of nature, modifying Vitruvian theory to conform to his own intense studies of the human form.

Leonardo's drawing suggests a variety of proportional relationships; for example, a man's reach is equal to his height, and his height is approximately eight times the length of his head. In one of his treatises on proportion, Leonardo indicated that the width of the man's shoulders is approximately one-fourth of his height, and the distance from the ground to the hip joint at the top of the femur (thigh bone) is one-half the body's length, or four heads high. This lower portion can be divided in half at the knees. The upper half of the body can be divided into two equal parts at the nipples, and the uppermost quarter can be halved again under the chin.

Two other proportional studies by Leonardo present front and back views of a standing male nude, Figures 3.2 and 3.3. The model's pose is intended to permit the artist to study the body's structure, proportions, and musculature. If you check these proportions against those suggested by Leonardo's schematic drawing of the man in the square and circle, using the head as the primary unit of measure, you will find them essentially the same.

During the Renaissance, numerous other artists were attempting to work out codes and canons for

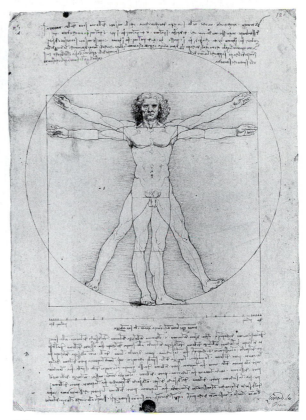

**3.1**
Leonardo da Vinci. *The Vitruvian Man (Proportions of the Human Body).* Pen, metal point, and brown ink, 13 1/2 x 9 5/8" (343 x 245 mm). Galleria dell'Accademia, Venice.

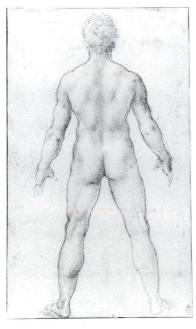

**3.2**
Leonardo da Vinci.
*Standing Male Nude.*
Red chalk on red paper outlined with ink, 23.6 x 14.6 cm.
Royal Library, Windsor Castle, Berkshire. © 1990
Her Majesty Queen Elizabeth II.

**3.3**
Leonardo da Vinci.
*Standing Male Nude (back view).*
Red chalk on white paper,
270 x 160 mm (27 x 16 cm).
Royal Library, Windsor Castle, Berkshire. © 1990
Her Majesty Queen Elizabeth II.

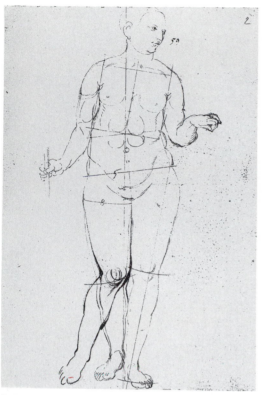

**3.4**
Albrecht Dürer. *Nude Woman with Staff.*
11 3/8 x 7 5/8″. Sächsische Landesbibliothek,
Dresden.

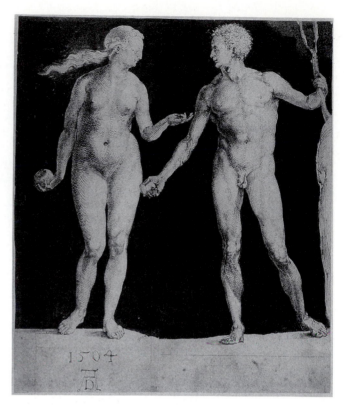

**3.5**
Albrecht Dürer. *Adam & Eve.* 1504. Pen and brown
ink with wash. Pierpont Morgan Library, New York.
I, 257D.

determining human proportions. The most popu-
lar treatise was Dürer's, published in 1528. It was
so widely read that the book went into fifteen edi-
tions and was used respectfully by many succeed-
ing generations of artists throughout Europe.

Dürer made methodical studies of the propor-
tions of all kinds of body types. Figure 3.4 shows
his attempt to analyze, in terms of simple geomet-
ric relationships, the body's gesture and propor-
tions. Dürer applied the results of his investigation
in Figure 3.5, showing both male and female fig-
ures, side by side, as representations of Adam and
Eve. If you were to take a caliper or ruler and mea-
sure the size of the head and then use that as a unit
of measure, you would discover that Dürer used a
proportional standard of 7-1/2 heads high. Unlike

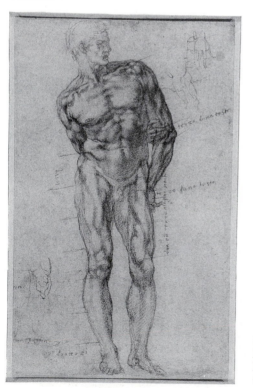

**3.6**
Michelangelo. *Male Nude.* Red chalk, 11 1/2 x 7 1/8″.
Royal Library, Windsor Castle, Berkshire.
© 1990 Her Majesty Queen Elizabeth II.

Leonardo, who divided the body in half at the hip joint, Dürer uses four head-length units to measure from the top of the head to the groin, with equal divisions at the nipples and the navel. He then uses four head units to measure from the ground to the hip joint, which is above the groin and thus overlaps the upper section by half a head length. This division of the body's proportions is quite logical when you consider that when viewed from the front, the torso appears to fit down into the formation of the hips.

Michelangelo, too, was keenly interested in human proportions. The figures in his earlier works had approximately the same classical proportions as those defined by Leonardo and Dürer, but his drawing of a male nude (Figure 3.6) defines graphically the proportions of the human body

he grew to prefer. Like Leonardo, Michelangelo made numerous anatomical studies, but the proportions of his figures are often less the result of objective observation than the expression of Neoplatonic idealism. His figures take on the epic proportions of the superhuman, such as this one, which approaches a height of nine head lengths. They are elongated, with larger-than-average legs and a broader torso. In this drawing, it is the length of the face that has been used as a unit of measurement and scaled off alongside the body.

This expression of the body's fluidity and elongated proportions was further developed by the Mannerists. Pontormo's study of three male nudes, Figure 3.7, clearly shows Michelangelo's influence. For example, notice how long the legs are in comparison with the upper body.

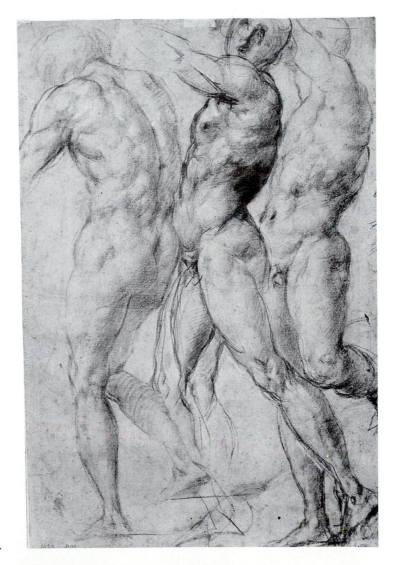

**3.7**
Jacopo Pontormo.
*Study of Three Male Nudes.*
Red chalk, 400 x 267 mm.
Musée des Beaux Arts, France.

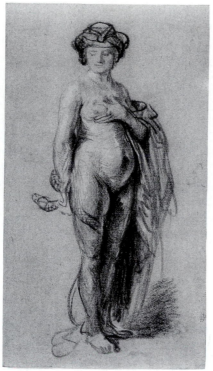

**3.8**
Rembrandt van Rijn. *Nude Woman with a Snake (as Cleopatra).* c. 1637. Red chalk heightened with white chalk, 9 11/16 x 5 7/16" (24.7 x 13.7 cm). J. Paul Getty Museum, Malibu.

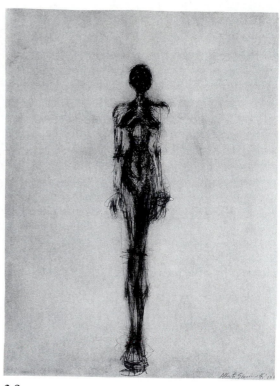

**3.9**
Alberto Giacometti. *Standing Woman.* Pencil, 35 1/8 x 19". © 1990 Artist Rights Society, New York, location unknown. A.D.A.G.P.

What society as a whole or the artist as an individual considers the ideal proportions or the perfect body type has continued to evolve. The society in which Rembrandt lived and painted seemed to prefer a smaller, more robust female body, as suggested by his portrayal of Cleopatra, Figure 3.8, considered by legend to be an enchanting beauty. She stands a slight seven heads high. For Giacometti, who often greatly elongated his figures, the distortion and exaggeration of the body's normal proportions were an expressive device. His drawing, Figure 3.9, depicts a woman who stands 12 heads high—not intended to represent an accurate physical likeness but, rather, a reflection of the artist's aesthetic preference. Hopper's sketch of a standing nude, Figure 3.10, presents a woman who, in the model of Dürer's figures, stands 7-1/2 heads high. By comparison, contemporary realist William Beckman presents an almost photo-

graphic likeness in Figure 3.11, where the figure is again eight heads high. Her physical characteristics also reflect contemporary society's ideal of a more athletic body type.

## The Eight-Heads-High Standard of Proportions

It would be impossible to derive a proportional standard to which all body types would conform and all artists adhere. It might be useful, however, to follow in the steps of Leonardo in determining a proportional standard that can be used as a basis of comparison when drawing from a model, or as a guide when drawing the figure from memory or imagination. Toward that end, the eight-heads-high standard applies to the adult male and female figures in Figure 3.12, which provides a comparison of the front, back, and side views of the body.

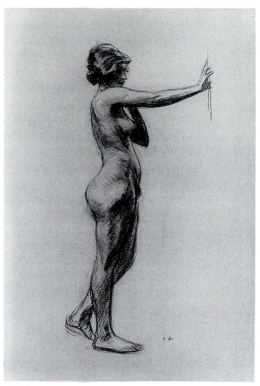

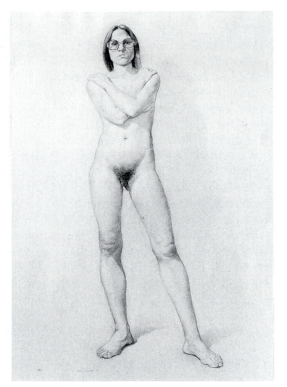

**3.10**
Edward Hopper. *Standing Nude.* c. 1920.
Sanguine on paper. 18 x 12 1/8"
(45.72 x 30.8 cm). Josephine N. Hopper
Bequest (70.328); Collection of Whitney
Museum of American Art, New York;
Geoffrey Clements Photography.

**3.11**
William Beckman. *Study for Diana IV.* 1980.
Pencil, 29 x 23".
Frumkin/Adams Gallery, New York.

**3.12**
Diagram of the Proportions of Eight-Heads-High Adult Male and Female Figures,
with Infant and Child Proportions.

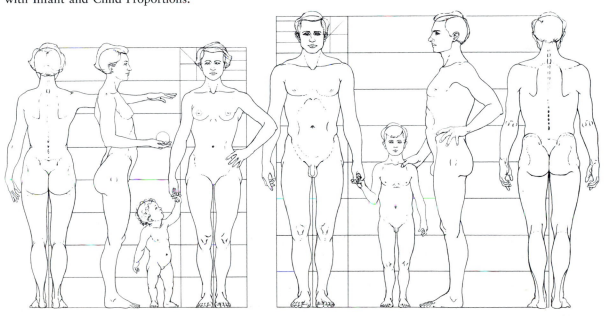

Although many other proportional standards have been suggested, those offered by Leonardo are simple and conform well to visually perceivable reference points on the body, such as the knee, hip, navel, nipples, and chin. Notice that the horizontal midway point of the chart is level with the hip rather than the waist, and the wrist is also level with the hip when the arm hangs at the side. Notice, too, that the width of the shoulders is approximately equal to two head lengths.

Study this proportional chart further to see what other comparisons you can make and what proportional differences exist between the male and female figures. You might also find it interesting to use a yardstick and measure the proportions of your own body or those of a friend to see how they compare with Leonardo's *Canon of Proportion* (Figure 3.1) and those in Figure 3.12. Using your own head as the unit of measurement, try to determine how many heads high you stand and, also, where you would locate your body's midpoints.

Understanding how to analyze and compare the body's proportions simplifies the complex problem of drawing the human figure. It also allows you, like Leonardo and Beckman, to record realistically what you observe or, like Michelangelo and Giacometti, to manipulate proportions as a vehicle for personal expression.

## Sight Measuring Proportions

When the artist wishes to draw with accuracy the correct proportions of a model, it is neither practical nor desirable to physically measure the body's proportions. The artist must measure them as they *appear*, rather than as they exist physically, determining the body's proportions as seen from the artist's point of view, in his or her field of vision. These proportional relationships often vary considerably from what the actual physical measurements might be because of the configuration of the model's pose or the angle from which the pose is viewed. Therefore, what the artist must achieve is a means of visually measuring and comparing the various units of the body from a distance. This can be done intuitively, especially after years of drawing experience; mechanically, with the aid of a camera or viewing device; or from direct observation, with a technique called *sight*

*measuring*. Sight measuring enables you to reliably measure the body's proportions from a distance, while allowing you to retain the freshness of freehand drawing.

Sight measuring is a simple technique that artists have used for centuries. All that is required is a thin, straight stick, for which you need look no further than one of your longer drawing pencils. Holding your pencil at arm's length between you and the model, use it as a measuring stick, sighting with one eye along its edge to make useful visual comparisons, as illustrated in Figure 3.13.

To determine the general relationship of the various body parts and how they align with one another, the artist holds the pencil vertically as a plumb line or horizontally as a level. For example, Figure 3.13A, shows how the body's organic mass is proportionally distributed along a vertical axis. If there is any curve or sway in the spine, it is easier to analyze its movement by comparing it to the straight line of the pencil's edge. In Figure 3.13B, the artist holds the pencil as a horizontal level in order to calculate the degree of slant in the shoulders, hips, knees, or feet.

To measure proportions and compare the size of one form with the size of another, again hold the pencil out at arm's length between you and your subject. Align one end of your pencil with one edge of the form you wish to measure. While holding this end of your pencil stationary, slide your thumb down the pencil until it is aligned with the other end of the form to be measured. For example, in Figure 3.13C, we see the artist measuring the distance from the top of the thigh bone, at the hip, to the top of the head. Now, with your thumb held in place, shift the pencil so that the end aligns with the edge of a new portion of the body and compare this with the previous measurement (as in Figure 3.13C and 3.13D). This procedure can be used to compare any proportion of the body with another.

You might imagine the types of measurements and comparisons made by fifteenth-century Italian artist Luca Signorelli when he drew Figure 3.14. You can see how the body's sway and curvature of the spine could be related to the straight vertical plumb line. Notice how the right leg, which is straight and carries most of the body's weight, slants slightly inward, and how the bent leg causes the hip on that side of the body to drop in counterpoint to the action of the shoulders.

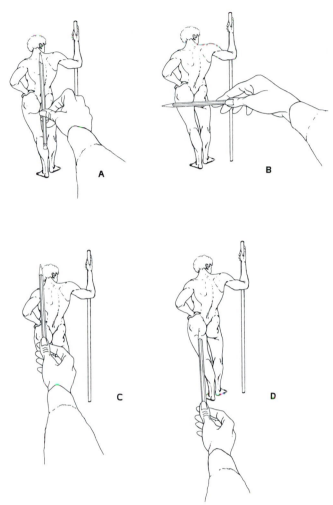

**3.13**
Diagram of sight measuring using level and plumb lines.

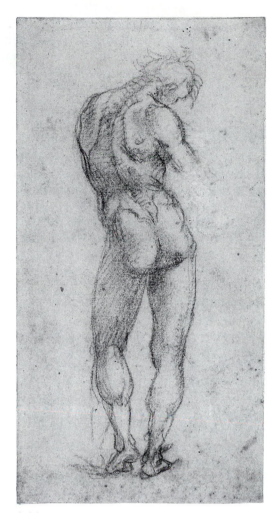

**3.14**
Luca Signorelli. *Study of a nude man.*
Black chalk, 270 x 136 mm.
Reproduced by courtesy of the Trustees
of the British Museum, London.

## PLOTTING THE BODY'S PROPORTIONS

Plotting the body's configuration and proportions is an analytic procedure whereby the interrelationships of its various parts are compared to the whole. Each part is viewed in relationship to the others, and the proportions and alignment are noted. Leonardo offered the following advice: "When you begin to draw, form in your mind a principal line, let us say, a perpendicular. Observe the relationship between the various parts of your subject to that line: whether they intersect it, are parallel to it, or oblique."[1]

These observations, then, form the basis for a lightly drawn linear diagram, or plot plan. This process is similar to schematic sketching, as described in the preceding chapter, except that plotting the body's proportions is more methodical, involving sight measuring and carefully checking the proportions of the body and the alignment of its parts as a prelude to a more descriptive drawing.

Essentially, a preliminary plotting separates the complex problem of accurately determining the body's proportions and defining its contours and surface appearance into two logical, sequential steps. The general configuration, scale, and proportional relationships are determined prior to considering the contours, so that the artist is free

to concentrate on the precise path of the contour lines and any description of details, confident that the proportions have been accurately determined. The underlying structural notations and plotting lines become submerged as the drawing develops, buried beneath subsequent layers of drawing.

## CHANGING SCALE WITH SIGHT MEASURING

When plotting the body's proportions, you do not need to draw a sight-measured form the same size as the actual distance between your thumb and the end of your pencil. These measurements represent a scale comparison of one unit to another. You can draw the figure as large or as small as you would like, as long as you keep each part of the body in scale with others and in the same alignment. For example, if you have determined that one form is half the size of another, you need to keep the same size relationship, whether you are increasing or reducing the overall size of the figure you are drawing. If the model's ear, hip, and ankle align vertically, maintain that spatial relationship no matter what size you draw the figure.

Compared to gesture drawing, sight measuring to plot the body's proportions may seem a bit self-conscious, but it is a simple and reliable technique for objectively comparing proportions. Even artists with years of drawing experience still use sight measuring occasionally to double-check the proportions and the alignment of the model's form. If an accurate description of what you see is desired, it is by far better to take the time to ensure that your perceptions are correct than to waste hours rendering details on a figure whose proportions have been inaccurately drawn.

# Learning to See: Beyond Preperception

True vision requires more than 20/20 vision, and it is more involving than just seeing something well enough to tag it with its name. For the artist, seeing is *perceiving*, a word derived from the Latin *percipere*, which means "to grasp or comprehend."

## PREPERCEPTION

To know an object thoroughly, to fully perceive it, takes a greater effort than casual observation. It requires one to go beyond what the American psychologist and philosopher William James (1842-1910) referred to as *preperception:* the storing of visual concepts. In our everyday life, this stored visual knowledge facilitates our recognition of objects, but it can often prevent us from looking more than superficially at objects we have previously experienced. Psychologists have noted that three of the strongest preperceptions we have about the human figure involve its size, shape, and symmetry. For that reason, we are likely to be frustrated when the body is presented in a way that does not conform with the visual image stored in our minds. For example, we know intellectually that both arms and legs are the same size, that the body has a particular shape, and that it is structured symmetrically, with a right and left side of equal size and proportion. These preperceptions are limiting to the artist, creating obstacles when faced with drawing a pose or stance that alters the figure's symmetry or proportional relationships. We generally share a strong subconscious desire to modify what we actually see and to fashion in our drawing something closer to the simplified image of our preperceptions—the symmetrical proportions of a standing figure—rather than draw what is presented. One means of overcoming the influence of our preperceptions is through an understanding of how to measure what the eye sees and how to apply the principles of perspective to drawing the figure.

## DÜRER'S WINDOW

*The Screen Draftsman,* Figure 3.15, illustrates a very particular technique that Albrecht Dürer experimented with as a means of counteracting the subconscious influence of preperception and objectively transcribing the proportions of a reclining figure. Although this apparatus may be cumbersome and impractical, the fundamental concept can provide some important insight into both the nature of visual perception and the basic principles of perspective. For example, the vertical shaft over which the artist appears to be sighting ensures a stationary *point of view*. The artist looks at the model through a window divided by a grid pattern that corresponds in scale and proportion to the grid on his paper. To accurately transcribe the proportions of his subject, the artist notes where and how the contours of the body visually intersect the grid lines in the window between the artist and the

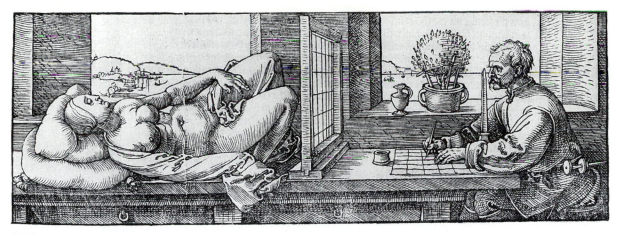

**3.15**
Albrecht Dürer. *The Screen Draftsman*. Woodcut, 75 x 215 mm.
Metropolitan Museum of Art, New York.

model, then duplicates these configurations of line on the gridded paper before him. In this way, Dürer's artist could objectively measure the angles and proportions of the subject *as they were perceived*, avoiding the influence of preperceptions in terms of the body's shape and symmetry.

Dürer's print also illustrates that whenever you draw a three-dimensional object on a piece of paper, you are representing on that flat *picture plane* of your paper what you view through an imaginary picture plane between you and your subject, as if seen through a window or the viewfinder of a camera. Rather than using a grid screen in front of you from which to take measurements, as in Dürer's Figure 3.15, you can use sight measuring, the basic principles of which are essentially the same. When you extend your arm, as in sight measuring, you are, in effect, placing your pencil up against an invisible window, the imaginary picture plane between you and your model.

## Perspective and Its Influence on Proportions

Perspective and perception are interrelated. The word *perspective* comes from the Latin *perspectus,* which means to see through or into. A modern dictionary defines perspective as a point of view, as an evaluation or assessment, as seeing things in their proper relationship and proportions, and also as a technique for representing three-dimensional objects and depth relationships on a two-

dimensional surface. Although each of these meanings could be applied to drawing, the latter definition has the most direct bearing on our study of the figure. There are several kinds of perspective devices that artists can incorporate in drawing the human figure. For example, *overlapping*, when one form is placed on top of another, suggests that one object is in front of the other in space; *vertical positioning*, where some forms are lower and others placed higher on the drawing surface, suggests that the higher forms are farther away; and *size differentiation* suggests that the smaller forms are farther away from view. *Atmospheric perspective* is based on the observation that as objects recede in space, light fades, colors dull, and details become obscured.

*Linear perspective* is based on the general observation that the size of proportional units appears to diminish as an object recedes in space and its distance from the viewer increases. The role of linear perspective is not as obvious when drawing the human figure as with a building or a landscape because the three-dimensional space the figure occupies is not as great, nor are the lines as simple to determine. But perspective is a significant determinant of the visual perception of the figure. When viewed from a three-quarter angle, from above, or in a reclining position, the figure is said to be *foreshortened,* or in perspective. Understanding linear perspective helps us more accurately perceive the way the body's physical proportions are visually altered in one of these less straightforward views.

## THE DEVELOPMENT OF LINEAR PERSPECTIVE

Linear perspective as a drawing system was an invention of the Italian Renaissance. Like most inventions, it was developed to solve a problem and meet a particular need of the time. Although its basic principles can be found in Greek art and the works of the classical scholars Euclid, Ptolomy, and Vitruvius, it wasn't until the Renaissance that the concept started to come together into an applicable drawing system. At that time, linear perspective became a subject of passionate interest.

The flat representations of the human figure in Byzantine, Romanesque, and Gothic art were adequate for expressing the nature of human spirituality, but the artists of the Renaissance were striving for more natural expressions of the physical world. Drawings from the sketchbook of early Renaissance artist Antonio Pisanello reveal his conflicting interest in subject matter and style. Although trained in the highly decorative International Gothic style, Pisanello was interested in giving his figures a more convincing three-dimensionality. His *Study of the Nude and an Annunciation*, Figure 3.16, reflects this dichotomy between the spiritual and the secular world. It also illustrates that Pisanello was an artist in transition between two very different drawing styles—one for conveying spiritual matters and lofty subjects and another for describing the body as a physical object. The two figures in the upper left corner are examples of Gothic stylization with its flat representation of the figure. In contrast, the four lower studies of the female nude are quite clearly drawn from life and present a persuasive illusion of the

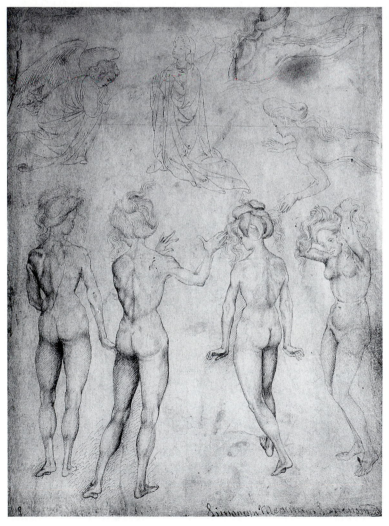

**3.16**
Pisanello. *Study of the Nude and an Annunciation.* Pen and ink,
8 3/4 x 6 5/8".
Museum Bozmans van Beuningen,
Rotterdam, the Netherlands.

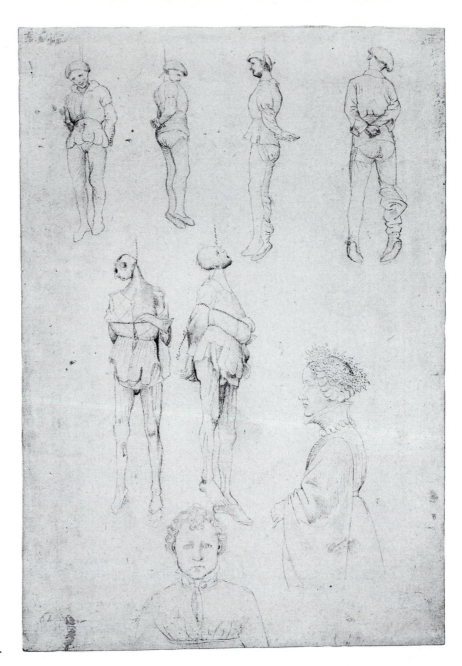

**3.17**
Pisanello. *Sketchbook page
with hanged men.*
Reproduced by courtesy of
the Trustees of
the British Museum, London.

body's three-dimensionality. The two studies at right reveal a concern for perspective in the position of the feet and the suggestion of the floor as a receding plane.

Another page from Pisanello's sketchbook, Figure 3.17, presents portrait studies that remain relatively flat, where those of the hanged men reveal a fascination with the physical existence of the body's volume and weight as it stretches the neck and twists from above. If you look carefully at

these hanging figures, you will notice that the body's proportions have been foreshortened in compliance with the principles of perspective. The feet and legs are enlarged, whereas the torso and head are slightly smaller than normal because they are farther from view. The lines of the body appear to converge as the form recedes.

Andrea Mantegna understood the dramatic potential of perspective as a means by which to increase the viewer's participation in a drawing.

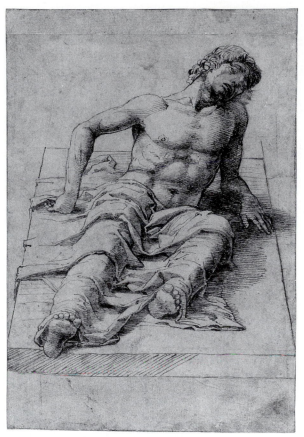

**3.18**
Andrea Mantegna. *Man on a Stone Slab*. Pen and brown ink over traces of black chalk, 16.3 x 14 cm. Reproduced by courtesy of the Trustees of the British Museum, London.

Through Mantegna's use of scale and perspective, his *Man on a Stone Slab*, Figure 3.18, pulls us into the picture to share in the man's suffering. Dürer was an admirer of Mantegna's work, and his own drawing of *The Dead Christ*, Figure 3.19, is similar to Mantegna's famous painting of that title. Dürer's insatiable appetite for knowledge took him across the Alps with the hope of meeting Mantegna and studying the principles of perspective. Mantegna died before Dürer arrived, but Dürer later completed many drawings and woodcuts, including *The Screen Draftsman* (Figure 3.15), to illustrate what he had learned both from the Italians and from his subsequent investigation.

Perspective drawing, more than any other discovery, changed the face of Western art. With perspective, Renaissance artists liberated the figure from the limitations of the static world of flat symbolism. In its stead, they gave us a three-dimensional world of drama and illusion, an illusion based on a rational system that made it possible to produce a convincing likeness of the human body in its physical surroundings.

## THE ELEMENTS OF LINEAR PERSPECTIVE

We have defined *perspective* as a technique for representing three-dimensional objects and depth relationships on a two-dimensional surface. *Linear perspective* could be further defined as any method of drawing by which three-dimensional

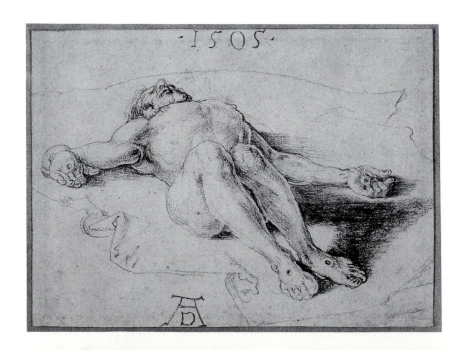

**3.19**
Albrecht Dürer.
*The Dead Christ*. 1505.
Charcoal, 172 x 235 mm.
Cleveland Museum of Art,
Ohio. Gift of the Hanna
Fund, 52.531.

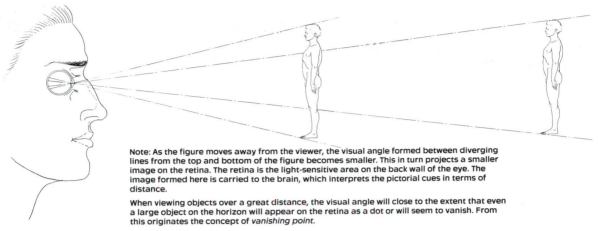

Note: As the figure moves away from the viewer, the visual angle formed between diverging lines from the top and bottom of the figure becomes smaller. This in turn projects a smaller image on the retina. The retina is the light-sensitive area on the back wall of the eye. The image formed here is carried to the brain, which interprets the pictorial cues in terms of distance.

When viewing objects over a great distance, the visual angle will close to the extent that even a large object on the horizon will appear on the retina as a dot or will seem to vanish. From this originates the concept of *vanishing point*.

**3.20**
*Diagram of visual angle.*

volumes and spatial relationships are represented in terms of their geometric relationship to the viewer's eye. We are capable of vision because of the impact of light waves on the retina as they are reflected from perceivable objects. The object forms the base of a triangle and light waves reflected from the object form the two converging sides, with the apex at the eye's lens. The lens recreates the image of the object in direct proportion on the wall of the retina. This geometric relationship, diagrammed in Figure 3.20, illustrates a principle of sight known as Euclid's law and forms the basic element of linear perspective. It explains why objects that are far away appear smaller than objects close to us. As the object moves away from the viewer, the visual angle formed by diverging light rays reflected from the object's extremities becomes smaller and, in turn, produces a smaller retinal image, even though the actual size of the object remains constant, as illustrated in Figure 3.20.

In Figure 3.21, the progressive reduction in scale of the three soldiers produces an optical illusion of depth by imitating on paper what is visually experienced in reality. The drawn figures produce progressively smaller retinal images, and, as a result, imply distance and depth even though the images of all three exist in reality on the same plane of the drawing surface.

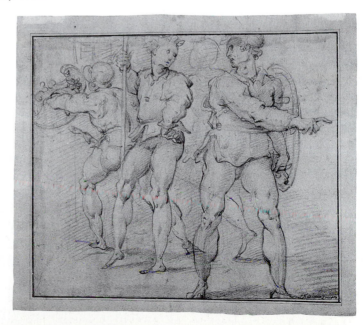

**3.21**
Maso da San Friano.
*Three Standing Soldiers.*
Black chalk, 8 1/4 x 9 1/2".
Los Angeles County Museum of Art,
M. 75.34, Gift of the Graphic Arts
Council.

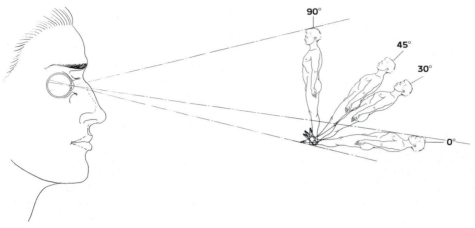

**3.22**
*Diagram of Angle of Recession (side view).*

Another factor that determines the size of the visual angle and of the image on the retina is the degree to which a form recedes in space, as illustrated in Figure 3.22. As this figure reclines, its visual angle narrows and the image it projects onto the retina shrinks, even though the size of the figure has not physically changed. The greater the form's *angle of recession* is away from the viewer, the more compressed or *foreshortened* the body's normal proportions will appear. Figure 3.23 illus-

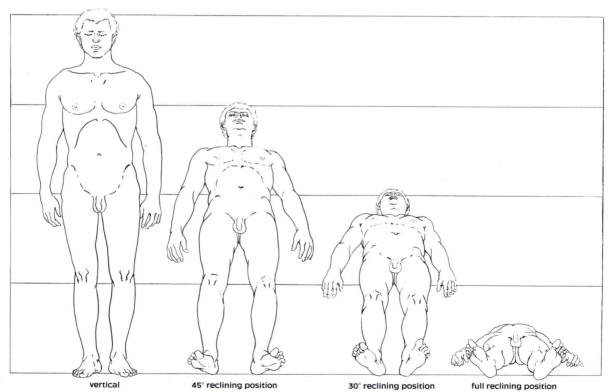

| vertical | 45° reclining position | 30° reclining position | full reclining position |

**3.23**
*Diagram of Angle of Recession (front view).*

**3.24**
Pavel Tchelitchew. *Tchelitchew.* 1934. Pen and ink
and sepia wash, 16 1/4 x 12 3/4″.
Edward F. W. James Foundation, West Dean,
Chichester, England.

trates what the viewer actually perceives as the
figure changes position from standing to full
reclining.

Pavel Tchelitchew's self-portrait, Figure 3.24
(done with feet propped up in front of a mirror),
shows the combined influence of distance and re-
cession on the proportions of his body. Even
though we can see only part of the body, he sug-
gests his full length by greatly reducing the propor-

tion of his head and hand in relationship to the
size of his feet.

A change in *eye level* can also visually alter pro-
portions. Eye level refers to the actual position or
level of the artist's eye. It is also the *point of view,*
or *point of perception.* The normal eye level of a
standing person would be approximately five feet
above the ground. But it is possible to be looking
down at an object from high above, as in "a bird's
eye view," or to look up at an object from a
"worm's eye view," or ground level. Every change
in position brings a related change in the perceived
shape and proportions of the subject. For exam-
ple, Figure 3.25 shows two students drawing the
same figure from two different eye levels, and indi-
cates how that difference alters the visual propor-
tions of the same reclining figure. To ascertain the
body's correct visual proportions, the artists each
use sight measuring.

When sight measuring, you, in effect, measure
the width of the visual angle projected by a form at
a distance in front of you. It is as if you are taking
the measurement from an invisible plane between
you and the model. With this process, you apply
the principles of perspective to your drawing of
the figure.

Figure 3.26 depicts the body from a very low
eye level. In this kind of situation, one's knowl-
edge of normal proportions of the body is no
longer relevant. Our subconscious preperceptions
about the body's symmetry will exert their influ-
ence. Sight measuring, however, enables the artist
to maintain a high degree of objectivity in perceiv-
ing the visual presentation of the figure in
perspective.

Eye level not only indicates the position and
view of the artist who created the drawing, it also
manipulates the viewer by dictating a particular

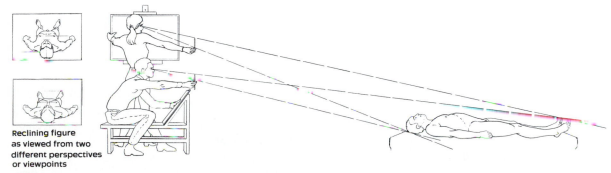

**Reclining figure
as viewed from two
different perspectives
or viewpoints**

**3.25**
*Diagram of eye level and angle of perception.*

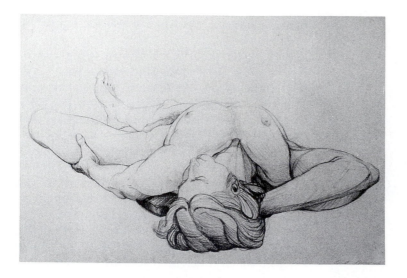

**3.26**
Clint Brown. *Reclining Nude*. 1990.
Colored pencil, 24 x 36″,
Corvallis, Oregon.

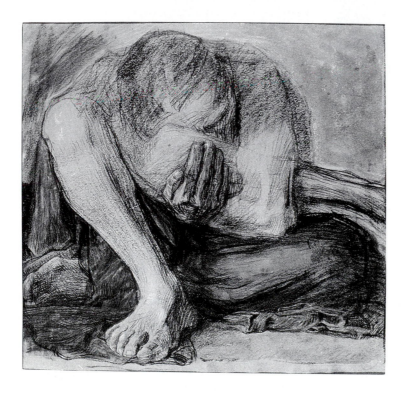

**3.27**
Käthe Kollwitz. *Woman
with Dead Child*. 1903.
Charcoal and tempera on paper.
Courtesy Galerie St. Etienne,
New York.

point of view. For example, in Kollwitz's drawing of a *Mother with Dead Child*, Figure 3.27, she does not allow the viewer to maintain a safe, psychological distance. Rather, by drawing her figure large and establishing a low eye level, Kollwitz brings you in close, down on your knees, to mourn this child's death along with its grief-stricken mother.

The artist's eye level is also what determines the height at which one sees the horizon line. The *ho-*

*rizon line* is an imaginary line in the distance, where earth and sky meet, which remains at your eye level, moving up or down as your eye level changes. As foreshortened forms recede, their angle of recession is directed toward the horizon line, the visual angle narrowing to the extent that the image on the retina is reduced to a point or appears to vanish altogether. *Vanishing point*, then, is an imaginary point on the horizon toward which parallel receding lines appear to converge

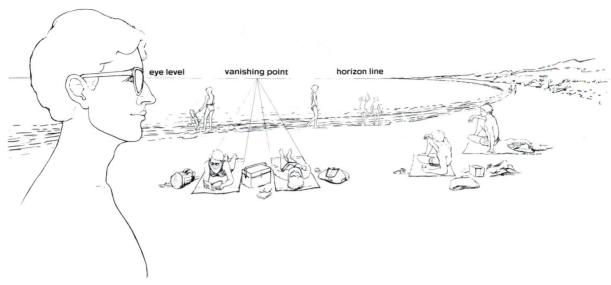

**3.28**
*Diagram of horizon line, eye level, and vanishing point.*

and the proportions of receding forms progressively reduce in size. Figure 3.28 demonstrates these concepts, where the artist's eye level is the same as that of the figure in the foreground. The complexity of the human figure—its ability to bend at different angles and assume a variety of configurations—means that within a single pose, parts of the body often recede or taper toward different vanishing points. This is referred to as *multiple-point perspective*.

## The Figure in Perspective

In Eakins's drawing, Figure 3.29, we can see the extent to which he often geometrically plotted the perspective relationships of his subjects as they receded toward their vanishing points on the distant horizon. While the parallel receding lines converge toward a single vanishing point *(one-point perspective)*, the lines of the shell and of the rowers themselves recede in different directions (multiple-point perspective).

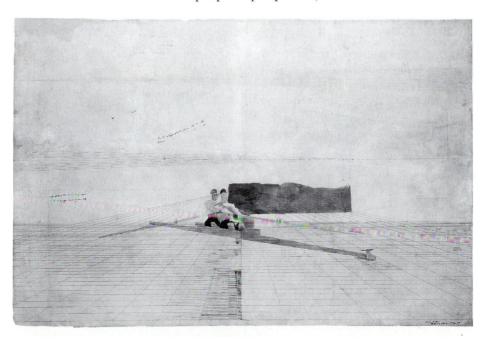

**3.29**
Thomas Eakins.
*Perspective Drawing for "The Pair-Oared Shell".* 1872.
Pencil, ink, and watercolor on paper.
Philadelphia Museum of Art, Philadelphia.

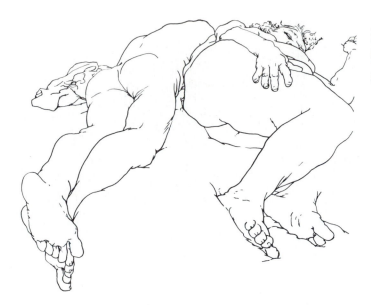

**3.30**
Eleanor Dickinson. *Ann and Wally,
from "Lovers" series.*
1972. Ink on paper, 35 x 46″.
San Francisco. Courtesy of the artist.

In a line contour drawing by contemporary artist Eleanor Dickinson, Figure 3.30, two nudes bend in more or less parallel alignment as they lie side by side, but as the bodies progress upward on a converging perspective path, limbs bend and project to several different vanishing points. Dickinson sensitively combines the aspects of compressing proportions with a suggestion of spatial progression defined with overlapping lines. It was not necessary for Dickinson to plot the perspective lines of each form; however, every line conforms with the underlying principles of perspective.

Even when drawing a standing pose, we often see the body from a diagonal point of view, which affects its normal symmetry and proportions. As Figure 3.31 illustrates, the artist drawing the figure from a *three-quarter view* or *oblique view* does not see the line that symmetrically divides the body in the middle of the form as it would be viewed by someone with a frontal view. The right and left side of the body are no longer visually equal. In this situation, sight measuring from points along the body's normal symmetrical center (such as the nose, breastplate, navel, or spine) to the outer edges enables you to accurately establish the visual proportions of the two sides of the body and the degree of turn or twist in the pose. Notice, too, how in the drawing done from the oblique view, the principles of perspective affect the positioning of the figure's feet and shoulders and the relative length of the two arms.

In Pontormo's drawing, Figure 3.32, the normal symmetry of the face has been changed by the

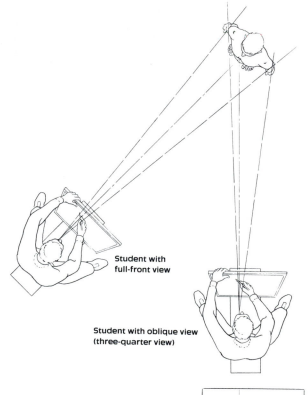

Student with
full-front view

Student with oblique view
(three-quarter view)

What student sees from
oblique view

**3.31**
*Diagram of oblique view,
standing pose.*

three-quarter viewing of it, and the arms vary dramatically in size. The arm pointing at the viewer is greatly foreshortened in that it is perpendicular to the picture plane, whereas the other is nearly parallel to it.

When a reclining figure is drawn from an oblique view, the symmetry and proportions of the figure are even more dramatically altered. Figure 3.33 illustrates how the proportions of the upper body are significantly smaller than those of the lower body (divided at the hip joint). Sight measuring, using visual reference points on the body as a basis for objective visual comparisons, assures a more accurate and, therefore, more believable representation of the figure in perspective.

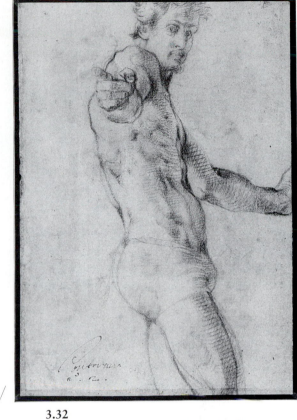

**3.32**
Jacopo Pontormo. *Nude Study*. Chalk. Reproduced by courtesy of the Trustees of the British Museum, London.

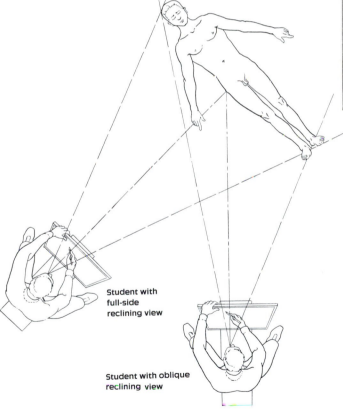

Student with full-side reclining view

Student with oblique reclining view

What student sees from oblique view

**3.33**
*Diagram of oblique view, reclining pose.*

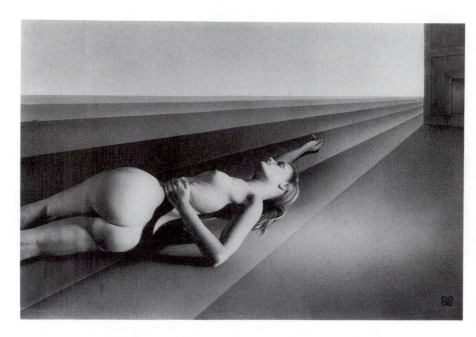

**3.34**
George Staempfli.
*Kate Dreaming.* 1982.
Pencil and watercolor,
12 x 18″.
Staempfli Gallery,
New York.

George Staempfli's drawing, Figure 3.34, uses perspective not only to plot the foreshortening of the figure as it recedes diagonally in space, but also to create the surreal landscape in which it exists. This drawing illustrates how parallel lines converge toward a single vanishing point and how the body's form is apt to be likewise affected. Notice how the overall dimensions of the form alter as it recedes toward the distant horizon.

Catherine Murphy's drawing of *Alison Sleeping,* Figure 3.35, presents us with a similar subject in a much more mundane setting. Here we perceive the tapering of the large, rectangular shape of the cot beneath the figure, both of which recede toward an implied vanishing point at our eye level that exists beyond this interior. The configuration of the body moves diagonally through the picture plane at an oblique angle to the viewer. While we

**3.35**
Catherine Murphy.
*Alison Sleeping.* 1975.
Pencil on paper, 9 x 12″.
Lennon, Weinberg
Gallery, Inc., New York.
Private collection,
New York.
Photo by Bruce C. Jones.

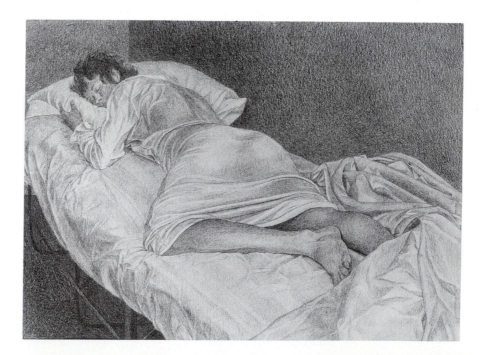

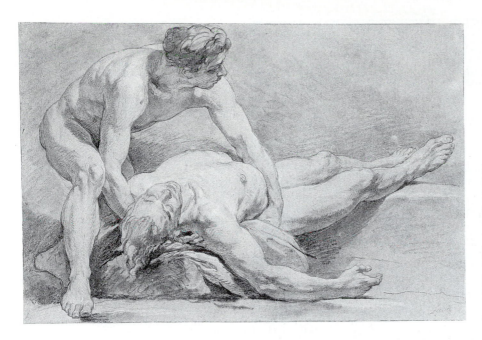

3.36
Nicolas-Bernard Lépicié.
*Two Nude Male Figures.*
Charcoal, stumped, black
chalk, heightened with
white on gray-green
paper, 33.6 x 50.8 cm.
Metropolitan Museum
of Art, New York.
Harry G. Sperling Fund,
1981. (1981.15.4).

see the full dimension of the one uncovered lower leg, we can sense the foreshortened form of the rest of the body beneath her robe. To a certain extent, the wrinkles in the robe function as cross-contour lines, revealing the form of the body as a sort of secondary skin.

Consider how many different proportions of the two male figures in Figure 3.36 have been altered to conform to the principles of perspective. Because the arms and lower leg of the crouching figure and the visible arm of the reclining figure are placed on a parallel axis to the picture plane, they can be drawn proportionally full scale; however, just about every other form projects at a divergent angle to the picture plane and, therefore, is foreshortened.

Each pose presents unique drawing problems and requires different considerations. A general understanding of perspective should provide a clearer picture of the physical and visual phenomena involved in perception. The key, and what will make the greatest difference in your drawing, is thinking in three dimensions rather than two. If you conceive of the body as three-dimensional and study it in terms of perspective, your drawing will express the depth of your perception. To a great extent, the skill and craft of a representational artist involve the ability to present a graphic facsimile that transmits to the retina of the viewer the same visual relationship transmitted from the actual three-dimensional figure to the artist. What linear

perspective provides is a guidance system for the analysis and indexing of the body's structure. By indexing, we mean the process of discerning, arranging, and prioritizing graphically the structural characteristics of the body. In every drawing, it is the expression of these relationships that forms the real subject of the drawing.

## Planar and Structural Analysis

The effects of linear perspective can be more easily observed in objects with clearly defined lines, such as in a box or cube, where the parallel lines of the edges can clearly be viewed as receding toward a vanishing point on the horizon line. With the softer organic form of the human body, the lines of perspective are not so clearly delineated. Another technique that can assist in the analysis of the body is to simplify its forms into their underlying geometric components. As Paul Cezanne once suggested, "treat nature by the cylinder, the sphere, the cone, everything in proper perspective."[2]

Long before Cezanne, sixteenth-century artist Luca Cambiaso had discovered that interpreting the body's form as simple geometric volumes and its surface as planes makes it easier to grasp and reconstruct its structural relationships. He made elaborate geometric constructs that helped him work out the complexity of elaborate figurative

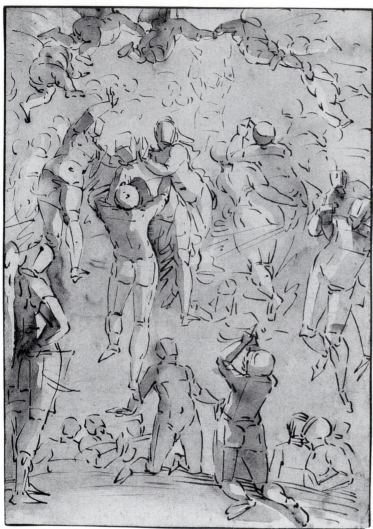

**3.37**
Luca Cambiaso. *The Elect Ascending into Heaven.*
16th century. Pen, brown ink, and wash,
11 15/16 x 8 7/16″. University of Michigan
Museum of Art, Ann Arbor. Gift through the
Estate of Edward Sonnenschein, 1970/2.12.

**3.38**
Giovanni Paolo Lomazzo. *Foreshortened
Nude Man with Arms Uplifted.*
16th century. Pen and brown ink,
7 1/4 x 4 3/4″ (19 x 12 cm).
The Art Museum, Princeton University.
(x1947-136 verso). Gift of
Frank Jewett Mather, Jr.

compositions. In Figure 3.37, *The Elect Ascending into Heaven,* we can see how linear perspective guided the plotting of his figures and how interpreting the body as rectangular, boxlike units clarified their structure. Cambiaso reportedly used articulated wooden models of the human figure for the purpose of studying the effects of perspective and the play of light.

A study by Giovanni Paolo Lomazzo, Figure 3.38, illustrates a less rectilinear mapping of the body's structure with line. Notice how the artist's line moves over the form with an elliptical encirclement of the legs and torso. These lines link with the vertical lines to describe the body's mass and establish its perspective relationship to the viewer who is seeing it from below. Like Cambiaso, Lomazzo is not concerned with the details that

would give the figure an individual personality. Rather, he focuses on the universality of its structural elements.

Contemporary British artist Martin Froy uses a network of lines to describe planes and to construct an architectonic framework of his model's three-dimensional form, Figure 3.39. Notice how both the vertical and horizontal lines imply that the planes of the body are directed toward a vanishing point; and notice how the tipping of the horizontal hip plane and shoulder lines, as well as the proportional difference in the size of the shoulders and head, suggests that the viewer is looking up at this figure.

Giacometti gets more detailed than the previous examples in his planar analysis drawing, Figure 3.40. His line plots the angular breaks between the

**3.39**
Martin Froy. *Figure.* c. 1948–51.
Graphite pencil, gouache, and colored pencil on
2-ply Bristol paper, 383 x 279 cm.
Santa Barbara Museum of Art, Santa Barbara.
Gift of Margaret Mallory to the
Ala Story Collection, 1973.6.3.

**3.40**
Alberto Giacometti. *Seated Nude from Behind.*
1922. Pencil, 48.5 x 31.5 cm.
Alberto Giacometti Foundation, Kunsthaus Zürich,
Switzerland. Photograph by Walter Dräyer,
Zurich. © 1990 ARS N.Y./ADAGP.

planes on what he sees as the body's multifaceted surface. His division of the surface terrain may have been derived from an observation of the play of light and shadow over the planar forms of the model, but it is also descriptive of how the body's structure might be defined if it were fabricated in sheet metal as a sculpted volume.

Even though each of these examples has a geometric or architectonic quality, the drawings are also stylistically different. In most drawings, the structural notations lie beneath the surface and, like the steel scaffolding of a skyscraper, are not seen, although they are vital to the structure. In these drawings, which emphasize the body's underlying geometry, the discovered structural relationships can be both informative and aesthetically potent.

# In the Studio

## Warm Up with Schematic Sketches

**Pose** - 1 to 2 minutes
**Media** - Charcoal or graphite on drawing pad, 18″ x 24″

An ideal way to begin a drawing session on the study of proportion and perspective views of the figure is by warming up with some quick schematic sketches, as described in Chapter 2. These sketches should emphasize plotting the larger forms of the body.

## Study in Human Proportions

**Pose** - 30 minutes; standing at ease, weight on one foot
**Media** - Charcoal or graphite on drawing pad, 18″ x 24″

The purpose of this exercise is to study the proportions of a standing model, using sight measuring to make comparisons. Keep in mind the proportional relationship of an eight-heads-high figure as a standard while attempting to discover how the individual model's proportions may vary. Concentrate on the size relationships of larger body sections before drawing details. During one drawing period, plot the proportions of the model from the front, back, and side, spending approximately 30 to 45 minutes on each view. The purpose here is not to develop a highly finished drawing, but to feel that you have accurately measured and plotted the proportions of your model as they are presented visually.

**Review of Sight Measuring for Plotting Proportions** The following suggests a step-by-step study of proportions that points out what to look for and what comparisons you may want to make when drawing a standing figure. Assuming that you wish to include the full figure in your drawing, begin by lightly drawing a straight vertical line on your paper to indicate where the figure is to be placed and its full height. This line relates to what Leonardo referred to as the "principal line," to which all proportions and alignments are compared. With short horizontal lines at both ends, indicate the placement of the top of the head and the bottom of the feet. With another short horizontal line, divide the vertical line in half; then add two others that dissect it into equal quarters, as in Figure 3.41A.

Keep in mind the proportional units used by Leonardo and the points of reference discussed earlier in this chapter. According to Leonardo's standard, the midpoint should be at the hip joint (not the waist). The knee should be located midway between the hips and the floor. The upper half of the figure is divided by head lengths: from the top of the head to the underside of the chin, from chin to midchest, from midchest to navel, and from navel to hips. Each division is approximately one-eighth of the height of the full figure. Using your sight measuring, determine how this canon for the body's proportions applies to your model and your viewing angle. You may discover that you will need to make some adjustments to the horizontal lines drawn on the vertical to establish the body's true midpoint and placement of the knee, navel, and midchest points.

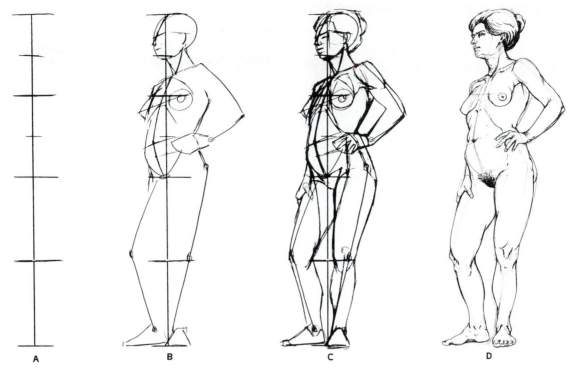

**3.41**
*Diagram of plotting the figure's proportions.*

Next, hold your pencil out horizontally, as if it were a level, to establish the positions and angle of the feet, knees, hips, and shoulders. Mark their position with line, indicating the angle of any tilt; then observe and plot the location and angle of the head and limbs. Use an oval to suggest the general shape of the head and straight lines running through the center of the limbs from joint to joint, as in Figure 3.41B.

One way to check the location of the joints and other points of reference is to sight along the vertical or horizontal pencil, held out at arm's length, to determine how these points of reference line up with others on the body. For example, you may discover that one of the ankle bones is directly below the ear and the hand, or that an elbow is at the same height as the model's navel. You will also want to plot the often subtle but essential gestural rhythms in the torso by comparing the curvature of the spine, seen easily from the back (or the line of division over the breastplate and abdomen on the front), with the vertical line of your pencil when sight measuring.

To plot the width and outer contours of the torso and limbs, simply compare the horizontal widths with the vertical proportions you have

plotted. For example, the width of the shoulders can be compared with the length of the head or the distance from the floor to the knee. These proportions should be lightly inscribed with straight lines on your paper, as in Figure 3.41C.

This diagrammatic plotting of the major proportional relationships represents only a fraction of the time you would spend working on a figure drawing. Before going on to complete the drawing, however, step back from your sketch so that you can compare, from a distance, the proportions of the figure on paper with those of the model. Stepping back enables you to more easily make comparisons because the visual scale of the drawing more closely matches the scale in which you view the model. Because your eye can take in the whole drawing at a glance, you can see and compare the proportional relationships more directly. Make any adjustments you deem necessary, and, when you are satisfied that you have captured the essential elements of the pose—its gesture and balance, as well as its proportions—you are ready to proceed by confirming the figure's contours, adding details, and describing form with value (Figure 3.41D).

### Planar Analysis of the Body in Perspective

**Pose** - 30 minutes; reclining or semireclining pose
**Media** - Graphite or charcoal on student-grade
drawing paper, 18″ x 24″

Begin by first plotting the overall configuration of the model's pose, using sight measuring techniques and straight lines to indicate the size of various limbs and relevant points of reference. Then, attempt to interpret each unit of the body in geometric, blocklike terms, seeking out the underlying structure and its perspective alignment. If you understand how to draw a rectangular box in perspective, you should find that when you draw the figure in perspective, it helps to think of its shapes as geometric solids, such as cubes, rectangles, and cylinders. Divide these larger shapes into secondary and tertiary units that suggest the angle or recession of the surface planes. Note that light reflection and shadows provide clues as to the shift in surface structures.

### Drawing the Figure in Perspective

**Pose** - 2 to 3 hours; reclining or semireclining pose
**Media** - Graphite or charcoal on student-grade
drawing paper, 18″ x 24″

The goal of this exercise is to develop an accurate description of the figure in perspective. Begin by very lightly plotting the configuration of the entire pose, using sight measuring techniques to make proportional comparisons, and observe the alignment of various points of reference. You will find it useful when plotting the diagonals of receding forms to analyze the degree of angles by comparing them with your pencil held out as a true vertical or horizontal.

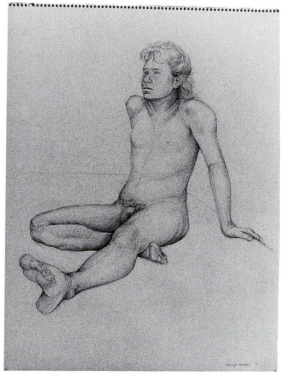

**3.42**
Nancy Semus. *Student drawing, Oregon State University. Proportion study in perspective.* Charcoal.

**3.43**
Lisa Pelletier. *Student drawing, University of Connecticut. Example of dramatic foreshortening and perspective view.* Charcoal.

Keep in mind the influence of preperceptions. It will be easy to be fooled when part of the body is altered by foreshortening—subconsciously, you will want to elongate forms that are foreshortened and present the body as symmetrical. Make careful observations and accurate comparisons to achieve the precise position and relationship of each form, then proceed with a more detailed description of the form, as in Figure 3.42.

### Plotting the Figure in a Dramatic, Foreshortened Pose

**Pose** - 1 hour; reclining pose
**Media** - Charcoal or graphite on student-grade drawing paper, 18″ x 24″

To further dramatize the foreshortening of the body, the model should be posed on a table or a raised model stand. As you draw, try to keep in mind the horizon line (which is at eye level), and attempt to visualize the various forms of the body receding toward their respective vanishing points. As you begin, do not hesitate to draw light guidelines or elliptical cross-sections on your figure. Then, develop the drawing, adding value and line to more fully establish volume and a sense of depth, as in Figure 3.43.

### Independent Study:

1. Invent or imagine your own pose for the figure, which would be seen dramatically foreshortened. A person falling or jumping, for example, as seen from above or below. 2. You can also use a mirror with yourself as a model and do a foreshortened self-portrait. Figure 3.44 shows that the student used a mirror placed above him to create this unusual self-portrait. You might also sit on the floor with your feet stretched out toward the mirror. You can draw what you see in the mirror or even

**3.44**
Rick Beckjord. *Student drawing, University of Maine at Orono. Dramatic use of perspective in self-portrait.* Charcoal.

try a double image, which includes part of your body in front of the mirror as well as what is reflected.

### Endnotes

[1] Leonardo da Vinci, quoted in Emery Kelen, ed., *Leonardo da Vinci's Advice to Artists* (Philadelphia: Running Press, 1990), 38.

[2] Paul Cezanne, quoted in Robert Goldwater and Marco Treves *Artists on Art* (New York: Pantheon Books, 1945), 363.

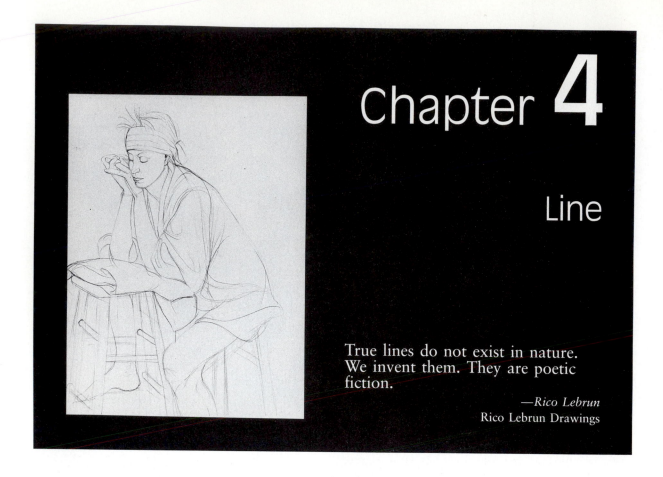

# Chapter 4

## Line

True lines do not exist in nature. We invent them. They are poetic fiction.

*—Rico Lebrun*
Rico Lebrun Drawings

Although much has been made of the invention of the wheel, the first use of a line for symbolic representation was truly a quantum leap in the development of humankind. Whereas a wheel transports tangible goods, a line is capable of storing and transmitting ideas. Physically, a line is nothing more than a two-dimensional mark on a surface. But when that mark traces the configuration of an object, it traps within its confines the conceptual essence of that object, which it holds through time. Used in this way, line fashions a sort of magic. It conjures the form of an object upon the blank page, bringing it into being on the drawing's surface and in the viewer's mind.

Line communicates nonverbally, but it can be as expressive as any thought fashioned with nouns, verbs, and adjectives. As Lebrun said, lines are "poetic fiction": fiction because of the illusion they invoke to pique our imaginations, and poetic because of the expressive way they can refer to their subject and trigger our emotions.

One of the greatest fictions perpetrated with drawing is the illusion of dimension. Throughout the history of art, artists have sought to transcend the limitations of two dimensions, the static plane of a flat sheet of drawing paper or the taut surface of a stretched canvas. It is something of a paradox that line, also stationary and firmly bound within the two dimensions of the page, has become a key instrument by which to create the illusion of three-dimensional form.

Egon Schiele's drawing, *Couple Embracing*, Figure 4.1, illustrates how a simple line can provoke our imagination. This drawing, believed to be a portrait of himself and his wife, exhibits the characteristics of a blind contour sketch, drawn by looking in a mirror, without the artist's referring to the paper upon which he worked. Although this line is broken at times, and parts of the body appear to be out of alignment or missing, it nevertheless suggests the couple's entanglements. The spectator must complete the image, however, by letting his or her imagination participate in Schiele's illusion. Every drawing thus elicits the participation of its viewers, and, in part, we measure the quality of a drawing by how skillfully the

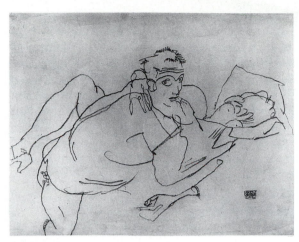

**4.1**
Egon Schiele. *Couple Embracing*. 1916.
Black oil crayon on paper, 410 x 518 mm
(16 1/8 x 20 3/8″).
Santa Barbara Museum of Art, Santa Barbara.
Anonymous gift to the Ala Story Collection.

the kinetic energy by which it was created and, in turn, directs the movement of our eye through the drawing. Line can be imbued with an amazing range of qualities, from a soft and gentle touch to a frenetic flailing upon the drawing surface.

Jean-Auguste-Dominique Ingres's drawing, Figure 4.2, demonstrates nicely the dual function of line, even though it was not considered a finished work nor intended as a public statement. This is clearly an exploratory study in which the artist researches the possible position of arms and makes a preliminary study of the head. Toward this end,

artist shapes the line to evoke this involvement. The public was often offended by the open eroticism of Schiele's drawings, which tells us something about the seductive power of even a loosely constructed line drawing.

## The Function of Line

In figure drawing, line fulfills both utilitarian and aesthetic functions, depending on the artist's intent. We may admire one drawing because of the authentic and convincingly descriptive quality of its lines. Another drawing may be impressive because of the line's expressiveness or playfulness. For artists who use the figure as a recognizable subject in their drawing, line must correspond on some level to the figure it symbolizes. In so far as we desire our drawings to possess an added aesthetic quality, line must also be an emotive vehicle that gives the figure its particular character and simultaneously reveals the artist's imagination.

The *utilitarian function* of line lies in its ability to describe and inform. When representing the human figure, line can outline its shape and describe its configuration, dimensions, proportions, and topography—all of which contribute toward the creation of a communicable symbol. Line does not, however, directly imitate nature. Instead, line alludes to nature, intellectually engaging us as visual metaphor.

The *aesthetic function* of line comes from line's calligraphic quality. A line serves as a recording of

**4.2**
Jean-Auguste Dominique Ingres. *Copy after Study for "Raphael and the Fornarina"*. Pencil, 331 x 200 mm.
Courtesy of the Fogg Art Museum,
Harvard University, Cambridge, Massachusetts,
Gift of Grenville L. Winthrop.

Ingres's line has to fulfill a needed practical function. Still, as his line defines the solidity of the body, it softens the form, giving it a sensuousness as well as structure. Ingres makes his lines an element of grace and refinement, like the subject they represent. What is particularly revealing about this example of Ingres's private working drawing is the process through which he would achieve his final expression of a form. This was a side of his creative process that he went to great lengths to conceal in his more public works. Ingres felt that "one should make all traces of facility vanish."[1] He did not want the media or the process by which the work was created to disturb the serenity of his subject matter.

In contrast to Ingres's neoclassic refinement, the abstract expressionist de Kooning said: "Art never seems to make me peaceful or pure. It always seems to be wrapped in the melodrama of vulgarity."[2] His presentation of a woman, Color Plate V, is the antithesis of Ingres's careful rendering. Like another drawing by Jean Dubuffet, Figure 4.3, de Kooning's drawing is an anarchistic proclamation that drawing is essentially an emotion-laden mark-making process. Dubuffet's and de Kooning's lines are expressive rather than functional. The figure is peripheral to the real content of both drawings: the unrestrained catharsis of expressive energy. These artists had little need or desire to restrain their line and make it conform to the delineation of the figure's visual appearance or form. Yet for both de Kooning and Dubuffet, as well as Ingres, line remains a tool with which to symbolize nonverbal ideas.

## Line Phrasing

In addition to acknowledging line's communicative and expressive modes, we can also make some general classifications in the way line is contrived to describe the human form. This, in turn, determines much of a line's communicative and aesthetic character. What distinguishes one technique from another is the way an artist *phrases* line to describe the subject. "Phrasing" is a term used by Philip Rawson in his book, *Drawing*.[3] A

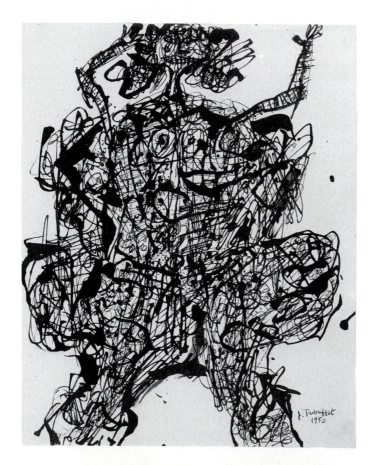

**4.3**
Jean Dubuffet. *Nude (Novembre)* from *"Corps de dames" series*. 1950.
Pen, reed pen, and ink, 10 5/8 x 8 3/8.
Museum of Modern Art, New York.
The Joan & Lester Avnet Collection.

4.4
Albrecht Dürer. *Constructed Head of a Man in Profile.* Pen and brown and red inks, 9 9/16 x 7 1/2″. Pierpont Morgan Library, New York. I 257B.

*phrase*, according to Rawson, is a single line's uninterrupted movement from beginning to end. Each phrase is a separate impulse, and a progression of such impulses eventually determines the character of the finished drawing. Although the following classifications are broad, we believe they will serve to differentiate some of the basic ways line is phrased and will assist us in exploring the visual dynamics of line when drawing from life.

## OUTLINE

Outlining is the simplest way in which to circumscribe and symbolize an object. An outline is primarily a tool for demarcation, which encloses form by defining its outer perimeters and, thus, separates the figure from its background. The line itself is consistent and continuous in its weight and application, giving the impression that it was made in one long, uninterrupted tracing—one unbroken line phrase. Of all the types of line used to describe the figure, outline is the most generic. It draws the least amount of attention to its own existence. When outlining, the artist's attention

focuses on the edge of the figure, and the reality of the flat, two-dimensional drawing surface dominates over the physical reality of the figure as a three-dimensional volume. The human figure becomes a silhouette and appears as a flat enclosure.

Albrecht Dürer's *Constructed Head of a Man in Profile,* Figure 4.4, presents a two-dimensional diagram. The lines of the grid serve simply to divide space into smaller units without any metaphoric inference, whereas the outline takes on a symbolic role because of our ability to recognize the image by its silhouette. The outline, as two-dimensional as the grid, details only the eye, mouth, and ear to suggest any dimensionality. Dürer darkens the background to further emphasize the distinction between figure and ground and to bring out the head's stencil quality.

In Figure 4.5, Lachaise employs an even, non-fluctuating outline in long phrases to give a light and airy quality to his figure. Although the body

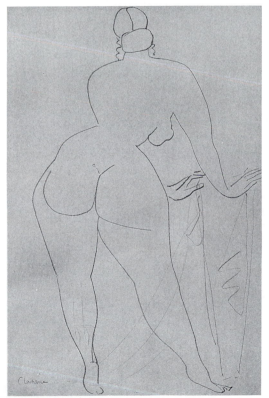

4.5
Gaston Lachaise. *Standing Nude.* c. 1922–32. Pencil on paper, 17 3/4 x 11 3/4″ (45.09 x 29.85 cm). Collection of Whitney Museum of American Art, New York, Purchase 38.46; Geoffrey Clements Photography.

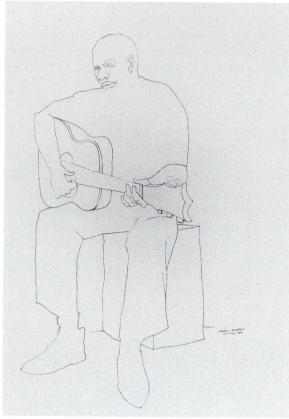

4.6
Benny Andrews. *Yeah, Yeah.* 1970. Ink on paper,
17 3/8 x 11 1/2″. Arkansas Arts Center
Foundation Collection: The Museum Purchase Plan
of the NEA and THE Barrett Hamilton.

Lachaise encircles is quite large, the image remains
two-dimensional. His line expresses the edges of
form rather than its volume. Yet the viewer ex-
trapolates from these clues—the curvature ex-
pressed as a dimension of width—and assumes
that the form also extends forward and back in
depth.

Benny Andrews's Figure 4.6 provides another
example of the continuous line phrasing of outline
that conforms to the outer edge, enclosing the
form. Although the outlines of some facial features
and the guitar have also been traced, the body is
defined primarily as a silhouette, and it is our
imagination that is called upon to provide any fur-
ther description.

## BROKEN OUTLINE

A less confining outline of the figure can be
achieved by breaking the line into a series of line

phrases—each describing a segment of the body.
The looser structure of the broken line moves us
through the gaps from foreground to background,
a beginning suggestion of depth. Matisse inher-
ently appreciated the transcendental effect of such
an outline, but spoke, too, of learning to discipline
the use of line. "What I dream of is an airy bal-
ance, of purity and serenity. . . . One must always
search for the desire of the line, where it wishes to
enter or where to die away."[4] In Figure 4.7, Ma-
tisse incorporates a broken outline, which por-
trays his refined phrasing of line. For Matisse, the
primary reality of a drawing remains two-dimen-
sional, yet he delineates his subjects without re-
stricting them or reducing them to static objects.
His figures become conceptual rather than tangi-
ble. They are meant to be held mentally, not physi-
cally. Matisse regarded his ink drawings as his

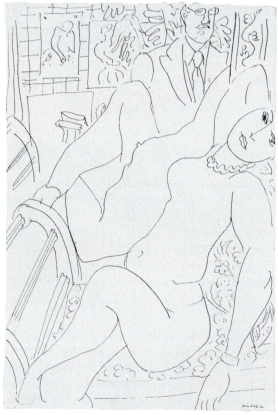

4.7
Henri Matisse. *Artist and Model Reflected in
a Mirror.* 1937. Pen and ink on paper,
24 13/16 x 16 1/16″.
Baltimore Museum of Art, Baltimore. The Cone
Collection, formed by Dr. Claribel Cone and
Miss Etta Cone of Baltimore, Maryland, BMA
1950.12.51

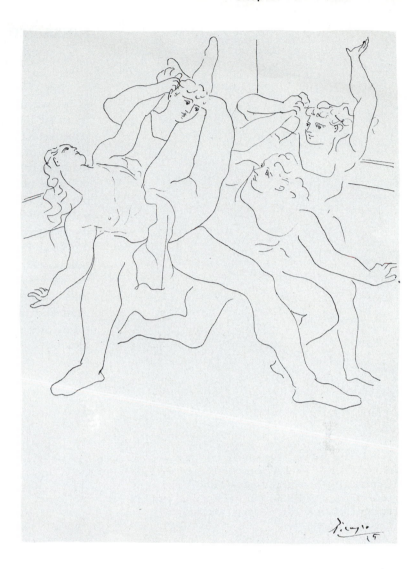

4.8
Pablo Picasso. *Four Dancers*. 1925.
Ink, 13 7/8 x 10″.
Museum of Modern Art, New York.
Gift of Abby Aldrich Rockefeller.

purest translation of form, but it is important to realize that his ink line drawings were often preceded by preliminary sketches in charcoal.

Pablo Picasso uses a similar broken, thin-line phrasing to portray the light and fleet-footed dancers in Figure 4.8. His line flows rhythmically, exploiting its directional nature to lead us at a sprightly pace through the composition. The occasional line breaks contribute to the drawing's airiness and allow the viewer to move freely from one dancer to the other, carrying the line's momentum across open intervals. This connecting gap, the space between lines that the viewer links visually, permits the artist to express the body's gesture and form economically without completely enclosing shapes, therefore permitting greater movement between them. Picasso uses the force of this implied line—its ability to project beyond its length—

to express the transitory quality of dancing rather than describe the muscular physiques of the dancers. Implied line, the most illusory graphic presentation possible, is sensed rather than seen. In this drawing, Picasso relies on the viewer's willingness to make the connections from one line to the next. The only other technique Picasso and Matisse use in these examples to suggest the existence of spatial relationships is overlapping line.

## OVERLAPPING LINE

Whenever a line terminates at an intersection with another line, its momentum may continue, but the fact that it is no longer visible suggests that it is submerged. Dominant, uninterrupted lines suggest forms close to the viewer; subordinate lines that submerge or disappear behind others indicate recessive forms.

**4.9**
Egon Schiele. *Crouching Nude—Front View.* 1918.
Black chalk, 18 3/4 x 12 1/2″ (47.5 x 31.5 cm).
Marlborough Fine Art, London, England.
Private Collection.

## MODULATED LINE

Modulating line weight produces a calligraphic effect that is both functional and aesthetically pleasing. The word *calligraphy* is derived from the Greek word *kalligraphia*, which means "beautiful writing." However, it was the Oriental artists who really understood its meaning and, perhaps, were the most practiced and sensitive artists in terms of manipulating line through disciplined gestural movements of hand and sumi brush. An ink drawing attributed to Hokusai, *One of the Nio*, Figure 4.10, shows only a fraction of this virtuoso's ability to let line speak. Here he creates a figure of power and grace through the rhythmic manipulation of line, which suggests both rising and receding surfaces. For instance, dark lines sink into the folds of the garment, whereas those defining the head and face sharpen our focus and make the forms they describe appear to advance. We enjoy Hokusai's drawing both for the efficiency with

In Schiele's drawing, Figure 4.9, such overlapping lines suggest overlapping body parts. The unbroken lines of the legs overlap the lines of the arms, clarifying their relative spatial positions. The thighs cover the lines of the breasts and abdomen, and the lines of the lower legs establish their position as the farthest forward. Each overlapping line represents a step back in space and thus helps to suggest the body's three-dimensionality. In comparison to Picasso's metaphoric use of line in his drawing of the four dancers, Schiele's line deals more with the physical presentation of the body, stationary and firmly situated before us. Schiele's line conforms more tightly in this drawing to the configuration of the body than it did in Figure 4.1, giving attention to enough details to convey the physical presence of a particular individual rather than a generic symbol or an abstract ideal.

**4.10**
Katsushika Hokusai (attributed). *One of the Nio.*
c. 1815—49. Black ink on paper, 15 7/8 x 11 3/8″.
Seattle Art Museum,
Eugene Fuller Memorial Collection, 39.162.

**4.11**
Mary Cassatt. *In the Omnibus.*
c. 1891. Black chalk
and graphite,
14 7/8 x 10 3/4″ (.379 x .271 m).
National Gallery of Art,
Washington, D.C.
Rosenwald Collection.

which it communicates and for its rhythmic beauty. Hokusai's drawing is an ideogram of the traditional goals of Oriental aestheticism: achieving creative innovation through the marshaled control of hand and brush.

Line's diversity in terms of weight and thickness is a means of accentuating some lines and deemphasizing others. Phrasing lines so that they appear to fluctuate back and forth in space, as if moving in and out of focus, contributes more to the feeling of spatial differentiation than an unmodulated line might suggest. Variations in weight along the length of a line add a rhythmic component, suggesting an elasticity that encloses without restricting and permits the forms to breathe.

Mary Cassatt's sketch, Figure 4.11, is a compositional study she made while riding on a bus. Overlapping lines are significant in implying the spatial relationships of the various figures and the bus itself. The line functions both to define the shapes of the figures and to divide the larger picture plane. Cassatt's lines are phrased with a brisk, slashing action, so at times, one line may seem to block another by cutting across its path. She gives new direction to existing lines by laying over a new line that emphasizes a slightly different course. The result is a multifaceted line made of many partially overlapping lines. Cassatt began the sketch with pencil and continued with bolder chalk lines, which enabled her to modulate the line

and emphasize some parts of the drawing more than others. Restating the edge in this manner can be referred to as multiple phrasing.

## MULTIPLE PHRASE OR REPEATING LINE

Line is often given more life and strength through the act of restating—in the same way that a rope or thread may be made stronger by twining several strands of fiber. Similarly, multiple phrasing can refer to a series of repeated lines, each with a slightly different interpretation of the body's contour, like the complementary play of musical instruments in an orchestral composition.

Gustav Klimt's drawing, Figure 4.12, embraces the outer limits of the body's form in a way similar to an outline. However, Klimt's line is sketchier, more indefinite and therefore more flexible, and he defines the figure in thin linear phrases that vary more in length and quantity than in weight or

width. A single line defines the figure's left arm and hip, but the multiple strokes, often repeating and restating the other extremity of the body, allow the figure to expand and contrast slightly, as in the stretching movement of the abdomen and neck. Like Schiele's figures, Klimt's have often been defined as erotic. In part, this is certainly due to the pose of his models, but it is also conveyed through his use of line. Klimt's contour lines are more tactile than mere outline in that they seem to provide an extension of touch. What would otherwise be a static outline is augmented through repetition into a line charged with anxious energy. This differs from the quiet appearance or simplicity of a continuous outline. Multiple line never really confirms the exact perimeters of the figure, thus we vacillate between lines and around the edge of the form. As Klimt phrases his line, his hand moves forward along the contour then often retreats on itself before moving forward again. In this way, he regulates the pace with which our eye encompasses his figures, at times fleeting quickly along the contour, at other times lingering or retracing.

With a heavier hand, Suzanne Valadon amplifies her line through repetition in Figure 4.13, using chalk to lay down a broader stroke than did Klimt. She builds her lines through multiple phrasing, each repeating passage adding renewed conviction as it echoes the previous refrain. She blends both modulated line and multiple strokes to deftly carve the heavy folds of fabric, to outline the limbs as they labor. The bold lines at the edge of the figure function as an abbreviation for the dark, shadowy surroundings as well as the containment of the form. Contemporary artist Shelley Jordon's drawing, Figure 4.14, accomplishes a similar end but with a lighter touch.

In another contemporary work, Figure 4.15, Diebenkorn phrases his line in response to the body's mass. His line is straighter, more forceful and angular, seemingly made from stiff steel wire, whereas Klimt's rephrasing of a line seems woven from several strands of thin thread. Yet for Diebenkorn, line functions as a structural device, converting the three-dimensionality of the body into a delineation of shapes that break up the two-dimensional picture plane. Composition is important to Diebenkorn, and in many ways the figure is primarily a device for creating his compositions. He runs his lines out to the edge of the paper as a way of anchoring the interior to the borders of his

**4.12**
Gustav Klimt. *Seated Nude.* 1914–16. 56.9 x 37.3 cm. Graphik-Sammlung ETH, Eidgenössische Technische Hochschule, Zürich, Switzerland.

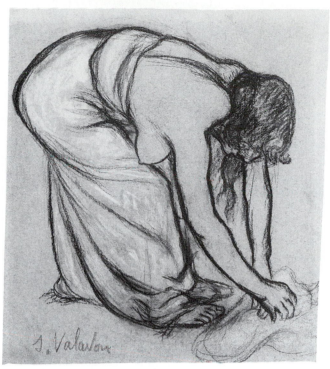

**4.13**
Suzanne Valadon. *Woman Bending Forward.* c. 1920.
Black and colored chalk on tracing paper,
6 3/8 x 5 5/8″ (16.3 x 14.3 cm).
Cincinnati Art Museum, Cincinnati.
Gift of Dr. and Mrs. J. Louis Ransohoff.
Photo CAM, Forth 6/90.

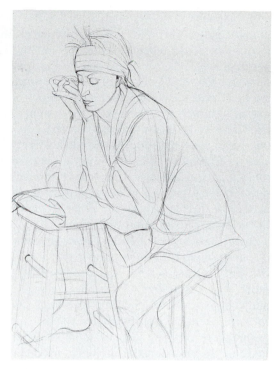

**4.14**
Shelley Jordon. *Seated Woman.* 1989.
Graphite, 22 x 30″.
Courtesy of the artist. New York.

drawing surface. His line corrals, shapes, and divides the drawing surface, focusing on the distribution of shapes within two dimensions rather than creating a persuasive illusion of three-dimensional form.

## Contour Drawing

Although the surface we draw on may indeed be flat, the human body is not; and for many artists the challenge is to get their line to symbolize volume. For them, an artist's skill is measured by the ability to create a convincing illusion of volume and space, defining structure and fullness. An artist draws upon a number of techniques to sug-

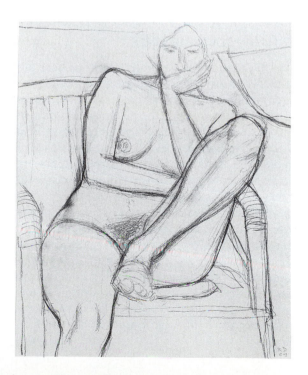

**4.15**
Richard Diebenkorn. *Seated Nude, Leg Raised.*
Metropolitan Museum of Art, New York.
Reproduced by permission of the artist.
Photograph by Douglas M. Parker Studio.

gest the physical vitality and dimensionality of the human figure through line. Collectively, these techniques could be referred to as *contour lines.* Outline, even when broken, repeated, or overlapping, for the most part notes the *configuration* of the body—its shape or position—without *modeling* its volume—sculpting it in three dimensions. Such lines make little attempt to describe the internal terrain of the body's surface between the clearly established edges. Contour lines, on the other hand, emphasize the body's three-dimensional reality, ignoring or even supplanting the flat surface of the paper with the fuller interpretation of the body's relief and dimensionality.

For the layperson, the word *contour* would be a direct synonym for *outline;* however, for most artists and artist-teachers, contour implies much more. The etymology of the word suggests the added dimension: Originating from the Latin *contormare,* to turn, and the Italian *contorno,* to go around, the contour line attempts to depict the body in the round. Contour lines, by definition, are more sculptural and descriptive of spatial relationships than outlines. They tend to depart from the edge and cross over a form. You may see many subtle variations and combinations in the use of contour lines, yet it is possible to define four general types, each representing a different approach toward expressing the figure's form in space: *gestural, schematic, anatomical,* and *modeling.*

## GESTURAL CONTOUR LINES

As the term implies, gestural contour lines are the result of an intuitive, energetic approach toward expressing volume and surface relief, where the artist responds with fluid lines to the dimensions of the human figure. These lines spring from the same attitude as a quick gestural drawing of the body's action, discussed in Chapter 2, but are as expressive of the body's three-dimensional form as they are of its action.

Rembrandt's sketches often possessed a strong gestural quality, with additional structural and three-dimensional connotations. In his study of an *Old Man Leaning on a Stick,* Figure 4.16, Rembrandt appears to have begun with a fine point to sketch faintly the gesture and proportions of the figure. Then, during the course of the drawing, his strokes become bolder. He flattens or broadens his pen point, applies increased pressure, and adds

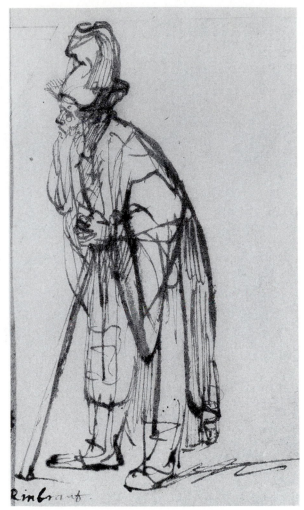

**4.16**
Rembrandt van Rijn. *Old Man Leaning on a Stick.*
c. 1635. Pen and bistre, 134 x 80 mm
(5 5/16 x 31 1/2″).
Metropolitan Museum of Art, New York.
Robert Lehman Collection, 1975 (1975.1.796)

forceful lines for accent. For example, notice the way he emphasizes the bend of the man's back and cuts back with bold lines the area under his hands, sleeve, and hat.

There is no denying the solidity and fullness of the figures in Henry Moore's *Row of Sleepers,* Figure 4.17, brought about by the artist's lines tracing across the form, up and down, around and over, and back again. Rembrandt and Moore create a network of lines as a three-dimensional scaffolding that crisscrosses the form. Both employ modulated line and multiple phrasing derived from the

gestural quality of line, but it is primarily the crossing action that implies dimension and form. The phrasing of a gestural contour line is essentially a response to the body's inner core rather than to its outer edges. The vector of the line, its implied force and direction, seem to continue around to the back of the form.

Alberto Giacometti's 1951 drawing of a head, Figure 4.18, illustrates further how each gestural line that crosses the interior can contribute to the density of mass, the containment of volume, and the description of facial topography. The line

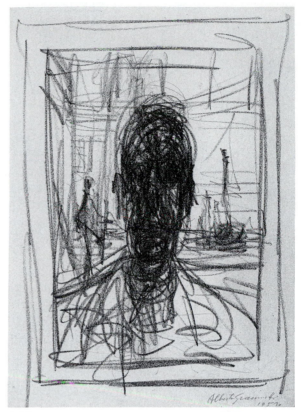

4.18
Alberto Giacometti. *Portrait of an Interior.* 1951. Litho crayon and pencil, 15 3/8 x 10 7/8". Museum of Modern Art, New York. Gift of Mr. and Mrs. Eugene Victor Thaw.

phrasing is flamboyant and spontaneous, gestural, and often continuous. What the line lacks in discipline, Giacometti gains in its dynamic expressiveness. This gestural line follows the artist's hand movement as it flows over and across the contour until the form is enveloped. Giacometti wraps his line around his subject to capture "the life that is housed in the skull," [5] drawing both front and back all at once, building both the form of the skull and the intensity of the image.

## SCHEMATIC CONTOUR LINES

The use of line to make a graphic construct of physical volume as an architectonic structure could be described as schematic in its approach. Such lines possess an essentially cool or mechanical quality. This does not mean that they lack aesthetic properties; indeed, they can be extremely elegant. For the most part, however, they are the

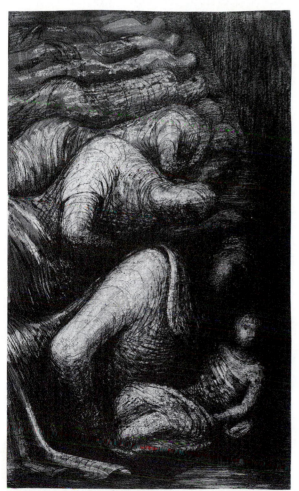

4.17
Henry Moore. *Row of Sleepers.* 1941. Wax, chalk, ink, and watercolor, 21 x 12 5/8". Henry Moore Foundation, Much Haddam, Hertsfordshire. Photo by Michel Muller. Reproduced by kind permission of the Henry Moore Foundation.

result of objective analysis, laid down with methodical precision with a geometric or diagrammatic appearance.

Pavel Tchelitchew's *Head,* Figure 4.19, is an example of how rich and intriguing a schematic contour drawing can be. Notice how his lines cross over the contour of the head, like lines of longitude and latitude on a globe. Tchelitchew's line, like Giacometti's, encompasses the head, enclosing its volume but in a more systematic way. Tchelitchew traces the circumference of volume rather than outlining its shape. In doing so, the two-dimensional realm of the paper is eclipsed by the artist's desire to encompass the third dimension. Notice, too, the differences between this drawing and Dürer's head study, Figure 4.4, discussed at the outset of this chapter. Both are schematic in nature, but Dürer focuses on the profile, which was enclosed with outline, and Tchelitchew diagrams volume with crossing contour lines.

Another aspect of Tchelitchew's drawing central to contour line drawing is the implication of a core or center around which the outer surface or lines of the body turn and encompass the form. Schematic contour drawings define the topographic relief of the body's surfaces but in a more deliberate fashion than gestural contour drawings. Notice how Tchelitchew's lines around the nose and eyes express the relief of the human body much as contour lines on a topographic map express elevation of the land.

**4.19**
Pavel Tchelitchew. *Head VI.* 1950.
Colored pencil on black paper,
19 7/8 x 13 3/4".
Museum of Modern Art, New York.
Gift of Edgar Kaufmann Jr.

**4.20**
Luca Cambiaso. *The Elect Ascending
into Heaven (detail).* Pen, brown ink,
and wash. University of Michigan
Museum of Art, Ann Arbor. Gift
through the Estate of Edward
Sonnenschein, 1970/2.12.

In Figure 4.20, Cambiaso builds his figures out of geometric planes with dispassionate, systematic line that reconstructs the figure in an abstraction of the human form. As Cambiaso's drawing suggests, one of the primary strengths of schematic contour line is its ability to simplify and diagram complex structures. The phrasing of Cambiaso's schematic contour line is tectonic, forming links with other line phrases to create a graphic construct of the body's underlying geometric structure.

## ANATOMICAL CONTOUR LINES

Many artists would argue that it is the body's anatomy that determines its structure. For them, the way a line is phrased should reveal the solidity of the musculature beneath the surface of the skin, which, in turn, determines the topography of the mass. With the anatomical approach to contour drawing, prior knowledge of human anatomy is useful, but not absolutely essential. Much can be learned through close observation and responding with sensitivity to its form. Muscles interlock, overlap, and wrap around the trunk and limbs, and the play of light and shadows can provide hints of their presence, directing your line phrasing to conform to these anatomical relationships.

The anatomical approach creates the illusion of three-dimensionality by applying overlapping lines to suggest a spatial progression of anatomical forms and linear vector to suggest a muscle's continuance around its core, the skeletal armature.

Compare Cambiaso's schematic contour drawing, Figure 4.20, with that of his contemporary, Giovanni Battista Ricci, Figure 4.21, whose drawing is more organic because his phrasing of line responds to the figures' anatomic forms. Cambiaso achieves a certain solidity; however, his figures remain rigid, largely because of the straight lines used to define and enclose the shapes. Ricci's line is applied in more fluid, curvilinear phrases and suggests softer forms. While both artists create a complex arrangement of human forms in

**4.21**
Giovanni Battista Ricci. *The Crucifixion of St. Peter*. Red chalk; pen, brown ink, and wash, 23.2 x 36.0 cm. Metropolitan Museum of Art, New York. The Rogers Fund, 1971 (1971.222.2).

**4.22**
Hyman Bloom.
*Wrestlers.*
c. 1930. Black crayon
on brown paper,
10 1/8 x 14 1/6″
(254 x 355 mm).
Courtesy of the Fogg
Art Museum,
Harvard University,
Cambridge,
Massachusetts.
Bequest of
Dr. Denman W. Ross,
'75.

**4.23**
Raphael. *Five Nude Men.* Pen and ink,
10 5/8 x 7 3/4″. Reproduced by courtesy of
the Trustees of the British Museum, London.

space, they approach the figure with very different assumptions expressed through their phrasing of line.

For a closer study of how anatomical contour line might be used, consider a twentieth-century artist's drawing of wrestlers, Figure 4.22. Like Ricci, Hyman Bloom responds to the structural character of overlapping muscular forms to give his figures solidity. Bloom's line describes the contour of his wrestlers in several of the ways we have been discussing. His external line varies greatly in value and weight. Also, notice how lines defining the outer edge of the body often turn inward, rolling with the cylindrical forms and evolving into a whole network of lightly drawn topographical contour lines, which define the bulging relief of flexed muscles. At the same time they create a richly interwoven, calligraphic circuitry that conforms to the ridges and furrows of the body's anatomy. Bloom combines multiple phrasing to emphasize and modulate his line, which directs us forcefully through the entanglement of the wrestlers, engaging us as spectators in their conflict.

Raphael's study, Figure 4.23, further demonstrates how the body's anatomy can suggest the artist's phrasing of line. The placement and length of each line refers to the physical structure: Where muscles cross over one another, so do lines. Where shoulder or hip bones or the spinal column appear at the surface, we see their proximity as contour lines. Be aware that Raphael did not actually see a physical line on the body, but he learned to "read" the slight rises or declines in the surface as clues to the anatomical understructure. Through these lines, Raphael describes the anatomical structure of his figures and implies the variations in surface relief.

## MODELING CONTOUR LINES

The concept of modeling the figure usually refers to the tactile art of sculpture, whereby the artist shapes from clay or other media the three-dimensional form of the human body. To model in two dimensions, when drawing, the artist creates the illusion of form, the suggestion of the third dimension. Drawing is conceptually tactile rather than physically so. The struggle to mold the figure with drawing media, however, is every bit as intense and requires as full an understanding of the body in the round as it would to model in clay.

Line can be an effective conceptual modeling tool when arranged in parallel, sequential strokes, referred to as *hatching*. Each stroke is a distinct linear phrase, crossing over the interior contour of the body. It is the accumulation of these traversing lines that enables the artist to define broad areas and thus differentiate planes from edges.

Raphael's drawing, Figure 4.23, employs hatching lines, phrased quite differently from the longer and generally darker anatomical contour lines that denote the muscular flow of the body. Notice that these groupings of shorter lines suggest the area and slope of the surface planes.

This drawing method begins to blur the distinctions between line and value, because when the individual hatch marks lose their individuality, they cease to be line in any conceptual sense. Even though, as in Raphael's drawing, they might physically retain the qualities of line, these parallel contour lines "read" as value planes. Hatching, like its counterpart cross-hatching, serve the primary purpose of creating value, which is the central topic of the following chapter.

## Summary

Every drawn mark is a record of the hand's movement, of a human impulse. Line clearly exists as a visual trail of the hand's movement as well as the artist's mental processes. It signifies the way we conceptualize. Line not only enables us to grasp the representation of the figure as a general idea, it gives the presentation of the figure its individuality. Just as an expanded vocabulary can increase your effectiveness in verbal or written communication, expanding your awareness of the communicative properties of line can heighten your skill as a visual artist.

For the sake of simplicity, this chapter has attempted to isolate different line characteristics and discuss them individually; however, most drawings display a variety of line techniques as an integrated network. Each contributes in its own way to the presentation and communication of the image as a whole. For example, notice the variety of ways Augustus John phrases line in his double drawing, Figure 4.24. The line running down the lower back and leg of the front-facing figure on the right is essentially an outline, defining the edge. The line running down the front of the same

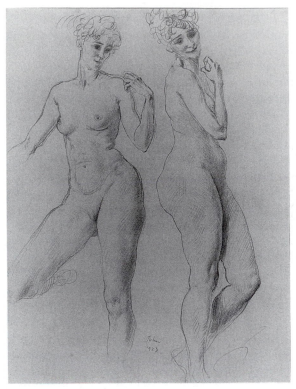 

**4.24**
Augustus John. *Two Views of a Female Nude.* 1923. Graphite pencil on rag paper,
450 x 339 mm (31 3/4 x 25 3/8″). Santa Barbara Museum of Art, Santa Barbara.
Gift of Wright S. Ludington.

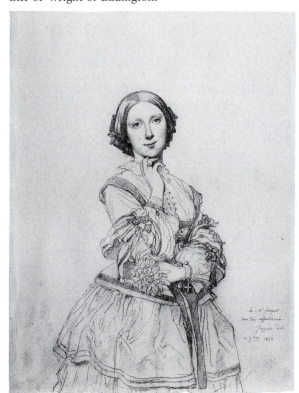

figure fills out the shape, while over the hips of the left figure, the rephrased lines suggest movement. At times, his contour line responds to anatomical clues, turning inward and evolving into a further description of the topography of the form, as with the bent arm, shoulder, and abdominal area of the far left figure. In addition, over the interior of the form, the accumulation of shorter, linear hatching lines suggests the curvature of the surface and begins to develop as value into shadow areas. In the legs of several figures, John uses implied line to encourage the viewer to carry the image beyond the end of the line.

During his lifetime, Ingres did a large number of pencil portraits that displayed a master's reper-

**4.25**
Jean-Auguste Dominique Ingres. *Portrait of Mme Cécile-Marie Tournouer née Panckoucke.* 1856. Graphite, 12 15/16 x 9″ (32.3 x 24.2 cm). Detroit Institute of Arts, Detroit. The Detroit Institute of Arts, Founders Society Purchase, Anne McDonnell Ford Fund and Henry Ford II Fund.

toire in the descriptive use of line. Notice in Figure 4.25 not only the diversity of Ingres's use of line but also the variety of surfaces it is capable of expressing. Ingres uses line to describe and decorate as well as to celebrate the countenance of his subject. Few artists are capable of imbuing line with this degree of descriptive and poetic richness. Ingres held such a high regard for the importance of line that upon meeting the youthful Degas, he gave him this advice: "Draw lines, young man, many lines; from memory or from nature—it is in this way that you will become a good artist."[6]

# In the Studio

## Quick Line Variation Exercises

**Pose** - 5 minutes
**Media** - Conté, graphite, or ink with reed pen on newsprint, 18″ x 24″

The goal of this exercise is to experiment with the weight and thickness of your line. In a gestural line fashion, use your drawing tool to trace the scanning action of your eyes over the form of the model. Move your hand continuously, frequently changing the amount of pressure you apply and the way you hold the tool. Vary your lines: make them bold and dark, crisp and thin, light and soft. Don't hesitate to redraw the same forms. Also, it is not necessary in this exercise to rationalize the variations in weight, where a line should be light and where dark. Let your intuition suggest where lines should be accentuated by variation in your touch. You will discover that as your line becomes more rhythmic it will also fluctuate in depth, infusing line with an abstract richness separate from its functional role, as in Figure 4.26.

## Outlining More than the Outside Edge

**Pose** - 10 minutes
**Media** - Dark pencil or ink on regular drawing paper, 18″ x 24″

Many students of life drawing share a natural predilection for using line primarily as outline, as a device for indicating the outer edges or borders of the body only. The goal of this exercise is to encourage a more descriptive and informative use of line. Begin by drawing the general configurations of the body, then find smaller shapes within the larger ones by tracing shadows or indicating defi-

4.26
Sandra Butler. *Student drawing, Oregon State University. Example of overlapping and varied line to create rhythm and depth along the body's contour.* Conté crayon.

nite shifts in value where you can see ridges or furrows representing anatomical structure. Let the weight or thickness of the line suggest what you feel is the form's significance by making the more important lines darker (see Figure 4.27).

**4.27**
Darin Anderson. *Student drawing, St. Cloud State University. Example of outlining exterior and interior edges.* Black marker.

### Multiple Phrase or Repeating Line

**Pose** - 15 minutes
**Media** - Soft charcoal or conté on regular drawing paper, 18″ x 24″

The purpose of this exercise is to discover how repeating, or redrawing, the contour of the figure with several lines can accentuate that contour and give more force to your drawing. Begin with a light sketch of the model's gesture, capturing the configuration of the pose. Then, let the drawing evolve through a continuous process of rephrasing your line, adding to existing lines or using a new line adjacent to the previous one to suggest another interpretation of the contour. Do not erase your earlier lines, but allow them to remain and be followed by more emphatic statements of line along the same contour. After 15 minutes, allow the model to rest, but continue to work on your drawing for several more minutes. Think about what the drawing needs and what you could do to give it more presence (see Figure 4.28).

### Schematic Contour Lines

**Pose** - 30 minutes
**Media** - Graphite or charcoal on regular drawing paper, 18″ x 24″

With this exercise, the goal is to fully exploit the schematic and diagrammatic potential of line. The approach to the figure is essentially one of distilling it to its underlying geometric structure and of using line as an expression of empirical observation to systematically reconstruct a graphic diagram of its structural configuration.

Your line should constitute a diagram of horizontal and vertical lines that suggest its geometric volumes and multifaceted surface, as in Figure 4.29. An analogy would be that you are to construct a linear scaffolding that encloses the figure's mass with line, much the way the steel framework of a skyscraper defines the shape of the building before the exterior walls are hung over it.

**4.28**
Jeffrey Schoonhoven. *Student drawing, Oregon State University. Use of multiple phrase and repeating line to give added emphasis and energy to the body's outline.* Charcoal.

4.29
James Bodio. *Student drawing, Oregon State
University. Schematic contour line sketch.*
Graphite.

## Anatomical Contour Lines

**Pose** - 30 minutes
**Media** - Graphite or charcoal on regular drawing
        paper, 18″ x 24″

The objective of this exercise is to make line as
descriptive and informative of the body's volume
as possible through a description of its surface
anatomy. Begin by lightly plotting the gesture and
proportions of the body. As your drawing pro-
gresses, try to visualize the body's roundness, its
fullness and curvature. As you observe and draw
the outer edge of the body, find as many places as
possible where the line of an anatomical form
turns in on the interior. Some of the most obvious
lines will be folds or wrinkles where the limbs and
torso bend. Attempt also to discover the more
subtle suggestions of overlapping forms that may
only be implied by a slight furrow or ridge in the
surface. Figure 4.30 uses line to mark the changes

in the surface planes and also as a position from
which to hang the addition of value in the form of
parallel hatching lines.

Figure 4.31 illustrates typical features of con-
tour lines that are phrased in accordance with the
body's anatomical structure. One of the first
things you will notice is how much more depth
and volume appear in the two outside drawings
than in the middle drawing, which describes the
same pose with simple outline. This is because the
two outside drawings phrase the line as a sequen-
tial progression of overlapping lines. Essentially,
the lines that express the edge turn in and begin
crossing over the contour of the interior space of
the limbs in accordance with the known anatomy
of the body. In effect, every time the line begins to
cross the contour, it contributes a bit of informa-
tion about the body's anatomical structure. All
three of these drawings have the same silhouette.
Notice, if you haven't already, how the two out-
side drawings change our viewpoint and, there-
fore, the direction in which the legs appear to

4.30
David Robinson. *Student drawing, Memphis State
University. Example of contour line
to model surface planes and terrain.*
Terracotta-colored pencil.

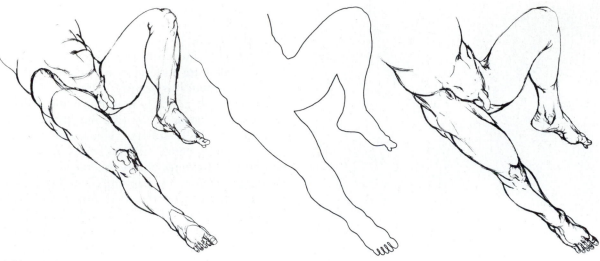

**4.31**
*Diagram of Anatomical Contour Line.*

recede in space. This is determined by reversing the sequence of overlapping lines. In essence, it is a matter of expressing nearer contour of the anatomy with lines that overlap those of farther contours.

Use lightly drawn lines to indicate the interior terrain of the body, such as the bumps found at the knee, stomach, back, and chest or the hollows of the underarm, lower back, neck, and face. Do not expect to see lines on the body in these areas. Remember, lines do not exist at the edge of the body either. Use your lines as notations of the form you see, creating a visual illusion that corresponds to the figure's anatomical structure.

### Independent Study:

1. Using a figure from a photograph or magazine as your model, trace the silhouette of a figure with a continuous outline on thin typing paper or tracing paper. Then lay another piece over the first and redraw the pose, incorporating overlapping line. On a third sheet, use modulated line, changing the line's weight and restating it several times. Then, using another sheet of paper, suggest the interior form with schematic lines that break the figure into multifaceted planes. On a final sheet, use free-flowing gestural lines that cross over the interior of the figure and define its contours. In each of these exercises, note how changes in line phrasing alter the character of the figure. 2. With a drawing you began in class as a quick sketch or simple line drawing, visualize the full volume of the body, then describe its shape with lines of longitude and latitude that would encompass the contours of the form as if on a globe. 3. Position yourself in front of a good-sized mirror, stretching your arm or legs toward your mirror image. Using only sequential contour lines, draw yourself, starting with the very tip of your pointed finger or toes and slowly working your way back. Observe how lines that suggest the outer edge frequently turn into the interior, suggesting that some forms appear to emerge from behind preceding ones.

### Endnotes

[1] Jean-Auguste-Dominique Ingres, quoted in Claude Marks, *From the Sketchbook of the Great Artists* (New York: Thomas Y. Crowell Co., 1972), 234.

[2] Willem de Kooning, quoted in Dore Ashton, ed., *Twentieth Century Artists on Art* (New York: Pantheon Books, 1985), 199.

[3] Philip Rawson, *Drawing* (Philadelphia: University of Pennsylvania Press, 1987), 89.

[4] Henri Matisse, quoted in Jack D. Flam, *Matisse on Art* (London: Phaidon Press, 1973), 38.

[5] Alberto Giacometti, quoted in Ashton, op. cit., 57.

[6] Ingres, op. cit., 284.

# Chapter 5

## Value

*If I could have had my own way, I would have confined myself to black and white.*

—*Edgar Degas*

The art world would not be as rich if Degas had so restricted himself, but his statement attests to his high regard for the strength of simple value drawings. *Value* refers to the range of tones between the two extremes, black and white. Graphic designers and photographers use *gray scales* to signify the steps or gradations in value or shades of gray between black and white, and computers are able to reproduce some 256 individual tones of gray. Although the human eye is extremely adept at seeing and interpreting even the most subtle shifts in value, much of our response is subconscious. The intent of this chapter is to increase your awareness of how the artist uses value when drawing from life.

The real power of value lies in its ability to present the illusion of light and shadow and to graphically model three-dimensional forms. Before investigating these two important descriptive functions of value, we must acknowledge that value, like line, also involves a more basic and abstract aesthetic function. For example, in Matisse's drawing of a reclining nude, Figure 5.1, line con-

structs the strongest illusion of the body, whereas value makes only a ghostlike reference to the shape of the figure, floating freely outside the confines of the figure's contour lines, without reference to its volume or to reflected light. Rodin, Figure 5.2, uses value in the form of water color washes primarily to fill out the body's shape and to more forcefully distinguish its silhouette from the background. Value serves as a substitute for color in that it distinguishes the figure from the background, the flesh from the hair, and so forth.

In her ink drawing of a reclining nude in a landscape, Figure 5.3, Mary Frank does away with line. She uses value alone to construct her image by overlapping textured layers of ink that suggest the fluidity of the body's gesture. Again, like Matisse, the artist uses value more to provide an aesthetic sensation than to convey information about light or human anatomy. Diebenkorn's drawing, Figure 5.4, shows how value is often used as a means of differentiating shapes, of breaking up the pictorial format of the drawing's surface to establish the composition with flat pattern. Value is also

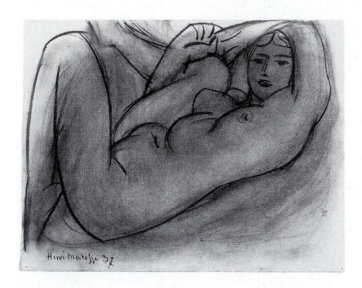

**5.1**
Henri Matisse. *Reclining Nude.* 1937.
Charcoal, 15 x 19". © 1990 Art Institute of
Chicago. All rights reserved.

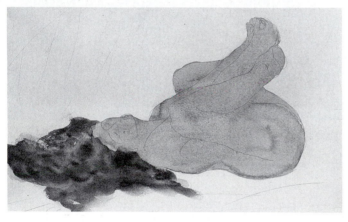

**5.2**
Auguste Rodin. *Untitled.* Victoria and
Albert Museum, London.

**5.3**
Mary Frank. *Untitled (Reclining
nude in landscape).*
1965. Ink on paper,
17 7/8 x 23 1/3" (45.4 x 59.6 cm).
Collection Whitney Museum of
American Art, New York.
Purchase with funds from
Susan and David Workman.
Geoffrey Clements Photography.

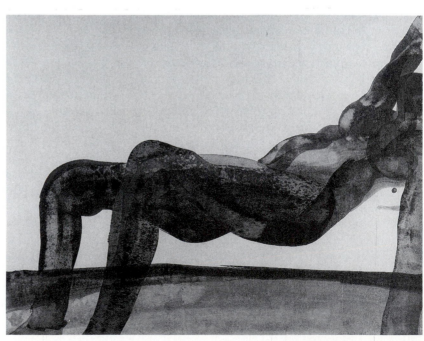

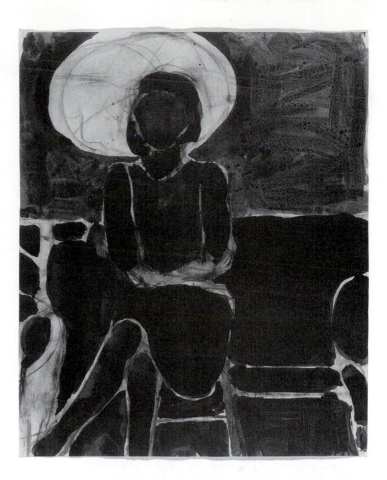

**5.4**
Richard Diebenkorn. *Seated Woman,
Umbrella.* 1967. Ink and charcoal,
17 x 15″. Collection
Mr. and Mrs. Richard Diebenkorn.
Reproduced by permission of the artist.
Photo by Douglas M. Parker Studio.

used in these drawings as a substitute for color, assigning different gradations to distinguish one shape from another. In this respect, value can be thought of as being more painterly than line. Whereas line runs to circumscribe shapes and forms, value lingers to define them. Value can be applied arbitrarily, for purely aesthetic reasons; or it can adhere to reality, describing what the artist sees (the reflected patterns of light) and knows about the figure (its shape, contour, and anatomy).

## Rendering Light and Modeling Form

Artists commonly refer to using value in drawing as a process of rendering or modeling. In the minds of many, these terms are synonymous. But there is an important distinction; and we contend that *rendering* and *modeling* each represent a different way of conceptualizing and, thereby, manipulating value to describe either light or form. *Rendering* refers to the process of graphically in-

terpreting reflected light. *Modeling* almost physically shapes the form in three dimensions, as if it were being sculpted. The misconception is that with drawing, one technique is automatically and simultaneously a representation of the other. The ambiguity between these distinct biases stems, in part, from the fact that most artists incorporate aspects of both approaches, and their drawings blend the two techniques. Another reason is that we assume that value in a drawing exclusively represents a differentiation in the amount of light and shadow on the body. Unlike a photograph, which depends on a chemical process induced by reflected light, a drawing depends on only the artist's discretion to determine the degree of value. The presentation of value in some drawings is essentially indifferent to the effects of light and instead is expressive of volume, implying tangible changes in the surface that are often not revealed by light sources.

When rendering to depict light and shadow patterns, we are directed mainly by what we can see with the eye as an optical sensation. When model-

ing to shape volumes, we are directed more by what we know on the basis of tactile experience. In the process of modeling, value substitutes for the tools a sculptor would use to physically mold the figure, to push a form back or to round out a volume in space.

In *The Artist's Mother*, Figure 5.5, Seurat's aim is to render the presence or absence of light as a camera would by applying varying gradations of value to areas where the light does not fall, thereby permitting the white of the paper to show through and distinguish the most illuminated areas. Seurat is not concerned that much of his subject remains unknown; the shape of the woman's head and the texture of her clothing are obscured by his use of value as shadow. His drawing takes us only as far around the body as the light takes the artist's vision.

In contrast, Michelangelo reveals a very different bias in his sketch, Figure 5.6. He uses value as a modeling tool to express his knowledge of the body's physical structure and anatomy rather than to describe the effects of light. His application of

**5.6**
Michelangelo. *Crucifixion of Haman*. Black chalk, 159 x 81 mm. The British Museum.

value neither implies, nor is directed by, a consistent source of light, as was the case in Seurat's drawing. Here, Michelangelo sculpts and shapes the three-dimensional form of the body with value. Optically we experience the modeling of the body's form as if it could be touched. Dark areas represent recesses in form rather than shadows. Changes in value depict physical changes in the surface terrain and equate to tactile experience rather than to the illuminating quality of light.

Our knowledge of the body is derived from both tactile and visual sensations, interwoven and interrelated. Light reveals the form of the body, and the body's form modulates the light patterns that fall on its surface. The artist who seeks to render the play of light on the form will unavoidably suggest the form itself, and the artist who models form with value creates a suggestion of the play of light. Yet, because light and the absence of light can also obscure form, the artist's purpose in using value—whether to render light or to model form—makes a significant difference in the final drawing.

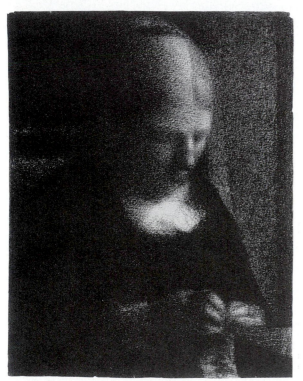

**5.5**
Georges Seurat. *The Artist's Mother*. Black conté on Ingres paper, 12 3/8 x 9 1/2″. Metropolitan Museum of Art, New York. All rights reserved. Joseph Pulitzer Bequest, 1955 (55.21.1).

Although Seurat allows the light to control the rendering of his subject, Michelangelo's drawing demonstrates that an artist can willfully manipulate light to make value more descriptive of the body's form and surface topography.

## Techniques for Applying Value

In pursuing either modeling or rendering, the artist has available two basic means of applying value: *continuous tone* or *hatching* and *cross-hatching*. Although both techniques can depict either light or form and may be combined in a single drawing, each has its particular advantages. Continuous tone, the application of value in indistinct strokes that blend together to form unbroken gra-

dations of tone, lends itself most readily to rendering light and shadow patterns over large areas, as in Sidney Goodman's Figure 5.7. Seurat's Figure 5.5 is also an example of this technique. Hatching and cross-hatching, applying value with a series of parallel or crisscrossing lines, are especially effective when describing the topography of the form, as contemporary artist Paul Cadmus does in Figure 5.8.

Comparing the Cadmus drawing with Figure 5.9 by Degas should help to further illustrate the differences between modeling form and rendering light, as well as the distinctions between the two techniques for applying value. Degas uses continuous tone to render the effects of light, creating the impression that the dancer stands between us and

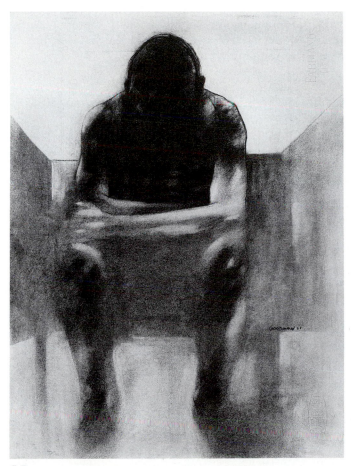

5.7
Sidney Goodman. *Man Waiting*. 1961. Charcoal, 25 3/4 x 19 1/8". Museum of Modern Art, New York. Gift of Mr. and Mrs. Walter Bareiss.

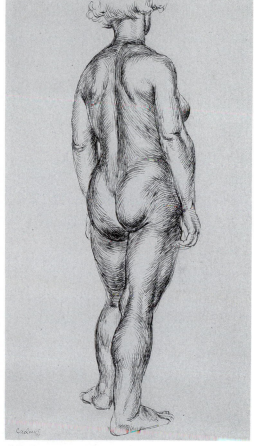

5.8
Paul Cadmus. *Female Nude (From My Sketchbook #H)*. c. 1936. Pen and ink, 9 1/16 x 5 1/2". Midtown Payson Galleries, New York. Collection of the artist.

a bright source of light. The distribution of dark pigment on the paper suggests shadow and, therefore, implies light in areas without pigment. At the same time, it suggests that the body is an object of substance, standing out as a dense, physical mass through which the light does not pass, except near the outer edge of the gauzy skirt material and where the light spills over the body's contour.

Although Degas uses some line, value serves as the medium for conveying both light's energy and the physical presence of the body. Light has no shape. It is energy: elusive, ephemeral. It illuminates the body but cannot be touched or held. Form is matter: tangible, solid. We can wrap our arms around form and sense its mass and volume. The way an artist applies value depends on whether the primary goal of the drawing is to render the visible effects of light or to model the form as if it could be touched. When Degas made this drawing, his focus was on the effects of light, and although he gives us the impression of a figure before us, he does not use value to model its form. We are left with an optical sensation, a visual impression.

Cadmus's drawing, Figure 5.8, creates value areas with linear hatch marks. His hatching and cross-hatching lines are directional, suggesting the roundness or curvature of the form. It is as if the artist were a sculptor, applying a chisel or file to carve out the contours of the figure, the hatch lines tracing the action of the tools. Notice the top of the shoulders are as dark in value as the underform of the buttocks; Cadmus uses hatching to describe form, not light. We read his use of value as he distributes it over the body to define shapes, not as shadows cast by a light source. The two techniques are often used together, but the artist's intent determines to what purpose they are applied. In Figure 5.10, Toulouse-Lautrec combines continuous tone and hatching to capture both the antics of the performer and the visual effects of stage lighting.

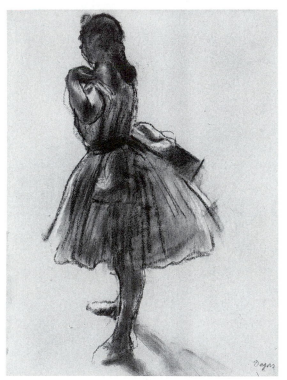

**5.9**
Edgar Degas. *Dancer Adjusting her Dress.*
Pastel on paper, 23 3/8 x 12″. Oregon Art
Institute, Portland. Bequest of Winslow B. Ayer.

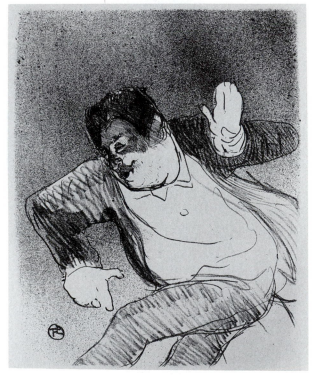

**5.10**
Henri de Toulouse-Lautrec. *Caudieux Dansant
au Petit Casino (Caudieux Dancing
at the Little Casino).* Litho print, 10 5/8 x 8 5/16″.
Metropolitan Museum of Art, New York,
All rights reserved. Harris Brisbane Dick Fund, 1923
(23.30.3/8).

of broad tonal areas. This drawing most likely began with thin, sketchy lines, like those on the youth's head. On top of the line drawing, Rembrandt then applies the aqueous medium as value, first flooding large areas of the figure with a diluted solution of ink to lay down soft, pale tones, as on the face and part of the arm, then creating darker value areas with successive strokes to suggest the recessed folds in the garment. In the cast shadow and a few other areas on the body, you can see the grainy effect of dry brushing, where the pigment has been deposited only on the raised tooth of the paper, similar to the effect achieved when charcoal or conté is applied with a light touch.

### Modeling Form with Continuous Tone

While continuous tone is particularly well-suited for rendering light, it can effectively model form as well. Kollwitz's mournful drawing, *Prisoners Listening to Music*, Figure 5.12, illustrates a

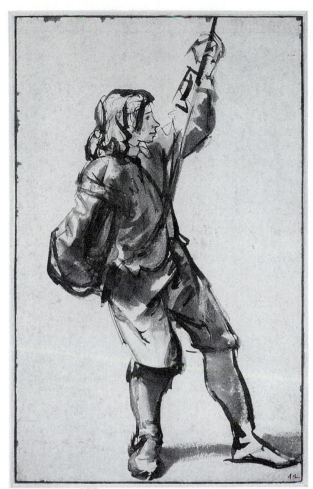

**5.11**
Rembrandt van Rijn. *Study of a Youth Pulling at a Rope.* Brown ink and wash. Rijksprentenkabinet, Noord, Holland, The Netherlands.

## CONTINUOUS TONE

Of the two methods of applying value, continuous tone is generally easier to understand and master. The primary characteristic of continuous tone is the gradual transition in tonal gradation. The media-applying strokes are not obvious because the application is either so broad or so evenly blended that the directional force or vector of the individual marks is nullified for the sake of achieving homogeneous value areas. Both wet and dry media can effectively create the subtle value gradations of continuous tone.

In Rembrandt's study of a boy pulling on a rope, Figure 5.11, we can see how his painterly application of the ink achieves a rich arrangement

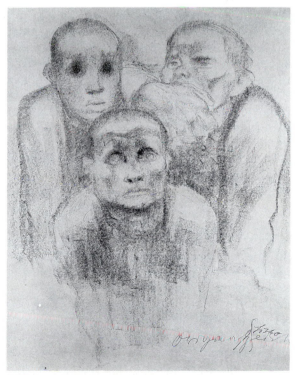

**5.12**
Käthe Kollwitz. *Prisoners Listening to Music.* 1925. Crayon drawing, 17 1/4 x 14 1/2" (.440 x .372 m). National Gallery of Art, Washington, D.C. Rosenwald Collection.

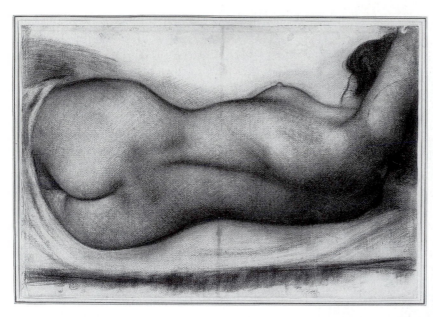

**5.13**
Aristide Maillol. *Reclining Nude.*
1932. Red conté, traces of
charcoal on white laid paper,
21 1/4 x 30 11/16″
(53.8 x 77.8 cm).
© 1990 The Art Institute
of Chicago. All rights reserved.
Gift of Mr. & Mrs.
William N. Eisendrath Jr.,
1940.1044.

continuous tone application of value as a model-
ing tool. Some remnants of her line drawing can
still be seen in the hand and running down a
sleeve, but notice how the tonal values spread our
attention out over the surface. Kollwitz applies
pigment with a fairly light pressure, resulting in a
pale, ghostlike image of the three huddling men.
Much of the expressive power of Kollwitz's draw-
ings and prints can be attributed to her dramatic
use of value. In most of her work, however, she
uses value not to depict light but to give the body
form and substance. She builds a density that sug-
gests the body's molecular adhesiveness. Her fig-
ures are an accumulation of particles compiled
and arranged to represent solid matter, yet the use
of soft tones with limited contrast helps to intro-
duce a stillness and frailty to these faded figures.
Value rounds off the heads and shoulders, estab-
lishing recessive forms with darker gradations.

The sculptor Aristide Maillol also uses continu-
ous tone as a graphic technique for sculpting the
body on paper. In his crayon drawing, *Reclining
Nude,* Figure 5.13, Maillol molds the body, ex-
tending the outline of the figure with value across
the interior of the form, fading as it moves up and
out. The darker edge of the outline now represents
the deeper recesses, and the paler values read as
the advanced area of a rounded form. Maillol, like
Kollwitz, uses the pointed end of the drawing stick
for line work and then lays the same tool on its
side to broaden the line and model the contour. In
doing so, he takes full advantage of the textural

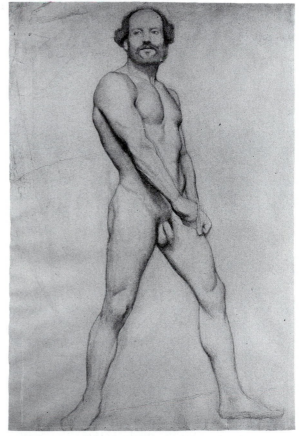

**5.14**
Edgar Degas. *Male Nude.* c. 1856–58.
Charcoal on pale-gray French charcoal paper,
18 3/8 x 24″. Gift of W.G. Russell Allen,
Courtesy, Museum of Fine Arts, Boston.

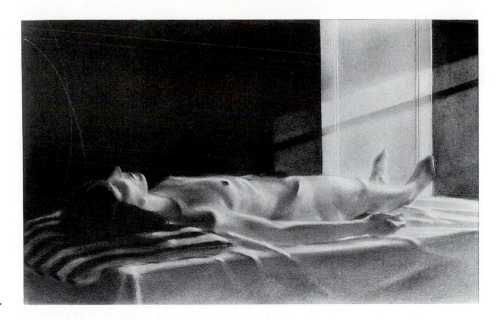

**5.15**
Norman Lundin.
*Supine Model.* 1980.
Charcoal, 14 x 28″.
Courtesy of the artist.
Collection of Marie
Chun, Los Angeles.
Photo by Gary Waller.

*tooth* of the paper to control the grain of the value areas, allowing more paper to show for the emerging surfaces and less for the recessed forms.

In the charcoal study of a standing male nude by Degas, Figure 5.14, the outer contour lines of the body are, in effect, built up and extended over the interior of the form as continuous tone. Notice how the edges seem to be pushed back with the darker value. Here, fine individual strokes of charcoal are placed tightly together and optically and conceptually blended into tonal gradations to model the solidity of form. This academic drawing was made prior to Degas's involvement with the Impressionists and their passionate concern for light. Its classical approach emphasizes the body's anatomical forms. He starts with soft lines (see the foot on the right side of the drawing), which are then darkened to more firmly state the presence of his subject and to solidify its mass. Compared with the Kollwitz and Maillol drawings, Degas's modeling is more specific. He uses the pointed end of his charcoal, not the flat side, to build up his blended tonal areas. Some of the individual strokes are visible around the knee. This is a slower, more meticulous method by which to distribute pigment, but it allows greater control over details.

### Rendering Light with Continuous Tone

A camera has no awareness of form. It is sensitive only to light and is designed to record its reflection from surfaces. The human eye is more sensitive, although not often as objective as the camera; yet some artists strive for that level of objectivity. Objectivity is a practiced discipline that the artist maintains by keeping a physical as well as psychological distance between the artist and the subject, focusing primarily on the mosaic patterns of light and shadow. Of course, an artist is much more than an organic camera. The artist is selective, which explains why even the most realistic drawings have a specificity that photographs lack.

Continuous tone is particularly adept at mimicking the play of light and shadow because the artist can use it to create subtle gradations of tone as an optical response to reflected light. In Norman Lundin's drawing of a reclining nude, Figure 5.15, we sense that the figure exists primarily as a reflective surface. At first glance, Lundin seems to respond to his subject with the impersonal detachment and objectivity of a camera. Even his application of pigment takes on the evenness of a photograph. Upon closer consideration, however, we become aware that the artist has chosen this situation with a great deal of deliberation, using the interplay of light and shadow as well as the nude as compositional components in his drawing. By applying value as continuous tone without a traceable record of the artist's drawing action, Lundin gives his drawing a sense of stillness and quiet.

**5.16**
Edward Hopper.
*Study for Morning Sun.* 1952.
Conté on paper, 12 x 19″
(30.48 x 48.26 cm).
Josephine N. Hopper Bequest
(70.290). Collection of Whitney
Museum of American Art,
New York.

In Figure 5.16, a study done as a prelude to his painting *Morning Sun,* Hopper renders the effects of the early morning sunlight. At first he uses his conté to sketch with line the configuration of the body; then he turns the tool on its side to create large areas of continuous tone, which serve to break up the surface into two generally designated areas of sunlight and shadow. Notice how relatively even and flat the shadow areas are, and that the use of value in these areas makes little attempt to mold the contours of the body. Hopper uses value to differentiate shapes created by the light as pictorial elements.

Another characteristic that distinguishes a drawing done in response to light patterns is the importance given to cast shadows, such as that of the leg in Hopper's drawing. In this sketch, the breaking edge of a shadow on the cheek and on the arm corresponds to structural changes and suggests the figure's volume, but the edge of the cast shadow on the leg is even more pronounced and not related to the body's structure. To define the profile and the extremity of other shapes, Hopper uses line as a conventional means of containment. Color differentiation in his painting, however, will make this enclosing line unnecessary. In drawing, chiaroscuro is a traditional drawing technique that, in effect, employs value to eliminate the need for line.

## CHIAROSCURO

The Italians combined two words—*chiaro,* for light, and *oscuro,* for dark—to create the term *chiaroscuro,* which is generally expressed in drawing

as a pictorial representation that describes with lights and darks. However, chiaroscuro is more specifically a rendering technique that contrasts areas of illumination with those of shadow. Like its French equivalent, *clair-obscur,* it also means clear and obscured. As the light reveals and clarifies objects, the shadow masks and obscures them, thereby blurring the edges of forms, a technique known as *sfumato,* which means "smoke" in Italian. Sfumato expands the concept of chiaroscuro in that it refers to transitions of tone from light to dark by almost imperceptible stages. Leonardo and Caravaggio were among the first to pioneer the study of light and to give its rendering precedence, even if doing so meant losing the clarity of form in shadow. Leonardo, in his notes, said that light and shade should blend "without lines or borders, in the manner of smoke."[1] In effect, chiaroscuro and sfumato are attempts to eliminate the unnatural use of lines of enclosure at the edges of form by using contrasting tonal areas in the background, adjacent to the figure as well as on the figure itself. As a result, the figure becomes assimilated into its surroundings. Chiaroscuro can produce some highly dramatic effects with figures that appear to emerge into light, out of the shadowy background.

Georges Seurat's continuous tone drawings offer some of the most sophisticated examples of the atmospheric effects of chiaroscuro and sfumato, Figures 5.5 and 5.17. We sense that Seurat is as concerned with the environment surrounding the figure as with the figure itself. He generates the optical illusion that the body is emerging

from its shadowy background into a dimly lit foreground. The atmosphere Seurat creates is not just behind the figure; it moves between his subject and the viewer to shroud much of the body.

*The Music Teacher*, Figure 5.18, represents the opposite end of the light scale. The room is flooded with light that surrounds the figure in the way Seurat's figure was enveloped in shadow. In this drawing, it is the bright light streaming in from behind that causes the edge of the figure to be softened and obscured, sometimes dissolving completely. An artist concerned with modeling a concrete form, rather than rendering light, would have maintained a line at the edge of the figure. Debra Bermingham is more concerned with capturing the impression of a transitory moment. This soft blending of tone can be achieved by applying powdered graphite or carbon dust with a soft sable brush or a cotton swab.

The photographic quality of Manon Cleary's drawings is intentional and accomplished largely because she draws from a photograph rather than directly from her subject. Notice in her photo-

**5.17**
Georges Seurat. *Standing Female Nude.* c. 1881–82. Black crayon,
63.2 x 48.2 cm. Courtauld Institute Galleries, London (Courtauld Collection).

**5.18**
Debra Bermingham.
*The Music Teacher.* 1988.
Graphite on paper,
13 1/4 x 12 1/2″.
Midtown Payson
Galleries, New York.
Private collection.

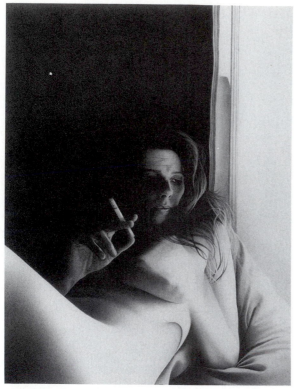

**5.19**
Manon Cleary. *Untitled, 5*. 1984. Graphite on paper,
23 x 29″. J. Rosenthal Fine Arts, Ltd., Chicago.
Photo by Breger & Associates.
Collection: The Artery Organization Inc.,
Bethesda, Maryland.

realist self-portrait, Figure 5.19, that the edge of
the shoulder and hand at the figure's left side dis-
solves into the background. The other hand blurs,
caused by its movement at the moment of expo-
sure. Cleary uses value to match what the camera
sees and makes no attempt to model form beyond
what the light reveals. Her drawing presents a fac-
simile of the patterns of reflected light as they were
captured on film.

Joseph Piccillo's drawing, Figure 5.20, like
Cleary's, obscures parts of the body in its shad-
owy surroundings, and other parts seem out of
focus. This drawing evinces a sense of mystery, not
just because of its unusual content, but because
in its contrast between light and dark, it both
reveals and conceals, in the fullest meaning of
chiaroscuro.

In a more expressive manner, Dine incorporates
aspects of traditional chiaroscuro in Color Plate
XI. Dine has instilled the figure with a kind of res-
onant energy. The large plots of dark tones in the
background bracket the body, encroaching on it
with the force of something more physical than
mere shadow, squeezing it together as well as for-
ward. Dine aggressively works and stirs the area
around the figure as well as the body itself, reso-
nating a personal energy in the way he applies
media to the surface.

**5.20**
Joseph Piccillo.
*Study F-8*. 1986.
Charcoal on paper,
46 x 68″.
Arkansas Arts Center
Foundation
Collection,
1989, 89.52.

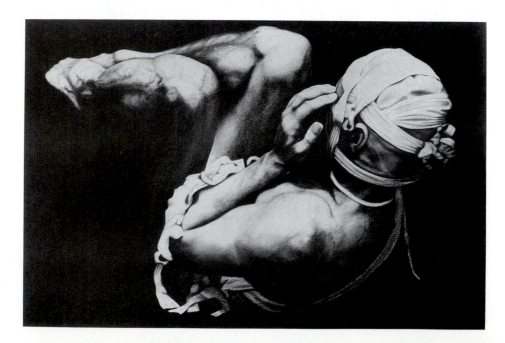

## HATCH AND CROSSHATCH

The other method by which to dispatch value involves using the pointed end of a drawing instrument to build up areas of tone through the distribution of adjacent linear strokes known as *hatch marks*. The lightness or darkness of the tonal area is determined by regulating the size or weight of the strokes as well as the intervals between them. The closer together the hatch strokes, the darker the value (assuming you are drawing with a dark medium on a light surface). It is possible to develop the entire value scale in a drawing by using only single-directional parallel hatch marks; however, one can also apply several layers of overlapping, perpendicular hatch marks, a technique referred to as *cross-hatching*.

### Rendering Light with Hatching and Cross-Hatching

Pearlstein's drawing of a female nude, Figure 5.21, creates value areas entirely with parallel hatch marks, all of which traverse with essentially the same vector. Pearlstein uses line for enclosure, defining the body's perimeter; and he uses value to describe the shaded portions of the body and its cast shadow. Notice how on the broader areas of the chair the hatching is more open and general than on the figure, where it is tighter and more specific to the subtle play of light on the form. Also, notice how the shaded area on the underside of the breast and the shadow cast by the breast are handled in the same manner with directional hatching. The single-directional hatch patterns are less active than crosshatch would be; and because all the marks follow the same slant, there is no specific meaning attached to their direction, such as the suggestion of surface planes or the slope of a form.

Contemporary California artist Wayne Thiebaud also uses a single-directional hatching pattern to create his value areas of shadow in Figure 5.22. Although the direction changes from one

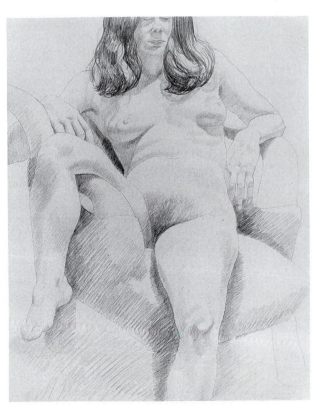

**5.21**
Philip Pearlstein. *Seated Female Model,
Leg Over Armchair*. 1971. Pencil, 23 7/8 x 18 7/8".
Frumkin/Adams Gallery, New York.

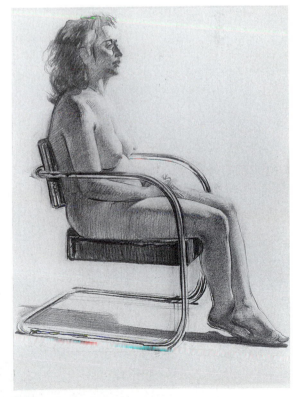

**5.22**
Wayne Thiebaud. *Nude in Chrome Chair*. 1976.
Charcoal on paper, 30 1/8 x 22 3/8". Photograph.
Courtesy of the artist. Photo by M. Lee Fatherree.

part of the body to another, it seems to be more suggestive of the bending of limbs than an attempt to model the surface planes. In this drawing, the white of the paper is not just negative space, but functions as solar energy surrounding the body in the same way that shadows enveloped Seurat's subjects. Value, distributed primarily with parallel hatching, defines the cool, shadowy side of the figure. Notice how the aura of hot white light bleaches out parts of the figure on the forehead, chest, and thigh. Thiebaud expands the definition of chiaroscuro, much as Bermingham does in Figure 5.18, allowing the precise edge of the body to be obscured by blinding light. Unlike Pearlstein, Thiebaud relinquishes the line that would contain the form. Notice, too, that the darkest values are not always on the far back or underside of the body, but often in the middle, as we see on the leg and arm. This suggests that light is reflected off the ground, illuminating the figure from the underside, the way sunlight bounces off the pavement on a hot summer day.

Some artists prefer to build tonal areas with several sequential sets of cross-hatching marks. In

**5.24**
James Whistler. *Study for "Weary"*. 1863.
Black chalk, 9 5/8 x 6 7/8".
Sterling and Francine Clark Art Institute,
Williamstown, Massachusetts.

**5.23**
Pablo Picasso. *Head of Boy (Tête de Jeune Homme)*.
1923. Grease crayon, 621 x 474 mm. Brooklyn Art,
Museum, New York. Museum Collection Fund,
39.18.

his *Head of a Boy*, Figure 5.23, Picasso crosses the direction of his lines to create value areas representing deep shadow, obscuring details such as the ear, yet giving an optical impression of form. The marks thin at the top and right side of the head as Picasso renders the light that falls over the boy's face. The texture, gesture, and direction of the lines contribute to the character of the drawing, giving it a sense of movement and energy that would not generally occur with continuous tone.

In Figure 5.24, American artist James Whistler combines a chiaroscuro depiction of atmospheric space, similar to that in Seurat's drawings, with Picasso's more active use of cross-hatching. Light is the medium that conveys information as an optical impression. Whistler uses value more to portray the ambience of the dimly lit bedroom than to solidify the form of his subject. The crosshatch patterns blanket his subject with an earthy feeling suggestive of homespun fibers.

With Picasso's and Whistler's drawings, it becomes more difficult to maintain the distinction between rendering light and modeling form because the hatch marks take on the characteristics of cross-contour lines. This is particularly true when the curvature of the hatching follows the surface forms. This dual function of hatching lines makes this an especially effective technique for modeling the body's contours.

Modeling Form with Hatching and Cross-Hatching

For some artists, light is too fickle and deceptive to be the primary focus of their attention. They would argue that the form of the body is consistent and doesn't alter with every change in the direction of light; therefore, value should be orchestrated to reveal the plasticity of the body, its structure and the nuances of its surface anatomy.

When modeling form is the artist's first concern, the direction of the hatch strokes takes on particular significance. In addition to establishing value areas, the hatching patterns provide special clues akin to elements of linear perspective. The degree of looseness or density in the hatch marks is not just read as lightness or darkness but becomes an indication of advancing or receding surfaces, of

the slant or curvature of the surface. In this way, each hatch stroke conveys information about the terrain of the body.

To visualize this phenomenon, imagine a net or wire screen with even-sized openings wrapped around a white cylinder. On the surface nearest you, the openings would appear at full size. But as the net revolves around the cylinder, the spacing in the net would appear to get smaller. At the outer edge, where the form rolls back and around to the other side, the interim space would disappear, the lines converging into a darker value. The lines themselves would curve with the roundness of the cylinder. In like manner, the hatching pattern of inscribed lines can create value areas descriptive of volume that have no direct reference to the play of light.

The hatching pattern used by the sixteenth-century Dutch draftsman Jacob de Gheyn II in Figure 5.25 demonstrates this concept. First, notice how nearly every line, no matter how short, suggests the curvature of the form over which it lies. This is clearest on the arm of the center figure, where only single hatching is used to turn the form. On the torso of that figure we can also see how the cross-hatching pattern becomes tighter toward the back of the torso. These lines are contour modeling, which, when taken collectively, are

**5.25**
Jacob de Gheyn II.
*Nude Studies*. Pen and
chalk, 10 3/8 x 13″.
Musées Royaux des
Beaux-Arts, Belgium.
Collection de Gres.

also conceptualized as value. However, the primary role of these hatch marks is to sculpt the form of the body and represent a recession of the surface toward an edge, ideally implying the turning of the form around the other side. Any suggestion of the illuminating effects of light is secondary to the sculpting of the form. In this drawing, value does not fall lightly over the surface as an indication of ephemeral shadows; instead, it builds with the accumulation of contour modeling lines that collectively shape the body and define its spatial relationships.

For another example of the use of cross-hatching to model form, look at the Northern Renaissance portrait by Lucas van Leyden, Figure 5.26. Although the artist creates a chiaroscuro backdrop behind the figure with cross-hatching, the primary function of van Leyden's lines is to model the head as a three-dimensional volume and to sculpt the relief of its surface. Each hatch mark functions as a fragment of a cross-contour topographical line. Notice how the lines indicate the slant of planes and facets at the cheek and chin and on the collar of the coat. Notice also the concave and convex curve of hatch marks as they follow the surface contours of folds and wrinkles on the skin. The same short, repeating curves that indicate the rolling form at the ends of the hat flaps and on the

wrinkles of the coat also suggest with a softer touch the rolling curvature of the lips. On the cylinder-shaped collar, we see how the mesh of cross-hatching tightens and darkens in value as the form recedes. Van Leyden does not disregard the play of light. In fact, when modeling the volume of the head, he deepens his hatching on the shaded side so that it reinforces the natural effects of light. The value areas are conveyors of both shadow and volume, but they come about primarily through a sculptural articulation of the figure. As a result, the value created through hatching contributes to the form without obscuring it in shadow.

Signorelli also uses cross-hatching to describe the mass of the human body, Figure 5.27. Signorelli's figure is a symbol of energy and power. Value supplements his contour lines, which systematically plot the large anatomical units of the body. A small diagnostic sketch in the upper corner hints at the kind of linear scaffolding beneath the hatch patterns of the larger figure. The strength and monumentality of the figure are due, in part, to Signorelli's accentuation of anatomy and the solidity with which he models the forms. The convex curves of Signorelli's hatching tightly shape the body, seeming to embody the very fibers of the muscles. The dark value areas along the spine and between the legs push forms back and

**5.26**
Lucas Van Leyden. *Portrait of a Young Man.* 1521. Black chalk, 262 x 323 mm. National Museum of Sweden, Stockholm.

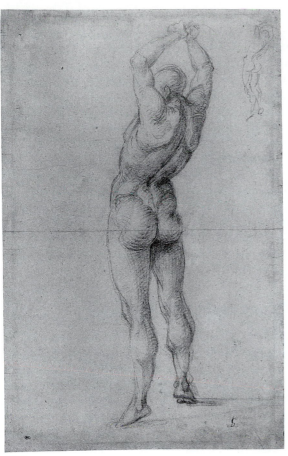

under. Each curving hatch stroke adds a bit of momentum to the illusion of the body as a solid, elliptically shaped mass. "Signorelli's figures are an expression of Florentine passion for the solidly comprehensible, that which can be grasped alike by mind and hand," wrote Kenneth Clark in his treatise, *The Nude*.[2]

A magnificently rich and deeply moving drawing in the Florentine tradition, Michelangelo's *Study for a Pietà* (Figure 5.28) is an informative documentary of his step-by-step modeling of form with cross-hatching. The legs show the initial sketching of the figure with very light lines. Notice that these lines are more searching notations of the contour and anatomical topography than they are unequivocal representation. Notice, also, the two smaller studies of the right arm. They were probably sketched after the larger study as alternative positions for this arm and hand. However, because they have not been finished to the same degree on the central figure, we can rightly interpret them as Michelangelo's preliminary method of using anatomical contour line to define the body prior to developing his cross-hatching, which has been added to the more developed central figure. Here the left arm is particularly interesting because the strokes of the crosshatch are bolder and easier to see. The beginning and ending points of

**5.27**
Luca Signorelli.
*Nude Man From Rear*.
Black chalk, 16 1/8 x 9 7/8".
Musées Nationaux-Paris,
France. © R.M.N.

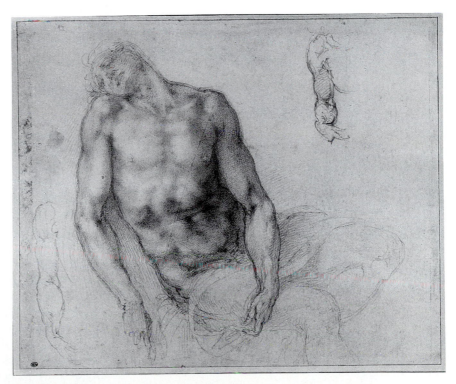

**5.28**
Michelangelo.
*Study for a Pietá*.
Musées Nationaux-Paris,
France. Chliché des Musées
Nationaux-Paris. © R.M.N.

the hatch marks most often conform to the position of the lightly drawn topographical lines. If, for example, the drawing of the legs had been finished to the same degree as the upper torso, those faint topographical notes in the interior of the legs would have served as cues for the cross-hatching and the modeling of the form.

The abdominal area is most fully developed into a darkened hollow, but the form is still clearly visible. By regulating the space and interval between each hatch stroke, Michelangelo develops a tonal network that reveals the form underneath and gives it definition. The transition from light to dark is very subtle, and whether we see an area in terms of continuous tone or linear hatch marks with directional significance is to a large extent determined by the scale of the stroke and the distance from which we view the drawing.

Although Edme Bouchardon's drawing, Figure 5.29, is executed in a pedantic manner, lacking the passion of the Florentine artists, it demonstrates how contour-following hatch strokes can modulate the flowing, anatomical forms of the body. The regularity of the hatching makes it easier to see individual linear strokes, which graphically sculpt the figure in relief.

## Drawing on Toned Paper

Most drawings are created by applying dark pigments on a white or off-white ground, with the surface of the paper functioning as the lightest value. Traditionally, however, artists have achieved wonderful results by drawing with both light and dark pigments on a toned drawing surface, which itself functions as a middle value. Today, you can buy paper of practically any color and value, but traditionally, artists prefer natural or neutral colors, such as buff or gray, which do not compete with the drawing itself. Often, artists would prepare the ground themselves, toning the paper with a colored wash or dry pigment before beginning to draw. Drawing on a toned surface is a slightly more complicated process, for it actually involves several interlocking drawings. Generally, the darker-pigmented drawing defines the fundamental structure of the figure, as it would when drawing on white paper, and the lighter medium renders the highlights.

Michelangelo's drawing of *Madonna and Child,* Color Plate I, done on a light terra-cotta ground, shows varying stages of development that demonstrate his procedural approach to drawing on a middle-value surface. Michelangelo first drew the Madonna and child with black chalk, defining the gesture and composition. He drew the child's lower leg in several positions, and you can see a pentimenti of the Madonna's head looking down at the child, drawn prior to the more developed sideward glance. Hatch marks of black chalk also established some basic spatial relationships and

**5.29**
Edme Bouchardon. *Standing Male Nude with Staff.*
Red crayon on white laid paper,
580 x 295 mm (31 3/4 x 20 1/2″).
Santa Barbara Museum of Art, Santa Barbara.
Museum Purchase.

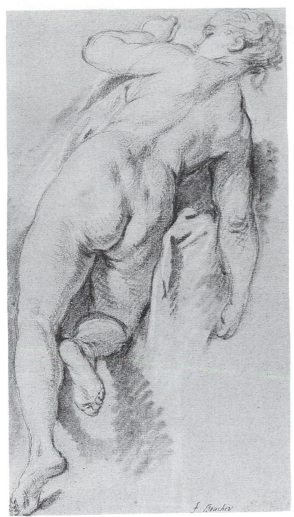

**5.30**
François Boucher. *Minerva*. Black chalk with
white chalk highlight on tan paper, 14 x 7 3/4″.
The Fine Arts Museums of San Francisco,
Achenbach Foundation for Graphic Arts,
James B. Phelan Bequest Fund.

The tan paper functions as the middle ground be-
tween the raised drawing in white and the recessed
drawing in black. Boucher suggests a light source
coming in from the upper left side of the composi-
tion, but his primary focus remains on the form.
Boucher's technique and aesthetic sensibility were
greatly influenced by Watteau, Color Plate II, and
Rubens, Color Plate XII.

Another artist who successfully transformed the
nude model into classical ideals was the court por-
traitist of Napoleon, Pierre Paul Prud'hon. His *La
Source*, Figure 5.31, illustrates his soft hatching
style, which combines a neoclassical concern for
clarity of form with a baroque interest in chiaro-
scuro. Prud'hon's preferred drawing materials
were black and white chalk on blue-gray paper.
His hatching techniques consist of parallel lines
that delicately describe the play of light as it falls
on his subjects. However, the direction of his
hatching is not without content. Notice how the

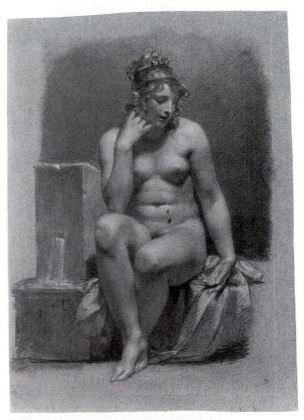

**5.31**
Pierre Paul Prud'hon. *La Source*. c. 1801.
Black and white chalk on blue paper,
21 3/16 x 15 5/16″.
Sterling and Francine Clark Art Institute,
Williamstown, Massachusetts.

began to model the volume of the child's body.
Reddish chalk blended as continuous tone further
modeled and softened the child's form. White
highlights added last were blended with red and
black.

François Boucher, like his predecessor Watteau,
drew extensively on toned paper. Figure 5.30 is a
typical example. In this drawing, Boucher models
the forms with both black and white hatch and
crosshatch strokes that ride over the surface. The
dark charcoal defines the recesses and the white
chalk creates the opposing drawing, which high-
lights the raised or forward portions of the form.

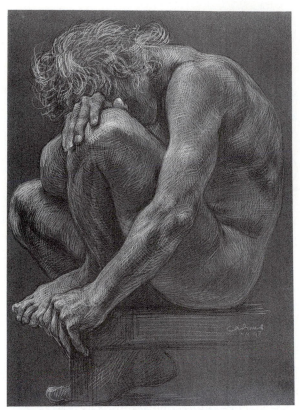

**5.32**
Paul Cadmus. *Male Nude #NM 197*. 1986.
Conté on green canson paper, 22 7/8 x 16 3/8″.
Midtown Payson Galleries, New York.
Private collection.

coarser, more erratic hatching to define the figure on a dark gray paper, Figure 5.32. Because Cadmus uses primarily a light medium on a darker ground, he reverses the traditional drawing process, and the result is a drawing with dramatic contrast that gains energy with the artist's raspy strokes.

## Summary

When rendering only light, the artist is concerned with matching light and shadow patterns, irrespective of whether they reveal or obscure the form. The artist responds to optical sensations.

hatch marks align with the dominant direction of a form, running along its length. As a form changes direction, so does the hatching pattern, thus indicating the direction of each body part while suggesting its illumination. The flannel-like gray surface of his paper contributes to the chiaroscuro, functioning as a middle ground between the dark recesses of space and the white advancement of forms.

A similar technique can be seen in a drawing by Early American artist John Trumbull, Color Plate XIII, that beautifully blends an understanding of the body's anatomical structure with the natural appearance of light. Notice in particular how Trumbull contrasts the highlighted upper portion of the figure against the dark background, and the dark lower portion against the white surface of the couch.

In comparison to Prud'hon and Trumbull, contemporary artist Paul Cadmus uses white conté in

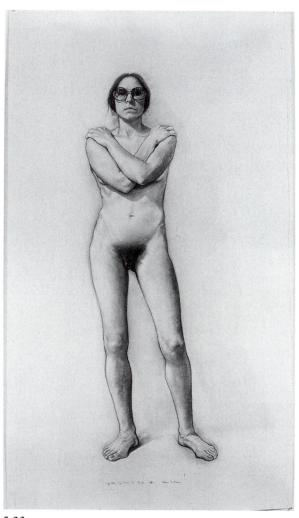

**5.33**
William Beckman. *Final Study for Diana IV*. 1980.
Charcoal and pastel on paper, 88 x 51″.
Frumkin/Adams Gallery, New York.

Light is both the artist's inspiration and the drawing's content. On the other hand, the artist who is primarily concerned with modeling form interprets the body's physical terrain, describing with value what he or she knows of the figure's structure, regardless of the natural pattern of light. Each bias has its particular advantages and aesthetic appeal. Using value to model form creates a concrete solid and also encloses the object. Light is more open—it is everywhere, more pictorial and integrating, more transitory and dramatic than physical and stable. This difference does not mean that the two methods are incompatible. Most artists mix these techniques in their use of value, indicating cast shadows and indicating the direction of a light source to their modeling of form. Others who attempt to render light patterns often feel obliged to use dark lines and added value beyond what is visible to accentuate depth and give clarity to the body's form. Beckman's Figure 5.33 provides such an example of combining application techniques, effectively synthesizing his interest in both light and form.

## In the Studio

### Using Value to Distinguish Figure and Ground

**Pose** - 5 minutes
**Media** - Charcoal, conté, ink wash on newsprint, 18″ x 24″

Value is a way of distinguishing the figure from its surrounding space and of separating the figure from the background. This can be done by either presenting the figure as a dark on a light ground or the opposite, as in Figure 5.34, where the negative space around the figure has been defined with dark value. Without using any lines, draw the figure as a dark silhouette on a light ground. Then, using another sheet of drawing paper, define the body's configuration by drawing its surrounding space with a dark value. Squinting at the model while drawing makes it easier to see the general shape of the body rather than the small details.

### Modeling Volume with Continuous Tone

**Pose** - 30 minutes
**Media** - Conté, charcoal, graphite, or ink and brush on regular drawing paper, 18″ x 24″

The objective of this exercise is to model form with a continuous tone application of dry or wet pigment. Begin the drawing with line, then use the side of a solid medium or a broad brush to extend the line out over the form of the body (see Figure 5.35). Model volume by using progressively darker values to roll a form back to the edge line or as a distant value change to suggest a step back

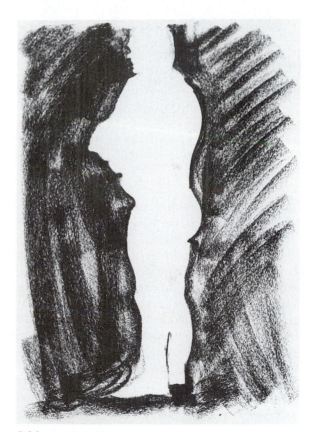

5.34
Robert Irwin. *Student drawing, Oregon State University. Using value to distinguish figure-ground relationship by drawing the dark background.* Compressed charcoal.

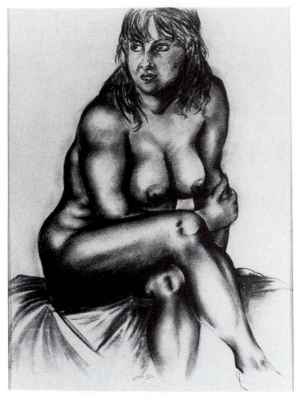

**5.35**
Joan Zei. *Student drawing, Hartford Art School,*
*University of Hartford. Modeling form*
*with continuous tone.* Charcoal.

more time to disperse value over a broad area with hatching than it does with continuous tone. Start with the largest areas and with long, light hatch marks. Follow with shorter strokes in the same direction for smaller value areas, gradually building density. A single-direction hatching is adequate for rendering light patterns; use denser patterns of hatch marks to achieve darker values. You do not have to make an effort to suggest the contour or slant of the surface. Figure 5.36 uses hatch marks having the same vector, describing shadow areas created by a light source from above left.

from one form to another, such as an arm overlapping another part of the body. If you choose wet media, begin with a diluted mixture, then gradually add layers of media to define recessive forms. Any concession to cast shadows should be made only after the volume of the body and the spatial relationships of the form are fully established. Try to think of your application of value as a tool that can physically turn and push forms back and away from you.

### Rendering Light with Single-Directional Hatching

**Pose** - 2 hours
**Media** - Pencil, graphite, charcoal, or ink on regular
white drawing paper, 18″ x 24″

Lightly delineate the configuration of the pose, illuminated by a single light source, then add the shadow areas with single-direction parallel strokes. You will find that it takes considerably

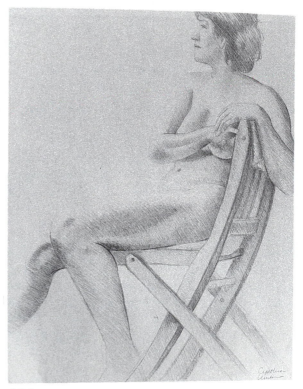

**5.36**
Cynthia Limber. *Student drawing, Oregon*
*State University. Single-directional hatching*
*used to render shadow patterns.* Graphite.

### Modeling Volume with Cross-Hatching

**Pose** - 3 hours; illuminated to clearly reveal all
aspects of the form
**Media** - Pencil, graphite, or charcoal on regular
drawing paper, 18″ x 24″

When an artist is using hatching and cross-hatching to model the body's volume, the strokes

actually represent the surface, not the shadow over it, and the lines follow the flow of the body's contours. Also, value builds in density to represent recesses, not shadow, although the recessive areas are most often shadow areas as well. Before attempting to draw the model, you might practice drawing a round ball on a sheet of newsprint. Try to imply the curvature of the ball as you apply your hatch marks, turning the ball back at its edges with a greater density of strokes.

Begin this drawing with line to lay the groundwork for your hatching pattern. Make as complete a cross-contour drawing as you can, allowing the edge lines to turn in and over the form and using light lines to note the terrain of the surface. (Refer to contour line exercises in Chapter 4 if necessary.) Then, apply hatch strokes over the internal forms of the body to establish spatial position, using value to step forms back or turn them under. Work from the general to the specific, indicating the character of the terrain over which values fall, hinting at the slant and slope of a surface and suggesting, with curved lines, whether the surface is concave or convex. Refer to Figures 5.27, 5.28, and 5.29 in the text for visual examples.

### Rendering Light with Continuous Tone (Chiaroscuro)

**Pose** - 1 hour
**Media** - Conté or charcoal on regular drawing paper, 18″ x 24″

The light that illuminates the model should be adjusted so that it leaves clearly visible highlights and shadows. It is also helpful to have the model pose in front of a dark backdrop. The objective is to use value to record the light and shadow patterns, much as a camera does. Although you might wish to employ line to plot the configuration of the pose, the role of line in the finished drawing should be minimal. Depending on your lighting, the form of the body may, at times, become obscured by either the highlights or dark shadows and dissolve into its background. The idea is to be objective as you match the value of your created tones with those on the body and also create a sense of atmospheric space surrounding the figure, as in Figures 5.37 and 5.38.

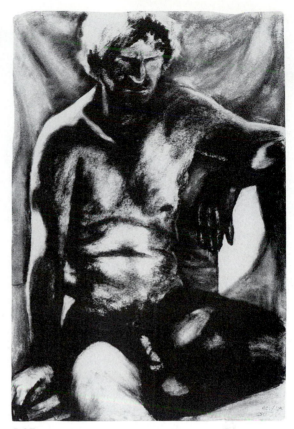

**5.37**
Su J. Choi. *Student drawing, University of Virginia. Rendering light and shadow patterns with continuous tone.* Pastel.

### Using Hand-Toned Paper: Additive and Subtractive Methods

**Pose** - 1 hour
**Media** - Graphite, charcoal, conté, and erasers on regular 18″ x 24″ paper toned with pigment

The object of this exercise is to become familiar with a subtractive method to render light patterns as they fall around the figure. This technique requires that you tone a piece of paper with your drawing media—graphite, charcoal, or conté. To do this, simply cover your paper with a fine layer of pigment and rub it evenly into the surface with a soft chamois cloth or paper tissue until you establish a middle-value ground over the entire drawing surface. Begin your drawing by using your eraser to subtract pigment from the paper to represent brighter areas, and then use your drawing tools to add pigment in areas that require darker values.

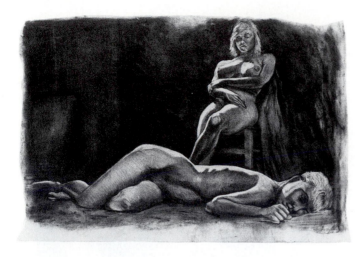

**5.38**
John Liebler. *Student drawing,*
*University of Connecticut.*
*Rendering light patterns with*
*continuous tone.* Charcoal.

### Drawing with Light and Dark Media on Manufactured Toned Paper

**Pose** - 2 to 3 hours
**Media** - Black charcoal, conté, or graphite with white
    charcoal or conté on gray paper

This technique incorporates the paper as a middle value and requires that you draw with tools that are both lighter and darker in value than the drawing surface. You can apply the pigment either as continuous tone, in broad strokes, or as more linear hatch and crosshatch marks. Use value to render the play of light patterns over the form. Essentially, this technique involves integrating two drawings: one that draws the recessed forms or shadow areas and another that renders the advancing forms or highlights. Figure 5.39 uses line to establish the configuration of the pose, then deepens shadow recesses with black conté as continuous tone. Figure 5.40 uses broad strokes of dark and light media in a painterly fashion on a middle-toned paper to define an overall composition in fairly abstract value patterns.

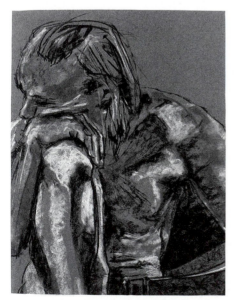

**5.39**
James Totulis. *Student drawing,*
*Arizona State University. Value study*
*in light and dark media on gray paper.*
Black, white, and red conté on
gray paper.

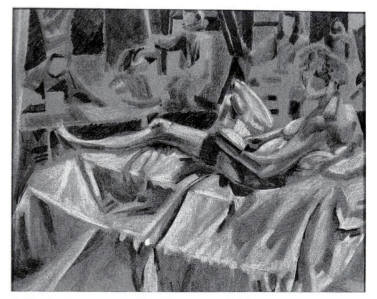

**5.40**
Jannie M. Fleming. *Student drawing, University of Virginia.*
*Composition with light and dark media on a middle-tone ground.*
Graphite and white chalk on charcoal-toned paper.

**Independent Study:**

1. Use either a commercially prepared toned paper or one you have prepared yourself as a ground for a portrait of yourself or a friend. 2. To understand more the way a camera sees light, either use a black and white photograph with strong value contrasts from a magazine and attempt to match it as a drawing; or, if you have access to a slide projector, mount a black and white negative in a slide mount so that you can project it onto a drawing paper and duplicate its value patterns. 3. To be-come more adept at modeling form with cross-hatching, practice using this technique to draw the larger units of the body, such as an arm or leg, sculpting the volume and curvature of the form with your hatch marks.

Endnotes

[1] Leonardo da Vinci, quoted in Peter and Linda Murray, *A Dictionary of Art and Artists* (Baltimore, MD: Penguin Books, 1959), 297.

[2] Kenneth Clark, *The Nude: A Study in Ideal Form* (Garden City, NY: Anchor Doubleday Books, 1956), 265.

1515

Raffahell de vrbin der so hoch peim
pobst geacht ist gewest hat der sal
diss nacket bild gemacht vnd hat
es dem albrecht dürer gen nornberg
geschickt Im sein hand zu weysen

# SECTION TWO

# Anatomy

I have bought myself a very beautiful book on anatomy. . . . It was in fact very expensive, but it will be of use to me all my life. . . . The key to many things is in thorough knowledge of the human body.

—*Vincent van Gogh, in a letter to his brother, Theo*

## Introduction to Anatomy

To a large extent, the key to understanding the human body is a thorough knowledge of its structure, and the structure of the body is determined by its anatomy. Some artists and drawing instructors would prefer to de-emphasize or even forego the study of anatomy altogether for fear that the life drawing process will become too self-conscious, the students' drawings lose their spontaneity and the honesty of direct observation. For some, the study of anatomy is reminiscent of the *académies*, whose regimented approach to the study of anatomy often led to overstating it, giving drawings from life the rigidity of dead anatomical charts. For the sensitive artist, the study of anatomy has always been a means to an end, not an end in itself. One's knowledge of anatomy should not become an instrument with which to flay the body but, rather, should enliven the artist's work with greater appreciation for the body's organic structure and animation.

In his portrayal of the first couple, *Adam and Eve* (Figure II.1), Jan Gossaert relies on his understanding of anatomy to give his subjects a convincing sensuality, as well as structure. Gossaert's figures are much more than skin stretched over an unknowable framework. We see evidence of the supporting structure—the skeleton and the fullness of flexing musculature. Gossaert's emphasis on anatomy adds to his expression of the physical nature of his subjects' being.

**II.1**
Jan Gossaert. *Adam and Eve.*
Black chalk, 24 3/4 x 18″.
Rhode Island School of Design
Museum of Art, Providence.

The purpose of studying anatomy is not so it can be forcefully corseted around your model but rather so that you may approach your subject with prior knowledge and, thus, with greater sensitivity. Knowledge is liberating, when used as a guide to understanding, and the more you draw, the more your understanding of anatomy will integrate naturally with your expressive potential, increasing the power and authority with which you draw.

# Chapter 6

# Foundations of the Human Structure

Many, . . . in order to appear great draftsmen, make their nudes wooden and without grace, so that it seems rather as if you were looking at a sack of nuts than a human form or at a bundle of radishes rather than the muscles of nudes.

—*Leonardo da Vinci*, Notebooks

## A Brief History of Artistic Anatomy

Historically, the Greeks, who saw all things—even their gods—as having human characteristics, were the first to study anatomy in the context of art, as well as medicine. In his writings, Aristotle mentions the teaching of anatomy through the use of drawings. During the Middle Ages, however, the powerful Roman Catholic church and its emphasis on the spiritual world brought the direct study of anatomy from the human body virtually to an end. The burgeoning study of medicine in the early 1400s reaffirmed the need for accurate information about human physiology; and, although the church did not officially lift its ban on dissection until the mid-sixteenth century, the overwhelming desire for knowledge of anatomy continued to grow and gave new impetus to its study. The University of Florence authorized dissection for the purpose of anatomical study, which both artists and physicians attended, using cadavers of the disenfranchised members of both church and society, such as criminals or traitors.

Historical accounts describe many of the master artists in their active study of anatomy. Signorelli is said to have had such a passionate interest in learning anatomy that he visited burial grounds looking for subjects. Anatomical studies such as Figure 6.1 by Michelangelo lend support to biographical accounts that he, too, made anatomical drawings from cadavers. His investigations of anatomy, like those of most of his contemporaries, focused primarily on the bones and muscles that affect surface appearances.

Leonardo was an exception. His studies of anatomy were significant scientifically as well as artistically. His interest went far beyond anatomy that determined the figure's outer appearance, as illustrated in his remarkable x-ray drawing of a female torso, Figure 6.2. At one point, Leonardo fully intended to publish his own treatise on anatomy, which was to include drawings illustrating the skeletal and muscular structure. As he wrote in the margin of his notebook: "With what words, O writer, will you describe with like perfection the entire configuration which the drawing here does?

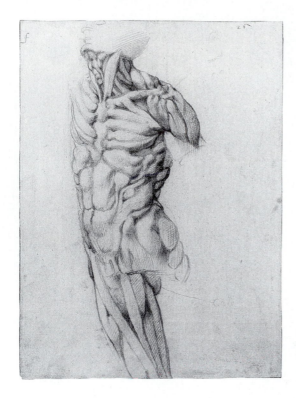

... do not meddle in things appertaining to the eye by making them enter through the ear."[1]

In 1505, Leonardo reportedly dissected two bodies at the hospital of Santa Maria Nuova in Florence. His scientific study of these figures produced extensive drawings and notes, as in Figure 6.3, where he compares the skeletal arrangement of the human leg with that of a dog's. Although he wrote, "In the winter of 1510 I hope to complete all this anatomy,"[2] he never finished the project. Much of what Leonardo sought to achieve was soon to be realized by the anatomist Andreas Vesalius, who published his anatomy volumes in 1538 and 1543, the most complete study of the time. The superb wood engravings, such as Figure 6.4, illustrate how Vesalius's artisans gave their subjects a more natural appearance by placing them within a landscape.

6.1
Michelangelo. *Ecorché.* Red chalk, 28.1 x 10.8 cm. Windsor Castle, Royal Library.
© 1990 Her Majesty Queen Elizabeth II.

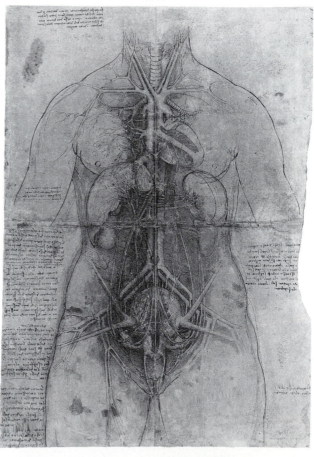

6.2
Leonardo da Vinci.
*Anatomical Study: Principal Female Organs.*
Pen and ink wash over black chalk,
47 x 32 cm. Windsor Castle, Royal Library.
© 1990 Her Majesty Queen Elizabeth II.

**6.3**
Leonardo da Vinci. *Study of Legs*.
Black chalk, gone over with pen and
ink on white, 26.5 x 18.6 cm.
Windsor Castle, Royal Library.
© 1990 Her Majesty Queen Elizabeth II.

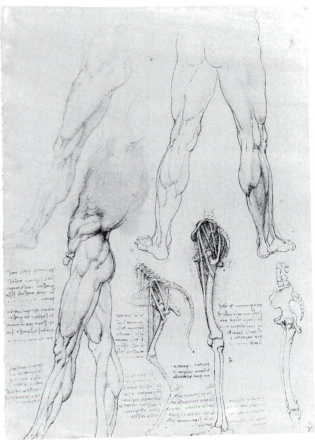

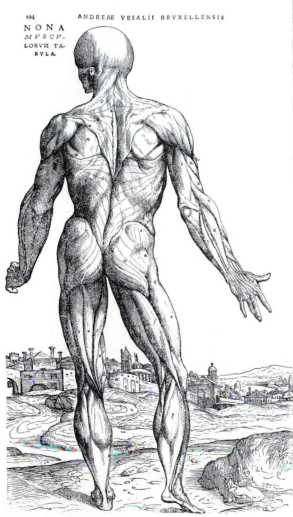

**6.4**
Andreas Vesalius.
*Anatomical chart of the muscles*.
Harvard Medical School, Boston.
Francis A. Countway Medical Library.

It wasn't until a professor of anatomy and surgery in the Netherlands, Bernhard Siegfried Albinus, 1667–1770, began a fresh examination of the human form and incorporated the latest refinement in copperplate engraving that the graphic quality of Vesalius's work was eclipsed. Out of respect for the skill and beauty of artisan Jan Wandelaar's work (Figures 6.5 and 6.6), Albinus chose to use a separate labeling plate rather than mar the fine engravings with labels.

By the nineteenth century, the study of anatomy for medical purposes had increased enormously, and the demand for cadavers gave rise in some parts of England to the illicit business of the "resurrectionist," who would steal bodies from fresh graves. Art academies and many of the newer art schools also offered anatomy lectures, which gave rise to the publication of texts designed particularly for the artist as an alternative or supplement to study from cadavers. One such text was the 1849 publication by Dr. Julian Fau, *The Anatomy of the Extended Forms of Man,* which provided many of the illustrations used in this section.

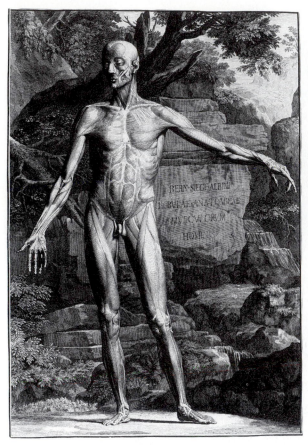

**6.5**
Albinus. *Anatomical illustration by a student of Titian. First order of muscles, front view.* Harvard Medical School, Boston. Francis A. Countway Medical Library.

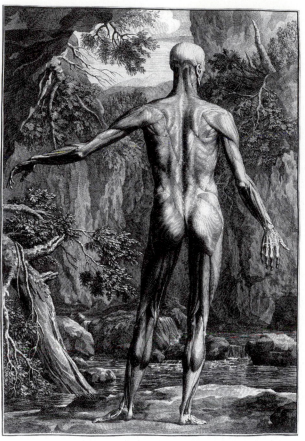

**6.6**
Albinus. *Anatomical illustration by a student of Titian. First order of muscles, back view.* Harvard Medical School, Boston. Francis A. Countway Medical Library.

## Method

Anatomy and drawing texts, such as this one, usually divide the presentation of this material into two distinctly separate units, the first dealing with the skeleton and the second with the muscles. When the skeleton and muscles are studied separately, however, the reunification of bones and muscles is often difficult to visualize. For that reason, this text presents a more holistic approach, which emphasizes the interrelationship of bones, muscles, and fat within the different regions of the body.

In general, we emphasize the larger, more significant aspects of human anatomy that make the most impact on the general character of each region of the body. You are also encouraged to use your own body as a readily available resource on which you can feel the bones and muscles de-

scribed in the text and accompanying diagrams. When your fingers find and trace on your own arm the edge of the *ulna* and feel the shifting of the *radius* as you turn your palm from up to down, you will begin to make the connection between the physical anatomy and its graphic representation.

## Anatomy as a Whole

Before dealing with the specific regions of the body, it is worthwhile to discuss, in general, the ways the skeleton and the muscles influence the external form. Although integrated, each structural system performs a different function, and the influence each has on the various regions of the body, such as the torso or the limbs, is determined by those functions.

THE SKELETON   is the body's armature (Figures 6.7, 6.8 and 6.9). Without the skeleton to hold it up,

the rest of the body would lie on the floor like a heap of discarded clothes. Although the skeleton of the human body may not be externally visible, as is a crustacean's, its influence on the external form of the body is profound. You have only to feel your own wrist, elbows, knees, head, and ribs to confirm the presence and influence of the skeleton. In addition to providing support to the softer tissue, the skeleton is the primary determinant of the body's proportions and its articulation. The skeleton also influences the presentation of the muscles that surround and attach to the bones.

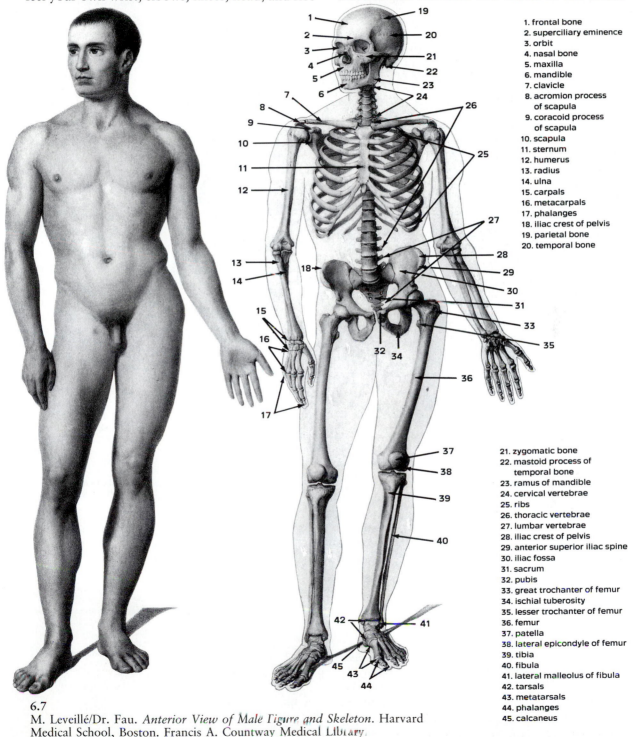

1. frontal bone
2. superciliary eminence
3. orbit
4. nasal bone
5. maxilla
6. mandible
7. clavicle
8. acromion process of scapula
9. coracoid process of scapula
10. scapula
11. sternum
12. humerus
13. radius
14. ulna
15. carpals
16. metacarpals
17. phalanges
18. iliac crest of pelvis
19. parietal bone
20. temporal bone

21. zygomatic bone
22. mastoid process of temporal bone
23. ramus of mandible
24. cervical vertebrae
25. ribs
26. thoracic vertebrae
27. lumbar vertebrae
28. iliac crest of pelvis
29. anterior superior iliac spine
30. iliac fossa
31. sacrum
32. pubis
33. great trochanter of femur
34. ischial tuberosity
35. lesser trochanter of femur
36. femur
37. patella
38. lateral epicondyle of femur
39. tibia
40. fibula
41. lateral malleolus of fibula
42. tarsals
43. metatarsals
44. phalanges
45. calcaneus

6.7
M. Leveillé/Dr. Fau. *Anterior View of Male Figure and Skeleton*. Harvard Medical School, Boston. Francis A. Countway Medical Library.

Though the muscles vary in shape, they inevitably follow the structure of the skeletal armature.

In some regions of the body, the skeleton houses and protects internal organs. The skull, for example, forms a protective helmet for the brain, eyes, and eardrums. The ribs form a cage that sur- rounds and protects the heart and lungs. The pel- vic girdle cradles the intestines, bladder, and womb. In these three areas—skull, rib cage, and pelvis—the bones determine volume and are lo- cated near the surface. In the limbs, the bones are more likely to be buried by layers of muscle and

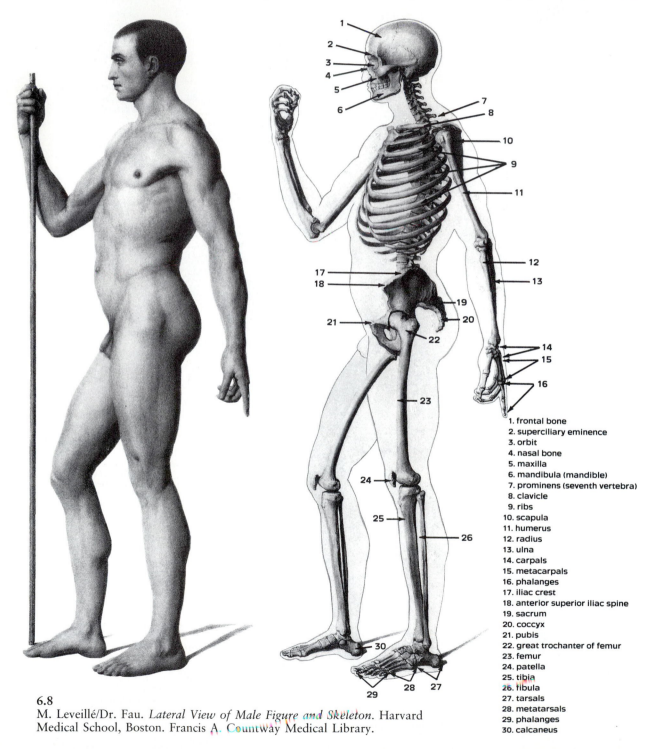

1. frontal bone
2. superciliary eminence
3. orbit
4. nasal bone
5. maxilla
6. mandibula (mandible)
7. prominens (seventh vertebra)
8. clavicle
9. ribs
10. scapula
11. humerus
12. radius
13. ulna
14. carpals
15. metacarpals
16. phalanges
17. iliac crest
18. anterior superior iliac spine
19. sacrum
20. coccyx
21. pubis
22. great trochanter of femur
23. femur
24. patella
25. tibia
26. fibula
27. tarsals
28. metatarsals
29. phalanges
30. calcaneus

6.8
M. Leveillé/Dr. Fau. *Lateral View of Male Figure and Skeleton.* Harvard Medical School, Boston. Francis A. Countway Medical Library.

tissue; yet even in the limbs, the shape and size of the bones play an important role in the outward appearance of the form. By learning the location and the shape of the bones, you begin to anticipate predictable structural relationships. Artists with this understanding are generally better able to de-termine proportions and structure as well as estab-lish a greater sense of three-dimensional solidity in their drawings.

THE MUSCULAR SYSTEM gives the body its locomotion. Unlike bones, muscles are elastic and can change in length as well as thickness as the body moves.

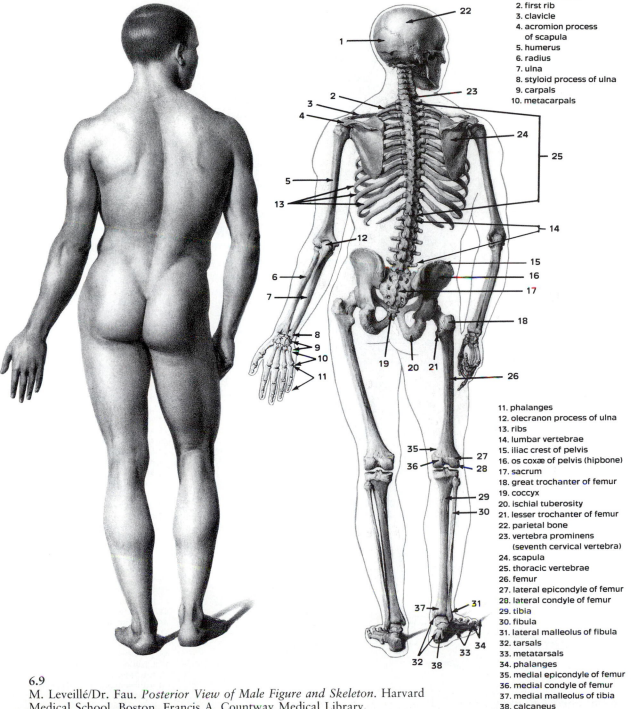

1. occipital bone
2. first rib
3. clavicle
4. acromion process of scapula
5. humerus
6. radius
7. ulna
8. styloid process of ulna
9. carpals
10. metacarpals
11. phalanges
12. olecranon process of ulna
13. ribs
14. lumbar vertebrae
15. iliac crest of pelvis
16. os coxæ of pelvis (hipbone)
17. sacrum
18. great trochanter of femur
19. coccyx
20. ischial tuberosity
21. lesser trochanter of femur
22. parietal bone
23. vertebra prominens (seventh cervical vertebra)
24. scapula
25. thoracic vertebrae
26. femur
27. lateral epicondyle of femur
28. lateral condyle of femur
29. tibia
30. fibula
31. lateral malleolus of fibula
32. tarsals
33. metatarsals
34. phalanges
35. medial epicondyle of femur
36. medial condyle of femur
37. medial malleolus of tibia
38. calcaneus

6.9
M. Leveillé/Dr. Fau. *Posterior View of Male Figure and Skeleton.* Harvard Medical School, Boston. Francis A. Countway Medical Library.

The muscles are the major factor in determining the surface topography, and, in the case of the limbs, muscles also constitute the majority of the mass. Individual muscles vary greatly in shape and size and are attached to the skeleton with nonelastic tendons. The larger, bulkier muscles are generally located on the limbs, especially those linking the limbs to the torso. The muscles of the trunk tend to be broader and thinner. Figures 6.10 and 6.11 will serve as constant references to the musculature of the whole body throughout this section on anatomy.

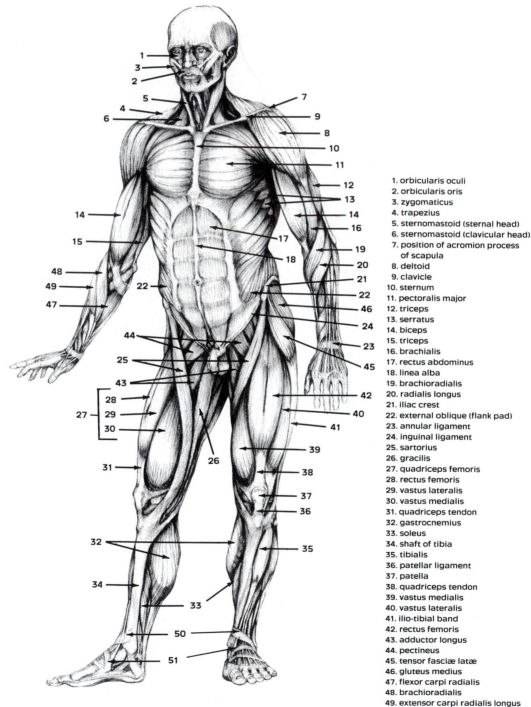

1. orbicularis oculi
2. orbicularis oris
3. zygomaticus
4. trapezius
5. sternomastoid (sternal head)
6. sternomastoid (clavicular head)
7. position of acromion process of scapula
8. deltoid
9. clavicle
10. sternum
11. pectoralis major
12. triceps
13. serratus
14. biceps
15. triceps
16. brachialis
17. rectus abdominus
18. linea alba
19. brachioradialis
20. radialis longus
21. iliac crest
22. external oblique (flank pad)
23. annular ligament
24. inguinal ligament
25. sartorius
26. gracilis
27. quadriceps femoris
28. rectus femoris
29. vastus lateralis
30. vastus medialis
31. quadriceps tendon
32. gastrocnemius
33. soleus
34. shaft of tibia
35. tibialis
36. patellar ligament
37. patella
38. quadriceps tendon
39. vastus medialis
40. vastus lateralis
41. ilio-tibial band
42. rectus femoris
43. adductor longus
44. pectineus
45. tensor fasciæ latæ
46. gluteus medius
47. flexor carpi radialis
48. brachioradialis
49. extensor carpi radialis longus
50. transverse ligament
51. cruciate ligament

6.10
*Musculature (front view).*

Like bunches of rubber bands, the muscles both hold the skeletal armature of the body together and power its movement. As a muscle contracts and shortens, it exerts force at the points of attachment. At the same time, opposite sets of muscles are relaxing and elongating. In this way, the alter-nating performance of the muscles controls the body's movement. The muscles that bend the skeleton are called *flexors*. For example, the *biceps* of the arm are flexors that bend the forearm up and toward the body, whereas their opposite, the *triceps*, are *extensors*, which straighten the arm and

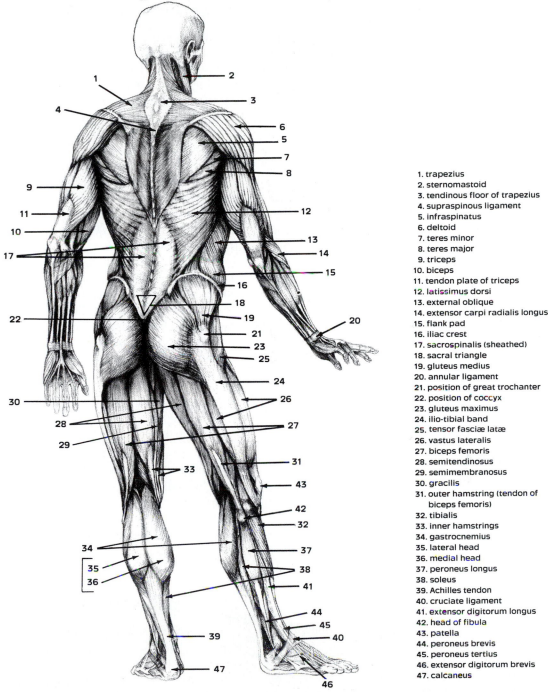

1. trapezius
2. sternomastoid
3. tendinous floor of trapezius
4. supraspinous ligament
5. infraspinatus
6. deltoid
7. teres minor
8. teres major
9. triceps
10. biceps
11. tendon plate of triceps
12. latissimus dorsi
13. external oblique
14. extensor carpi radialis longus
15. flank pad
16. iliac crest
17. sacrospinalis (sheathed)
18. sacral triangle
19. gluteus medius
20. annular ligament
21. position of great trochanter
22. position of coccyx
23. gluteus maximus
24. ilio-tibial band
25. tensor fasciæ latæ
26. vastus lateralis
27. biceps femoris
28. semitendinosus
29. semimembranosus
30. gracilis
31. outer hamstring (tendon of biceps femoris)
32. tibialis
33. inner hamstrings
34. gastrocnemius
35. lateral head
36. medial head
37. peroneus longus
38. soleus
39. Achilles tendon
40. cruciate ligament
41. extensor digitorum longus
42. head of fibula
43. patella
44. peroneus brevis
45. peroneus tertius
46. extensor digitorum brevis
47. calcaneus

6.11
*Musculature (back view).*

extend it out and away from the body. There are also opposite sets of muscles that power rotation movements, such as the twisting of the trunk or the rotation of the forearm. Each muscle has a unique function for some aspect of the body's movement; however, most of the body's complex movements are only possible because the muscles work in concert, assisting each other in the performance of their tasks. Thus, we often find large muscular units that not only work together but also are grouped together as a mass. It is the accumulative mass of a muscle group, such as the muscles of the forearm, which is most significant. Thus, it is not always necessary to study every individual muscle in order to understand the external form. The storage of fat also contributes to the figure's form and appearance. As much as we may wish to reduce its influence on our own bodies, fat is a natural part of human anatomy and, therefore, cannot be ignored. The consequences of fat distribution on the outward appearance of the figure—how it obscures the skeletal and muscular structures underneath and sometimes alters the shape of the figure—must be taken into account in your study of anatomy and will be discussed whenever appropriate.

What we see as the outward appearance of the body is determined by many factors: the structure and proportions of the skeletal framework, the volume of musculature and overlaying fat, and the movement and gestures created by the action of the muscles. Next, we will look more closely at the various regions of the body—the torso, the arms and legs, the hands and feet, and the head.

## Anatomy of the Torso

The torso, or trunk, of the body includes the neck, shoulders, and pelvic region and the chest, stomach, and back. Some of the muscles we will discuss in the shoulder and pelvic areas belong jointly to the limbs in that they form the connection between the limbs and the torso. Therefore, there will be some slight overlapping between this chapter and the next in our discussion of the musculature in these regions.

The skeleton, rather than the muscles, determines the volume of the torso because of its protective function as well as its importance as a supportive armature. Notice in Figure 6.7 the close proximity of the bones of the torso to the external surface of the body. The general form and proportions of the trunk are determined by three distinct skeletal units: the rib cage *(thorax)*; the hip girdle *(pelvis)*; and the backbone *(spinal column)*. The upper and larger section of the trunk consists of two separate skeletal units: the rib cage and the shoulder girdle.

## FRONT (ANTERIOR) VIEW OF THE TORSO

The rib cage, or thorax, is made up of twelve sets of curved bones that originate along the upper region of the spinal column. It forms an enclosure housing the heart and lungs and remains flexible enough for the lungs to breathe (Figure 6.7). The first ten sets of ribs are anchored to the breastplate *(sternum)* with sturdy bands of cartilage. The eleventh and twelfth pairs, called floating ribs, end freely. Notice the downward slope of each rib as it curves from the back toward the front of the chest, where the cartilaginous attachments make an abrupt turn upward to the sternum. When seen from the anterior, or front view, this cartilage linking of the ribs to the sternum creates the *thoracic arch*, an inverted V form with its apex at the lower tip of the sternum. This arch also forms a line of demarcation between the muscles of the chest and those of the abdomen. Due to the relative elasticity of the muscular abdomen in comparison to the bony ribs, the area just below the thoracic arch may appear as either a hollow, recessed pocket or a paunch, depending upon the body's physique and posture.

The shoulder girdle is composed of the collar bones *(clavicles)* and the shoulder blades *(scapulae)*, to which the clavicles attach at the shoulders. The clavicles run from the notch at the top of the breastplate to the top of the shoulders (Figure 6.12, left side). With your fingers, find the points of the clavicles that sit at the pit of your throat where they attach atop the sternum, and note the hollow formed between them, which is evident in both figures in contemporary artist Julie Schneider's drawing, Figure 6.13. You can easily trace the shape of the clavicle to the shoulder, where it caps the shoulder socket formed with the scapula.

The pelvic girdle is actually a fusion of three bones (Figure 6.12, left side). The largest portion consists of the two irregularly shaped pelvic bones, which unite to form a nonmoveable joint in the front known as the pubic crest *(symphysis pubis)*, just above the genitals. This joint aligns on the

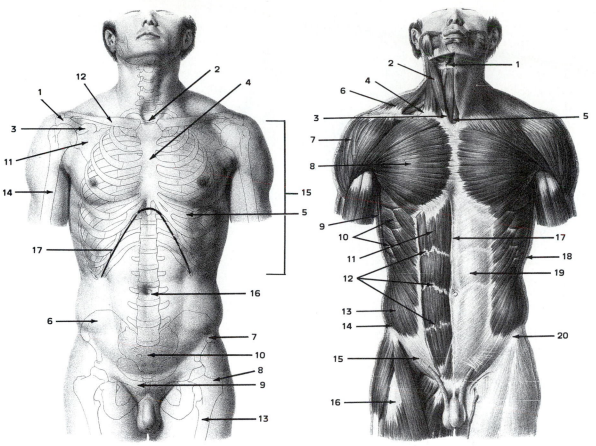

**6.12**
M. Leveillé/Dr. Fau. *Anterior View of Skeleton and Musculature of Torso.* Harvard Medical School, Boston. Francis A. Countway Medical Library.

**Left Side**
1. acromion process of scapula
2. pit of the neck
3. coracoid process of scapula
4. sternum
5. ribs 1 through 12
6. pelvis
7. anterior-superior iliac spine
8. great trochanter
9. symphysis pubis
10. sacrum
11. scapula
12. clavicle
13. femur
14. humerus
15. thorax (rib cage)
16. spinal column
17. thoracic arch

**Right Side**
1. hyoid bone
2. sternomastoid
3. (sternal head)
4. (clavicular head)
5. pit of the neck
6. trapezius
7. deltoid
8. pectoralis major
9. latissimus dorsi
10. serratus anterior
11. tendinous intersections of rectus abdominus
12. rectus abdominus
13. external oblique (flank pad)
14. iliac furrow
15. inguinal ligament
16. rectus femoris
17. linea alba
18. fat layer
19. sheath of rectus abdominis (aponeurosis)
20. anterior-superior iliac spine of pelvis

front of the torso with the sternum. The third bone of the pelvic girdle, a specially modified vertebra known as the *sacrum,* lies at the base of the backbone, or spinal column. The sacrum and two pelvic bones form a cup or funnel surrounding the large *pelvic cavity,* which gives support to delicate internal organs and, in the case of the female body, furnishes a cradle for the womb. Notice how the general shape of the pelvic girdle in Figure 6.12 (left side) is hinted at in the exterior appearance of the trunk and how the bones of the pelvis influence the pattern of the muscles in the figure shown at right. The general cup shape of the pelvis tips slightly forward. What might be thought of as the upper lip of this cup, the upper ridge on each side of the pelvis, is known as the *iliac crest,* which you can feel on your side at the top of the pelvic bone. The line of this crest terminates in the front at a protuberance known as the *anterior superior iliac spine.* From the two anterior superior iliac spines,

a pair of *inguinal ligaments* stretch to the pubis, forming a fairly noticeable U-shaped furrow just above the more sharply V-shaped furrow of the groin between the trunk and thigh (Figure 6.12, right side). The line of the inguinal ligaments

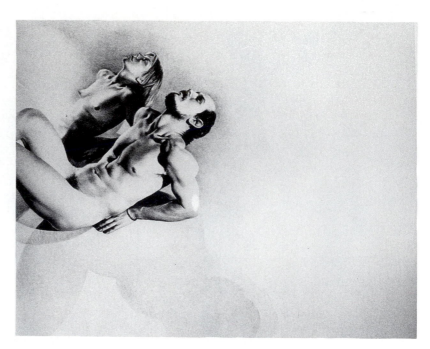

**6.13**
Julie Schneider.
*Agamemnon's R and R.* 1977.
Graphite, 23 x 29″. Minnesota
Museum of Art, St. Paul.

forms a natural continuum on the front of the torso of the iliac crest, which creates an important line of demarcation over which no muscles cross. The iliac crest and the inguinal ligaments function as a border between the muscles of the upper trunk and those affiliated with the legs.

When viewed from the front, the pattern of muscular fiber over the skeletal frame of the trunk generally relates to the T configuration established by the vertical dividing line of the sternum-abdominal furrow *(linea alba)* and the horizontal cross-members of the clavicles. The linea alba, Latin for "white line," is a tough, fibrous ligament, widest at the navel, that runs from the sternum to the pubis and forms a vertical muscle division over the full length of the front of the torso. It serves as a midline for the front view and is also useful for determining proportions and perspective when viewing the figure at an oblique angle.

The fan-shaped chest muscle *(pectoralis major)* (Figure 6.12, right side) originates in a semicircular pattern of muscle strands attached to the sternum, the ribs, and the clavicle, then it twists and tucks under the shoulder muscle *(deltoid)* to attach on the arm bone *(humerus)*. Where it attaches to the arm under the shoulder muscle, it forms the frontal half of the armpit *(axilla)*. When contracted, this muscle pulls the arm forward and across the chest. The twist in the muscle before it attaches to the humerus allows for tremendous arm mobility. Extend your own arm straight out

to the side or above your head, then, as you pull it straight out in front of your chest, you can both see and feel the movement of the pectorals.

The stomach muscles *(rectus abdominus)* run as two vertical, parallel bands on either side of the central linea alba ligament. These two muscular bands stretch from their upper attachment beneath the pectorals on the rib cage to the pubis at the front of the pelvic girdle. Slightly narrower at the bottom than the top, the lines of the muscles contribute to the V-shaped configurations converging at the groin. Each abdominal muscle strap is divided horizontally into four segments, the upper three of approximately equal portions and the lower segment, stretching from the navel to the pubis, being longest (Figure 6.12). The visibility of this segmentation depends to a great extent on the individual's physical condition and the amount of body fat present. As these muscles constrict, they bend the torso, pulling the rib cage closer to the pelvis. When the figure bends forward, as in doing sit-ups, the furrows that form on the abdominal wall generally conform to the separate segments of the rectus abdominus.

On either side of the abdominal muscles are the muscles of the flank *(external oblique)*, which span the gap between the rib cage and the pelvis. Originating in eight progressive steps intertwined with the *serratus anterior* muscles along the lower ribs, the external obliques terminate with a slight bulge just above the pelvis, attaching at the iliac

crest of the pelvic bone. This bulge, called the *flank pad*, is prominent in Figure 6.12. Along the bottom edge of a well-developed flank pad, an indentation known as the *iliac furrow* sometimes conceals the raised ridge of the iliac crest, indicating the top of the pelvis. This line is generally more pronounced on the male figure than on the female. Also, with obesity the iliac furrows become quite deep, evolving into clefts where the flank pads and stomach might overhang the iliac crest.

The neck region consists of the uppermost portion of the spine and the muscles between the skull and the shoulder girdle. One could say that the neck is a cylindrical form, but that would be an over-simplification. For example, when viewed directly from the front, the contour of the neck is defined by a pair of neck muscles *(sternomastoids)* that originate at the base of the skull just behind the ear and extend diagonally to where their tendons attach at the joint of the clavicle and sternum (see Figure 6.12 and Schneider's Figure 6.13). Here, they help to create the "pit of the neck" at the top of the sternum. The visual effect of this muscle pair is to modify the cylindrical nature of the neck with their V-shaped orientation. The physical function of the sternomastoid is the tipping and rotating of the head. Between the sterno-mastoid in the top of the V just below the chin is the protruding form of the windpipe *(trachea)*. In front of the trachea, just under the chin is a small, slender *hyoid bone* that accounts for the indentation in the neck just above the elevation called the "Adam's apple," which is, in fact, part of the carti-lage of the voice box *(larynx)*. The Adam's apple is more prominent in the male than in the female and is most noticeable when the head tips back. Another muscle that makes a visual impact on the form of the neck when viewed from the front is the *trapezius,* called the cowl or hood muscle because of the way it lies on the shoulders. This muscle is physically located on the back side of the neck, but it is partly visible from the front. It attaches at the base of the skull in back and fans out to the shoulders, suggesting a pyramid shape. One function of the trapezius is to tip the head back; another is to raise the shoulders, which results in a deep pocket between the trapezius and the clavicles. Notice this pocket and the bunched trapezius muscle of the male figure in Schneider's Figure 6.13. Raise your shoulders and you can feel the contracted trapezius muscle and visually note the pockets formed between it and your clavicles.

In Michelangelo's study of Adam, Figure 6.14, we see a dynamic expression of the anatomical elements we have been discussing, and we can sense the weight and girth of the body. Even though this is a small sketch, it expresses the almost panoramic quality exhibited in Michelangelo's Sistine chapel frescoes, for which this was a study. Beneath skin and muscle, we see evidence of a fully expanded rib cage pushing out the contour of the body. The furrow indicating the position of the sternum appears as a deep shadow, and the linea alba continues over the abdominal area to the navel. Here, the rectus abdominus swells just above the line of the inguinal ligament, which runs

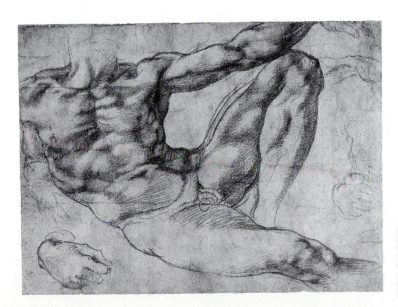

**6.14**
Michelangelo. *Adam (Study for the Sistine Ceiling Fresco).* c. 1511. Red chalk, 7 1/2 x 10 1/4″. Reproduced by courtesy of the Trustees of the British Museum, London.

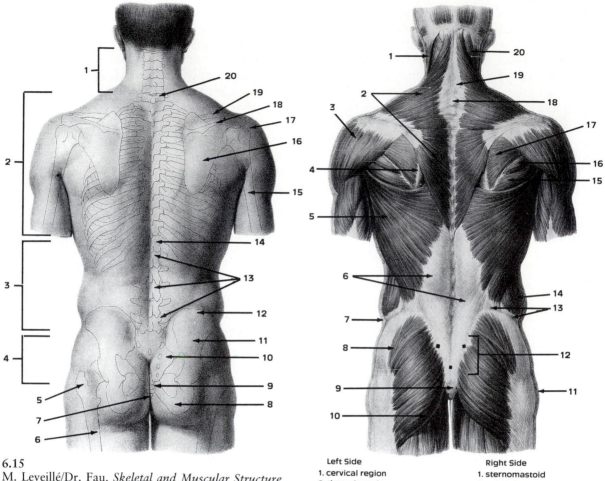

**6.15**
M. Leveillé/Dr. Fau. *Skeletal and Muscular Structure of Torso (Back View)*. Harvard Medical School, Boston. Francis A. Countway Medical Library.

**Left Side**
1. cervical region
2. thoracic region
3. lumbar region
4. sacral region
5. great trochanter
6. femur
7. gluteal fold
8. tuberosity of pelvis
9. coccyx
10. sacrum
11. pelvis
12. iliac crest
13. vertebrae
14. spinal column
15. humerus
16. scapula
17. acromion process of scapula
18. spine of the scapula
19. clavicle (distal end)
20. prominens (seventh vertebra)

**Right Side**
1. sternomastoid
2. trapezius
3. deltoid
4. vertebral border of scapula
5. latissimus dorsi
6. bulge of sacrospinalis
7. iliac furrow
8. gluteus medius
9. coccyx
10. gluteus maximus
11. fat
12. sacral triangle
13. iliac crest
14. external oblique (flank pad)
15. teres major
16. teres minor
17. infraspinatus
18. prominens (seventh cervical vertebra)
19. tendinous floor of trapezius
20. position of mastoid process

from one point of attachment on the iliac crest of the pelvis to the other. On the figure's right side, the flank pad of the external oblique stretches out but still swells slightly over the iliac crest. On the figure's left side are deep folds in the flank area—corresponding to the horizontal segmentation of the rectus abdominus muscles—made visible by the lateral tipping of the pelvis. Adam's position of repose also causes some modification in the upper portion of his torso. Both shoulders have been raised by the action of the arms, showing clearly the cleft between the trapezius and the clavicle. We can see how the body's leaning on one elbow has raised the shoulder on the figure's right side, giving the clavicle a diagonal rather than horizontal alignment. The other shoulder is raised even higher by the arm's reaching action, further heightening the diagonal orientation of the clavicle

on that side. The overall effect is that the normal T formation of the clavicle and sternum has been changed to a Y, deepening the pockets on each side of the neck. Notice, too, the V formation of the sternomastoid muscles on the neck. Another result of the raised arm can be seen in the way the pec-

torals pull up and stretch out. The contour along the underside of this muscle flows up into the arm and the shoulder, revealing the underside of the arm and the armpit (axilla). Beneath the axilla, under the raised arm, you can see the small ridges of the serratus anterior muscles, which might be mistaken for ribs.

## BACK (POSTERIOR) VIEW OF THE TORSO

The skeleton plays a more prominent role in the formation of the back view of the torso than in the front view (Figure 6.15). The shoulders, ribs, and upper portion of the pelvis are discernible, and the spinal column, which only indirectly affected the frontal view of the body, is now a major visual as well as structural element.

The backbone (spinal column) runs all the way from the base of the skull to where the wedge-shaped sacrum, which means "sacred bone," inserts into the pelvis. The spine is composed of many small interlocking bones (vertebrae), each specifically modified for its precise position in the four general regions of the spine: the neck (cervical), the ribs (thoracic), the small of the back between the rib cage and pelvis (lumbar), and the pelvis (sacral).

No muscles cross over the spine from pelvis to skull, which is why the spinal column is such a prominent visual element when viewed directly from behind. This line is strengthened visually as well as physically by the strong back muscles, sacrospinalis, which lie directly alongside the spinal column. These muscles, named because they stretch from the sacrum along the length of the spine, offer support to the back, working in opposition to the rectus abdominus muscles on the stomach. Although not visible in Figure 6.15, because they are covered by more superficial muscles, the thick sacrospinalis bands are significant in the lumbar region, where their bulk creates the furrow for the spine. This furrow, and the muscles that form it, are defined with value in Martha Mayer Erlebacher's drawing, Figure 6.16.

The process, or protuberance, of the seventh vertebra (prominens) at the base of the neck is generally visible as a slightly more pronounced bump on the spinal column and signals a shift in the curvature of the spine. This protrusion also marks the top of the rib cage and the beginning of the thoracic region of the spinal column.

The rib cage is evident in the broad, bellowing contour of the back. Notice how the form of the

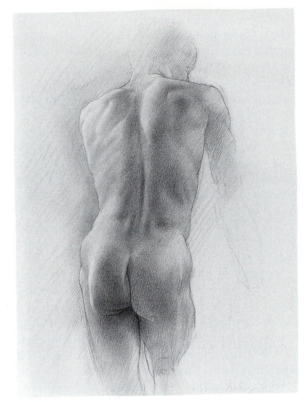

**6.16**
Martha Mayer Erlebacher. *Male Back*. 1980. Pencil on paper, 11 7/8 x 8 7/8". Arkansas Arts Center, Little Rock. Foundation Collection: Donation Box Acquisition Fund, 1982. 82.31.1.

back follows the general orientation of the rib cage and is affected by its proximity to the outer surface (Figure 6.15). Notice, too, the diagonal sweeping curve of the ribs from the spine toward the front of the body.

The shoulder blades (scapulae) make up the posterior half of the shoulder girdle (Figure 6.15, left side). These two flat, triangular-shaped bones are slightly dished to conform to the contour of the rib cage over which they ride. The inner margins, the edges of the scapulae facing the spine (vertebral border), are parallel, and the lower corners are about level with the nipples on the front of the chest. When the arms hang at the sides of the body, the vertebral borders of the scapulae can be detected under the flesh as the rims alongside what may appear as a large, horseshoe-shaped hollow in the center of the upper back. The less-visible exterior margins, the outside edges of the scapulae facing the arms, run at a diagonal up to the shoulders, where each lateral angle or head

forms part of the socket for the arm bone (humerus). The raised ridge, known as the *spine of the scapula*, that runs along the top of the scapula is an important landmark because it forms a point of attachment for the muscles on the back of the torso, much as the clavicle does on the front. The spine of the scapula ascends laterally from the vertebral border to conclude as a projection over the roof of the shoulder socket, the *acromion process*, which you can easily see and feel on the exterior of the shoulder. You may wish to use your fingers to detect the location of the spine of the scapula as a bony ridge just beneath the skin on the back of the shoulder. The scapulae are most dramatically visible when the arms are pulled back, forcing the inner margins of the scapulae closer together.

The form of the neck on the posterior is dominated by the upper portion of the large, diamond-shaped trapezius muscle, which attaches to the base of the skull and spreads the cylindrical mass of the neck outward toward attachments on each side along the spine of the scapula. Alongside the trapezius, just in back of the ears, a small portion of the frontal sternomastoid muscle is discernible. However, the V formation of the frontal neck muscles is inverted on the back of the neck by the dominant trapezius. A small, diamond-shaped opening at the base of the neck *(tendinous floor of the trapezius)* is in part responsible for the visibility of the projecting vertebrae in this area. The trapezius extends down the back as a flat wedge shape, but it is too thin in this region to significantly affect the exterior form of the lower back.

The *latissimus dorsi* is the broadest muscle of the back, with an extensive origin running along the lumbar region of the spine and the iliac crest of the pelvis. This muscle envelops the lower portion of the thoracic region, wrapping around the ribs like a bodice as it moves out from the spine and upward to its point of insertion at the underarm. At its origin this muscle forms a thin, triangular layer of tendinous fiber over the lower back, veiling the sacrospinalis muscles that lie alongside the spine. The upper portion of the latissimus becomes increasingly fleshy until it forms a thickened lateral mass that makes up the posterior side of the armpit (axilla) opposite the chest muscles (pectoralis major) on the anterior side of the torso. The upper edge of the latissimus passes over the lower corner of the shoulder blade, preventing it from becoming separated from the rib cage as it pivots with arm movement.

The sacrum, which forms the base of the spine and an important component of the pelvic girdle, lies just beneath the skin at its upper portion and is visible as a flat, triangular shape (the *sacral triangle*). This bone is lodged between the two halves of the pelvis, with most of the lower portion covered by the fatty padding of the buttocks. The sacrum's wedge shape is designed to transmit the weight of the upper body from the spinal column downward through the pelvis to the thighs. Often two dimplelike depressions appear as a local expression of the uppermost edge of the sacral triangle, indicating the roots of the sacrospinalis muscles at the sacrum. Erlebacher's Figure 6.16 reveals these depressions with value at the base of the sacrospinalis.

The iliac crest of the pelvis rises from both sides of the sacrum and lies just beneath the skin. This important muscle border, the attachment of the external obliques above and the *gluteal muscles* below, can be traced as a furrow (iliac furrow) around to the side and front of the torso.

Below the iliac crest lie the thick gluteus muscles *(maximus, medius, and minimus)* of the buttocks, which mask most of the irregular form of the pelvis (Figure 6.15). For example, the lower, rounded, thick end of the lower pelvis, the *tuberosity*, which supports the weight of the body when sitting, is completely covered. In addition, much of the cushion covering the pelvis is provided by a thick layer of fat that considerably modifies the external form of the lower pelvic region, partially obscuring the sacrum and the tailbone *(coccyx)* at the tip of the spine, which is deeply recessed. Fat also extends the buttocks downward, forming the *gluteal furrow*, where the gluteus muscles overhang the muscles at the back of the leg (see Figure 6.15, left side).

The three gluteus muscles originate along the lateral borders of the sacrum and the iliac crest (Figure 6.15, right) and attach to the thigh bone *(femur)*. These muscles extend the leg at the hip joint, straightening it as for climbing stairs or standing after stooping. Although this group of muscles is thick and rounded on the back of the pelvis, it is the combination of muscles and fat that accounts for the total mass of the buttocks and hips.

The width and contour of the hips is determined by the *great trochanter*, the large process (protuberance) on the outside upper end of the femur. This prominent process acts as a lever for

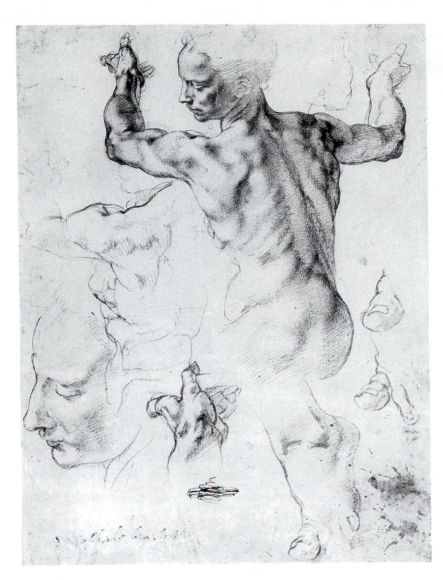

6.17
Michelangelo.
*Study for Libyan Sibyl.*
Red chalk on paper,
11 3/8 x 8 3/8". Metropolitan
Museum of Art, New York.
Purchase, 1924,
Joseph Pulitzer Bequest
(24.197.2).

the muscles controlling the hip joint, and you can feel it at your side beneath a covering of thin tendons about a hand's span below the iliac crest. Notice in Figure 6.15 (left side) that the great trochanter actually protrudes farther to the side than does the top crest of the pelvis.

Michelangelo's study for the Sistine chapel, Figure 6.17, provides marvelous anatomical details to help us apply our knowledge of the anatomy of the back view of the torso to the drawn figure. Notice how he applies value to disclose the existence of the muscles beneath the surface without outlining each edge. Michelangelo's most extensive attention is given to the upper portion of the back. Here the double twisting movement (*contrapposto position*) of the spine gives a dynamic, animated qual-

ity to his seated figure. Although the hips are in profile, the torso twists to reveal the full breadth of the upper back. At the same time, the neck turns the head back and into profile.

We are immediately aware of the full expanse of the rib cage, even though we can detect the precise position of only a few of the lower ribs on the left side of the figure. As the arms swing in opposition to the hips, the torquing action is expressed most visibly in the oblique angle of the spinal column and the emphasized bulging of the adjacent back muscles (sacrospinalis). The seventh vertebra (prominens) at the base of the neck appears as a white highlight, followed by hints of lesser vertebrae along the furrow of the backbone to the pelvic region. Here, there are subtle suggestions of the

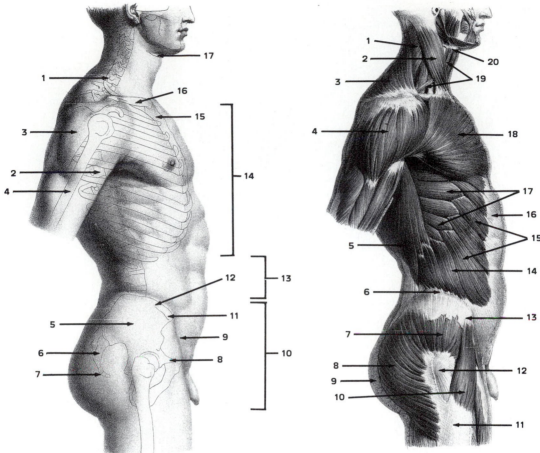

**6.18**

M. Leveillé/Dr. Fau. *Side View of Skeletal and Muscular Structure of Torso.* Harvard Medical School, Boston. Francis A. Countway Medical Library.

| Left Side | Right Side |
|---|---|
| 1. prominens (seventh vertebra) | 1. splenius |
| 2. spinal column | 2. sternomastoid |
| 3. scapula | 3. trapezius |
| 4. humerus | 4. deltoid |
| 5. hipbone (os coxæ) | 5. latissimus dorsi |
| 6. sacrum | 6. iliac furrow |
| 7. coccyx | 7. gluteus medius |
| 8. pubic crest | 8. gluteus maximus |
| 9. inguinal ligament | 9. fat |
| 10. pelvis | 10. tensor fasciæ latæ |
| 11. anterior-superior iliac spine | 11. iliotibial band |
| 12. iliac crest | 12. great trochanter of femur |
| 13. lumbar | 13. anterior-superior iliac spine |
| 14. thorax (rib cage) | 14. flank pad |
| 15. sternum | 15. external oblique |
| 16. clavicle | 16. rectus abdominis |
| 17. hyoid bone | 17. serratus anterior |
| | 18. pectoralis major |
| | 19. omohyoid |
| | 20. hyoid bone |

iliac furrow, the external obliques, and the flank pad. More pronounced is the rhythmic repetition of the curvature of the ribs, which leads into the latissimus dorsi stretching out along the contour of the torso to the underarm. In spite of the neck's twisting action, we can follow the contour of the trapezius from the back of the skull out over the acromion process of the scapula on the top of the shoulder. The up and outward reach of the two arms not only draws the viewer back in space but also pulls the scapulae forward. Michelangelo indicates the diagonal orientation of the near shoulder blade with shadow.

## SIDE (LATERAL) VIEW OF THE TORSO

After studying the torso from both the anterior and posterior, the lateral view will review some of the material already discussed and provide a means of unifying the front and back. The lateral view (Figure 6.18) conveys more clearly the dimension and interrelationship of the anatomical components and reveals important aspects of the form not clearly discernible when viewing the body directly from the front or back. For example, the S curvature of the spinal column is now conspicuous, as is its influence on the orientation of

the rib cage and pelvis. Notice how both of these skeletal units follow the spine's path: The pelvis tips forward from the lumbar region down over the plane of the sacrum, and the rib cage is counterpoised, establishing a rhythmic equilibrium between these two important anatomical forms. The contour of the back reverses the S curvature where the buttocks extend diagonally over the roof of the sacrum before returning and tucking into the gluteal furrow. Follow the contour of the woman's back in Degas's life study, Figure 6.19. The spine curves down and out from the neck, back in at the lumbar, and out with the sacrum. The curvature of the buttocks draws the line back down into the legs.

The diagonal orientation of the neck is also a direct result of this curvature of the spine (Figure 6.18). This directional movement is reinforced by the shape of the trapezius, from the skull to the spine of the scapula. The windpipe (trachea) at the front contour also follows the backward slant of the vertebrae. However, the muscular bands of the sternomastoid form an oblique counter movement from behind the ear forward and onto the front of the shoulder girdle, where the collarbone (clavicle) and the breastplate (sternum) join.

Below the clavicle and along the profile of the sternum, you can see the chest muscle (pectoralis major) as it wraps over the upper form of the chest and tucks under the shoulder muscle (deltoid) of the arm. By running your hand down the side of your own body, beginning at the armpit (axilla), you can detect the general form of the chest and feel how thin the muscles are that cover the ribs. Below your bottom rib is the flank pad of the external oblique. A progressive sawtooth pattern of ridges easily mistaken for ribs is actually an indication of the serratus anterior muscles. The serrated pattern of these muscles can be seen in Figure 6.18, just under the axilla and pectorals. Notice also how the general profile of the abdominal wall tends to follow the movement of the spine, protruding toward the front, opposite the lumbar curve of the back.

## ARTICULATION OF THE LIMBS AND TRUNK

From the side view, Figure 6.18, we can clearly see the location of the top of the pelvis (iliac crest) as a furrow and as a separation between the flank pad of the external oblique on the upper torso and the muscles of the hips and buttocks (gluteals). The effect suggests that the leg is a separate entity, attached to the torso in the manner of a department store mannequin. This line of demarcation does, however, have a strong basis in anatomy. The iliac crest marks the division of the musculature between torso and leg. Everything below this line and the inguinal ligament can properly be considered as inherent to the articulation and function of the lower limbs, which will be discussed extensively in the next chapter.

The movement of the arms at the shoulder joint has a modifying effect on the anatomy of the upper torso. For that reason, one cannot fully understand the form and structure of the torso without taking into account how the position of the arm may alter the normal muscular patterns and skeletal alignment.

The fact that the shoulder blade (scapula) rides freely over the rib cage and is held in place only by the elasticity of the muscles allows for a high degree of arm movement. Conversely, arm movement can greatly alter the orientation of the

**6.19**
Edgar Degas. *Life Study of a Standing Nude.*
c. 1856–68. Pencil, 11 1/2 x 8 1/2″. Sterling and
Francine Clark Art Institute,
Williamstown, Massachusetts.

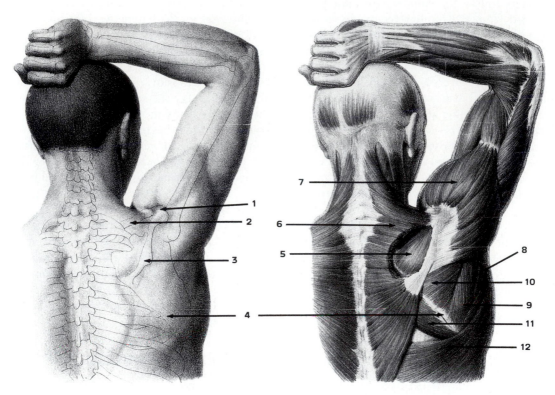

**6.20**
M. Leveillé/Dr. Fau. *Back View of Skeletal and Muscular Structure of Shoulder, arm raised.* Harvard Medical School, Boston. Francis A. Countway Medical Library.

1. acromion process
2. clavicle
3. spine of scapula
4. vertebral border of scapula
5. supraspinatus (under trapezius)
6. trapezius
7. deltoid
8. teres minor
9. teres major
10. infraspinatus
11. rhomboid
12. latissimus dorsi

scapula. In Degas's life study (Figure 6.19), the scapulae become more prominent because of the slight shrug of the woman's shoulders. Notice in Figure 6.20 (left side) that as the left arm is raised, the scapula pivots at the shoulder joint and the inner margin (vertebral border) tips out so that it is no longer parallel to the backbone. Also notice how a pocket forms above the shoulder around the acromion process from the flexing of the thick shoulder muscle (deltoid) as it draws the arm upward. At the underarm, the back muscle (latissimus dorsi) draws up along the outer contour of the torso, and the lower corner of the scapula swings out to the side, following the upper border of the latissimus dorsi.

When this action is viewed from the front (Figure 6.21), the chest muscle (pectoralis major) also pulls up and stretches out. The contour along the underside of this muscle flows into the arm and the shoulder. This action also reveals the under-

side of the arm and the axilla. The clavicle raises with the shoulder (Figure 6.21, left side), changing its normal alignment from horizontal to diagonal. The best way to deal with modifications in appearance caused by arm movement is to consider the shoulder girdle as an extension of the arm, just as the pelvis is an extension of the legs. As the arms move forward, reaching out in front of the body, the back is rounded off. When the arms and shoulders are both drawn back, the vertebral borders of the scapulae become more visible and form a hollow between them. The combined effects of these two actions are visible in a drawing by Raphael,

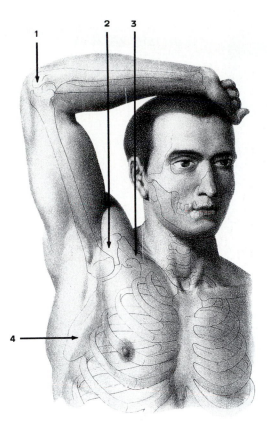

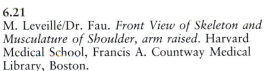

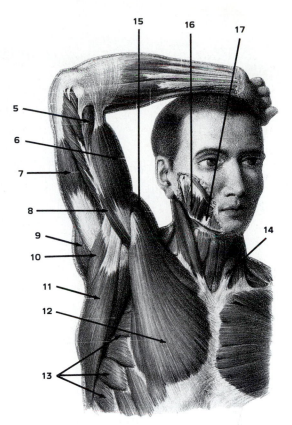

**6.21**
M. Leveillé/Dr. Fau. *Front View of Skeleton and Musculature of Shoulder, arm raised.* Harvard Medical School, Francis A. Countway Medical Library, Boston.

1. olecranon process of ulna
2. acromion process of scapula
3. clavicle
4. scapula
5. brachialis
6. biceps
7. medial head of triceps
8. coracobrachialis
9. teres minor
10. teres major
11. latissimus dorsi
12. pectoralis major
13. serratus anterior
14. sternomastoid
15. deltoid
16. masseter
17. mandibula

Figure 6.22. Notice on the figure at right how the position of the arms has modified the external form of the back in two distinctly different ways. The forward-reaching arm has pulled the scapula forward, rounding the back on that side and reducing the scapula's visual impact. In contrast, the other arm pulls toward the rear of the body, pushing the scapula closer to the backbone where the vertebral border seems to lift off of the rib cage.

Raphael firmly establishes both the rib cage and the pelvis as a foundation beneath the layers of muscle. Each figure has its distant axis along the S-shaped curvature of the spine, which Raphael records both as an accurate record of anatomy and as an aesthetic element adding to the rhythmic gesture of the forward figure.

The iliac crest, which is clearly indicated on both figures in Raphael's drawing as a shadowed furrow, provides the line of demarcation between the muscles controlling the upper and the lower halves of the body's movement. Notice how the hip and the pelvis form a continuation of the leg. You can see a suggestion of the great trochanter as a protrusion on the hips, especially on the figure at left. As the large gluteus muscles flex with the stride of the figure on the right, a hollow forms on the buttock just behind the hip, and the gluteal furrow is also sharply defined as the leg draws back.

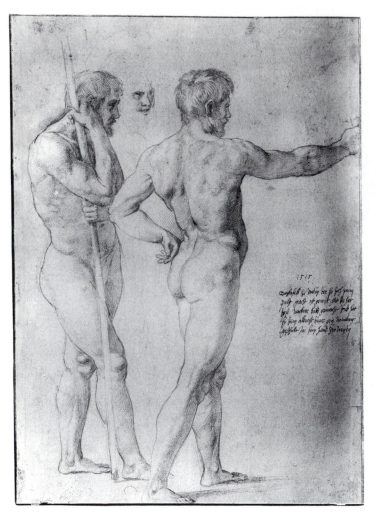

**6.22**
Raphael. *Two Men for the Victory of Ostia.* 1515. Red chalk over stylus, 403 x 281 mm. Graphische Sammlung Albertina, Vienna, Austria.

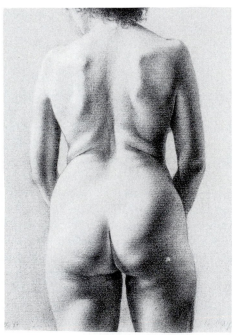

**6.23**
Martha Mayer Erlebacher. *Standing Torso Back.* 1982. Pencil, 13 1/2 x 11".
J. Rosenthal Fine Arts Ltd., Chicago.

## Anatomical Differences between Male and Female Figures

Martha Mayer Erlebacher's drawing, *Standing Torso Back,* Figure 6.23, presents an anonymous figure, but the artist's concern for anatomical accuracy is apparent. Notice the prominence of the sacral triangle and the way the scapulae break up the thoracic region into broad planes. There is no doubt as to the sex of the model, even though all of the more obvious clues as to the figure's gender have been omitted, even from the drawing's title. The primary indications that this is a female torso are the proportional differences between the rib cage and hips and the way the pelvic region appears to extend to the base of the rib cage.

Albrecht Dürer's *Adam and Eve*, Figure 6.24, provides an excellent opportunity to compare the male and female physique. Aesthetically, his presentation of Adam and Eve is more classical and reserved than that of Gossaert's, Figure II.1. The fact that the genital region of both figures has been modestly covered with foliage won't impede our comparison because the anatomical differences between the genders are more a matter of proportion and emphasis. The skeletal and muscular structure of the male and female are the same, although the bones of the female are typically smaller than those of the male, both in length and circumference, and the muscles are generally less bulky and sinewy. The trunk area represents the area of greatest differentiation between the sexes, the key factor being the relative size of the rib cage in comparison with the pelvis. This is clearly indicated in Dürer's *Adam and Eve*, where the male's rib cage is as wide or wider than his pelvis, which gives the male torso its straighter appearance. The female's rib cage is smaller in comparison to her pelvis, and as a result, her torso exhibits more curvature. The ribs of the male are also usually more

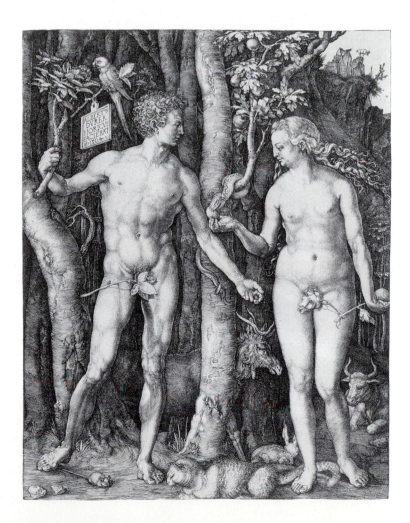

6.24
Albrecht Dürer. *Fall of Man (Adam and Eve).* 1504.
Engraving, 9 7/8 x 7 5/8″.
Metropolitan Museum of Art,
New York. Fletcher Fund, 1919.

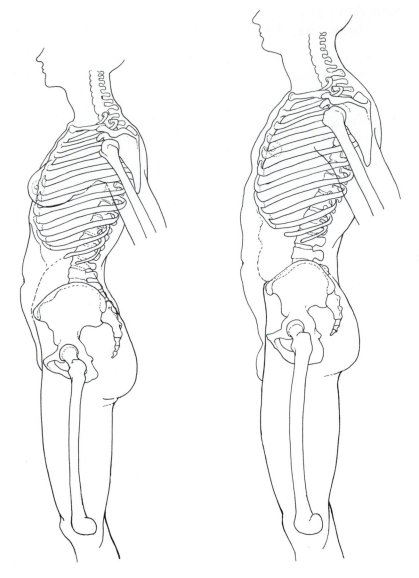

**6.25**
*Diagram comparing female
and male (Side view).*

convex and elevated. Compare the dimensions of the male and female torsos in Figure 6.24. In the female figure, the shoulders, rather than the rib cage, most closely approximate the width of the pelvis.

Figures 6.25 and 6.26 indicate that the male's pelvis is slightly elongated and funnel-shaped, whereas the female's is shallower with a proportionately larger internal cavity, created by the more dramatic inclination of the lumbar portion of the spine. The insertion of the sacrum, which is shorter but broader in the female than in the male, is more to the posterior of the pelvis, which, in turn, brings the coccyx back farther. The outward projection of the sacrum affects the external form of the female in the appearance of a flatter, in-

clined plane over the sacral region. The iliac crest of the pelvis also has a more fluid curvature from the sacrum to its frontal point (the anterior superior iliac spine), which characteristically protrudes slightly farther forward in the female than in the male. These factors combine to give an overall visual appearance that the whole pelvis tips forward with a greater diagonal orientation for the female than for the male. The larger pelvic cavity in females also spreads the hip joints farther apart, which, in turn, affects the angle of a woman's thighs as they slant at a more oblique inward angle from hip to knee than they do in those of her male counterparts (Figures 6.24 and 6.26).

Another important characteristic is that the pelvic region of the female appears to extend to the

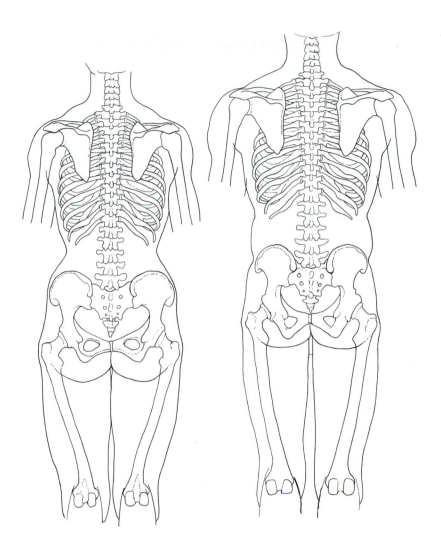

**6.26**
*Diagram comparing female and male (Back view).*

rib cage (Figure 6.26), whereas on the male, it ends at the iliac furrow on the crest of the pelvis. Referring to the Dürer *Adam and Eve*, Figure 6.24, notice how the top of the pelvis is clearly marked by the indication of the iliac furrow on Adam's body. On Eve, we don't see this indentation below the flank pad. Instead, the contour line of the pelvis continues over the flank, with little indication of the iliac crest, up to an indentation at the base of the rib cage.

Variations in the way males and females store and distribute body fat further dramatize sexual differences, especially in the lower torso, where the stomach and buttocks are common areas for fat storage. Fat cells lie under the skin in virtually every part of the body. In general, the muscular presentation in males tends to be more pro-

nounced, in large measure because the female body carries additional fat cells beneath the skin, which serve to obscure muscle definition, making the surface appear smooth. The male seems to store fat primarily in the stomach and upper pelvis or midsection of the trunk, and the female body stores fat first in the lower region of the hips and thighs. The accumulation of fat in this region may obscure or soften the precise location of hips, as well as the iliac crest.

Because a male's fat accumulation is primarily in the stomach, above the iliac crest and the inguinal ligament, these lines become more distinct furrows with added fat. As the male puts on weight, his belt line drops. As the female puts on weight, the belt line rises. Age and lack of exercise further accentuate these differences.

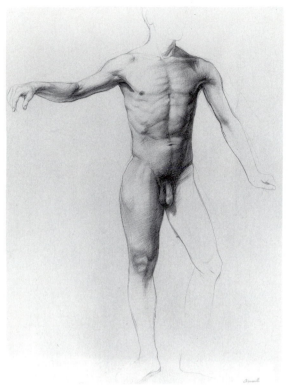

**6.27**
Steven Assael. *Untitled.* 1982.
Ball point pen, 11 x 15".
Staempfli Gallery, New York.

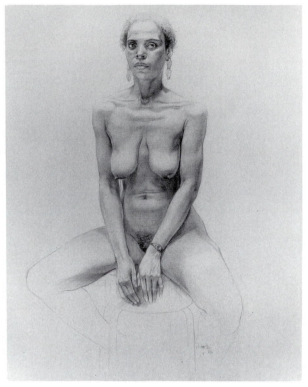

**6.28**
Steven Assael. *Female Nude.* 1986.
Ball point pen, 13 1/2 x 10 3/4".
Staempfli Gallery, New York.

Two drawings by Steven Assael, Figures 6.27 and 6.28, skillfully render the anatomy of a male and a female figure, neither of whom exhibit much fat accumulation. The shoulders of the female figure in Figure 6.28 are somewhat broader than her hips, but her rib cage appears smaller in relationship to her hips when compared to the male figure, whose rib cage approximates the width of his hips. Notice also that the breasts in Figure 6.28 do not entirely obscure the pectorals underneath. Assael's descriptive anatomy in both drawings becomes an aesthetic device that orchestrates his subtle use of value.

## Learning from the Masters

Although it is beneficial for drawing students to make copies from the more scientific illustrations in order to learn the body's physiology, studying the works of master artists reveals the expressive and aesthetic application of such knowledge. Whereas scientific illustrations attempt to give us an unbiased presentation of raw facts, the artist is much more selective in interpreting and representing these facts.

Another drawing by Raphael, Figure 6.29, is less refined than Figure 6.22 but in some ways more interesting. Here, we can follow the evolutionary process of the drawing and see how Raphael uses cross-contour lines that conform to the body's anatomy. As his lines break away from the outer edge, they become notations for the body's anatomical structure and surface terrain. His initial line phrasing is often reaffirmed with darker lines to emphasize anatomical rhythms as well as the gestural movement of the figures. Notice how he integrates the forms of the limbs with the torso at the pelvis and shoulder girdles. This drawing probably was not done from models, but was a compositional sketch conjured in the artist's mind. It suggests both a fluidity of thought and the solidity of the body, which were possible only because of the artist's knowledge of the human form as an integrated anatomical structure.

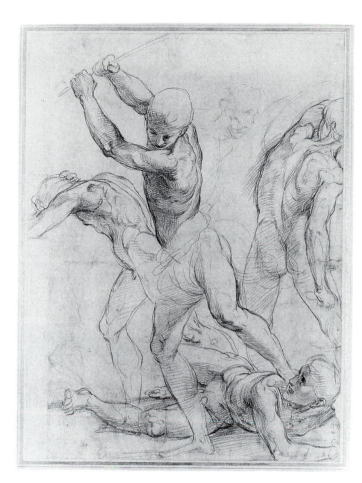

**6.29**
Raphael. *Combat of Nude Men.*
Red chalk, 14 13/16 x 11 1/8".
Ashmolean Museum, Oxford, England.

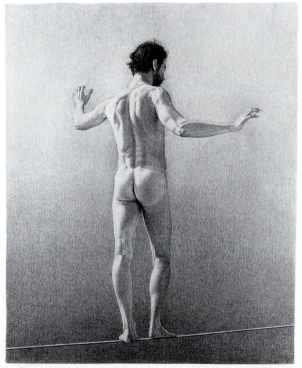

James Valerio's contemporary drawing, *Tightrope Walker*, Figure 6.30, involves a subtle balancing of light and applied anatomy that equals his subject's acrobatics. His realistic description of the muscles becomes an expressive device suggesting the body's flexing and tension, particularly in the back, where the muscles along the spine bunch and pull the arms and shoulders back, causing the vertebral margins of the scapulae to protrude. Also, the tension in the lower back muscles helps to clarify the location of the sacrum and the iliac crest, as well as the sacrospinalis muscles alongside the spinal column. Under the buttocks, the variation in the depth of the gluteal furrow attests to the varying degrees of tension between the supporting leg and the one advancing.

**6.30**
James Valerio. *Tightrope Walker.* 1981.
Pencil on paper, 29 x 24".
Frumkin /Adams Gallery, New York.

## Summary

Knowledge of anatomy can be used to create realistic representations of the figure, but it can also be a means for creative expression. For example, there is more than a description of the realistic appearance of body surfaces or gender in the drawings by Michelangelo and Raphael (Figures 6.31 and 6.32). Both artists used anatomy to express their particular ideals and artistic temperaments. For Michelangelo, the anatomical elements of the body became a means to symbolize strength and power, ennobling the body and exalting the spirit as well. In comparison, Raphael's figure projects a subtler, more sublime presence, conveying a sense of physical as well as divine grace.

Perhaps more than anything else, what separates a work of art from anatomy charts is the fact that the charts only provide information, while for the artist anatomy is an aesthetic characteristic and an expressive element that contributes to the artist's communication of something about the human condition. For example, Bloom's Figure 6.33 is a beautiful drawing of a subject that could be interpreted, in itself, as unsightly, even grotesque. But Bloom converts the woman's countenance into a rich concert of lines. His portrayal of this woman is beautiful for the same reasons that a poem can be beautiful: it is an aesthetic representation executed to be expressive. The twisting, turning, undulating action of the line picks up on the anatomical references of wrinkled skin hanging from a framework of bones. The repetition of line represents a visual equivalent of alliteration or

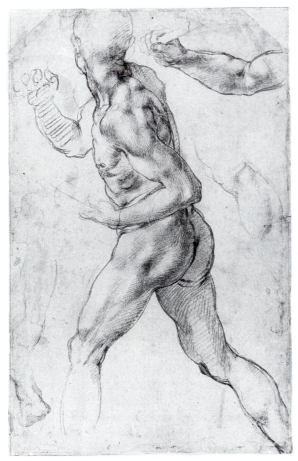

**6.31**
Michelangelo. *Study of a Male Nude Turning Leftward.* Black lead pencil and stylus, 16 1/8 x 10 3/8″ (40.3 x 26 cm). Teyler Museum, Haarlem, the Netherlands.

**6.32**
Raphael. c. 1518. *Nude Kneeling Woman (Study for the Toilet of Psyche).* Red chalk over stylus, 279 x 187 mm. National Galleries of Scotland, Edinburgh.

**6.33**
Hyman Bloom. *Nude Old Woman.* 1913.
Brown crayon, 11 5/16 x 8 15/16″. Collection
of the Grunwald Center for the Graphic Arts,
UCLA. Gift of the Esther Robles Gallery.

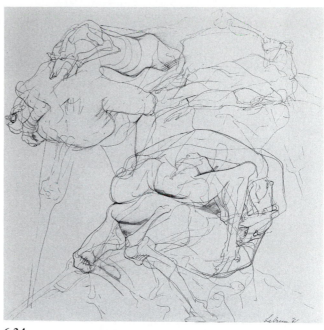

**6.34**
Rico Lebrun. *Three-Peny Novel—Beggars into Dogs.* 1961.
Pen and ink, 37 1/4 x 29 7/8″.
Worcester Art Museum, Worcester, Massachusetts.

rhyme, yet it simultaneously suggests the hesitant, quavering movement of the figure.

In a similar way, Rico Lebrun's drawing, Figure 6.34, uses anatomy of both the human figure and a dog as the point of departure for an equally rich improvisation with line. As with the Bloom drawing, Lebrun's description of anatomy is more energetic than realistic. His expressive, calligraphic lines compel us forward, deep into the drawing, impelling us to join the chase.

"Anatomy for art's sake" would be a fitting credo for this section of the text. As Leonardo's words at the beginning of this chapter suggest, the artist who lacks a thorough understanding of anatomy might as well concentrate on drawing inanimate objects, for that is how figures drawn in ignorance of anatomy often appear. Conversely, knowledge of the human form liberates artists to be expressive, confident that their drawings from life will be authoritative and enlivened.

## In the Studio

### Quick Sketch of the Skeleton

**Pose** - 5 minutes; using a real skeleton, if available
**Media** - Conté, charcoal, or graphite on newsprint,
    18″ x 24″

If an articulated skeleton is available, one of the best ways to begin a study of human anatomy is to use it as your model for quick gesture-type drawings. At first, the complexity of the skeleton is mind-boggling, often intimidating the student into losing track of the larger relationships in the midst of all the overwhelming detail. With quick sketches, attention is focused on the larger shapes and relationships, and soon the student can feel at

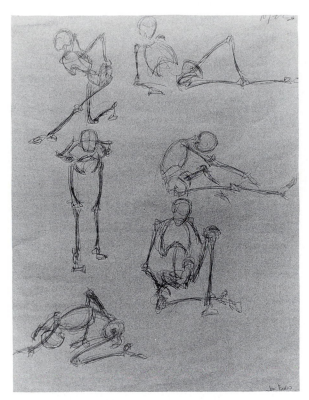

**6.35**
James Bodio. *Student drawing, Orgeon State
University. Gesture sketches of skeleton.* Graphite.

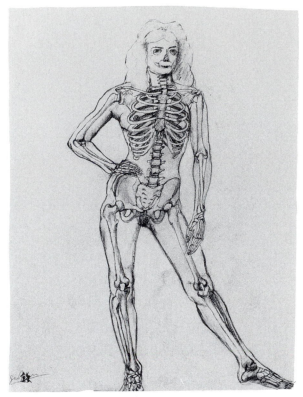

**6.36**
Jin Han Woo. *Student drawing, Oregon State
University. X-ray drawing of figure and skeleton.*
Charcoal and brown conté.

ease with the subject. If possible, do some sketches
with the skeleton off its stand and in a variety of
poses, such as lying down or sitting on a chair
(Figure 6.35).

### Skeleton and Surface Comparisons

**Pose** - 2 hours; standing is best for comparing
diagrams in text
**Media** - Graphite pencil, colored pencil, prisma, or
conté pencil on regular drawing paper,
18″ x 24″ or larger

Draw the configuration of the model's pose
with line, using light contour line to indicate sur-
face anatomy. If a skeleton is available, place it
near the model in approximately the same pose.
After completing the line drawing of the pose,
draw a small circle at the points where bones can
be detected just beneath the skin, as in the knee
caps, shoulders, or hips. Then, using the skeleton

or visual diagrams, draw the position and form of
the skeletal structure as you visualize it beneath
the surface, as if you had x-ray vision (Figure
6.36). You may want to use a different color for
drawing the skeleton. If time permits, repeat this
exercise from back and side views.

### Studying the Anatomy of the Torso

**Pose** - 3 views (30 to 45 minutes each)
**Media** - Graphite or conté pencils on regular drawing
paper, 18″ x 24″

Draw the model from three different views—
front, back, and side, concentrating primarily on
the anatomy of the torso. You may find it helpful
to complete the first Independent Study exercise
prior to drawing from the model, but you may
also refer to the anatomical illustrations in the text
as a way of identifying what you see on the model.
Lightly draw in the larger bones and muscles that

**6.37**
Kathryn Lee Burton. *Student drawing, Oregon State University. Skeleton and figure study.* Charcoal.

lie beneath the surface (as in Figure 6.36 and part of Figure 6.37), noting how their existence affects the outer appearance. Also, keep in mind how the anatomy of the torso differs between male and female figures. You might wish to spend one drawing session studying the male torso and another studying the female. Elements of both the male and female torso have been combined to develop a semiabstract composition in Figure 6.38.

### Independent Study:

1. Using the anatomical illustrations in this text as reference materials, study the interrelationship of the skeleton and the muscles of the torso by doing a layered drawing with different-colored pencils. First draw the skeleton, then the muscles, from front, back, and side views (Figure 6.39). Draw the bones and the muscles with pencils of two different colors. Then draw the muscles of the torso from memory. Check the accuracy of your memory, and make any necessary corrections on your drawing. Repeat this exercise every few days until you can accurately define the musculature of the torso from memory. 2. Identification: Select one of

**6.38**
John Dickinson. *Student drawing, Oregon State University. Torso study, composition with anatomy. Graphite.*

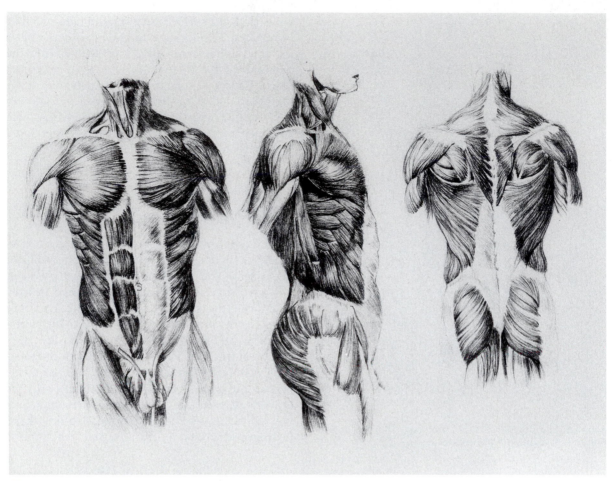

**6.39**
Erick Valdelomar. *Student drawing, Oregon State University.*
*Study of musculature of the torso.* Graphite.

the master anatomical drawings in this chapter (Figure 6.1, 6.3, 6.14, 6.17, or 6.22) and make a tracing that outlines the anatomical forms as presented by the artist. Then, label each form with its name, indicating both muscles and the points at which the skeleton nears the surface. 3. Make a drawing of the upper section of the torso from both front and back, showing how the shoulder girdle is affected by raising the arm. Show one arm raised and the other lowered. Use the text illustrations (Figures 6.20 and 6.21) as references.

Endnotes

[1] Leonardo da Vinci, *Leonardo da Vinci on the Human Body* (New York: Dover, 1983), 13.

[2] Ibid.

# Chapter 7

## Anatomy of the Limbs

It is necessary . . . in order to be able to fashion the limbs correctly in the positions and actions which they can represent in nude, to know the anatomy of the sinews, bones, muscles. . . .

—*Leonardo da Vinci*, Notebooks

Some of the bones and muscles affecting the articulation of the limbs with the torso, introduced in the previous chapter, should now provide a means of integrating the anatomy of the different regions of the body. The muscles that overlap both limbs and torso, tying them together visually and physically, allow tremendous flexibility of movement while maintaining the position of the skeleton at the joints underneath. Rubens's drawing of a powerful Hercules, Figure 7.1, maintains a sense of unlabored movement and energy. Rubens applies his knowledge of anatomy, gleaned from life studies and classical sculpture, without restricting or calcifying his figures. As he once explained, "Living bodies have certain dimples, changing shape at every movement and owing to its flexibility of the skin, now contracted and now expanded."[1]

This chapter will first present the anatomy of the legs and arms and then conclude with the hands and feet, which share structural similarity but are more complex and particularly difficult to draw.

## The Leg

The length and supportive capability of the leg are determined by the three longest bones of the body: the thigh bone *(femur)*, shin bone *(tibia)*, and calf bone *(fibula)*, which can all be seen in the x-ray views of Figures 7.2, 7.3, 7.4 and 7.5. A prominent projection adjacent to the head of the femur is often visible as the bulge of the hip (the *great trochanter of the femur*). This bulge serves as an important landmark on the body, approximately halfway between the heel and the top of the skull of a standing figure. Although the femur itself comes to the surface only at the hip and as protrusions at the knee, its slight bow from hip to knee is echoed in the general form of the thigh. At the knee, the knee cap *(patella)* is clearly visible and forms another important landmark in terms of the body's proportions. Notice in Figures 7.3 and 7.4 how near to the knee's surface are the ends of the leg bones—femur, tibia, and fibula—and how in combination with the patella their form is

**7.1**
Peter Paul Rubens.
*Hercules Over Discord
(Detail)*. Red chalk with
touches of black chalk,
47.5 x 32 cm. Reproduced
by courtesy of the Trustees
of the British Museum,
London, England.

reflected in the outer appearance of the knee. You can trace the patella's triangular shape with your fingers, and when your knee is relaxed, you can feel how loosely the ligaments attach it, holding it afloat above the knee joint. On either side of the patella, you can feel the *medial* and *lateral epicondyles of the femur.*

Just an inch below the patella you can feel a little bump, the *tuberosity of the tibia.* From this point, you can follow the forward edge and flat surface of the tibia down to the inner ankle *(medial malleolus of the tibia).* The outer surface of the tibia is not padded by muscle, which makes this bone easy to see as a long, flat shape running the length of the lower leg. The fibula, which runs parallel to the tibia, is smaller and buried under the muscles of the calf, except for a slight bump at the outside of the knee *(head of the fibula)* and at the outer edge of the ankle *(lateral malleolus of the fibula).*

## FRONT VIEW OF THE LEG AND ITS MUSCULATURE

When viewed from the front, Figure 7.2, the leg reveals several bony landmarks worth noting: the interior ankle (medial malleolus of the tibia), the anterior surface of the tibia, the patella, and the frontal point of the iliac spine on the pelvis, called the *anterior superior iliac spine*. This protrusion of the iliac spine is a point of origin for several large muscles known as the *quadriceps*, which contrib-

ute much to the bulk of the thigh. The *rectus femoris* is the most visible, occupying a central position running from the pelvis to the patella (Figure 7.2, right side). It is flanked by the *vastus lateralis* on the outer side and the *vastus medialis* on the inside, which extends lower, creating the fleshy pad you can feel on the inside of the knee when the leg is extended and tensed. The fourth quadricep, the *vastus intermedius,* is covered entirely by the rectus femoris. The quadriceps, joined by a common ligament called the *quadriceps tendon,* attach to

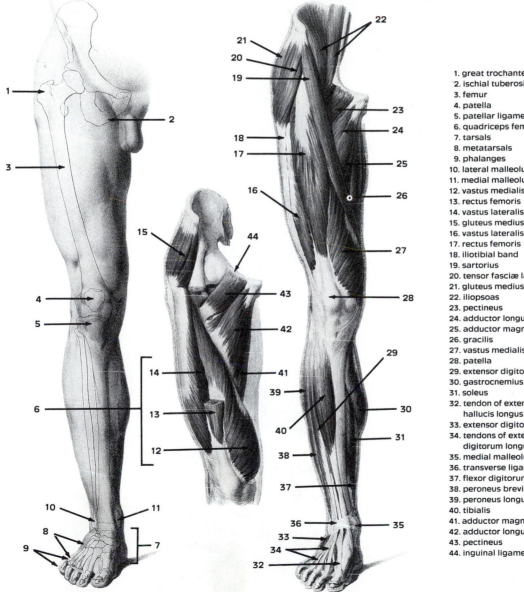

1. great trochanter
2. ischial tuberosity
3. femur
4. patella
5. patellar ligament
6. quadriceps femoris
7. tarsals
8. metatarsals
9. phalanges
10. lateral malleolus
11. medial malleolus
12. vastus medialis
13. rectus femoris
14. vastus lateralis
15. gluteus medius
16. vastus lateralis
17. rectus femoris
18. iliotibial band
19. sartorius
20. tensor fasciæ latæ
21. gluteus medius
22. iliopsoas
23. pectineus
24. adductor longus
25. adductor magnus
26. gracilis
27. vastus medialis
28. patella
29. extensor digitorum longus
30. gastrocnemius
31. soleus
32. tendon of extensor hallucis longus
33. extensor digitorum brevis
34. tendons of extensor digitorum longus
35. medial malleolus of tibia
36. transverse ligament
37. flexor digitorum longus
38. peroneus brevis
39. peroneus longus
40. tibialis
41. adductor magnus
42. adductor longus
43. pectineus
44. inguinal ligament

7.2
M. Leveillé/Dr. Fau. *Diagram of Skeletal and Muscular Structure of the Leg (Anterior View).* Harvard Medical School, Francis A. Countway Medical Library, Boston.

the patella and continue below it in the fibers of the *patellar ligament*. You can grasp the quadriceps tendon above the patella when the leg is straight and tensed; then by bending the knee you can feel the patellar ligament. Several *adductor muscles (iliopsoas, adductor longus,* and *pectineus)* fill the inside of the upper thigh, crossing over from the pelvis at the groin to attach along the femur (Figures 7.2 and 7.4).

Commonly called the "tailor's muscle," the *sartorius* is the longest muscle of the body. Narrow and flat, it originates at the anterior superior iliac spine and moves diagonally from the upper outside of the pelvis down to the inside of the thigh, attaching to the shaft of the tibia below the knee joint (Figures 7.2 and 7.4). The sartorius functions to flex and rotate the thigh. As this strap of a muscle crosses over the thigh from outside to inside, it

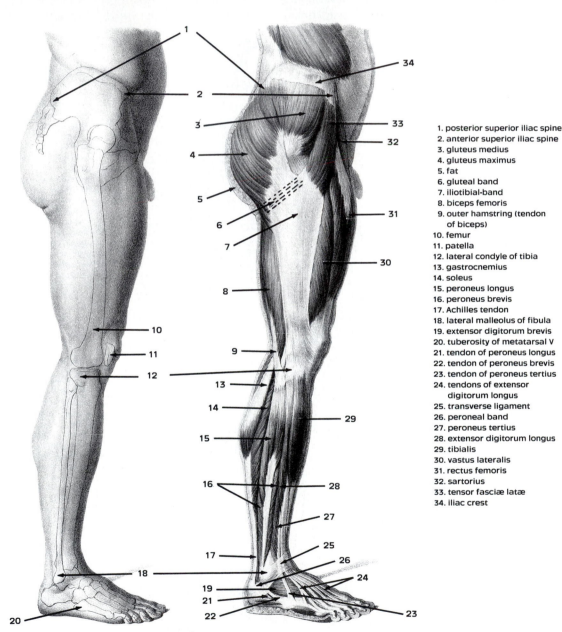

1. posterior superior iliac spine
2. anterior superior iliac spine
3. gluteus medius
4. gluteus maximus
5. fat
6. gluteal band
7. iliotibial-band
8. biceps femoris
9. outer hamstring (tendon of biceps)
10. femur
11. patella
12. lateral condyle of tibia
13. gastrocnemius
14. soleus
15. peroneus longus
16. peroneus brevis
17. Achilles tendon
18. lateral malleolus of fibula
19. extensor digitorum brevis
20. tuberosity of metatarsal V
21. tendon of peroneus longus
22. tendon of peroneus brevis
23. tendon of peroneus tertius
24. tendons of extensor digitorum longus
25. transverse ligament
26. peroneal band
27. peroneus tertius
28. extensor digitorum longus
29. tibialis
30. vastus lateralis
31. rectus femoris
32. sartorius
33. tensor fasciæ latæ
34. iliac crest

**7.3**
M. Leveillé/Dr. Fau. *Diagram of Skeletal and Muscular Structure of the Leg (Outside Lateral View).* Harvard Medical School, Francis A. Countway Medical Library, Boston.

accentuates the diagonal orientation of the front of the thigh from hip to knee. The sartorius skirts the edge of the quadriceps and, along with the vastus medialis, gives added mass and extends the diagonal movement around the inside of the knee from thigh to the lower leg. Adjacent to the sartorius is the tensing muscle *(tensor fasciæ latæ)*. The sartorius and tensor are called the *iliac muscles* because they attach at the iliac crest of the pelvis,

but they are also referred to as the "reins of the knee" because they help to keep the knee joint in alignment.

Leonardo's study of the legs and pelvic region of a nude male shows tremendous definition of several muscle groups, Figure 7.6. First, notice the beginning of the leg region on the torso, marked by the iliac crest of the pelvis, just beneath the flank pad. The first bulge beneath the flank pad on

1. iliopsoas
2. symphysis pubis
3. adductor longus
4. rectus femoris
5. sartorius
6. gracilis
7. vastus medialis
8. patella
9. fat
10. tibialis
11. flexor digitorum longus
12. tendon of tibialis
13. tendon of extensor hallucis longus
14. tendon of flexor digitorum longus
15. Achilles tendon
16. soleus
17. gastrocnemius
18. semitendinosus tendon
19. semimembranosus tendon
20. semimembranosus
21. semitendinosus
22. adductor magnus
23. gluteal furrow
24. fat
25. gluteus maximus
26. calcaneus
27. medial malleolus of tibia
28. tuberosity of tibia
29. fibula
30. medial epicondyle of femur
31. femur
32. anterior superior iliac spine
33. iliac crest
34. lesser trochanter

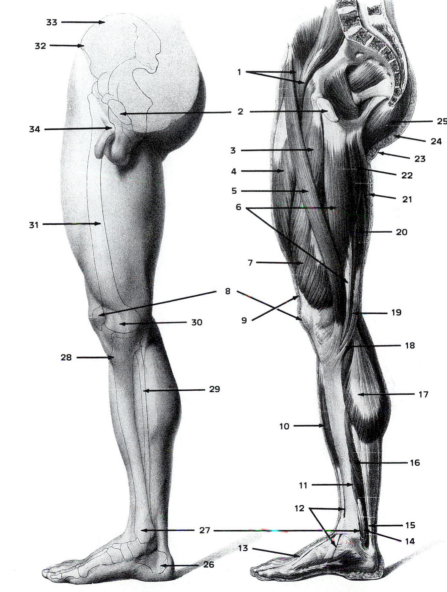

**7.4**
M. Leveillé/Dr. Fau. *Diagram of Skeletal and Muscular Structure of the Leg (Inside Lateral View)*. Harvard Medical School, Francis A. Countway Medical Library, Boston.

the exterior edge of the form represents the gluteus medius. The inverted V form on the front of the thigh consists of the *sartorius* on the inside and the tensor fasciæ latæ on the outside. The large muscular form emerging between the two represents the bulk of the quadriceps: the rectus femoris in the center, the vastus lateralis on the outside, and vastus medialis emerging as a large form above the knee. The muscles on the inside of the sartorius indicate the groin, or *adductor muscles*. The fig-

ure's left leg shows more clearly the path of the sartorius from the pelvis to its attachment at the knee, where the skeletal understructure is revealed.

## LATERAL VIEW OF THE LEG

Notice in the inner profile view, Figure 7.4, how the sartorius follows a curved path from the upper thigh to the back portion of the knee, at-

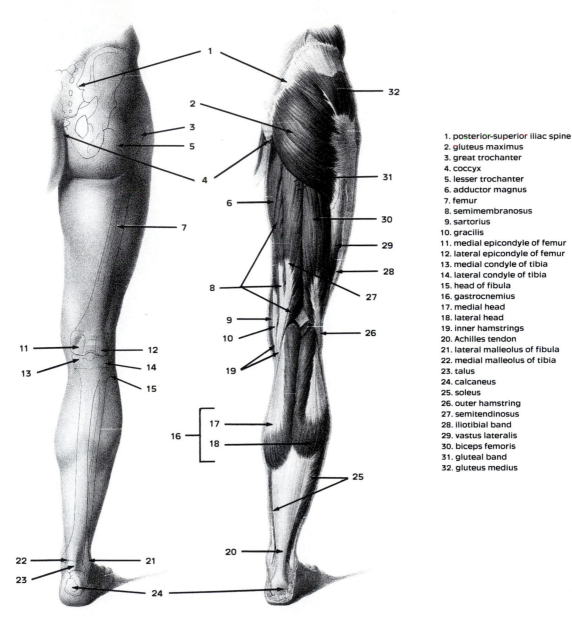

1. posterior-superior iliac spine
2. gluteus maximus
3. great trochanter
4. coccyx
5. lesser trochanter
6. adductor magnus
7. femur
8. semimembranosus
9. sartorius
10. gracilis
11. medial epicondyle of femur
12. lateral epicondyle of femur
13. medial condyle of tibia
14. lateral condyle of tibia
15. head of fibula
16. gastrocnemius
17. medial head
18. lateral head
19. inner hamstrings
20. Achilles tendon
21. lateral malleolus of fibula
22. medial malleolus of tibia
23. talus
24. calcaneus
25. soleus
26. outer hamstring
27. semitendinosus
28. iliotibial band
29. vastus lateralis
30. biceps femoris
31. gluteal band
32. gluteus medius

7.5
M. Leveillé/Dr. Fau. *Diagram of Skeletal and Muscular Structure of the Leg (Posterior View)*. Harvard Medical School, Francis A. Countway Medical Library, Boston.

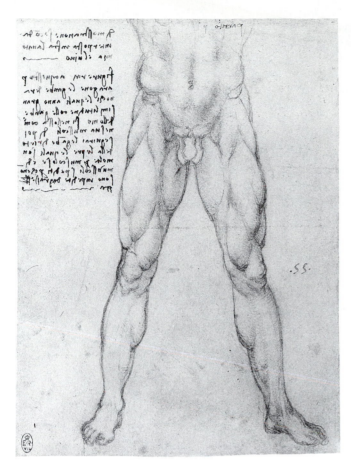

7.6
Leonardo da Vinci. *Study of the Lower Half of a Nude Man Facing Front (Detail).* Black chalk on white paper, 7 1/2 x 5 1/2″ (19 x 13.9 cm). Windsor Castle, Royal Library, Windsor, Berkshire. © 1990 Her Majesty Queen Elizabeth II.

taching together with several other muscles of the inner thigh via thick tendons at the tibia. This linear flow is amplified by the thigh muscles that move from back to front around the knee joint to the tibia. In the x-ray drawing illustrating the position of the bones in reference to the exterior, we can see how their position and shape combine with the muscles and tendons to create the forms of the knee. Also, the general flow of the sartorius and the posterior group of muscles (on the back of the thigh) is completed with attachment at the tibia.

The same view also illustrates an S curvature to the leg. From the contour of the quadriceps on the front, the exterior of the thigh flows in concert with the curve of the femur (Figure 7.4, left side), then through the knee to the back of the large calf muscle *(gastrocnemius),* and on through the *Achilles tendon* to the heel. The muscles of the calf originate on the femur, and their function is to flex the foot. Thus, the visual continuation of the femur curve into an S curve with the lower

leg is grounded in function as well as external appearance.

The outer profile, Figure 7.3, reveals a similar crossing action of the musculature from back to front. Follow the contour line of the gluteus maximus as it wraps around the back of the pelvis to its attachment on the femur, just below the hip (great trochanter), and its continuation in the *iliotibial band.* This strong, flat ligament sheathing joins the gluteus medius (at the side of the hip) and the tensor muscle on the broad face of the upper thigh (tensor fasciæ latæ) and stretches the length of the femur, curving around the knee to attach at the outside upper knob *(lateral condyle)* of the tibia in the lower leg.

### BACK VIEW OF THE LEG

When viewing the leg from behind, Figure 7.5, it is possible to see the full dimensions of the gluteus maximus, from its origin on the sacrum and iliac crest to the femur, where a layer of fat (indi-

cated on Figures 7.3 and 7.4) forms the gluteal furrow. Notice that the large hamstring muscles of the posterior group (the *semimembranosus, semitendinosus,* and *biceps femoris)* all emerge from under the gluteus maximus at their origins on the pelvis and move down alongside the femur to part and attach to the tibia and fibula on either side of the lower leg.

The calf muscles (gastrocnemius) emerge from their origin at the lower end of the femur behind the knee, out of the gap formed by the tendons of the parting hamstring muscles of the thigh. Although the gastrocnemius has three heads, two are

dominant (*medial* and *lateral)* and seen on the posterior surface as bulges that give the lower leg most of its definition. Leonardo's drawing, Figure 7.7, amplifies the underlying musculature of the legs as if his model were a well-trained body builder in the act of flexing his muscles. The gastrocnemius are especially apparent, along with their connection to the Achilles tendon. The vastus lateralis and biceps femoris muscles are well developed, and on the left leg we see a suggestion of the sartorius as it moves to the back of the knee from the front. In many ways, Leonardo's drawing clarifies the anatomical construct of the legs by index-

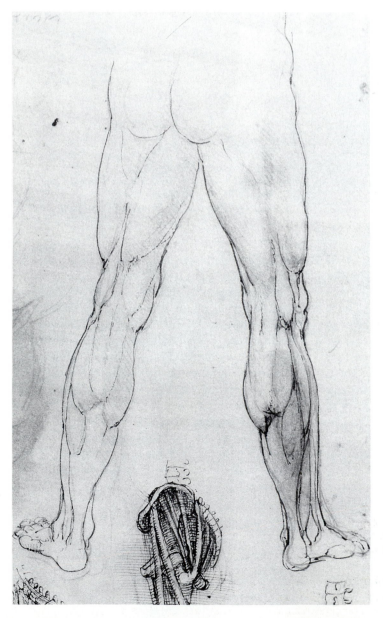

7.7
Leonardo da Vinci. *Study of the Lower Half of a Nude Man (Back View) (Detail).* Black chalk, gone over with pen and ink, 7 1/2 x 5 1/2″ (26.5 x 18.6 cm). Windsor Castle, Royal Library, Windsor, Berkshire. © 1990 Her Majesty Queen Elizabeth II.

ing, with his use of line, the essential relationships that influence the external form.

## THE BENT LEG

Four main points of articulation control the movement and alter the shape of the lower limbs: the hip, knee, ankle, and ball of the foot. Figures 7.8 and 7.9 illustrate how the form and musculature of the leg would be arranged if the leg were bent with all four joints flexed. In the exterior pro-

file (Figure 7.8), take note of how the subtle bow of the thigh bone is accentuated by the muscles on the outside upper edge and how the bones of the leg relate to one another in length. The great trochanter of the hip rests almost directly above the ankle. The gluteal furrow on the underside of the buttock is stretched out and no longer visible. Note also that at the knee, the bones of the lower leg pivot around to the back of the bulbous knob of the femur *(lateral epicondyle)*, and the position

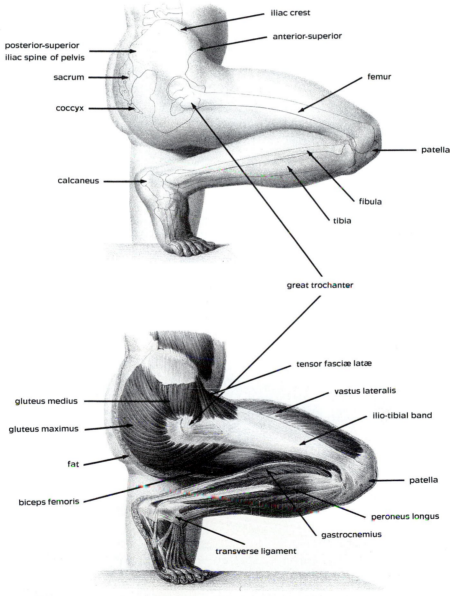

7.8
M. Leveillé/Dr. Fau. *Diagram of Bent Leg (Outside Lateral View)*.
Harvard Medical School, Francis A. Countway Medical Library, Boston.

of the patella shifts from directly parallel to the femur (Figure 7.3, left side) to perpendicular (Figure 7.8, top).

The inner profile, Figure 7.9, reveals the sartorius as it pulls diagonally across the main flow of the thigh mass to attach at the tibia. Just above, you can see the large swelling of the vastus medialis over the interior side of the knee. Near the trunk, along the inguinal ligament, a hollow pocket forms in the region of the adductor mus-

cles, where the usually indistinguishable muscles and ligaments become more pronounced under the sartorius. Also, in this position the calf muscle contracts, projecting noticeably over the shaft of the tibia.

Michelangelo's study of the interior lateral view of a bent leg, Figure 7.10, describes the crossing action of the sartorius and the hollows formed (drawn in shadows) at either side of the sartorius on the upper thigh. The faint shadows at the knee

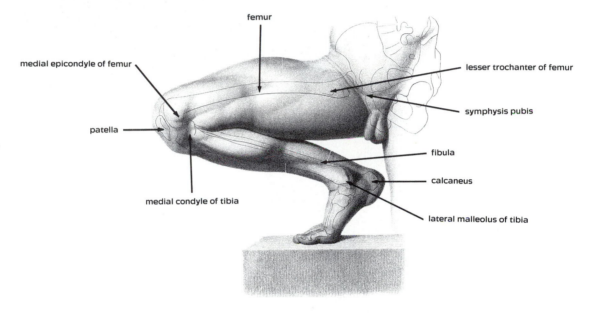

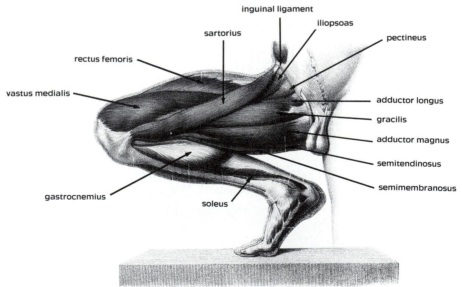

7.9
M. Leveillé/Dr. Fau. *Diagram of Bent Leg
(Inside Lateral View)*. Harvard Medical School,
Francis A. Countway Medical Library, Boston.

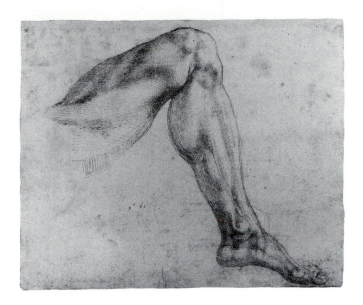

**7.10**
Michelangelo. *Study for Left Leg of Day.*
Black chalk, 16 1/8 x 8 1/8″. Teyler Museum,
Haarlem, the Netherlands.

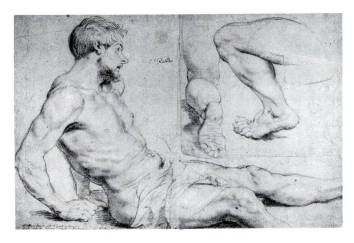

**7.11**
Peter Paul Rubens.
*Studies for three figures
in the miracles of St. Francis Xavier.*
Black chalk, 8 3/16 x 11 11/16″.
Victoria & Albert Museum, London.

hint at the skeletal obtrusions underneath: the medial epicondyle of the femur, the patella, the tuberosity of the tibia, and head and the lateral malleolus of the fibula. The drawing also shows the contraction of the calf muscle (gastrocnemius) as the figure applies pressure on the toes, raising the knee. The vertical lines at the front of the lower leg indicate the flat surface of the tibia and the *soleus muscle*, which appears slightly flexed between the tibia and the Achilles tendon. The ankle bone *(medial condyle of the tibia)* is also apparent.

The leg study in Rubens's drawing, Figure 7.11, showing a similar position of the leg from the outside lateral view, emphasizes the *peroneus longus,* which wraps from the side of the lower leg to attach behind the lateral malleolus of the fibula. You can also see the slight bulge of the soleus between

the peroneus longus and the gastrocnemius. At the knee, the bony understructure lies just beneath the skin. The kneeling leg, viewed from the back, shows the cylindrical shape of the calf muscles.

## The Arm

Leonardo's studies of the skeleton and musculature of the arm, Figures 7.12 and 7.13, include the shoulder girdle, which suggests that this part of the torso is as important to the form and function of the arm as the pelvic girdle is to the lower limbs. Here, Leonardo has also noted how a few of the smaller muscles attach to the bones and how the alignment of the bones of the forearm changes when the hand is turned (Figure 7.13, middle drawings). Figure 7.12 includes several layers of

muscle and ligament, showing the meticulous detail with which Leonardo documented his fascination with the human form.

When considered as a skeletal unit separate from the trunk, the arm begins where the bone of the upper arm (humerus) fits into the shoulder socket (Figures 7.14, 7.15, and 7.16). In addition to the humerus in the upper arm, the two bones of the forearm, the *ulna* and the *radius*, provide the armature and determine the proportion of the arm

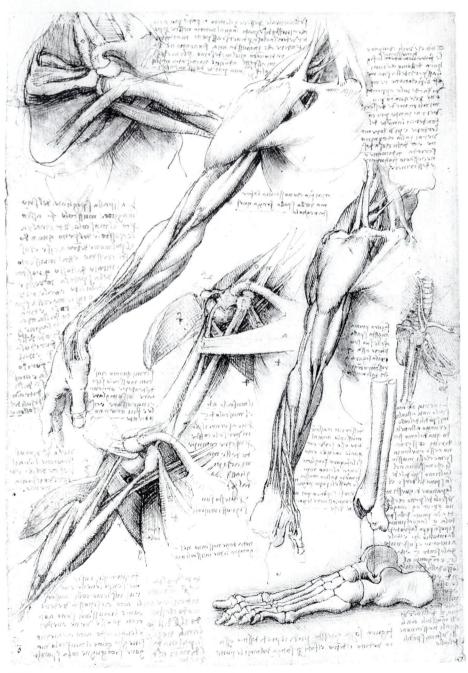

**7.12**
Leonardo da Vinci. *Study of Arms.* Windsor Castle, Royal Library, Windsor, Berkshire. © 1990 Her Majesty Queen Elizabeth II.

from shoulder to wrist. The hand, with all its anatomical complexity and gestural diversity, will be dealt with in the latter portion of this chapter.

Key points of reference for the skeleton of the arm include: the outside edge of the shoulder *(acromion process)* just above the joint; the point of the elbow, the *olecranon process of the ulna;* and the far ends of the ulna and radius at the wrist *(styloid process of the ulna* and *radius).* The humerus is quite straight and does not influence the

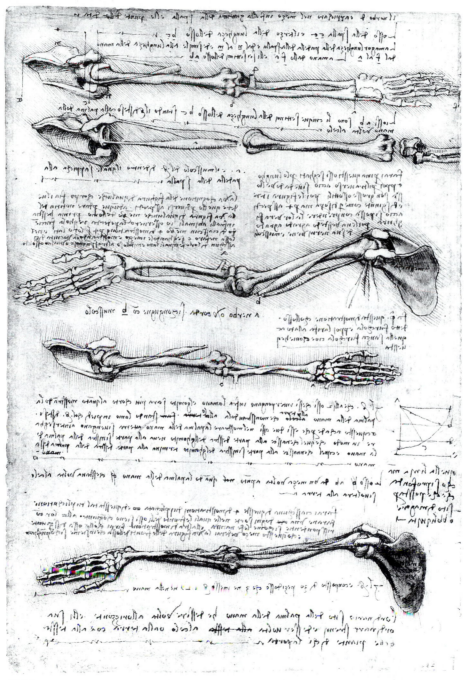

**7.13**
Leonardo da Vinci. *Study of Bones of the Arm.* Windsor Castle, Royal Library, Windsor, Berkshire. © 1990 Her Majesty Queen Elizabeth II.

external form of the upper arm in an overt way except at the elbow, where it widens considerably to create the socket for the olecranon process of the ulna (Figures 7.16 and 7.17). The ulna inserts between two bony protrusions, the *medial* and *lateral epicondyles,* at the end of the humerus to form a hinge-type joint, with the olecranon process being the actual tip of the elbow at the back of the arm. From this tip, you can easily follow the edge of the ulna with your fingers down to your wrist. This edge, known as the *ulnar crest,* forms a direct

line from the tip of the elbow to the head of the ulna, the styloid process, which you can feel as a bony protuberance on the upper outside edge of the wrist.

Due to the unique articulation of the bones at the elbow, the forearm can rotate the hand. Whereas the elbow end of the ulna is locked into position, the radius is free to turn and twist across the ulna, enabling the hand to turn over from a palm-up position, with the ulna and radius in parallel alignment, to a palm-down position, with the

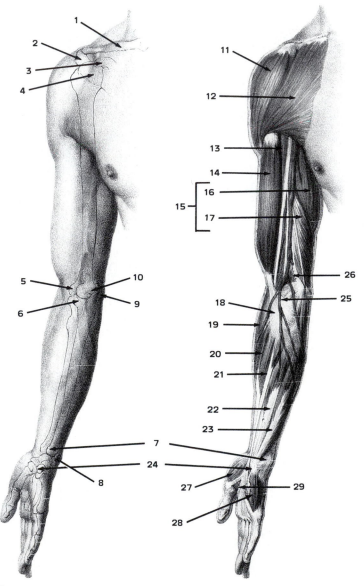

1. clavicle
2. acromion process
3. coracoid process
4. head of humerus
5. lateral epicondyle of humerus
6. coronoid process of ulna
7. head of ulna
8. styloid process of ulna
9. olecranon process of ulna
10. medial epicondyle of humerus
11. deltoid
12. pectoralis major
13. coracobrachialis
14. biceps
15. triceps
16. long head
17. medial head
18. bicipital fascia
19. brachioradialis
20. flexor carpi radialis
21. palmaris
22. flexor digitorum
23. tendon of flexor carpi ulnaris
24. pisiform bone
25. pronator teres
26. intermuscular septum
27. thenar eminence
28. hypothenar eminence
29. palmar aponeurosis

7.14
M. Leveillé/Dr. Fau. *Diagram of the Inner Arm.*
Harvard Medical School, Francis A. Countway Medical Library, Boston.

two bones of the forearm crossing, Figure 7.13. Rotate your hand from palm up to palm down, watching the action of the bones of your forearm, most visible just above the wrist. When the thumb is turned to the inside and down, the overall form of the forearm is modified and reflects the twisting, or crossing action, as seen in the lower portion of Figures 7.14 and 7.15.

The larger muscles of the trunk, linking both physically and functionally to the arm, are the pectorals and the latissimus dorsi, which form the armpit (axilla) and control the movement of the arm when it moves down or across the chest, as with swimming. The large shoulder muscle *(deltoid)* covers the shoulder socket, joining the shoulder to the arm and controlling the arm's vertical movement (Figures 7.16 and 7.17). Named for its resemblance to the Greek letter *delta*, the deltoid's shape can best be seen in Figure 7.15. The deltoid covers the insertion of the pectorals where they attach to the humerus, as well as the origin of the large muscles of the upper arm *(biceps* and *tri-*

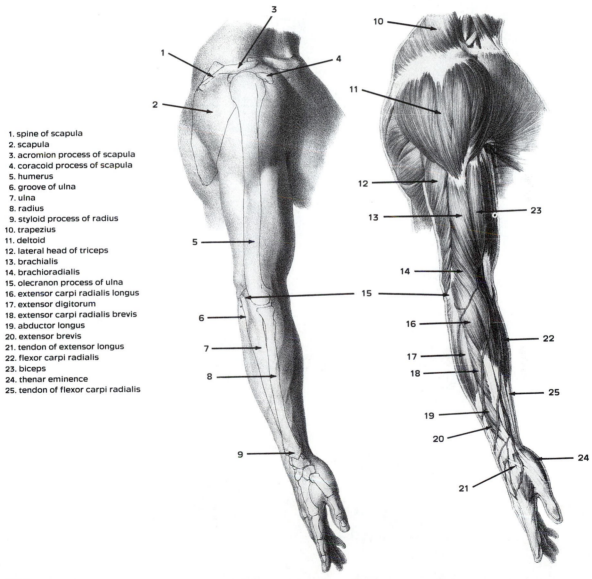

1. spine of scapula
2. scapula
3. acromion process of scapula
4. coracoid process of scapula
5. humerus
6. groove of ulna
7. ulna
8. radius
9. styloid process of radius
10. trapezius
11. deltoid
12. lateral head of triceps
13. brachialis
14. brachioradialis
15. olecranon process of ulna
16. extensor carpi radialis longus
17. extensor digitorum
18. extensor carpi radialis brevis
19. abductor longus
20. extensor brevis
21. tendon of extensor longus
22. flexor carpi radialis
23. biceps
24. thenar eminence
25. tendon of flexor carpi radialis

**7.15**
M. Leveillé/Dr. Fau. *Diagram of the Outer Arm.*
Harvard Medical School, Francis A. Countway Medical Library, Boston.

*ceps)*. Raphael's drawing, Figure 7.18, reveals the shape of the deltoid clearly in the forward figure.

Perhaps no single muscle in the human body is more familiar to us than the biceps. This great flexor is a symbol of power, and it will bend the arm of practically any youth hearing the command, "make a muscle." The biceps is assisted in its function by the *brachialis,* to a great extent covered by the biceps. The smaller brachialis appears in the forward arm in Raphael's Figure 7.18 as a slight bulge between the bent forearm and the more prominent biceps. Both of these muscles cross over the front side of the elbow joint as wide tendon bands to attach themselves to the ulna and radius in between the flexor and extensor muscle groups of the forearm, Figure 7.17. Flex your own biceps and feel the tendon pulling up on your forearm.

On the back of the upper arm is the triceps, an extensor muscle that straightens the arm, as when doing push-ups. As the name implies, this muscle originates with three heads that emerge from

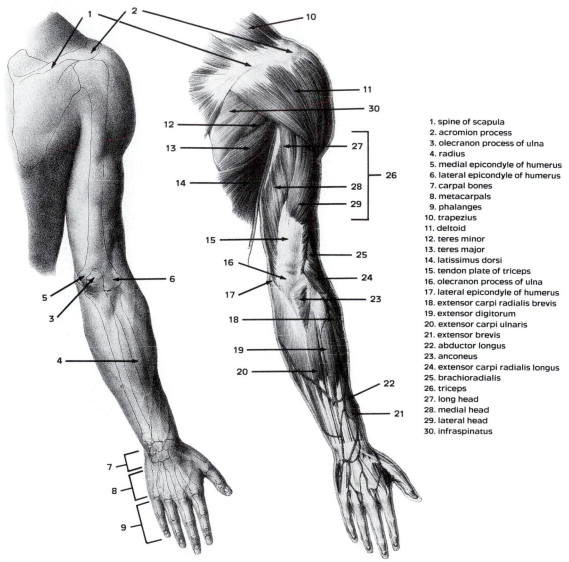

1. spine of scapula
2. acromion process
3. olecranon process of ulna
4. radius
5. medial epicondyle of humerus
6. lateral epicondyle of humerus
7. carpal bones
8. metacarpals
9. phalanges
10. trapezius
11. deltoid
12. teres minor
13. teres major
14. latissimus dorsi
15. tendon plate of triceps
16. olecranon process of ulna
17. lateral epicondyle of humerus
18. extensor carpi radialis brevis
19. extensor digitorum
20. extensor carpi ulnaris
21. extensor brevis
22. abductor longus
23. anconeus
24. extensor carpi radialis longus
25. brachioradialis
26. triceps
27. long head
28. medial head
29. lateral head
30. infraspinatus

**7.16**
M. Leveillé/Dr. Fau. *Diagram of the Arm, Back View.* Harvard Medical School, Francis A. Countway Medical Library, Boston.

under the deltoid midway down the back of the upper arm. The three heads are integrated into broad tendon fibers that cover the lower back side of the humerus to the elbow joint (Figure 7.16). You can feel this tendon section as a flat area on the back of the arm.

The fact that the muscles of the forearm are much thicker near the elbow and then become stringy tendons at the wrist gives the forearm its characteristic tapered appearance. The wrist is primarily an area of tendons and skin and bones,

whereas the upper forearm is fleshy. The two main muscular masses on the forearm are divided by the ulnar crest on the underside and, on the opposite side, by the tendon of the biceps as they go to two separate points of attachment on the humerus (Figures 7.14 to 7.17). Of these two muscle groups, those on the inside or underside nearest the body (called the *flexor group)* are those muscles that bend the hand toward the palm and rotate the wrist palm-side down (primarily, *flexor carpi radialis* and *flexor carpi ulnaris*). The *exten-*

1. acromion process of scapula
2. humerus
3. lateral epicondyle of humerus
4. ulna
5. radius
6. styloid process
7. head of ulna
8. pisiform bone
9. medial epicondyle of humerus
10. coracoid process
11. clavicle
12. pectoralis major
13. brachioradialis
14. pronator teres
15. extensor carpi radialis longus
16. palmaris
17. flexor carpi ulnaris
18. flexor longus
19. flexor digitorum
20. flexor carpi radialis
21. bicipital fascia
22. brachialis
23. triceps (lateral head)
24. biceps
25. short head
26. long head
27. deltoid
28. head of humerus
29. thenar eminence
30. hypothenar eminence

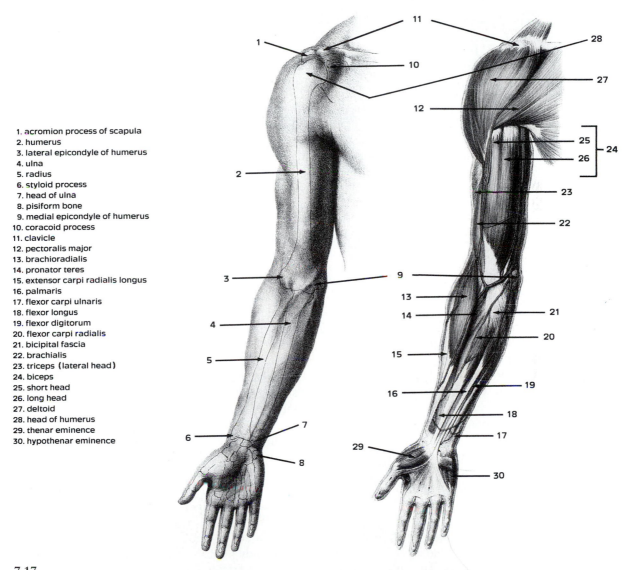

**7.17**
M. Leveillé/Dr. Fau. *Diagram of the Arm, Front View.* Harvard Medical School, Francis A. Countway Medical Library, Boston.

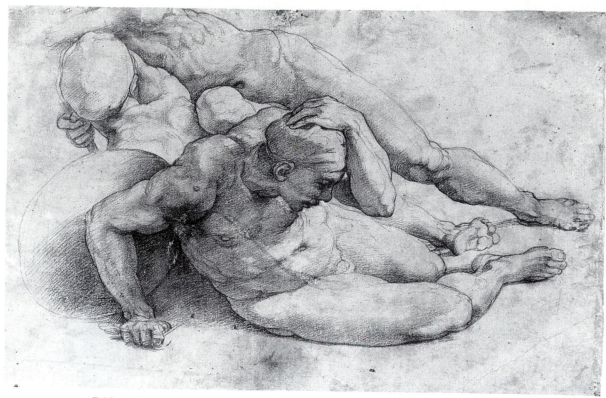

**7.18**
Raphael. *Three Guards*. Black chalk, 234 x 365 mm. Bakewell, Derbyshire.
Courtesy of the Trustees of the Devonshire Collection, Chatsworth. Photograph
courtesy Courtauld Institute of Art.

*sor group* (*brachioradialis* and *extensor carpi radialis longus,* primarily), on the top side of the forearm, extend the hand and rotate the wrist to a palm-up position. Notice in Figure 7.16 that the extensor group of muscles originates a short distance up the shaft of the humerus, and as it moves down over the elbow joint, it wraps over the radius of the forearm, moving down to the back of the hand.

The muscles controlling the flexing action originate at the *medial epicondyle process of the humerus* on the inside of the arm. From there, they extend down to the palm side of the hand. These muscles are relatively short and bulky and create a considerable knot when flexing the hand, as Figure 7.14 shows in the lower right drawing.

Michelangelo's several views of an arm in the same position, Figure 7.19, suggest that this study was for one of his sculptures. The pose is relaxed, but its muscular development expresses its potential for action. We can see the tapering of the fore-

arm from the swelling of muscles that articulate the bony elbow down to the narrow wrist. Several views also show the transition from the upper arm into the shoulder girdle. Notice that Michelangelo's contour lines do not stop the form of the arm at its edge, but instead, they imply its curvature. He also expresses the anatomy beneath the surface without diagramming the outline of each muscle. These qualities are manifest in another of Michelangelo's drawings, Figure 7.20. Notice the location of the ends of the ulna and humerus at the elbow. The indentation midway along the upper arm indicates where the tendon plate of the triceps joins the muscles of the triceps. This drawing also provides another opportunity to see how the movement of the arm affects the position of the scapula and the anatomy of the upper back.

A study by Rubens reveals both the anatomy of the underarm and its connection with the anterior of the torso, Figure 7.21. This drawing is similar to Michelangelo's in the rhythmic quality of its

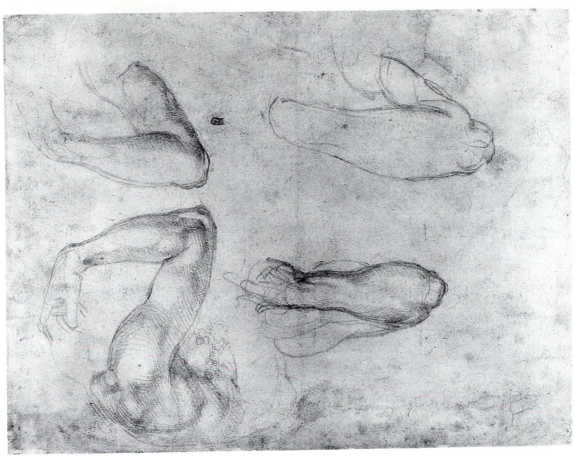

**7.19**
Michelangelo. *Study of Arms & Legs*. c. 1524–27.
Natural red chalk, touches of black, 258 x 332 mm.
Ashmolean Museum, Oxford, England.

line and the purposeful application of value,
which, in this case, seems to both model the anatomy and suggest its illumination.

In cross section, the muscles of the upper arm
lie primarily on the front and back of the humerus
and on the sides of the forearm. The opposing orientation of these muscles gives the cross section of
the arm an oblong shape and allows for the muscle
groups of the upper and lower arm to dovetail
where they cross the elbow joint. Figure 7.22 presents a schematic sketch of the interlocking dovetail pattern of the muscle groups at the shoulder
and the elbow. It also shows how the rotation of

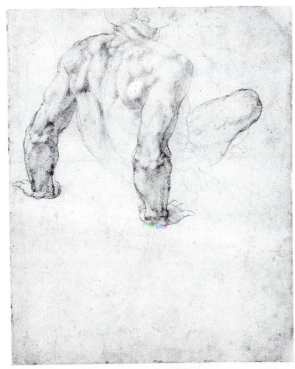

**7.20**
Michelangelo. *Study for One of the Resurrected
of the Last Judgment*.
Black and white chalk, 11 1/2 x 9 1/4".
Reproduced by courtesy of
the Trustees of the British Museum, London.

the hand crosses the radius and the ulna and thereby changes the parallel construction of the forearm into a twisting form.

## Hands and Feet

Hands and feet present particularly difficult challenges for the artist. They are complex, made up of many small bones and numerous joints, which allow freedom of movement and permit them to assume an ever-changing variety of postures. It may seem impossible to generalize about their form and proportion in such a way that would be consistently relevant and applicable from one drawing to the next. Some aspects of hands and feet do remain constant, however, and when understood, the problems of drawing these mutable appendages can become a welcome challenge.

### THE HANDS

Hands are as individualistic as faces, and in many ways reflect an individual's general character as well as express a momentary gesture. Compare the lifestyle suggested by the genteel hands so delicately playing an instrument in Figure 7.23 with the gnarly, big-knuckled hands of van Gogh's figure for the *Potato Eaters*, Figure 7.24. Without seeing anything more, we understand a great deal about the individuals to whom these hands belong. Yet even though they speak of different worlds, these hands share a common anatomy.

The hand is composed of three regions—wrist, palm, and fingers—defined by the skeleton, Figure 7.25. The smallest portion is the wrist, the joint that connects the forearm to the hand, which consists of a cluster of eight small bones *(carpals)* that enable the hand to bend frontward, backward, and from side to side. The large middle section, the palm, is made up of the largest bones of the hand, the five *metacarpals*. The palm is also the only region of the hand where one finds muscles, as opposed to the tendons and ligaments that stretch into the other regions. The four metacarpals connected to the fingers are linked horizontally by tendinous junctures, which greatly inhibit their movement. The fifth metacarpal, that of the thumb, is unrestricted and can move independently. The third region of the hand comprises the

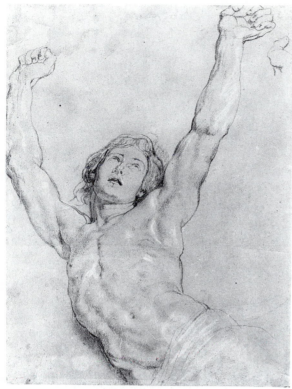

**7.21**
Peter Paul Rubens. *A Study for the Figure of Christ*. 1609/10. Black chalk heightened with white, 15 3/4 x 11 3/4" (400 x 298 mm). Courtesy of the Fogg Art Museum, Harvard University, Cambridge, Massachusetts. Gift of Meta and Paul J. Sachs.

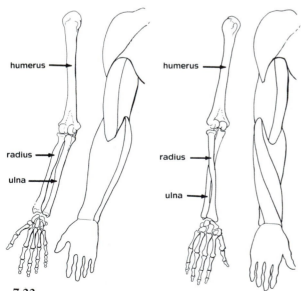

**7.22**
*Planar Analysis of the Arm; Radius straight and turned.*

**7.23**
Hyacinthe Rigaud. 1735.
San Francisco Museum of Fine
Arts, San Francisco.

**7.24**
Vincent van Gogh. *Study of
three hands.* 1885. Black crayon,
8 x 13″. Stedelijk Museum.
Vincent van Gogh Foundation/
National Museum Vincent van Gogh,
Amsterdam, the Netherlands.

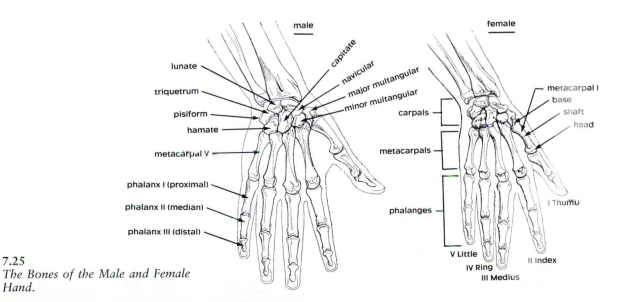

male

lunate
triquetrum
pisiform
hamate

metacarpal V

phalanx I (proximal)
phalanx II (median)
phalanx III (distal)

capitate
navicular
major multangular
minor multangular

female

carpals

metacarpals

phalanges

metacarpal I
base
shaft
head

I Thumb

V Little
IV Ring
III Medius

II Index

**7.25**
*The Bones of the Male and Female
Hand.*

five moving digits: the fingers, which have three *phalange* bone sections, and the thumb, which has only two phalanges.

Although many exceptions exist to disprove such generalities, the female hand is comparatively smaller in proportion, both in length and dimension, than the male's (Figure 7.25). Notice that the metacarpals and phalanges of the fingers are longer in proportion to their width, making the form of the female hand, in general, narrower and more tapered than the male's.

In Picasso's drawing, Figure 7.26, *Mother and Child*, his studies show the mother's hands as thin and elongated; and in the bottom sketch, where the fingers are together, we also see the characteristic taper of a woman's hand. In each hand, we can fully sense the three distinct regions: fingers,

palm, and wrist. Picasso uses a fairly schematic, sketchy style, which, in effect, blocks out the shape of the hand before he softens it through added drawing.

You can see a similar sketching of contours in Leonardo's study of hands for the *Mona Lisa*, Figure 7.27. This is clearest in the middle, unfinished hand and in the pentimento image on the upper hand, where the knuckles were once drawn larger and are now partly covered by hatch lines. Beneath the soft exterior and subdued gesture, Leonardo reveals the solidity of the hand's skeletal structure.

Albrecht Dürer made a number of studies that diagram the proportions of the hand, Figure 7.28. The schematic style of this drawing is similar to what one might find on a shop blueprint as a guide

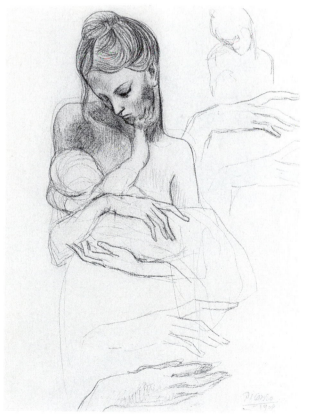

**7.26**
Pablo Picasso. *Mother and Child and Four Studies of Her Right Hand.* 1904. Black crayon on tan wove paper, 338 x 267 mm.
Courtesy of the Fogg Art Museum, Harvard University, Cambridge, Massachusetts.
Bequest of Meta and Paul J. Sachs.

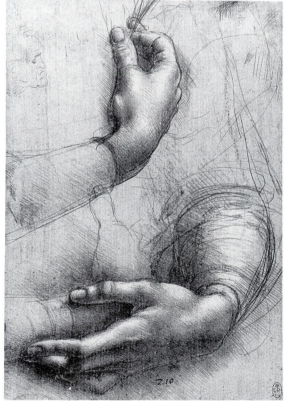

**7.27**
Leonardo da Vinci. *Study of Hands for the Mona Lisa.* Silverpoint heightened with white, 21.5 x 15 cm. Windsor Castle, Royal Library, Windsor, Berkshire.
© 1990 Her Majesty Queen Elizabeth II.

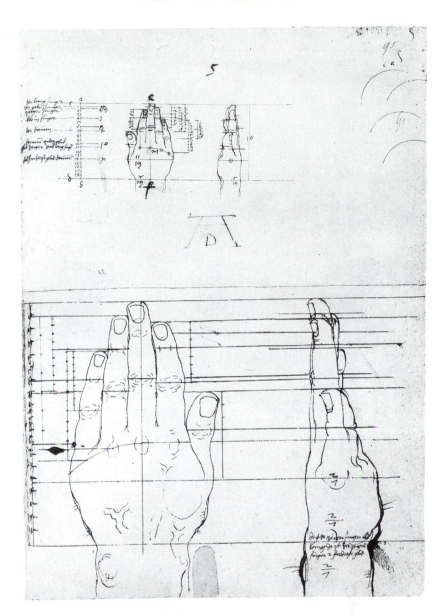

**7.28**
Albrecht Dürer. *Diagram of the Proportions of Hands.* Black ink, 11 1/2 x 8 1/8". Sächsische Landesbibliothek, Dresden, Germany.

for fabrication, which is how Dürer envisioned it used. It attempts to show all the units of measurement that correspond, for the most part, to the positions of the bones. Notice in the small upper drawing that he indicates the position of the first joint of the fingers with small circles and then draws an arch through them. He also indicates that the middle finger relates to the middle of the hand. In his notes, he wrote, "The hand's longest finger equals its width."[2] The middle finger is also the straightest, and its length approximates that of the palm and wrist sections combined.

The muscles that control most of the movement

of the hand do not reside in the hand itself but originate with the upper forearm, and only the tendons of these muscles pass into the hand at the wrist (Figures 7.29 and 7.30). This arrangement gives the hand a great deal of strength without adding excess weight at the arm's extremities. On the inside of the palm are some muscles that assist in moving the fingers and thumb. In Figure 7.30, two groupings make a noteworthy contribution to the form of the hand. The "heel" of the hand *(hypothenar eminence)* helps flex the little finger. The muscles that move the thumb in opposition to the fingers constitute the larger "ball of the thumb"

*(thenar eminence).* In many ways, the thumb and the ball of the thumb form an independent unit, which works in opposition to the rest of the hand and is divided like the two units of a mitten. The palm muscles and a thicker skin pad on the inside of the palm mask the skeletal structure lying underneath. On the back of the hand, Figure 7.29, bones, veins, and tendons are just beneath the skin and, therefore, play a more significant role in determining the form and visual appearance of the hand.

Bone structure also determines the shape of the fingers with the bulging of the knuckle joints *(epi-*

*condyles).* On your own hands, feel down from the fingertip of your index finger to where it widens at the first knuckle joint. The middle phalange tapers to the center then flares again to form the knuckles of the middle joint. The phalange joining to the palm of the hand is thicker but has the bony knobs at either end to accommodate the joints. On the back of the hand, you can still trace the lines of the bones down to the wrist. The most visible features on the back of the hand, however, are the tendons that run from the forearm under the *annular ligament* of the wrist and over each of the metacarpal bones to the fingers. Flex and bend

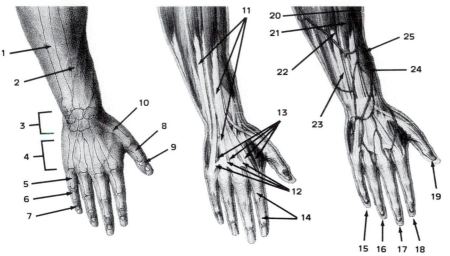

| | |
|---|---|
| 1. ulna | |
| 2. radius | |
| 3. carpals | |
| 4. metacarpals | |
| 5. phalanx I | |
| 6. phalanx II | |
| 7. phalanx III | |
| 8. phalanx I | |
| 9. phalanx II | |
| 10. metacarpal I | |
| 11. extensor tendons | |
| 12. tendinous junctures | |
| 13. dorsal interosseous muscles | |
| 14. joint ligaments | |
| 15. V Little | |
| 16. IV Ring | |
| 17. III Medius | |
| 18. II Index | |
| 19. I Thumb | |
| 20. extensor carpi radialis brevis | |
| 21. extensor digitorum communis | |
| 22. extensor carpi ulnaris | |
| 23. tendon of extensor digiti V proprius | |
| 24. extensor brevis | |
| 25. abductor longus | |

7.29
M. Leveillé/Dr. Fau. *Diagram of Hands, Top View.* Harvard Medical School, Francis A. Countway Medical Library, Boston.

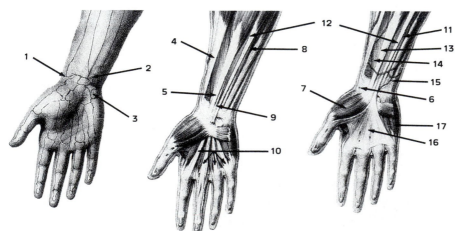

| | |
|---|---|
| 1. styloid process | |
| 2. head of ulna | |
| 3. pisiform bone | |
| 4. tendon of brachioradialis | |
| 5. tendon of flexor carpi radialis | |
| 6. annular ligament of wrist | |
| 7. thenar eminence | |
| 8. flexor digitorum | |
| 9. tendon of palmaris longus | |
| 10. tendons of flexor digitorum | |
| 11. flexor digitorum | |
| 12. palmaris | |
| 13. tendon of flexor carpi radialis | |
| 14. flexor pollicis longus | |
| 15. tendon of flexor carpi ulnaris | |
| 16. palmar fascia | |
| 17. hypothenar eminence | |

7.30
M. Leveillé/Dr. Fau. *Diagram of Hands, Palm View.* Harvard Medical School, Francis A. Countway Medical Library, Boston.

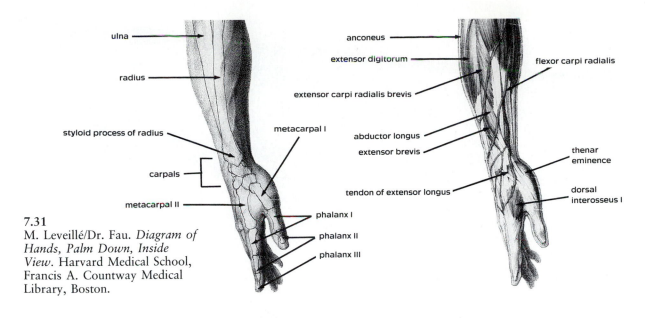

**7.31**
M. Leveillé/Dr. Fau. *Diagram of Hands, Palm Down, Inside View*. Harvard Medical School, Francis A. Countway Medical Library, Boston.

*Labels on figure 7.31 (left hand):* ulna · radius · styloid process of radius · carpals · metacarpal II · metacarpal I · phalanx I · phalanx II · phalanx III

*Labels on figure 7.31 (right hand):* anconeus · extensor digitorum · extensor carpi radialis brevis · abductor longus · extensor brevis · tendon of extensor longus · flexor carpi radialis · thenar eminence · dorsal interosseus I

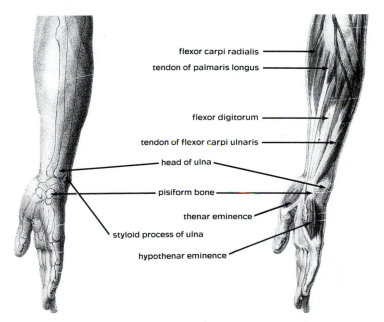

**7.32**
M. Leveillé/Dr. Fau. *Diagram of Hands, Palm Up, Outside View*. Harvard Medical School, Francis A. Countway Medical Library, Boston.

*Labels on figure 7.32:* flexor carpi radialis · tendon of palmaris longus · flexor digitorum · tendon of flexor carpi ulnaris · head of ulna · pisiform bone · thenar eminence · styloid process of ulna · hypothenar eminence

your fingers and watch the play of the tendons on the back of your hand.

Notice in Figures 7.31, 7.32, 7.33, and 7.34, where the hand is seen from the side, how close to the top outer surface the bones are and how much thicker the padding is on the inside. Also, notice how the knuckles in the clenched fist protrude, and how the flexor groups of the hypothenar eminence and the thenar eminence swell out the underside of the palm.

The visual impact of anatomical components is clear in another drawing by Dürer, Figure 7.35. The pair of hands on the left, often reproduced as the praying hands, have become a religious icon, although they were done simply as a study for one of Dürer's paintings. Notice the suggestion of finger bones, the bumps of the knuckles, and a hint of the tendons that run over the metacarpals and the fingers. Notice, too, that there are more wrinkles in the skin at the second knuckle joint than at the

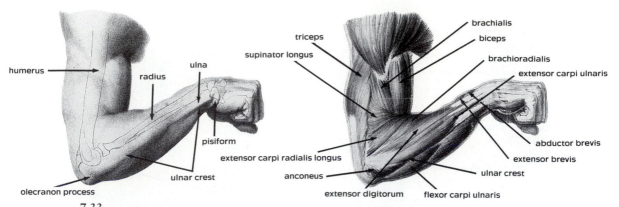

**7.33**
M. Leveillé/Dr. Fau. *Diagram of Arms Flexed, Outside View.*
Harvard Medical School, Francis A. Countway Medical Library,
Boston.

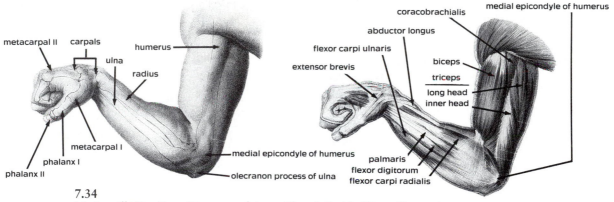

**7.34**
M. Leveillé/Dr. Fau. *Diagram of Arms Flexed, Inside View.* Harvard
Medical School, Francis A. Countway Medical Library, Boston.

**7.35**
Albrecht Dürer. *Study of Hands.* Pen with wash,
238 x 251 mm. Budapest Museum of Fine Arts,
Hungary.

**7.36**
Antoine Watteau. *Studies of Hands and Feet.* Red
and black chalk, heightened with white,
19.6 x 24.5 cm. Metropolitan Museum of Art, New
York. Rogers Fund, 1906 (06.1042.11).

**7.37**
Eleanor Dickinson. *Richard's Hands.* 1964.
Pen and ink, 337 x 260 mm (13 1/4 x 10 1/4").
Stanford Univesity Museum of Art.
Gift of Dr. and Mrs. Louis J. Rattner.

first or third, a characteristic of every hand. With old age, especially, the skin on the back of the hand becomes almost transparent, making the lines of bones, tendons, and veins more visible. (Andrew Wyeth's hands of *Beckie King,* Figure 8.14 in the next chapter, are an example.) The significant role of the skeleton in determining the overall form of the hand is clearly evident in Watteau's several studies, Figure 7.36.

In Figure 7.37, Dickinson uses line exclusively to portray various postures a hand can assume. Her use of line is disciplined, economically describing the complex configurations of the hand. She achieves depth only through overlapping line, "where it wishes to enter or where to die away,"[3] as Matisse once suggested.

George Staempfli's *Althea's Hands,* Figure 7.38, uses value as the primary tool for describing the anatomical form of the hand. To achieve a photographic likeness, Staempfli focuses his attention on the play of light, which he meticulously renders. The four sets of hands are sensitively arranged to allow the viewer to study them from a variety of perspectives and to compare the influence of the skeleton on the back side with the fleshier underside and its palm lines.

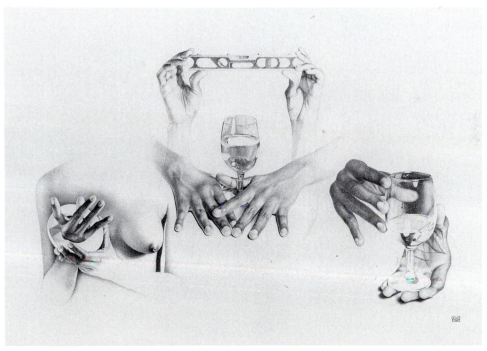

**7.38**
George Staempfli. *Althea's Hands.* 1982.
Pencil, 14 1/2 x 21". Staempfli Gallery, New York.

The Photorealist drawing by Canadian artist Ernest Lindner, Figure 7.39, like Staempfli's, is a form of portraiture. The interlocking arrangement of these hands and feet is composed to convey the posture and attitude of the figure as a whole.

## THE FEET

Drawing feet can also be a challenge, although perhaps not as difficult as drawing hands simply because the toes are shorter than the fingers and the diversity of movement is therefore limited. The foot, like the hand, consists of three parts, again defined by the skeleton, Figure 7.40. The *tarsal* bones comprise the section equivalent to the wrist. This section of the foot articulates with the leg and bears the weight of the whole body. The seven tarsal bones are all bigger than those of the wrist, and the heel bone *(calcaneus)* is the largest of the group. The part of the foot that forms its midsection, lying between the tarsals and the toes, is de-

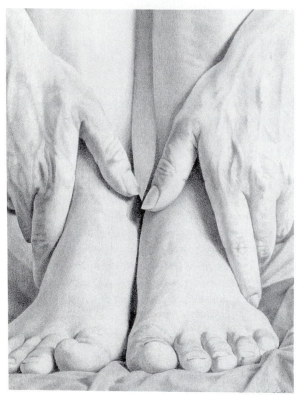

**7.39**
Ernest Lindner. *Resting*. 1975. Pencil, 29 x 21 1/2″ (74.3 x 54.6 cm, sight). Collection of the Norman MacKenzie Art Gallery, Saskatchewan, CANADA, Purchased with the assistance of the Canada Council Special Purchase Assistance Fund.

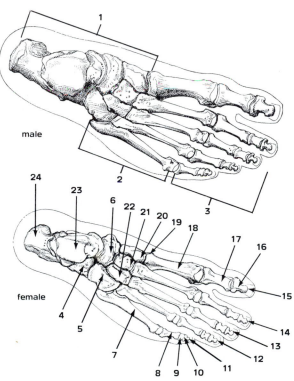

male

female

1. tarsal bones
2. metatarsals
3. phalanges
4. calcaneus
5. cuboid
6. navicular
7. metatarsal V
8. phalanx I (proximal)
9. phalanx II (median)
10. phalanx III (distal)
11. V
12. IV
13. III
14. II
15. I
16. phalanx II (distal)
17. phalanx I (proximal)
18. metatarsal I
19. midpoint of foot
20. cuneiform III
21. cuneiform II
22. cuneiform I
23. talus
24. tubercle of calcaneus
25. phalanx II (distal)
26. phalanx I (proximal)
27. metatarsal I
28. cuneiform I
29. cuneiform II
30. navicular
31. talus
32. calcaneus

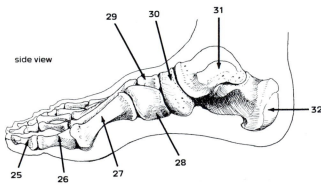

side view

**7.40**
*Diagram of Male and Female Skeletons of the Foot.*

fined by the five *metatarsal* bones. These bones curve slightly and are arranged in an arch that spans from the tips of the heel to the first joint of the toes (Figure 7.40, side view). The toes have three phalanges each, except for the big toe, which, like the thumb, has only two. The configurations of the foot differ from the hand's in the proportions of the bones and in the number of the bones in the tarsal and wrist sections. As with the hand, the bones of the female foot tend to be smaller, and the whole form is proportionately narrower than the foot of the male.

When the foot is in profile, Figures 7.41 and 7.42, you can see how the weight of the body is carried down the bones of the lower leg to the ankle. Here, the weight is transferred to the heel

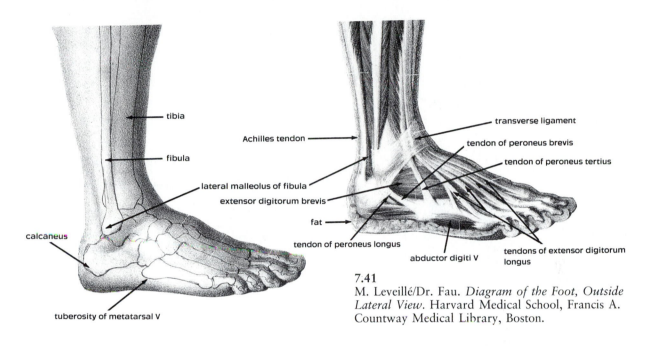

7.41
M. Leveillé/Dr. Fau. *Diagram of the Foot, Outside Lateral View.* Harvard Medical School, Francis A. Countway Medical Library, Boston.

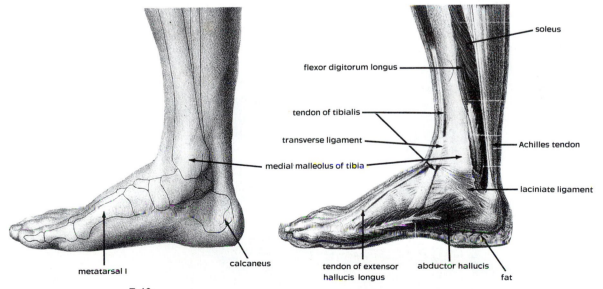

7.42
M. Leveillé/Dr. Fau. *Diagram of the Foot, Inside Lateral View.* Harvard Medical School, Francis A. Countway Medical Library, Boston.

and ball of the foot through the arch formed by the clustering of the tarsals and metatarsals. Notice how, near the surface, the metatarsals and phalanges are on the top of the foot. The bottom of the foot, as with the palm of the hand, contains more muscle and a considerable amount of padding. However, like the hand, most of the muscles that maneuver this appendage are not located on the foot itself but reside in the calf region of the lower leg and are attached to the foot proper with long tendons that pass over the ankle joint. On the top of the foot, these tendons fan out to each of the toes (Figures 7.43 and 7.44). When you flex and extend your toes, you can watch the visual effect of these tendons on the outer form of the top of the foot.

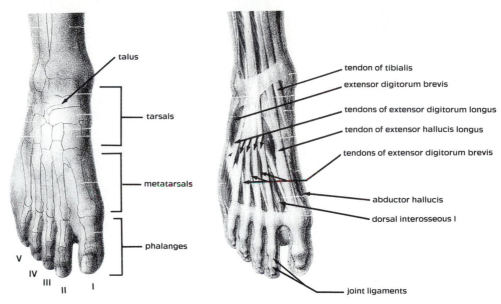

7.43
M. Leveillé/Dr. Fau. *Diagram of the Foot, Top View.* Harvard Medical School, Francis A. Countway Medical Library, Boston.

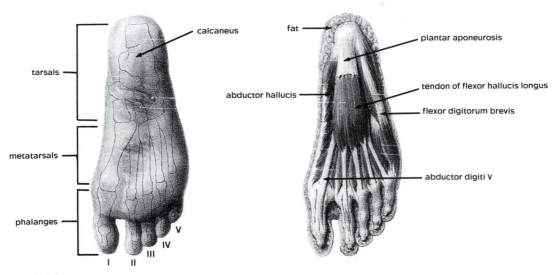

7.44
M. Leveillé/Dr. Fau. *Diagram of the Foot, Sole View.* Harvard Medical School, Francis A. Countway Medical Library, Boston.

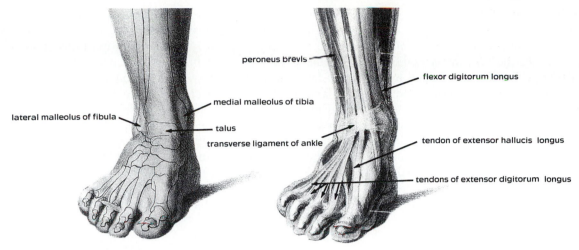

peroneus brevis

flexor digitorum longus

medial malleolus of tibia

lateral malleolus of fibula

talus

transverse ligament of ankle

tendon of extensor hallucis  longus

tendons of extensor digitorum  longus

**7.45**
M. Leveillé/Dr. Fau. *Diagram of the Foot, Front View.* Harvard Medical School, Francis A. Countway Medical Library, Boston.

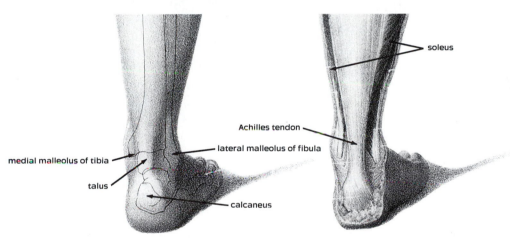

soleus

Achilles tendon

lateral malleolus of fibula

medial malleolus of tibia

talus

calcaneus

**7.46**
M. Leveillé/Dr. Fau. *Diagram of the Foot, Back View.* Harvard Medical School, Francis A. Countway Medical Library, Boston.

In the back, the thick Achilles tendon attaches to the heel (Figures 7.41, 7.42, and 7.45) and has a noticeable effect in defining the form of the back of the foot where it draws the ball of the heel into a teardrop shape. The two ankle bones (the end of the tibia on the inside and the fibula on the outside, slightly lower) are also prominent where they flare out just above the foot itself. The ankles and tendons are tightly wrapped by the *transverse ligament*, which defines the diagonal slant from the inside of the ankle to the outside of the instep, Figures 7.41 and 7.44.

Figures 7.41 and 7.42 emphasize the foot's wedge shape. When we stand, the heel and Achilles tendon form a right angle with the floor, and the instep rises on a diagonal incline to where it is flanked by the ankles. Notice that the outside of the foot in Figure 7.41 remains flat in contact with the floor along its extremity from heel to toe, reflecting the proximity of the metatarsals and phalanges of the little toe to the floor. On the inside, Figure 7.42, where the bones are raised, the line from the ball of the big toe to that of the heel lifts slightly, revealing the arch of the foot.

The muscles of the foot are mostly obscured by tendinous sheathing and layers of fat. A slight bulge on the outside edge of the foot represents the tuberosity of the fifth metatarsal. The sole of the foot (Figure 7.46) is dominated by a layer of fat and substantial fatty deposits, one at the heel and two at the ball of the foot. Each toe pad also includes a deposit of fatty tissue. This essential padding cushions the weight-bearing bones of the feet. For example, when running or squatting, all of the body's weight may be transferred to the forward portion of the foot. The articulation of this action can be seen in Figures 7.47 and 7.48.

The detail from Rubens's drawing, Figure 7.49, of the profile and underside of the foot displays some of the ways the basic proportions of the foot may become modified as it bends to extend and flex. Notice how the additional padding at the ball of the foot extends over much of the length of the underside of the toes, so that only the ends of the toes (toe pads) are visible, whereas they appear much longer in the profile view.

In Dürer's drawing, Figure 7.50, the upper diagram reveals the general wedge-shape of the foot from the side view. From the top view, a progressive stepping back of the toes forms an arch. Dürer

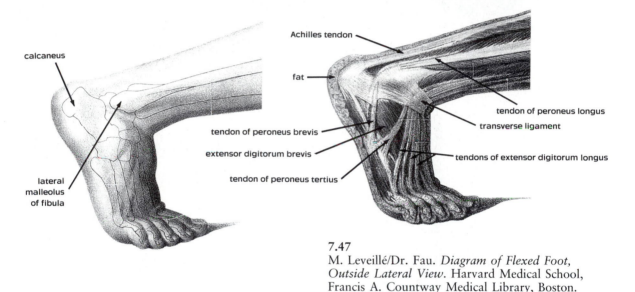

7.47
M. Leveillé/Dr. Fau. *Diagram of Flexed Foot, Outside Lateral View.* Harvard Medical School, Francis A. Countway Medical Library, Boston.

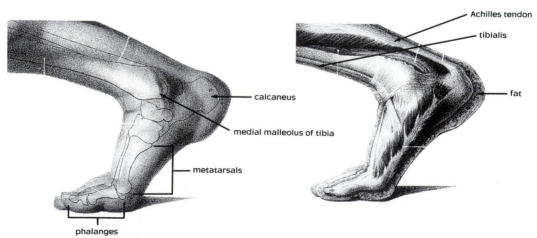

7.48
M. Leveillé/Dr. Fau. *Diagram of Flexed Foot, Inside Lateral View.* Harvard Medical School, Francis A. Countway Medical Library, Boston.

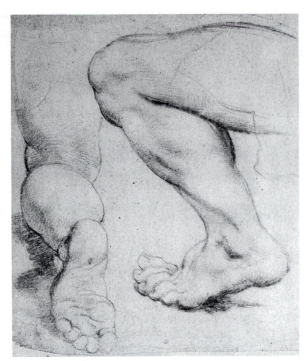

**7.49**
Peter Paul Rubens. *Detail, Nude Man Raising His Body; Study of Lower Leg and Foot.* Black chalk, 8 3/16 x 11 11/16". Victoria and Albert Museum, London.

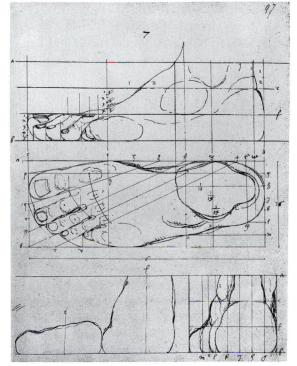

**7.50**
Albrecht Dürer. *Diagram of the Proportions of the Foot.* Sächsische Landesbibliothek, Dresden, Germany.

also provides a back view and two cross sections as part of his analysis. You might wish to see how the proportions of your own foot compare with those in Dürer's drawings by first tracing its outline and, then, drawing its top and profile views with the aid of a mirror.

As with any aspect of drawing the figure, you have to draw the hands and feet often in order to draw them well. Rather than avoiding the challenges they present, face them and include these appendages in all of your quick sketches. Also, make it a point to investigate their proportions and to analyze their structure. Use your own body as a resource, feeling your hands and feet to dis-

cover the bones, the muscular padding, and the tendons. Notice where and how they bend and how their movement brings about changes in their structure and appearance. An understanding of their basic anatomy will help alleviate the mystery and complexity of what you see. Most important of all, make a study of hands and feet through your drawings. Drawings are not just for showing what you already know; they provide a means of gathering new information. When we see masters like Leonardo, Rubens, van Gogh, or Picasso making studies of hands and feet, we must assume that we, too, may need to give them some extra attention.

# In the Studio

### Gesture Study of the Limbs

**Pose** - 1 minute for each study, several on a page
**Media** - Charcoal or conté on newsprint, 18″ x 24″

Fill several pages with gesture drawings of arms and legs, using a continuous line to describe the action and establish the form. As soon as you finish one sketch, begin another, first trying to capture the overall form. Include the hands and feet at the extremities, but concentrate primarily on the larger forms. After you've thoroughly studied the arms and legs, focus your sketches on the hands and, then, the feet, trying to capture the overall gesture of the forms without regard for details.

### Comparing Internal Anatomy with External Form

**Pose** - 1 hour
**Media** - Graphite and colored pencils on regular
drawing paper, 18″ x 24″ or larger

Prior to drawing directly from the model, you may wish to complete some drawing from anatomy plates, as suggested in Independent Study exercise number one (Figure 7.51). Having prior knowledge will facilitate your study of the anatomy of the legs and arms when drawing from the model. Use a graphite or hard charcoal pencil to plot the proportions and contours of the figure and limbs, then use colored pencils or conté to position the bones within the contour lines and to define the muscles. Refer to a skeleton, if available, and to the anatomical illustrations in the text for reference to the location and shape of the anatomical structures that lie beneath the surface of the figure. Vary the poses, studying the visual effects as the limbs are bent (Figure 7.52).

### Planar Analysis of the Limbs, Hands, and Feet

**Pose** - 10 minutes for each study, several on a page
**Media** - Charcoal or conté on newsprint, 18″ x 24″

The purpose here is to use a more analytic approach and a schematic style to define the structure of, first, the arms and legs and, then, the hands and feet. In general, this requires simplifying forms and describing them in terms of their basic geometric shapes. Begin by plotting the over-

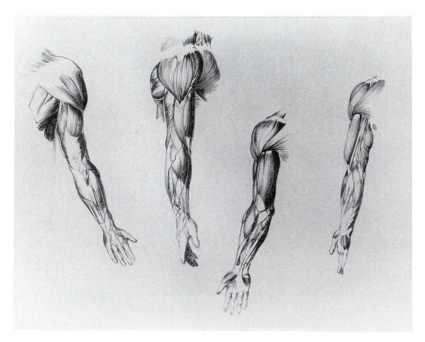

**7.51**
Erick Valdelomar.
*Student drawing,*
*Oregon State University.*
*Studies of the musculature*
*of the arm.* Graphite.

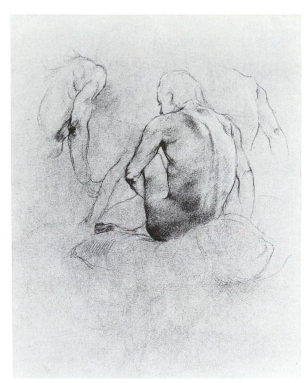

**7.52**
Stefan Pokorny. *Student drawing, Hartford Art School, University of Hartford, Connecticut. Torso and arm studies.* Charcoal.

all shapes, analyzing the angle and proportions of their configuration. Within the configuration, use your line to designate the placement of joints and any breaks in the surface planes. For example, the overall shape of the hand may be described generally as a wedge, with planes fracturing at the knuckles and along the tendinous ridges on the back. The fingers might be seen as elongated rectangles, divided into segments at the knuckles. You can expect to see a shift in value wherever there is a break in the surface plane.

### Line and Value Studies of Hands and Feet

**Pose** - 30 minutes; using either a model or your own hands and feet
**Media** - Graphite or charcoal pencil on drawing paper, 18″ x 24″

Begin with a gestural sketch, drawing the configurations of the hands and feet, as in the left side of Figure 7.53. Allow lines to overlap to suggest spatial position, and lighten cross-contour lines to suggest interior bumps and furrows. Then, use value to define the structure of the forms, indicating variations in the surface and modeling the forms as they recede in space. You will find that if you draw each hand and foot close to its full scale, you will have a much greater feeling for its sculptural qualities.

**7.53**
Cynthia Matthews.
*Student drawing,
Georgia State University.
Cross-contour line
hand studies.* Charcoal.

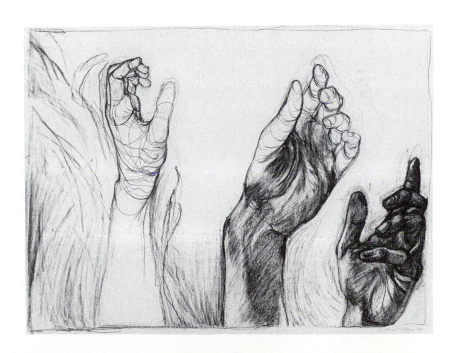

*Independent Study:*

1. Using the anatomy illustrations in this text as models, draw the bones and muscles of the leg and arm from various views until you believe you have committed them to memory. Then, draw the skeleton and muscles of the leg and arm, relying only on your memory. Check your drawing for accuracy and make any necessary corrections. 2. Use both your text and yourself to make a thorough study of the anatomy of the hands and feet, as seen in Figure 7.54. 3. Identification: Select one of the master anatomical drawings in this chapter (Figure 7.1, 7.6, 7.7, 7.8, 7.10, 7.20, or 7.21) and make a tracing that outlines the anatomical forms as presented by the artist. Then, label each form with its name, indicating the muscles and the points at which the skeleton nears the surface.

Endnotes

[1] Peter Paul Rubens, quoted in Robert Goldwater, *Artists on Art* (New York: Pantheon Books, 1945), 148.

[2] Albrecht Dürer, quoted in Walter L. Strauss, ed., *The Human Figure by Albrecht Dürer: The Complete Dresden Sketchbook* (New York: Dover Publications, 1972), 242.

[3] Henri Matisse, quoted in John Elderfield, *The Drawings of Henri Matisse* (London: Thames and Hudson Ltd., 1984), 25.

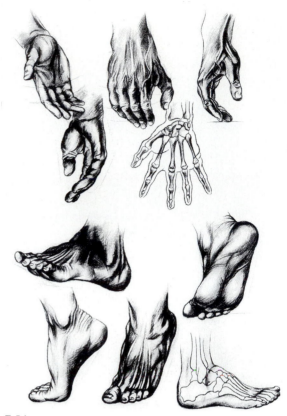

7.54
Christopher D. Forrest. *Student drawing, Oregon State University. Hand and feet studies, with skeleton.* Charcoal.

# Chapter 8

# Heads and Portraits

The character of a face in a drawing depends not upon its various proportions but upon a spiritual light which it reflects . . .

—*Henri Matisse*, Jazz

So much of an individual's personality is reflected through the face that drawing the face is often referred to as a "character study." Matisse's drawing, Figure 8.1, substantiates his statement in that while the facial characteristics are distilled to simple line phrases, the character of the person is reflected in the wry suggestion of a smile and the direct gaze. In China, face reading is known as *siang mien* and has been practiced for centuries. In nineteenth-century Europe, reading facial features was developed into a pseudoscience called *physiognomy*. Portraits are often said to have captured not only the subject's likeness but the essence of the individual's personality. The very word *portrait* comes from the Latin *portrahere,* which means "to draw forth and reveal."

During his lifetime, Michelangelo completed a number of elegantly drawn heads that were not studies for either his sculpture or his paintings, but were conceived as finished works in themselves, created as gifts for his close friends (Figure 8.2). The fictitious subjects of these "presentation drawings," so called because they were presented as gifts, were the heads of ennobled humans, endowed with virtue, strength, and beauty. The characters that Michelangelo portrayed came from his imagination and represented the personification of his ideals. In this regard, they are more a portrait of the artist's lofty aspirations for humankind than they are of any one living individual. The proportions and features of the heads he drew were, like many of his Neoplatonic beliefs, derived from classical antiquity.

In contrast to the immortal figures of Michelangelo, Paula Modersohn-Becker's profile view of a peasant woman, Figure 8.3, comes directly from nature, presenting a harsh depiction of down-to-earth reality. This profile has little resemblance to those classical features of antiquity, yet it captures a radiance and strength in the peasant woman's face. Placing the head in profile allows it to move across the divided background, out of the darkness and into the light, from a bent posture to an upright one. Modersohn-Becker uses nothing more to adorn her subject than the light reflected from her weathered skin.

**8.1**
Henri Matisse. *Tête de femme au collier.* 1950.
Chinese ink on paper, 20 1/2 x 15 3/4″. Lent by
the Donald Morris Gallery Trust, Birmingham,
Michigan/New York. Photo by Dirk Bakker.

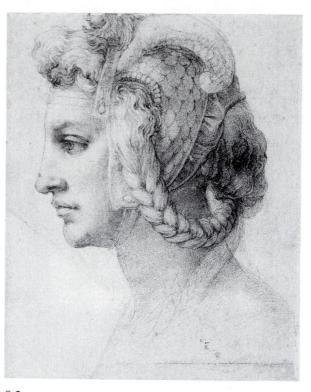

**8.2**
Michelangelo. *Ideal Head of Woman.*
Black chalk, 287 x 235 mm.
Reproduced by courtesy of
the Trustees of the British Museum, London.

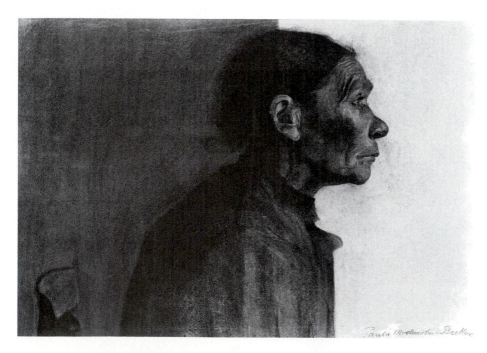

**8.3**
Paula Modersohn-
Becker. *Portrait
of Peasant Woman.*
1900. Charcoal on
buff wove paper,
17 1/2 x 25 1/4″
(43.3 x 63.9 cm).
Gift of the
Donnelley Family,
1978.26 © 1990
The Art Institute of
Chicago. Photo
by eeva-inkeri.

The intent of this chapter is not to offer a specific technique or method with which to draw a head but to present some universal information to establish a basic understanding of its structure—its proportions and anatomy—and how to analyze it from different points of view.

## The Proportions of the Head

As human beings, we all share some common structural features, yet it would be very difficult to distinguish one individual from another if it were not for subtle variations in the proportions of our heads and facial features. As you can see from Albrecht Dürer's study, Figure 8.4, it is possible to construct a head out of just about any variation in its proportions. Dürer's drawing has a gamelike quality as he attempts to fit heads into the prescribed limitations of his graph. He even invites you to participate by leaving one rectangle blank where you can add a profile view of your own. In all of these sketches, Dürer plays with variations in the size, position, and angles of the forehead, nose, mouth, chin, and ear, and with the way they relate to the overall contour of the head.

8.4
Albrecht Dürer.
*Proportion Studies
of the Head.*
Sächsische
Landesbibliothek,
Dresden, Germany.

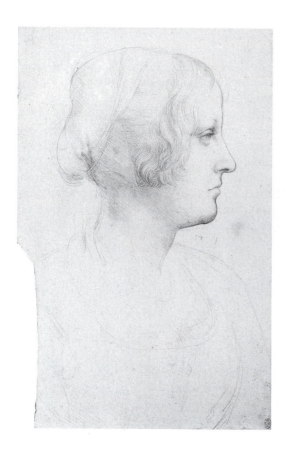

Dürer's drawing begins to suggest the innumerable variations to the facial configurations of humanity, but Leonardo has suggested a universal standard that may serve as a proportional guide when drawing the head. In describing the proportions of the face, Leonardo located the eyes as a midpoint between the chin and the top of the head. "And from the chin to the nostrils is a third part of the face. And the same from the nostrils to the eyebrows, and from the eyebrows to the start of the hair."[1] These are precisely the proportional divisions of the face we find in Leonardo's delicate silverpoint drawing, Figure 8.5.

Figure 8.6 provides a simple schematic of the primary points of reference and proportional divisions that need to be considered when drawing the head from either profile or frontal views. The general proportional relationships presented here conform to those prescribed by Leonardo and suggest how the head and face might be divided into easily

8.5
Leonardo da Vinci. *Study for Isabella D'Este.*
1500. Silverpoint on light brown-toned paper,
30 x 20″ Windsor Castle, Royal Library, Windsor,
Berkshire. © 1990 Her Majesty Queen Elizabeth II.

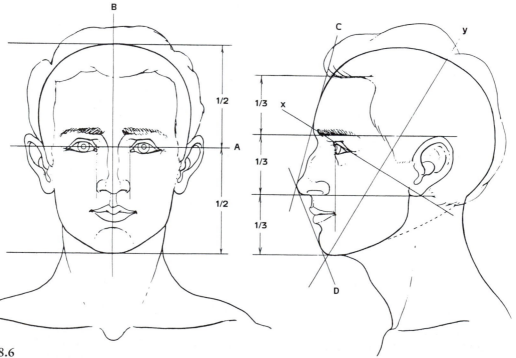

8.6
*Diagram of the proportions of the head, frontal view and profile view.*

remembered and comparable units. First, consider the overall shape or configuration of the head as an oval or an egg with the smaller, more tapered end in the position of the chin. Only after the appropriate location, size, and proportion of the head's contours are established will it be fruitful to draw the particular features of the face. Beginning artists typically exaggerate the size of the facial features and the area they encompass in comparison to the rest of the head. This is probably due to the degree of emphasis the face receives for identifying the individual and the amount of concentration such detailed information requires. The intersecting lines $x$ and $y$ in Figure 8.6 divide the head into quarters, illustrating that, in profile, the features of the face comprise only about one-fourth of the circumference of the head.

FACIAL UNITS: The face can be divided into three units of approximately equal proportion: from the bottom of the chin to the bottom of the nose; from the bottom of the nose to the eyebrow ridge line (this section also aligns itself with the bottom and top of the ear); and from the eyebrow ridge line over the forehead to the hairline. These divisions are helpful in making proportional comparisons but should only be considered as guides, not absolutes. Remember that the eyes are generally located midway between the bottom of the chin and the top of the skull. A common mistake is to place the eyes too high, making the upper portion of the head too small.

PROFILE ANGLE: This angle is created by a straight line drawn adjacent to the forehead and nose (Line C, Figure 8.6) that intersects with another straight line (Line D), drawn adjacent to the chin and the tip of the nose. Observing this angle correctly is critical to obtaining a likeness with a profile view. Look again at Michelangelo's and Modersohn-Becker's drawings in Figures 8.2 and 8.3. Try visualizing the outer egglike shape of these two heads, noticing the relatively small area the face occupies; then, compare the proportions of the three sections of the face and the profile angle of one face with that of the other.

## The Anatomy of the Head

Although the size and shape of individual features vary, the dominant factor in bestowing that universally human form to all heads is the configuration of the skull.

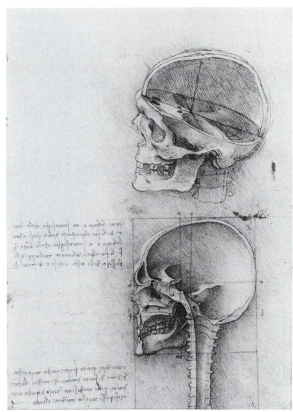

8.7
Leonardo da Vinci.
*Diagrams of cross-sections of the skull.*
Windsor Castle, Royal Library,
Windsor, Berkshire.
© 1990 Her Majesty Queen Elizabeth II.

The *skull* actually consists of twenty-two plate-like bones that are locked into an immovable unit, with the one exception being the lower jawbone (*mandible*). The oval shape of the skull can be divided into two parts, the larger of which houses the brain in a chamber known as the *cranial box,* or *cranium*. The other portion, the *skeleton of the face,* consists of several smaller chambers that contain sensory organs: the eyes, nose, and mouth. In Leonardo's cutaway study of the skull, Figure 8.7, the inner chamber of the cranium and the small orbs of the face are visible. Notice the relative proportions of these two regions here and in Figures 8.8 and 8.9. If you drew an imaginary line on the profile view of the skull, Figure 8.9, from the protuberance of the eyebrow (*superciliary crest*) over the ear canal and back to the base of the skull, it could serve as a line of demarcation between the cranium and the facial region. Again, notice the

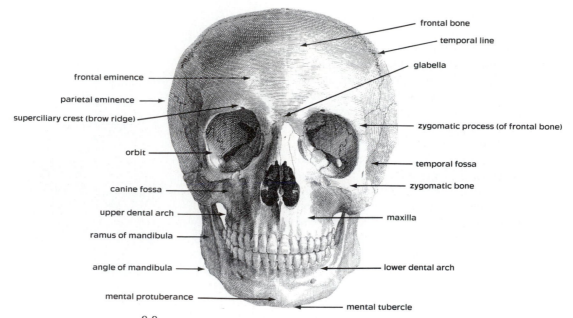

frontal bone
temporal line
glabella
frontal eminence
parietal eminence
superciliary crest (brow ridge)
zygomatic process (of frontal bone)
orbit
temporal fossa
canine fossa
zygomatic bone
upper dental arch
maxilla
ramus of mandibula
angle of mandibula
lower dental arch
mental protuberance
mental tubercle

**8.8**
Albinus. *Skull, front view. Illustration by a student of
Titian.* Harvard Medical School, Francis A. Countway
Medical Library, Boston.

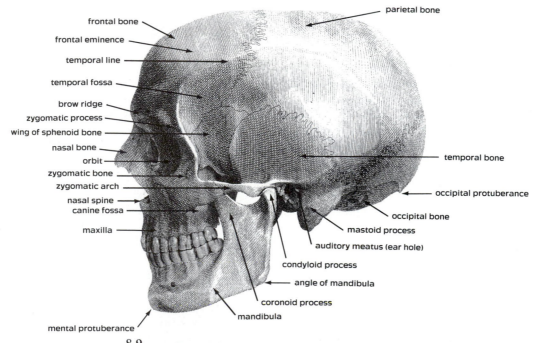

parietal bone
frontal bone
frontal eminence
temporal line
temporal fossa
brow ridge
zygomatic process
wing of sphenoid bone
nasal bone
temporal bone
orbit
zygomatic bone
zygomatic arch
nasal spine
occipital protuberance
canine fossa
occipital bone
maxilla
mastoid process
auditory meatus (ear hole)
condyloid process
angle of mandibula
coronoid process
mandibula
mental protuberance

**8.9**
Albinus. *Skull, side view. Illustration by a student of
Titian.* Harvard Medical School, Francis A. Countway
Medical Library, Boston.

volume of the cranium and its size in comparison to the region of the face.

Although the face is fleshier and, therefore, much more elastic than the cranial portion of the head, its external form and features still depend, for the most part, on its bony understructure. For example, the size and shape of the *orbits*, the hollow eye sockets, will vary with individuals and be reflected in the external appearance around the eye. Notice in Figure 8.8 that the orbits in this skull are slightly oblong, dropping on the outside. This will not always be the case; they might be more circular, or the brow may slant downward toward the nose. Also, some brows project farther than others and some orbits are more deeply set. The cheekbones *(zygomatic bones)*, which help to form the lower rim of the orbits, determine the width of the upper face and sculpt its relief. You can readily trace the contours of the orbitals and cheekbones in your own face. Use your fingers to feel their structure and to confirm the role of these bones in molding the external form of your head.

The prominence of the zygomatic bones, just under the eyes, is determined by the projection of the *zygomatic arch*, which extends the cheekbone like a buttress back to the ear, between the jaw and temple, where it forms a socket for the lower jaw, as in Figure 8.8.

The jawbone (mandible) is equally important in determining the characteristics of the face. Analyze the angle of the mandible below the zygomatic arch and the degree to which the chin *(mental protuberance)* projects in Figure 8.8. Note the mandible's width compared with that of the rest of the head, as seen in Figure 8.9. These lines distinguish what might be described as an individual's square jaw, weak chin, or round face. With your fingers pressing in front of the ear at the edge of the zygomatic arch, lower your jaw and feel the hollow formed as the joint moves forward, and feel how the angle of the jaw changes as the mouth opens.

Although the nose has bone only at its base, and much of its form is determined by an armature of cartilage, the size and angle of bones at its base greatly affect the molded form of the whole nose. This understructure is obvious in the *Head of a Monk*, Figure 8.10, by Spanish artist Francisco de Zurbarán. His strong use of value models the skull's form beneath the monk's habit, creating a somber mood while solidly molding the structure of the skull with its cheekbones and orbital pock-

ets. Zurbarán is also expressing the monastery's sobering credo that life on Earth is temporal.

In a more surrealistic approach, Tchelitchew's *Skull*, Figure 8.11, converts the skull into a snarling symbol of death. Whereas the bony structure of the head in Zurbarán's drawing served as a

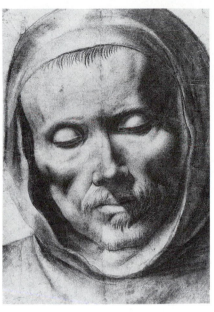

**8.10**
Francesco de Zurbaran. *Head of a Monk.*
Black chalk and gray ink on buff paper, 11 x 7 5/8".
Reproduced by courtesy of
the Trustees of the British Museum, London.

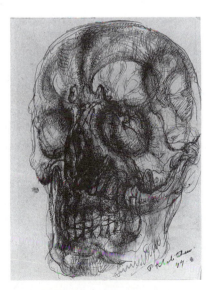

**8.11**
Pavel Tchelitchew. *Skull.* 1944. Pen and ink,
and charcoal on paper, 278 x 215 mm (15 1/8 x 11 3/8").
Santa Barbara Museum of Art.
Gift of Wright S. Ludington.

sanctuary for the monk's introspective spirit, Tchelitchew uses the anatomical features of the skull to create a defiant symbol that externalizes feelings as a grimacing sneer.

## Age and Sex Differences

No matter how methodically one attempts to render facial features such as eyes and lips and noses, the characteristics of a person's age and gender will be lost if an artist ignores the underly-

ing structure of the skull. These will, of course, vary from one individual to the next, but Figure 8.12 suggests some typical changes to anticipate in reference to age and sex differences.

The skull of the child is not only smaller, but the section containing the brain is disproportionately larger than the face. A child's jaw is not fully developed. Babies are born without teeth, and their first set of "milk teeth" are small. The frontal curvature of the forehead is more pronounced on

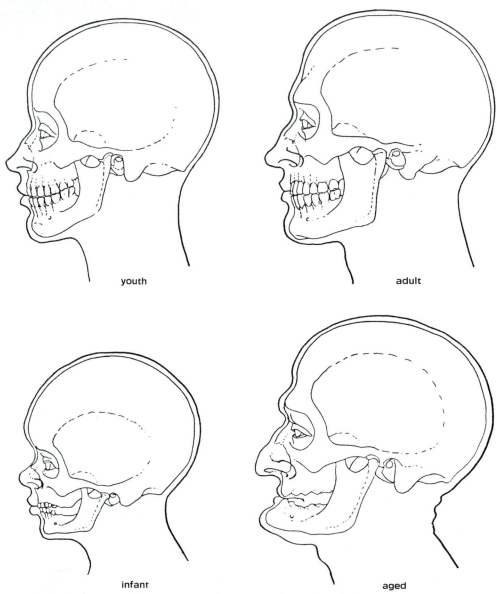

youth

adult

infant

aged

8.12
*Diagram of skulls at various stages of aging.*

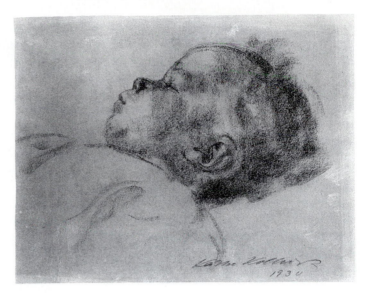

**8.13**
Käthe Kollwitz. *Sleeping Child, Facing Left.*
1930. Black chalk on paper. Galerie
St. Etienne, New York.

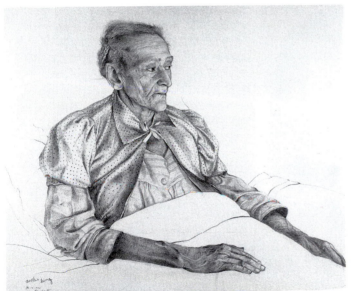

**8.14**
Andrew Wyeth. *Beckie King.* 1946. 30 x 36".
Dallas Museum of Art, Dallas, Texas.

the child's skull, whereas in the adult, the brows become more developed, flattening the forehead. This is particularly true of the male and not as prominent in the female, where the forehead tends to retain more roundness. The size and mass of the female head, as with the rest of the body, may be somewhat smaller. Her jaw line is also more likely to be rounded, not as large and angular as the male's. In addition, nasal bones and cartilage in the female skull may remain smaller compared to the male's. As we grow older, our noses and ears increase in size. In old age, teeth often wear down or are lost, and atrophy of the lower jaw may reduce its mass, causing the chin to become smaller and more forward in its projection. Lips and

cheeks, which are no longer as effectively supported by teeth, become wrinkled, and the cheeks and jawbones become more prominent.

Käthe Kollwitz depicts the characteristic proportions of a child's head with its relatively small facial area and the rounded, protruding forehead in her drawing, Figure 8.13. Wyeth's portrait of *Beckie King,* Figure 8.14, illustrates many of the characteristics typically found in the aged. His eye for details maps out the wrinkled terrain of the skin, the larger nose and ears, and the prominent chin. The tissue of the face hangs across the bony underframe of the skull. In her visage, it is also possible to see traces of the facial muscles, which are seldom discernible in youth.

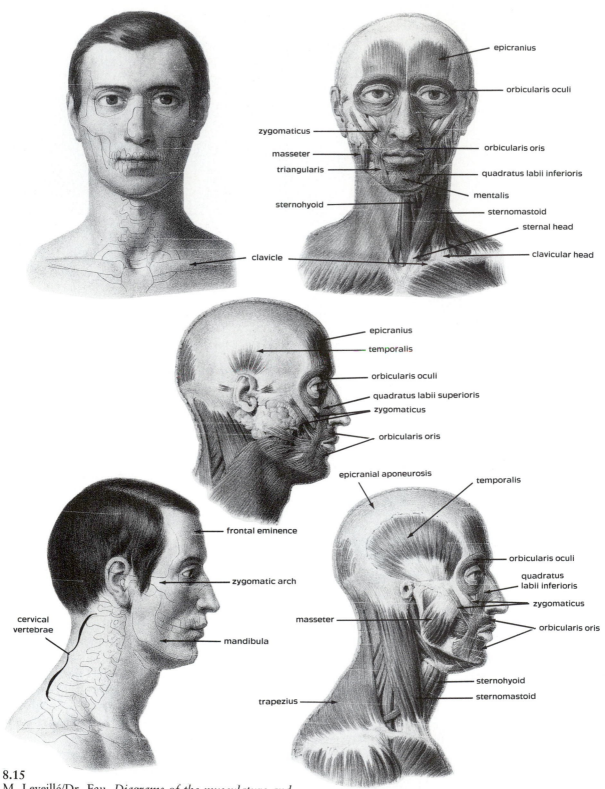

epicranius

orbicularis oculi

zygomaticus

masseter

triangularis

sternohyoid

clavicle

orbicularis oris

quadratus labii inferioris

mentalis

sternomastoid

sternal head

clavicular head

epicranius

temporalis

orbicularis oculi

quadratus labii superioris

zygomaticus

orbicularis oris

epicranial aponeurosis

temporalis

orbicularis oculi

quadratus
labii inferioris

zygomaticus

orbicularis oris

masseter

frontal eminence

zygomatic arch

cervical
vertebrae

mandibula

sternohyoid

sternomastoid

trapezius

**8.15**
M. Leveillé/Dr. Fau. *Diagrams of the musculature and
skeletal structure of the head and neck.* Harvard Medical School,
Francis A. Countway Medical Library, Boston.

## The Muscles of the Head

The musculature of the head is almost exclusively associated with the face, and the function of these muscles primarily involves the opening and closing of the eyes or mouth. However, these are also the muscles of our facial expressiveness. Figure 8.15 maps the muscles of the face and enables us to see how these relate both to the skull's framework and to the external appearance of the head and face. It is only in the face that muscles and fat fill in the skeletal framework and significantly modify the skull's contour. For example, when looking at the head in profile, we see that the hollows above and below the zygomatic arch are filled with two muscles that raise the mandible when closing the mouth. Above, on the temple, lies the temporal muscle *(temporalis)*. Below, the jaw muscle *(masseter)* enables us to chew our food but also knots when we clench our teeth. Watch the play of this muscle in a mirror, and feel it with your fingers as you chew or clench your teeth.

Encircling the eye and mouth are disc-shaped *orbicular muscles,* which close these openings. The *orbicularis oculi* covers the front of the eye, attaching to the skull around the orbital cavity and forming the upper and lower eyelids. The *orbicularis oris* covers the teeth and forms the lips. Several bunches of small muscles radiate from the orbicularis oris and attach it indirectly to the bones of the face. The *zygomaticus minor* and *major,* which are attached to the cheekbone, draw the corner of the mouth upward when we smile. This in turn, bunches up the fatty tissue of the cheek. Likewise, muscles radiating from the mouth to the mandible *(triangularis, quadratus labii inferioris,* and *mentallis)* pull the corner of the mouth down when we are displeased. Similar action occurs around the eyes to change their shape and elevate, lower, or slant the eyebrows. These muscles *(epicranius)* also produce a wrinkled nose and furrowed brow. The thin epicranius muscles stretch over the cranium and draw the scalp backward and forward and raise the eyebrows.

*Study of a Head of an Old Man* by Jean Baptiste Greuze, Figure 8.16, furnishes a close-up examination of how the muscles of the face affect facial expression and surface structure. The muscles at the corner of the mouth are quite noticeable as they move from cheekbone to chin. We can also

8.16
Jean Baptiste Greuze. *Study of Head of an Old Man.* c. 1755. Red chalk, 15 5/8 x 12 5/8" (39.6 x 32 cm). Collection of the J. Paul Getty Museum, Malibu, California.

see how other muscles have wrinkled the nose and brow, which both draw in on the darkened eyes. Value effectively sculpts the surface planes to give us a clear presentation of the old man's facial expression.

The *muscles of expression* can be grouped into four different areas of influence: mouth, nose, eyes, and brow. The expression of emotions is often produced by the subtle and often subconscious use of these muscles. At times, the distinction between one emotion and another is a matter of degree, as between disapproval and anger. At other times, a slight shift or introduction of another muscle group, such as shifting the angle of an eyebrow, will distinguish horror from terror.

## Variations in Orientation of the Head

Drawing the head in profile, where facial features can be taken in as part of the contour, makes analyzing these features relatively easy. A full-face

**8.17**
Hans Holbein the Younger.
*Studies of Heads
and Hands.* c. 1532–43.
Pen and black ink,
charcoal, 132 x 192 mm.
Öffentliche
Kunstsammlung,
Kupferstichkabinett,
Basel.

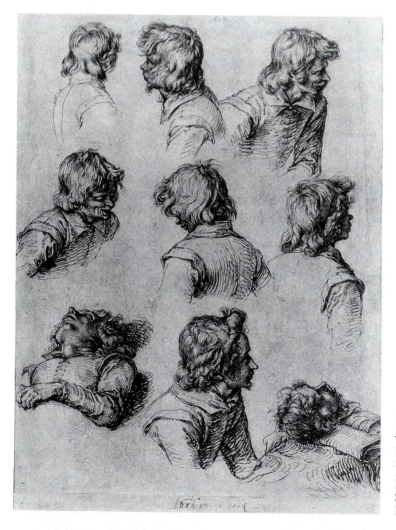

**8.18**
Jacob de Gheyn II. *Study of
Nine Heads.* 1604.
Pen and brown ink, 362 x 260 mm.
Kupferstichkabinett.
Photo by Jörg P. Anders.
Staatliche Museen PreuBischer
Kulturbesitz, Berlin (West).

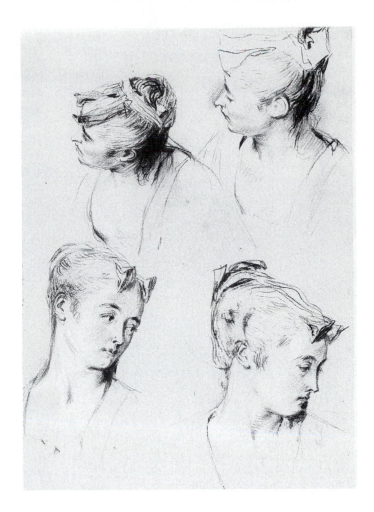

**8.19**
Antoine Watteau. *Four Studies of
the Head of a Young Woman.* Two shades
of red chalk, black and white chalk,
33.1 x 23.8 cm. Reproduced by courtesy of
the Trustees of the British Museum, London.

frontal view is a bit more difficult, but the symmetry of the face and some knowledge of its general proportions can assist the artist in plotting the facial features. Yet, often the head presents itself to us at angles that deviate from either the profile or frontal views. In such situations, drawing the head becomes a more formidable challenge because it loses its symmetry, and the features are often foreshortened. Keep in mind that, although the angle from which we view the head may change, its shape remains elliptical and the same lines of division can serve as points of reference. Correctly plotting the new location of the facial features is the key to success when drawing the head from an unusual angle.

The technique of plotting with elliptical lines the positions of the facial features as the head rotates and tips was known to the artists of the Renaissance and is illustrated in Figure 8.17, from a page in one of Hans Holbein's sketchbooks. After defining the general elliptical shape of the head,

Holbein inscribed the new position of the vertical midline over the nose and defined another elliptical ring indicating either the brow ridge line or the location of the eyes. These crossing lines of longitude and latitude plot the position and proportions of the facial features as the head rotates. It is also helpful to visualize the continuous elliptical path of a horizontal line through the corners of the mouth and another at the base of the nose. This will not only help with their positioning, it will also help to establish the location of the ears and see that the shape of these features follows the contour of the larger three-dimensional volume of the head.

Because the rotation of the head presented a special challenge, many artists found it beneficial to devote some extra time and effort in refining their skills by creating study sheets. Two examples of such head studies can be seen in Figure 8.18 by de Gheyn and Figure 8.19 by Watteau. Although we do not actually see elliptical plot lines running

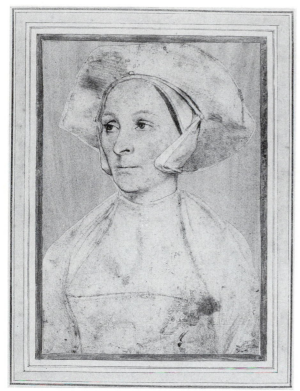

**8.20**
Hans Holbein the Younger. *Portrait of an English Woman.* Black and red chalk, heightened with white, 27.6 x 19.1 cm. Reproduced by courtesy of the Trustees of the British Museum, London.

round these heads, we can be assured that the alignment and proportion of facial features have been consciously considered in reference to the elliptical form of the heads.

In his *Portrait of an English Woman,* Figure 8.20, Holbein demonstrates how he conceptually applied the principle of diagramming heads, which was illustrated in his sketches. Holbein was an impeccable draftsman, able to achieve an almost photographic likeness of his subjects. His skill had as much to do with his cool and methodical analysis of the underlying structure as with his ability to render surface appearances. Notice that the visible portion of this lady's face can be divided horizontally into equal thirds, and that even though her hat conceals part of her head, we can sense its elliptical shape and egglike form. The nonconversant stillness of this woman's pose is typical of Holbein's formal and generally somber portraits and may substantiate, in part, the belief that Hol-

bein often used a mechanical sighting apparatus similar to Dürer's window (Figure 3.15 in Chapter 3) as a drawing aid. In comparison, we sense a more relaxed style and atmosphere in Rubens's *Portrait of Isabella Brant,* Color Plate XII.

An informal portrait sketch in which Rembrandt commemorated his betrothal shows a much higher degree of personal involvement between the artist and his model (Figure 8.21). Rembrandt inscribed on the portrait, "This is drawn after my wife, when she was 21 years old, the third day after our betrothal, the 8th day of June 1633." Rembrandt was full of optimism, and we can feel the warmth in Saskia's eyes as she obligingly sits for her artist, who documents both her beauty and their affection for one another.

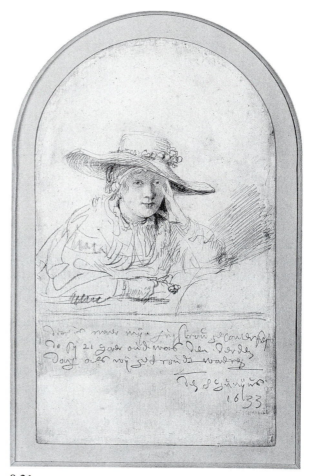

**8.21**
Rembrandt van Rijn. *Portrait of Saskia.* 1633. Silverpoint, 185 x 107 mm. Photo by Jörg P. Anders. Staatliche Museen PreuBischer Kulturbesitz, Berlin (West).

In a very different style and medium, American artist Grant Wood uses a slightly rotated position of the head to add greater significance to his depiction of *The Perfectionist,* Figure 8.22, as she looks down at the viewer from her window perch. The head, placed high in the picture plane, combines with its oblique positioning as an expressive device, a key to the personality of the character Wood portrays.

Joseph Stella places the viewer above his subject of an old man, Figure 8.23, whose head looks up to meet our downward glance. Although nearly the entire figure is included within the composition, this drawing is primarily a portrait of the old man's face. Stella describes a face rich with character that appears to be almost sinking into the heavy, dark overcoat. The face and hands are highly detailed, and the dark form of the coat sets them apart and contributes to the drawing's somber mood and sense of withdrawal.

Looking at Valerio's drawing of a reclining figure, Figure 8.24, we can imagine the elliptical path of the brow line and midline of the face from the forehead over the nose and how their position affects the foreshortening of the features. We can visualize the oval shape of the head, following the

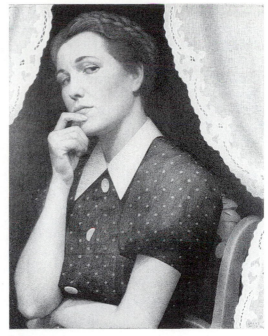

8.22
Grant Wood. *The Perfectionist.* 1936. Ink, crayon, charcoal, and gouache, 520 x 407 mm. The Fine Arts Museums of San Francisco, Achenbach Foundation for Graphic Arts, gift of Mr. and Mrs. John D. Rockefeller 3rd.

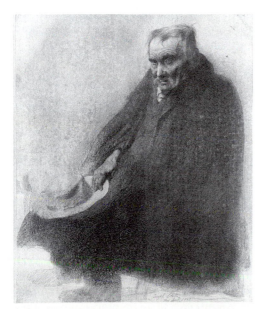

8.23
Joseph Stella. *Portrait of Old Man.* 1908. Graphite and color pencil, 11 3/4 x 9 1/4″. UNL-Howard S. Wilson Memorial Collection, Sheldon Memorial Art Gallery, 1977.U-2512, University of Nebraska-Lincoln.

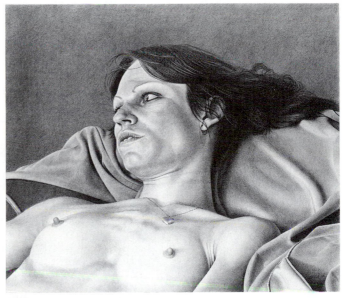

8.24
James Valerio. *Young Woman.* 1984. Pencil, 22 1/2 x 25 1/2″. Frumkin/Adams Gallery, New York.

shadow lines below the jaw, behind the ear, and around the top of the head. As the head lays back on the pillow, we see the underside of the chin and nose, which also have been foreshortened. Value in this drawing becomes a physical force that sculpts the volume of the head, taking us around to the back and down into the recess of the eye, nose, ear, and mouth, as well as into the folds of the blanket.

## Portraiture: Variations in Style

In previous chapters we have considered a variety of approaches to drawing the figure—everything from spontaneous gesture to objective analysis. These attitudes and techniques apply equally to the study of the head as to drawing the body as a whole. Gestural sketches provide an excellent introduction to drawing the head and can

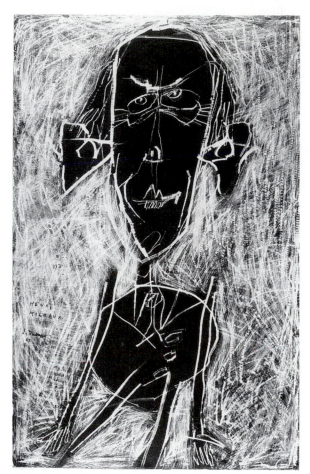

8.26
Jean Dubuffet. *Portrait of Henri Michaux*. 1947. Black India ink on scratch board, 19 3/4 x 12 1/2″ (50 x 31.5 cm). Bequest of Grant J. Pick (through exchange), 1966.348. © 1990 The Art Institute of Chicago. All rights reserved.

8.25
Gregoire Müller. *Winston*. 1983. Pencil on paper, 14 3/4 x 11″. Arkansas Arts Center, Foundation Collection, 86.33.1.

lead to some valid character studies, such as Gregoire Müller's drawing, Figure 8.25. The drawing maintains a sketchy quality with its gestural contour lines and multiple line phrasing that, in the end, give her subject a sense of wobbling animation.

With the energy and spontaneity of a tantrum, Dubuffet deliberately exaggerates and distorts the features of his subject, *Henri Michaux*, Figure 8.26. Dubuffet rejects both idealism and realism and, instead, expresses his personal preference for an image more closely approximating the ingenuous art of an unschooled child, a madman, or a tribesman.

The Matisse drawing at the start of this chapter (Figure 8.1) illustrates an abstract or minimalist

approach to portraiture, using gestural line to distill the form and facial features to their essence. Figure 8.27 expands his use of line only slightly in the face, adding definition to the eyes, nose, and mouth. Matisse's line transforms the physical mass of his subject into something more abstract and conceptual than physical. The title, as well as the elaborate use of line elsewhere, suggests that the drawing's subject is perhaps more the blouse than the woman wearing it.

In contrast, the photographic realism of Nancy Lawton's drawing, Figure 8.28, does away with lines or any suggestion of process. She applies value as continuous tone to render the light that illuminates the head from below. By reversing the usual shadow patterns and exaggerating the subject's proximity, Lawton suggests a surrealism that leaves the viewer feeling a little uneasy, despite the figure's overwhelming stillness.

## Inventive Abstraction of the Head

The human head has provided artists opportunities through which to explore structural and compositional concerns. A few such examples were seen in the work of Tchelitchew (Figure 4.19) and the sketches of Holbein (Figure 8.17). Figures 8.29, 8.30, and 8.31 suggest some other departures from realism into abstraction.

8.27
Henri Matisse. *The Rumanian Blouse*. 1937.
Pen and black ink on white wove paper,
14 13/16 x 19 11/16″ (63 x 50 cm).
Baltimore Museum of Art, the Cone Collection,
formed by Dr. Claribel Cone and Miss Etta Cone
of Baltimore, Maryland, BMA 1950.12.57.

8.28
Nancy Lawton. *Eyeglasses*. 1984.
Pencil on paper, 23 x 22 1/4″.
Arkansas Arts Center,
Foundation Collection, 1984. 84.47.2.

**8.29**
Umberto Boccioni.
*Head of a Woman.* 1909.
Pencil on ivory paper,
15 1/8 x 15 9/16″ (38.2 x 39.4 cm).
Margaret Day Blake Collection,
1967.244. © The Art Institute
of Chicago.

Umberto Boccioni's *Head of a Woman,* Figure 8.29, blends aspects of portraiture with planar analysis. Soon after this drawing was executed, Boccioni was to become the leading spokesperson for Futurism, which began to fracture objects into multifaceted planes as a way of suggesting the dynamics of movement. Evidence of this development can be seen both in the geometric division of the face and the animated depiction of the hair. He uses hatching lines to chisel the planes of the face,

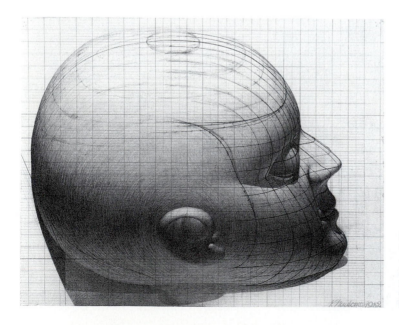

**8.30**
Victor Newsome. *Untitled (Head).*
1982. Ink and pencil,
12 5/8 x 16 1/2″. Arkansas Art Center,
Little Rock, Foundation
Collection 83.9.

but the drawing softens with the flowing lines of hair. The well-defined eyes look slightly askance, as if we are interrupting a moment of quiet pensiveness.

In contrast, Victor Newsome's approach in Figure 8.30 is refined and analytical, almost mechanical. His lines are phrased as meticulously inscribed schematic contour lines. Each follows its designated orbital path, plotting the head's topography with computerlike precision. Newsome also applies value as areas of continuous tone to both complement and supplement the network of lines in an effort to model the three-dimensional form of the head. In essence, Newsome's approach to his study of the head is a sophisticated extension of structural analysis. The feeling conveyed by this rational approach is one of order and stillness. It is just as expressive as any more freely made gestural drawing, but its expression takes a different form about different concerns. In many ways, this more technocratic approach can be seen as abstractly surreal as well as graphically beautiful. It is a mistake to assume that only freely made gestural marks are expressive.

For Richard Lindner, it is the way the structural elements of the head can be abstracted and inter-

preted as two-dimensional shapes that leads to the composition of his mixed-media drawing, Figure 8.31. Lindner's approach could be described as synthetic, rather than analytic, in that the figure in his work is an imaginative composite, based on mass-media imagery rather than distilled from one particular individual. This head is an amalgamation of components, a fictionalization of realistic appearance for the sake of expression and design.

Stylistic exploration provides the artist with an opportunity to expand his or her visual vocabulary. Whether you render with the realism of Lawton or distill your subject to a few simple lines in the style of Matisse, you experience the human head and face as both an expressive and a compositional device.

## Self-Portraits

Artists have several good reasons for doing self-portraits, long a standard in the artist's repertoire of subject matter. One reason may simply be the availability of an accommodating model, one who is as committed to the success of the drawing as is the artist. Another is that the artist knows he or

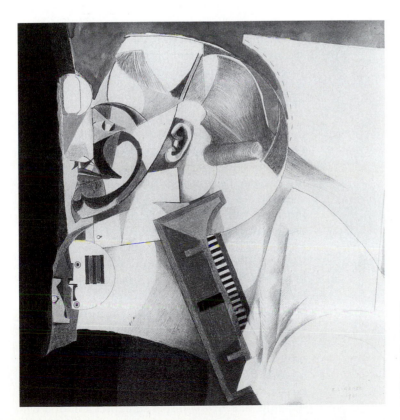

8.31
Richard Lindner. #1. 1961.
Gouache, crayon, pencil, and colored pencil on paper,
13 1/4 x 12 5/8″.
Arkansas Arts Center,
Foundation Collection,
1980. 80.5.

she is free to practice and experiment uninhibitedly without the need to flatter or the fear of offending. A third is that it can be a strong affirmation of the self as an artist, a means of satisfying an emotional desire to draw that is prompted by inner need rather than external patronage. As Dine once said, "Drawing is a kind of autobiography."[2] Although most self-portraits begin with a reflected mirror image, the artist soon sees another image in the drawing itself, and it is through drawing that the dialogue between artist as drawer and artist as subject takes place. Free to do whatever he or she pleases with a self-portrait, the artist is forced to come face-to-face with the person whose opinion ultimately matters most and who often is the harshest critic. Thus, a self-portrait, in a sense, becomes a form of self-evaluation that goes far beyond diagnosing one's own physical features.

Jack Beal's self-portrait, Figure 8.32, shows him looking over his spectacles with critical eyes at his mirrored image. In the background, we see enough to inform us that he is in his studio, standing or sitting in front of another drawing, which suggests how gestural the more detailed image of himself may have begun. In this drawing, Beal uses pastels on a textured, middle-toned paper, which allows him to develop his strokes into a continuous tone by taking advantage of the tooth of the paper. The natural value of the paper also permits a fuller development of highlights on his forehead and glasses. In Beal's shirt and hat linger the remnants of gestural contour lines, but in the face these lines have been subdued beneath value to create a greater illusion of three-dimensionality. In the end, Beal describes not only what he looks like, but how he works.

Robert Arneson once compared the making of a drawing with boxing, where the artist is engaged in a conflict with his or her own work, which, at times, the artist is losing but still hopes to win. His self-portrait as a boxer, Figure 8.33, reflects this sentiment as he confronts himself with his dukes up. The style of the drawing is physical in itself. He builds his large drawings stroke upon stroke, layer after layer; and, in a very real sense, the artist is involved in a strenuous workout. Arneson's analogy of drawing as physical struggle is apropos, reflecting what is, at times, the artist's dogged desire to give form and content to sometimes evasive concepts and unobliging media. When the artist triumphs, as Arneson does here, it is often simply because of stubbornness, refusing to quit when things weren't going right. Color Plate VIII reveals the full impact of Arneson's use of mixed media in another of his self-portraits.

Martha Miller's *Self-Portrait with Lipstick*, Figure 8.34, is a tongue-in-cheek interpretation of herself. She presents an image with four eyes, two sets of lips, and a suggestion that the head is pivoting back and forth on a swivel. Anyone who has attempted a self-portrait realizes that there is a mocking truth to this drawing, which seems to document the constant motion of her eyes, first looking at the mirror, then at the paper, and then back again. Her background shows that she is using the bathroom mirror, also an injection of humor, mocking other more staid self-portraits of artists in their elaborate studios. Frustrated by the endless interruptions and demands of being both artist and mother, she inscribes at the bottom of her drawing, "Hey, I'm trying to draw, Jehovah's witnesses knocking at the door, Lizbeth wanting me to draw ballerinas." In many ways, Miller's drawing, like Arneson's, is an expression of a will

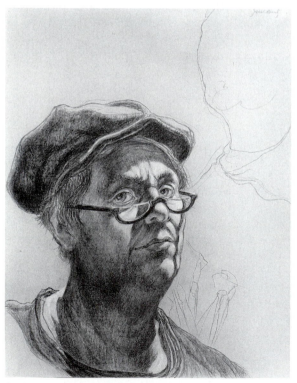

**8.32**
Jack Beal. *Self-Portrait.* 1982.
Pastel on paper, 25 1/2 x 20″.
Frumkin/Adams Gallery, New York.
Photo by eeva-inkeri.

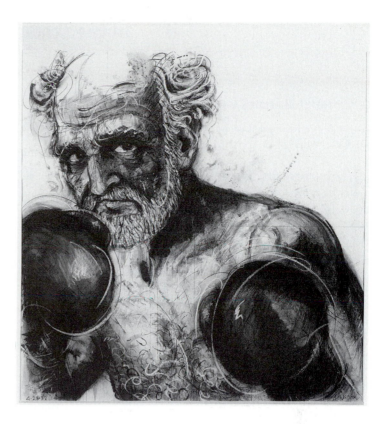

8.33
Robert Arneson. *The Fighter*. 1982.
Conté crayon on paper, 40 x 40″.
Frumkin/Adams Gallery, New York.
Photo by eeva inkeri.

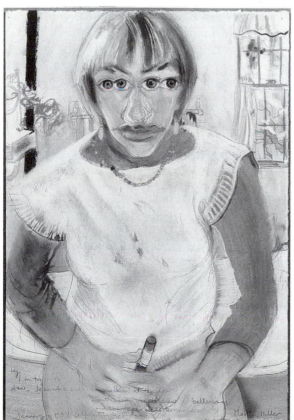

to create in spite of the obstacles. It clearly empha-sizes the internal reality more than the external, the way she looks. The use of the four eyes sug-gests that her head is reeling as she attempts to cope with everything and everyone.

The vibrant self-portrait, *Her Strength is in Her Principles*, by Elizabeth Layton, Color Plate X, suggests an individual sure of herself, not afraid to present the lines and wrinkles of her aged counte-nance. The flesh on the arms sags, as it does on the neck under the chin, but it doesn't daunt her ges-ture of triumph; and the flash of energy in the eyes is unmistakable, echoed in the brilliant aura that emanates a sense of personal power.

Every self-portrait involves the artist's ego in a conscious decision to draw oneself, but it should not be egocentric or self-flattering. It should com-bine intense observation with an honest expres-sion of what the artist believes will portray the self as artist, as well as the self as subject.

8.34
Martha E. Miller. *Self with Lipstick*. 1987.
Graphite, pastel, oil and turpentine wash on paper, 565 x 380 mm. The Fine Arts Museums of San Francisco, Achenbach Foundation for Graphic Arts, gift of Gary Bukovnik.

# In the Studio

### Quick Head Sketches with Line and Tone

**Pose** - 2 minutes; sit close to your subject
**Media** - Charcoal or conté on newsprint, 18″ x 24″

The purpose of this exercise is to sketch rapidly, indicating the general shape of the head, building up its form without worrying about details or creating an individual likeness. First, do several sketches that use only value tones created by placing the charcoal or conté on its side. Then do several using a continuous line to build up the head's form. This drawing may resemble a ball of string when it is completed. As your line goes over and around the head, it should build up its form out of the entanglement of overlapping lines.

### Analyzing Proportions, Front and Profile

**Pose** - 10 minutes, each pose
**Media** - Charcoal or graphite on newsprint, 18″ x 24″

This exercise emphasizes a more objective approach to the study of the head. The intention is not to do a finished portrait, but simply to analyze and plot the proportions of the head of an individual subject, either a model or classmate. The latter option is perhaps preferred, because each head can be more precisely studied and compared from both frontal and profile views, and you can actually take physical measurements as well as sight measurements of a classmate's head or face if desired.

**Frontal View**: Draw the head life-size. Begin by drawing an egg-shaped oval the size and shape of your subject's head. This oval, without any indications of eyes, nose, or mouth, should already resemble your subject in terms of its size and shape because all of the other proportions of the head are related to its overall shape. After drawing the external shape of the head, describe the location and proportions of the facial features. Keep in mind the guidelines established in this chapter (Figure 8.6). See how these standards conform to your subject, either by sight-measuring proportions or by physically measuring them by placing your pencil on the form to be measured. Inscribe on your drawing the proportional relationships you have discovered and further describe your subject's features as time permits.

**Profile View**: Again, begin your drawing with a life-size oval that closely approximates the shape of your subject's head. Attempt to visualize this shape, even though its exact form may be obscured by hair. Next, define the "profile angle" (Figure 8.6). Then, determine the spacing of various facial features, and calculate the depth of the eyes and the corners of the mouth, the location of the ears, and the angle of the jaw. The hair and any other details can be added as time allows.

**Three-Quarter or Foreshortened View**: Draw an oval that suggests the size and shape of the external form of the head, then add the elliptical curves that show the alignment of the eyes or eyebrows and the central dividing line that would run down the center of the nose. Follow by drawing the visible facial features so that they conform to these elliptical paths. Again, the purpose is not to draw a portrait but to gain experience analyzing proportions and plotting facial features from a variety of angles. Rather than finishing a drawing, do several sketches from different viewpoints with the head tipped or turned.

### Planar Analysis of the Head

**Pose** - 20 minutes
**Media** - Charcoal or graphite on newsprint, 18″ x 24″

The purpose of this exercise is to analyze the underlying structure and form of the head and face by reducing them to simple geometric volumes and planes. As you draw, you will find it helpful to analyze the structure of your own head by laying your hands over it to feel the planes and its skeletal understructure, as well as observing the way the light falls over your subject. In this way, you will be employing both optical and tactile means of gathering information. Use line to indicate the edges of planes and geometric facets, adding hatching lines to suggest tonal changes and the slope of surfaces.

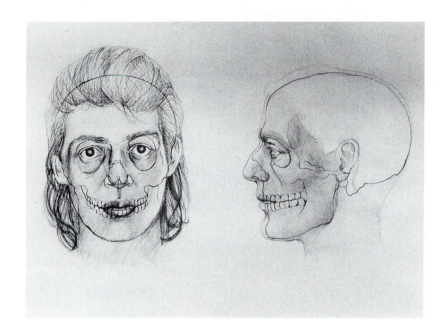

**8.35**
Erick Valdelomar.
*Student drawing, Oregon State University.*
*Study of skull and head.*
Graphite and colored pencil.

## Long Portrait Study

**Pose** - 3 hours
**Media** - Graphite or charcoal or conté on regular drawing paper or neutral-toned paper, 18″ x 24″ or larger

Create a detailed portrait study, drawn from either a model or yourself in a mirror, which describes the features of the head with line and value. Begin by working lightly, starting with the larger relationships then progressing to smaller, more detailed ones, analyzing the anatomical structure, comparing proportions, and plotting the angles and positions of the various features. You should begin to see the likeness of your subject long before you become concerned with details. Use value to both model form and render the play of light.

## Independent Study:

The way to become good at drawing heads and faces is to put some extra time and effort into this aspect of drawing from life. To study heads, you don't need a professional model, and, for some exercises, independent study is preferable to a large studio situation. 1. The goal of this exercise is to review how the bony structure of the skull influences the exterior appearance of the head. Begin with a life-size drawing of the skull, using the illustrations in this text as a reference (Figures

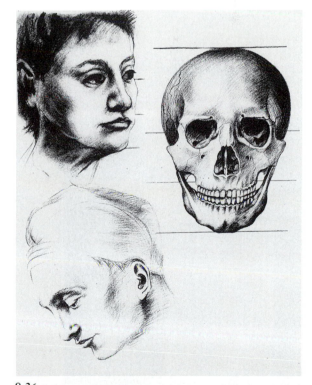

**8.36**
Christopher Forrest. *Student drawing, Oregon State University. Study of skull and heads, from Michelangelo and from life.* Charcoal.

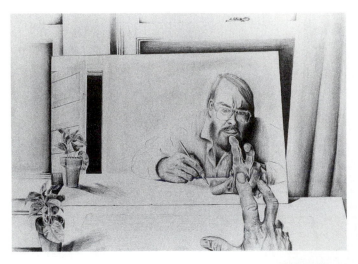

**8.37**
John Dickinson. *Student drawing, Oregon State University. Self-portrait.* Graphite.

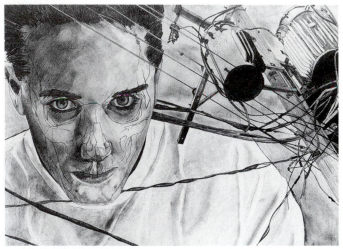

**8.38**
Chris Link. *Student drawing, Oregon State University. Self-portrait.* Graphite.

**8.39**
Jeanne M. Heywood. *Student drawing, Oregon State University. Self-portrait juxtaposing organic and inorganic forms.*

**8.40**
Laurel M. Campbell. *Student drawing, Georgia State University. Self-portrait; multiple study of facial features.*

8.8 and 8.9). Then, draw what you would imagine to be the exterior appearance of the head over your drawing of the skull (Figure 8.35). 2. To become more acquainted with the detailed shapes of the eyes, nose, mouth, and ears, practice drawing them as individual parts by filling a large page with multiple studies of each. 3. Take a sketchbook with you on a drawing outing and make character sketches of the people you see. A park, a coffee shop, a library, or a train station are just a few locations where you can see a variety of heads to draw and also discover a lot about human nature. 4. Much can be learned from studying the techniques of the old masters. Even Leonardo, Michelangelo, and Rembrandt did drawings from the works of their predecessors. Use original drawings in museums, or copy from the reproductions in this and other texts. Figure 8.36 includes a study at the lower left made after a work by Michelangelo. 5. Make a highly developed drawing of yourself that becomes something more than just a likeness by including in your drawing an object, animal, or multiple images, or by suggesting aspects of an environment, as in Figures 8.37, 8.38, 8.39, and 8.40. Play around with your idea by first doing small, rough compositional sketches to discover the full potential of your idea before you begin your larger drawing.

## Endnotes

[1] Leonardo da Vinci, quoted in Robert Goldwater, *Artists on Art* (New York: Pantheon Books, 1945), 83.

[2] Jim Dine, "Conversation with the Artist," *Jim Dine Figure Drawing 1975-1979*, exhibition catalogue by Constance W. Glenn (Long Beach, CA: The Art Museum and Galleries of California State University), Oct. 1979.

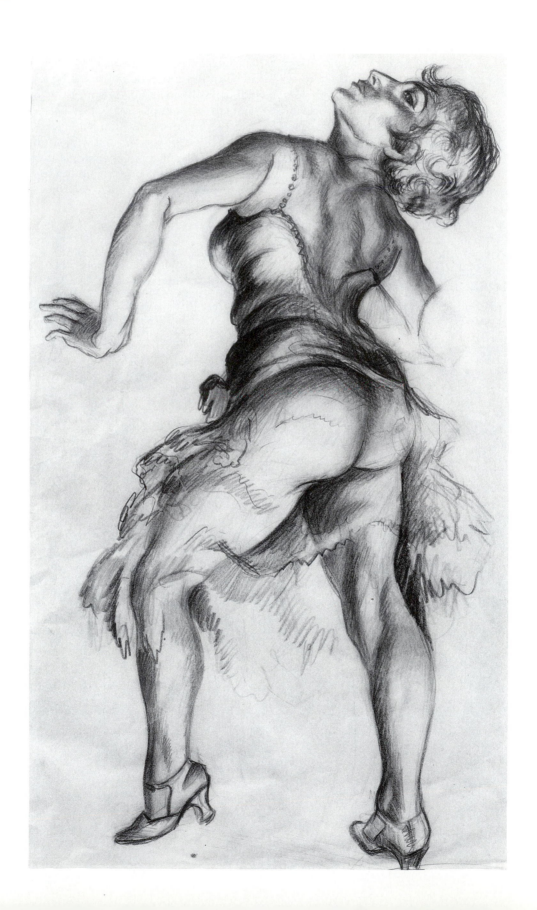

# SECTION THREE

# Composition and Expression

Λ picture is something which requires as much knavery, trickery and deceit as the perpetration of a crime. . . . The artist does not draw what he sees, but what he must make others see.

*—Edgar Degas*

This last section emphasizes the means by which a figure drawing becomes something more than a figure study. What determines the distinction is not necessarily the amount of time spent on the drawing, but, rather, how the representation of the figure functions to communicate ideas or aesthetic concepts broader than its physical appearance. For the old masters, the study of the figure was a continuous investigation, but not an end in itself. These artists considered drawing from life a prelude to works in other media, the figure serving as the vehicle through which to express both their formal and their humanistic concerns.

The emergence of drawing in the twentieth century as an independent art form has expanded the purpose and appeal of this medium, and many artists have rediscovered the aesthetic and expressive potential of the human figure as an art form. The new importance of drawing arises, in part, from the contemporary idea that art should be exploratory. Drawing lends itself to experimentation: ideas can be rapidly considered and developed, discarded, and redirected. As Degas once explained, "Drawing is the artist's most direct and spontaneous expression, a species of writing; it reveals, better than does painting, his true personality."[1] But beyond its appeal as a means of immediate expression, drawing may produce as complete and profound a statement as works of art in any other media.

This text began by presenting the notion that drawings evolve through both conscious and intuitive mental processes, on both objective and subjective levels. These two forces, however, are seldom equal at any one moment or within any creative individual. At times, the objective ap-

proach dominates, with the artist opting for a rational and orderly arrangement of formal elements; at others, the subjective side prevails, stressing a more intuitive or passionate expression of subject matter. In fact, in different periods of art history, one or the other side has gained ascendancy as the appropriate source of creativity. The battle between ethos and pathos, ideal and passion, can be traced in the dichotomy of classical and romantic forms of artistic expression.

It is primarily along these diverse lines of formal detachment versus emotional involvement that contemporary artists have extended figure drawing beyond the limits of an exercise and allowed it to stand on its own as an art form. Pearlstein describes the schism among contemporary figurative artists: "The major issues divided the group . . . into those who wanted their perceptual experience hot and full of the meaning of 'life' or with cool detachment."[2] Contemporary art is unique in art history in that it is dualistic, with approximately equal representation of these two temperaments among its figurative artists. The following section examines this duality and expands upon both the objective and subjective elements in drawing to show how they give a special emphasis and meaning to the terms composition and expression. The aesthetic manifestation of these two prevailing biases in contemporary art may be appropriately referred to as *figurative formalist* and *figurative humanist* points of view. These broad classifications encompass enormous variety in content and style, the extremes and amalgams of which only a few examples can be included here.

Although one can rightly argue that every drawing exists as both a composition and a form of expression, the figurative formalist places greater emphasis on composition than does the figurative humanist, whose primary focus is on the communication, or "expression," of subjective content. The distinction is a matter of emphasis or artistic focus. Artists like Picasso have created works of equal quality in either mode. You will also discover that many drawings display a blend of these two tendencies—a very cool arrangement of formal elements may carry an underlying message within the composition itself, while an overtly expressive drawing may gain some of its power of expression from the strength of its composition.

Ideally, the discussion that follows will enhance your awareness that, for the serious figurative artist, composition and expression are not incidental but essential concerns. You will also understand more fully one of contemporary art's most intriguing dialogues; and perhaps, in the process, you will discover more about your own interest in the figure.

Endnotes

[1] Edgar Degas, quoted in Ira Moskowitz, ed., *Drawings of the Masters: French Impressionists* (London: Weidenfeld and Nicholson, 1962), 13.

[2] Philip Pearlstein, "Why I Paint the Way I Do," *The New York Times,* Aug. 22, 1971, p. D29.

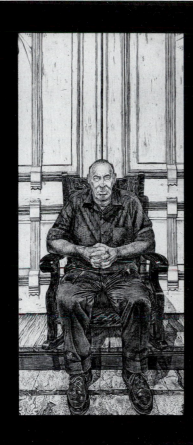

# Chapter 9

# Composition and the Figurative Formalist

But there is another tradition of artistic concern which deals with underlying structures or spatial relationships. . . . It seems to relate to existential philosophical questions of how to manifest, make visual, the experience of being. In this tradition, to which I relate myself, the primary experience is the artist's.

—*Philip Pearlstein*

## A Figurative-Formalist Bias

The formalist approach to the figure is primarily a disciplined and rational one, governed by the intellect. The artist maintains objectivity in analyzing the figure, focusing on physically observable phenomena—the play of light, the structural relationships of form, the body's spatial position and relationship to its environment, or the delineation of shapes on the two-dimensional picture plane. A figurative formalist is "relationship-minded" rather than "subject-minded." An artist with this bias is concerned with self-contained pictorial relationships rather than conveying meaning or expressive content.

Contemporary artist Wayne Thiebaud verbalized this formalist philosophy: "The figures . . . are not supposed to reveal anything. It's like seeing a stranger in some place like an air terminal for the first time. You look at him. You notice his shoes, his suit, the pin in his lapel, but you don't have any particular feeling about him."[1] With the same detachment, Thiebaud's drawing of a standing nude, Figure 9.1, is void of sentiment; in her isolation, she is used as any other solitary object the artist has included as the sole determinant of his composition. The formalist chooses to use recognizable objects, such as a life model, as a point of departure into a study of the formal construction of the drawing. The artist views the figure as a compositional device, often posing it within a space consciously chosen for its structural arrangement.

## Composition

Composition can be defined simply as the organization of line, value, texture, shape, form, and color into a unified whole. The composition not only unifies a drawing but also establishes implicit relationships that can make a series of drawings of the same model—even the same pose—unique.

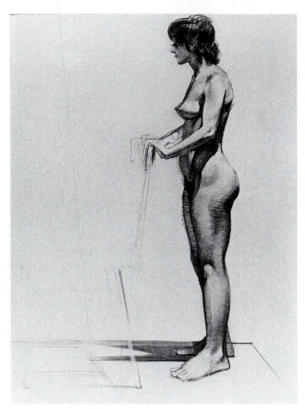

9.1
Wayne Thiebaud. *Girl with Chair*. 1974.
Charcoal, 30 x 22″. Private collection.
Photo by Matt Bult. Courtesy of the artist.

For along with its ability to differentiate visual elements within a work of art, composition formulates the visual idea. Composition is to the visual arts what syntax and grammar are to writing. For the figurative formalist, the study of composition is an intellectually intriguing and creative endeavor. Drawing is a sophisticated mental game of image making, played with media and form; composition is the logical arrangement of the pieces during this game. The figure is a desirable subject for the formalist because it serves as a kind of aesthetic catalyst that can provide innumerable compositional variations and renewed intellectual challenges.

These artists may refer to their drawings as "expressive"; however, this term means something particular for the formalist. As Matisse explains: "Expression, to my way of thinking, does not consist of the passion mirrored upon a human face or betrayed by a violent gesture. The whole arrangement of my picture is expressive. The place occupied by figure or objects, the empty spaces around them, the proportions—everything plays a part."[2]

For Matisse, the goal is to make the composition expressive as an aesthetically pleasing experience. In his sketchy drawing, Figure 9.2, his deep concern for the arrangement of shapes is revealed as he manipulates them to achieve his desired com-

9.2
Henri Matisse.
*Artist and Model
Before a Mirror.*
1935. Pencil on
paper, 9 3/4 x 12 3/4″.
Arkansas Arts Center,
Little Rock,
Foundation
Collection:
The Fred W. Allsopp
Memorial
Acquisition
Fund, 1984, 84.18.1.

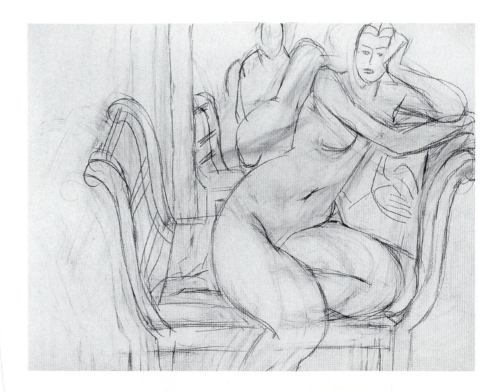

position. He flattens and abstracts his subject matter for the sake of the design in his pictorial format.

Some formalists choose to abstract, dissect, or flatten the body, whereas others insist on photographic realism; however, there exists a common desire to arrive at an aesthetically unified whole. Because structure and composition embody the content of the drawing, any changes in a model's pose result in both a change of composition and a change in content—a new pictorial idea.

The formalist brings into figurative art the notion at the core of modern art: art should be about art. The formalist is involved only with solving aesthetic problems. Drawing the human figure, by extension, should involve no more emotional pangs or political significance than the objects in a still life or the scenes of a landscape.

James Whistler, an outspoken American artist, first gave voice to the modern art credo, "art for art's sake," in a lecture delivered in London in 1885. He wished to rid art of sentimentality and moralizing narratives. In his words, "Art should be independent of all clap-trap—should stand alone, and appeal to the artistic sense of eye or ear, without confounding this with emotions entirely foreign to it, as devotion, pity, love, patriotism and the like."[3] Art, according to Whistler, should

be treated simply as "an arrangement of line, form, and color."[4] Although he himself was a flamboyant dandy in his personal life, he strove to maintain an aesthetic aloofness from his subjects, which enabled him to title a painting of his own mother, *Arrangement in Gray and Black No. 1.* Another composition, for which Figure 9.3 is a sketch, was titled *Symphony in White No. 3.* The general public considered Whistler's strange titles an affectation, like his style of dress, but it was an earnest attempt to affirm his belief in the autonomy of art. In these works, Whistler posed his subjects as aesthetic entities, carefully positioning them to harmonize and balance. He viewed the figure in terms of its abstract qualities.

Degas also used the figure primarily as an aesthetic device by which to break up the picture plane and on which to hang his color. He created numerous variations on such themes as the dancer and the bather and even the poor laundry woman. Yet these figures, in themselves, have no particular significance as individuals but, instead, exist as studies of form and light. Facial features, which might have distinguished his model's personality or revealed her emotions, are most often hidden from view or simply dissolved in a bath of light or color (see, for example, Figure 5.9 and Color Plate III). These drawings, like many of his paintings,

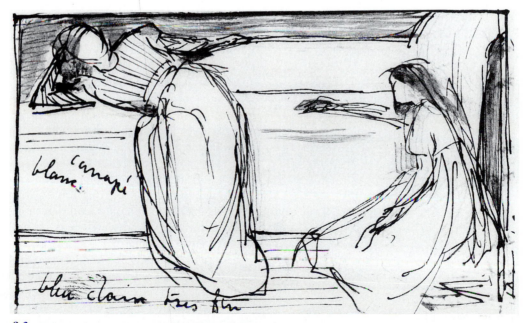

**9.3**
James Whistler. *Study for Symphony in White No. 3.* Pen and ink. Library of Congress, Washington. By permission of the National Galeries of Scotland.

are based on his research and experimentation with light and color. His methodology of executing numerous studies of the same theme, with subtle compositional changes and alterations in lighting conditions, is typical of the figurative-formalist approach, where the artist investigates aesthetic factors in the disciplined and controlled manner of a research scientist. As he once said, "No art is less spontaneous than mine."[5]

Juan Gris's drawing, Figure 9.4, represents an extreme abstractive approach within the formalist bias. Gris first analyzes the figure to derive abstract shapes, then he synthesizes these shapes into an arrangement of his own invention. Gris is primarily concerned with designing the two-dimensional picture plane; his line directs our eyes along the path of the linear scaffolding he has created. Although Gris has abstracted the figure, his composition is so orderly and rational that it bestows a new, equally acceptable reality on his drawing. The formalist, whether abstracting the figure in two dimensions, as in the Gris drawing, or rendering a deep illusionistic space surrounding the figure, is inevitably concerned with constructing an aesthetically pleasing, well-designed pictorial arrangement.

## Breaking Up the Pictorial Space

Edward Hopper's small compositional sketch, Figure 9.5, and his study of an isolated standing female nude, Figure 9.6, are both preliminary drawings for his painting *Morning in a City,* Figure 9.7. This work, with its single figure situated in an interior space, is a typical theme for Hopper and shares a similarity of feeling with several of his other drawings discussed in this text. The painting and the two drawings that preceded it document an external world that Hopper both observed and consciously arranged for the picture plane of his canvas. Taken as a group, these three works document Hopper's focus on formal aesthetic concerns. The content or drama comes not from narrative but, rather, from the interaction of light with form and space. The value sketch of the whole interior, Figure 9.5, is a notation of the structural components of the room that will determine the design of Hopper's canvas. The isolated figure drawing, Figure 9.6, is a record of how the form of the body obstructs light. The nude in the painting is an important compositional component, which helps both to define the three-dimensional space and to divide the two-dimensional picture plane. The figure, like the light, is frozen within a consciously composed arrangement. The nudity of the figure and the rumpled bed are not intended to be alluring symbols; Hopper neutralizes these potentially emotional objects, stoically filtering out feelings by turning the figure to the window, rather than toward the viewer, and stripping the interior of any embellishment. His work denotes a sober, almost monastic preference for austerity as he simplifies and eliminates all that is unnecessary, all that might distract us from the basic compositional elements. As he once said of a similar work, "Any psychological idea will have to be supplied by the viewer."[6]

Hopper's concern for integrating the organic form of the body within the formal geometric arrangement of the composition accentuates the sense of an eternal moment that is typical not only of Hopper's work but of most of the other drawings in this chapter. The figure is such an important structural element that you begin to feel that

**9.4**
Juan Gris. *Personnage Assis.* 1920.
Pencil on buff paper, 13 1/2 x 10 5/8″.
Arkansas Arts Center, Little Rock, Foundation
Collection: The Tabriz Fund, 1987. 87.47.2.

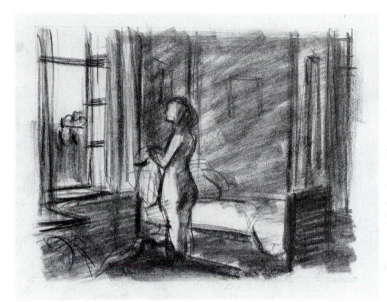

**9.5**
Edward Hopper. *Study for Morning in a City.*
1944. Conte and pencil, 8 1/2 x 11″.
Josephine N. Hopper Bequest, Collection of
Whitney Museum of American Art, New York;
Geoffrey Clements Photography.

**9.6**
Edward Hopper. *Study for Morning
in a City.* 1944. Conte, 22 1/8 x 15″.
Josephine N. Hopper Bequest, Collection
of Whitney Museum of American Art,
New York; Geoffrey Clements
Photography.

**9.7**
Edward Hopper.
*Morning in a City.*
1944. Oil on canvas,
44 x 60″. Williams
College Museum
of Art, Williamstown,
Massachusetts,
Bequest of
Lawrence H. Bloedel.

if it were moved, it would destroy the integrity of the composition as a whole. Although Figure 9.6 remains a figure study, it begins to express, in itself, the same isolated demeanor that we find in Hopper's major works.

This psychological distance from the nude can be seen in a drawing by Elmer Bischoff, Figure 9.8. Bischoff, Diebenkorn, Joan Brown, and others were dubbed the San Francisco Bay Area Figuratists in the late 1950s when their work was seen as a west coast antithesis to the New York Abstract Expressionism of the same period. In Bischoff's drawing, we see the model supposedly resting but, in fact, posing within a larger composition. She is but one part of the artist's studio, his world. As in Hopper's drawing, the figure forms the focal point of the composition, at the intersec-

9.8
Elmer Bischoff. *Model Resting.* 1973.
Charcoal on paper, 26 x 20″.
John Berggruen Gallery, San Francisco.
Private collection, San Francisco.
Photo by M. Lee Fatherree.

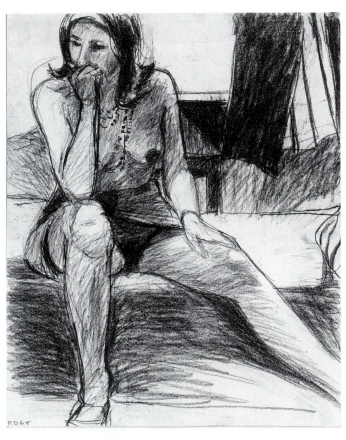

9.9
Richard Diebenkorn. *Seated Woman.*
Charcoal. Collection of Eve Benesch
Goldschmidt. Photo courtesy of the
Metropolitan Museum of Art, New York.

tion where the vertical panels of dark value in the background cross the horizontal structural elements of the table and counter. Bischoff's drawing extends the value pattern on the body into those of its surroundings, each shape supported by and attached to the next until anchored securely to the outer frame. In this way, he divides the space and defines the structural relationships as the main subject of the work. The model is "resting," like an heirloom that twentieth-century artists inherited from the past. She is treated with the same impartiality as the surrounding interior, the light fracturing her body into a pattern of light and dark along with everything else in the room.

Diebenkorn's figurative drawings, done before he turned to abstract compositions, employ the figure to the same end: a compositional arrangement of elements. Unlike Bischoff, Diebenkorn prefers to zoom in on his subject, letting the body fill more of the picture frame (Figure 9.9). Typical of both Diebenkorn and Bischoff, however, the details of the face are obscured and of no particular importance to the drawing. The artists thereby prevent psychological interaction or involvement with the model. According to John Elderfield of the New York Museum of Modern Art: "His models usually look down or away. They seem self-absorbed. Part of the reason for this is that Diebenkorn does not want to make psychological contact with the face. He wants us to grasp the meaning of a work from the whole composition and not have it filtered through the personality of the model."[7] The physical and purely visual relationships are what is relevant. Diebenkorn uses the model's pose as a profound determinant of the whole composition. He exploits the body's ability to change configuration and thereby suggest an infinite number of structural arrangements.

The figure in this drawing crosses from side to side, buttressing against the frame's outer edges and fragmenting the surrounding space. The artist is not merely drawing a figure, he is drawing a construct of forms that support and relate to one another. As Diebenkorn once said, "One of the reasons I got into figurative or representational painting . . . was that I wanted my ideas to be worked on, changed, altered, by what was 'out there.'"[8]

The external reality of the body suggests compositional possibilities to Diebenkorn, and he uses it as a graphic symbol through which to convey his pictorial concepts. As philosopher Suzanne Langer suggests: "Symbols are not proxy for their objects, but are vehicles for conception of objects . . . it is the conceptions, not the thing, that the symbols directly 'mean.'"[9] Here, Diebenkorn's presentation of the figure is drained of personality and even human sensuality to more freely communicate his aesthetic concern for pictorial design. Notice that the figure receives no more emphasis than the shapes that surround her. In fact, Diebenkorn seems to define the body as much by drawing its surroundings as by drawing the figure itself. The three-dimensional volume of the model and her environment is compressed and flattened to make it more adaptable to structuring the two-dimensional surface of his drawing. This treatment of the figure, as a component of design, forecasts Diebenkorn's even more formal, non-representational work of recent years.

Joan Brown, another Bay Area Figuratist, used figures to reflect a concern for design in two dimensions. Figure 9.10 presents a model in repose,

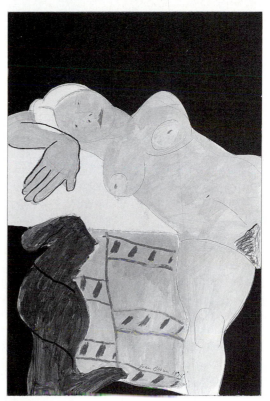

**9.10**
Joan Brown. *Untitled.* 1974. Acrylic, oil pastel, and ink on paper, 36 x 24″. San Francisco Museum of Modern Art, Purchased with the aid of funds from the National Endowment for the Arts, 1975 Soap Box Derby and the New Future Fund Drive.

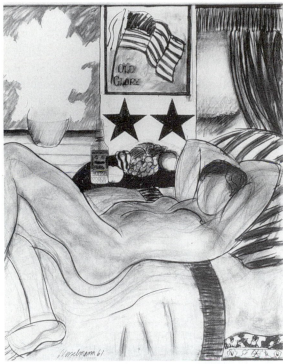

**9.11**
Tom Wesselmann. *Drawing from Great American Nude series.* 1961. Charcoal on paper, 152.7 x 121.6 cm. Sidney Janus Gallery, New York. © Tom Wesselman/VAGA.

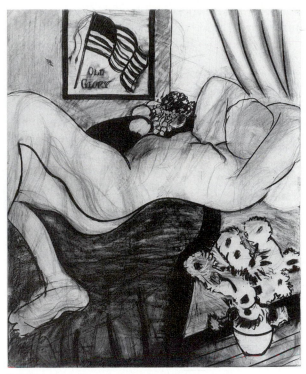

**9.12**
Tom Wesselmann. *Drawing from Great American Nude Series.* 1961. Charcoal on paper, 152.7 x 121.6 cm. Sidney Janus Gallery, New York. © Tom Wesselman/VAGA. Photo by Jim Strong.

and though her gaze seems direct, her face is impassive and devoid of individualizing characteristics. The thin lines work like shorthand to define form in the briefest means possible, flattening the space and figure in a manner similar to Matisse's drawings.

Tom Wesselmann's Figures 9.11 and 9.12 bear an even greater resemblance to Matisse's work. During the 1960s, Wesselman created a large body of work, collectively referred to as *The Great American Nude*. On one level, many of these works are erotic, yet on another level, they function as abstract formal arrangements of form and space. As we can infer from the pentimenti in Figure 9.11 and the similarity between these two compositions, Wesselman shares Matisse's concern for the design of the two-dimensional format. By flattening his subjects and eliminating facial features as he has in this drawing, Wesselman "cools down" his subject matter and converts what was often an erotic pose into an archetypal symbol, a more "acceptable" presentation of the nude. He creates a deliberate paradox between the

sacred and the profane, by juxtaposing it with the flag and by placing the nude in a symmetrically balanced composition reminiscent of religious icons. Again, in the words of Matisse, the whole arrangement of the picture is expressive.

## The Abstract Concerns of the New Realist

The artist who perhaps best exemplifies the formalist application of the figure in contemporary art and who has most articulately verbalized its philosophy is Philip Pearlstein. He is part of the so-called New Realist revolution, which presented a recent challenge to the dominance of Abstract Expressionism and nonfigurative Minimalism in contemporary art. Compared with Bischoff and Diebenkorn, Pearlstein is more concerned with depicting the body as a three-dimensional volume in a space one could occupy (Figure 9.13 and Color Plate IX). Pearlstein is equally concerned with composition, however: "The volumetric torso, limbs and other parts of the figure have to

move choreographically through measurable three-dimensional space; simultaneously they must be the primary architectonic units of the strongest possible two-dimensional structure."[10] Both the Abstract Expressionists and the Bay Area Figuratists placed an emphasis on exploration and promoted a free and expressive working of the drawing surface. In comparison, Pearlstein's approach is controlled, and his application of the media is precise, dispatched in carefully considered quantities as his focus narrows from the overall format to the depiction of minute surface details. Pearlstein once said he has rescued "the figure from its tormented, agonized condition given it by the expressionistic artist, and the cubistic dissectors and distorters of the figure, and at the other extremes I have rescued it from the pornographers."[11]

Pearlstein's nudes, in spite of their undeniable physical presence, are not to be interpreted as metaphorical symbols, as part of a narrative. "I don't want the burden of literature thrust upon me when I only want to use my eyes."[12] He seeks to remain completely objective. Pearlstein, like Diebenkorn, Bischoff, Hopper, and Thiebaud, wants his nudes to be psychologically inaccessible. They do not interact with the artist or the viewer or one another. Although he offers sensory material—furniture, oriental rugs, naked flesh—we are expected to keep our distance and to appreciate these objects on a higher, abstract level. Pearlstein draws his figures large within the picture frame, often cropping faces at the edge, which adds to their anonymity. He treats the body as a still-life object, observing and rendering it with the same detachment with which Cezanne painted his apples. Without sentiment or preaching, Pearlstein attempts to deal with nothing but the facts, nothing but the visual presentation of light and form. Yet at the same time, he directs our vision. We feel that we are seeing only what he wants us to see from a precise angle, framed exactly as he wishes it framed. As a result, the pictorial arrangement forcefully manipulates us, changes our own perceptions, and slowly increases our aesthetic sensitivity as it dissolves any preconceived notion we may have had about nudity. We can appreciate the drawing alone, for its own sake. "As a rose is a rose, so my paintings of models are paintings of models."[13]

By eliminating the narrative and expressive pathos, the figurative formalists have made their drawings from life more meditative. Meditation, as defined by Webster, is "deep continued thought" and "solemn reflection on sacred matters as a devotional act." For artists like Thiebaud, Brown, Hopper, Diebenkorn, and Pearlstein, art is a sacred matter, and the making of art to a great extent becomes a devotional act. In this context,

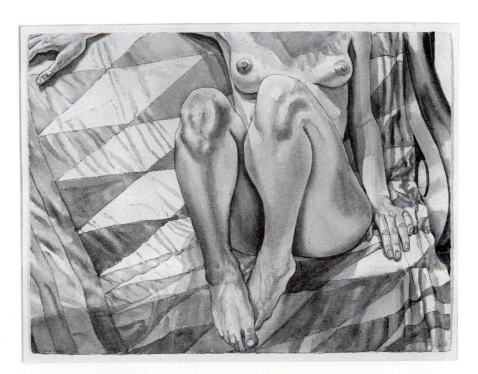

9.13
Philip Pearlstein.
*Female Model Seated on a Lozenge-Patterned Drape.* 1976. Sepia wash on paper, 44 x 30".
Oregon Art Institute, Portland, Purchase.

the nude is a highly revered, quasi-sacred symbol, which requires sophistication in order to appreciate the symbol on a purely aesthetic level.

Although he is considered a realist, Beckman's work appears to be about more than the depiction of simple visual appearance. In Figure 9.14, his drawing suggests a subject matter beyond compositional elements; it is about an artist's relationship with his immediate world, his studio. Beckman's figure drawings are often studies for his substantial portrait paintings of himself and his wife. For example, Figure 9.14 is, as the title suggests, a study for his painting *Studio* (Figure 9.15).

As a self-portrait, Beckman's drawing does not have the psychological distance of a Pearlstein; in fact, the intensity with which he stares back at us is almost confrontational. Compositionally, Beckman places himself in the center of that world as the medium who interprets and possesses the craft by which the physical is translated into the pictorial language of art. Although *Studio* is personal and reflective of a working relationship between the artist and his wife-model, Beckman's primary focus is on the formal relationship and the arrangement of objects compositionally within the picture plane. Notice the formality of the relation-

**9.14**
William Beckman.
*Study for Studio.* 1985.
Pencil on paper, 29 x 23″.
Frumkin/Adams Gallery,
New York.
Photo by eeva-inkeri.

ships of model-artist-painting, occupying equal thirds, and how the horizontal and vertical lines create a scaffolding, along with the picture frame, tying everything together. Notice, also, how the arrangement of the drawing is further refined by adjusting the precise size and position of all that is included. Beckman, like Pearlstein, is a realist who editorializes for the sake of establishing his desired structural relationships, and his drawing is primarily an intellectual pursuit of arranging objects and breaking up space. This drawing is as much about establishing a system of relationships as it is about creating a likeness.

In a more linear composition, Figure 9.16, Regina Granne uses the model as but one object in her interior still-life. Just as in the game of chess, where one move prompts another, in this work each line Granne draws takes into account all of the preceding ones. Her drawing is a record of the moves she made while playing the equally contemplative game of image making. Although she implies a great deal of space, the line works to divide the surface of the drawing and to penetrate it as a hallmark of linear perspective.

Steve Bigler uses value and line to take us back into a composition that balances the geometric

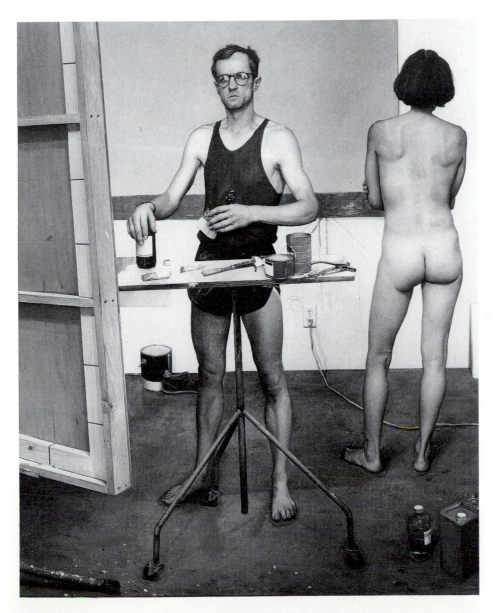

9.15
William Beckman.
*Studio.* 1985–86.
Oil on panel,
120 x 98 1/2".
Frumkin/Adams
Gallery, New York.
Photo by
eeva-inkeri.

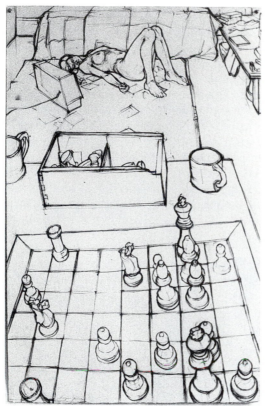

**9.16**
Regina Granne. *Table and Nude with
Chess Set*. Charcoal, 26 x 41".
Regina Granne, New York.
Courtesy of the artist.

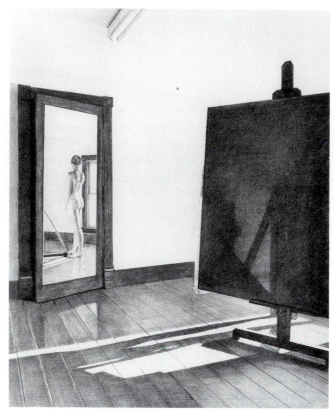

**9.17**
Steve Bigler. *Figure, Easel*.
Charcoal, pencil, 22 x 27".
Collection, Minnesota Museum of Art,
St. Paul.

**9.18**
Harvey Breverman.
*Interior:
Four Rooms*.
Babcock Galleries,
New York.
Photo by
Don Weigel Studio.

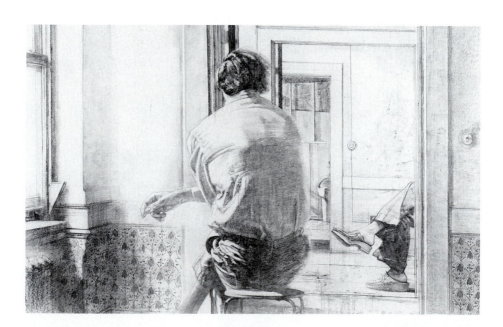

shapes of the mirror image with the easel in Figure 9.17. In many ways, the surface of the drawing paper is similar to that of the mirror image of the far nude in that it offers an illusion of form and space that we cannot physically enter and are expected to appreciate from a distance.

Similarly, Harvey Breverman's drawing, Figure 9.18, uses the architectural units of windows, molding, and door frames to create a pictorial scaffolding that divides his composition with geometric shapes like those found in a Mondrian painting. Again, the anonymity and passivity of the two figures suggest that they, like the interior itself, are included exclusively as compositional elements. Notice how the architectural lines are always parallel with the exterior edges of the format, forming right angles where they meet the frame. Why? Not just because that's the way they happen to appear. This arrangement represents the artist's conscious decision to create a harmonious and stable order.

Breverman demonstrates an essential characteristic for any artist: the ability to recognize aesthetic potential in the ordinary. In the same way that a poet takes everyday words and composes them in rhythmic relationships that imply, through sound reverberations, a higher meaning than that of common usage, the visual artist transforms the ordinary environment into an object of beauty through design. In Breverman's drawing,

the parallel construction of lines and edges is as visually unifying as alliteration and rhythm are to poetry.

## Light as Structure: The Camera's Influence

Since the camera was invented, artists have used it as a resource, and its influence can be seen in the work of Degas, Seurat, Toulouse-Lautrec, and Eakins, to name but a few.[14] The photograph can be a useful way to record and store information and an efficient means of studying the effects of light. For artists concerned with structure, its significance lies in its ability to focus and edit visual information.

Manon Cleary's drawing, Figure 9.19, shows the extent to which the photograph can detach the artist from the subject, even though the subject, in this instance, is the artist herself. Cleary bases her drawings on black and white photographs to create nude self-portraits. Her work presents, in the genre of the artistic nude photographer, drawings that, in part, are a parody of photography and its illusion of reality. She hones her compositions from paper already toned with a fine layer of graphite, using her eraser to "draw" by removing graphite to represent areas of lighter value. With an eraser as her drawing tool, Cleary can actually render the light patterns rather than infer them

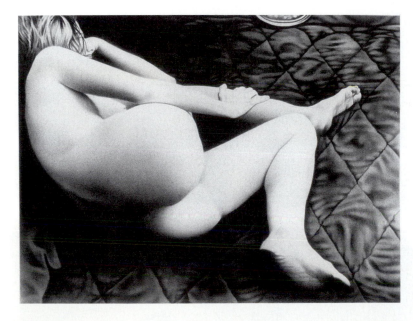

**9.19**
Manon Cleary. *Untitled.*
Graphite on paper, 23 x 29″.
J. Rosenthal Fine Arts, Chicago.

**9.20**
Ernest Lindner.
*In the Reeds.*
1975. Pencil,
22 1/2 x 29 1/2".
Private
collection.
Photo courtesy
art placement,
Saskatoon,
Saskatchewan.
Photo by
Zack Hauser.

indirectly by drawing the dark areas only. By employing the intermediate step of the photographer, Cleary remains objective, never easy when drawing one's own body, and she is able to experiment freely with scale, placement, and cropping. The camera freezes the image and the light yet permits some flexibility in the composition by allowing the artist to adjust the scale or position of the body within the drawing format. On the other hand, using a camera promotes a particular way of seeing and can depersonalize the drawing process. Therefore, a drawing may gain in terms of its realism, but it can also become generic, lacking the idiosyncratic traits that often give a self-portrait drawn directly from life its autobiographical character.

**9.21**
Norman Lundin.
*Model Standing
Before a
Blackboard.* 1974.
Charcoal, 24 x 36".
Collection of
the artist,
Seattle,
Washington.

As an editing tool, the camera can also capture and store images that can later be compositionally synthesized into a drawing. One such example is Lindner's pencil drawing, *In the Reeds,* Figure 9.20. Here, two photographically recorded images, each with its own distinct but not particularly unusual qualities, have been superimposed, one upon the other, to create a more interesting structural arrangement. By allowing the images of both the reeds and the figure to remain semitransparent, the artist makes them appear to dissolve into each other, creating an ambiguous, somewhat abstract spatial arrangement. Our focus moves back and forth from one image to the other as we attempt to resolve the ambiguity before succumbing to an appreciation of the drawing on an abstract level as a pattern of lines and value.

Strong light and shadow patterns in combination with the figure are the key structural components of Lundin's drawing, *Model Standing Before a Blackboard,* Figure 9.21, which is more indirectly influenced by the camera. These visual elements seem quite natural, the composition coincidental, except for the way the figure has been cropped. In Lundin's drawing, light itself becomes the central structural element. As the light coming from an unseen window streams diagonally into the picture plane, it rakes across the wall and the female torso, revealing both the flat plane of the blackboard and the round contours of the body. By carefully recording the value gradations in the chiaroscuro tradition, Lundin composes a convincing illusion of reality. The lines on the blackboard balance the position of the figure as a two-dimensional foil to the three-dimensional illusion of the model. Part of the magic of this composition lies in the way it convinces us that it was created by the light, rather than by Lundin himself.

In addition to drawing directly from the model, Valerio reportedly uses a large-format view camera as a tool for studying light and working out his compositions. *Dancer,* Figure 9.22, exhibits all the qualities of a fine-grain photograph and more. Valerio uses both linear and atmospheric perspective to penetrate the surface of his drawing paper with the illusion of depth. The deep space of the interior and the realistic modeling of the three-dimensional form of the nude figure tend to distract us from the fact that the composition has also been designed in terms of its two-dimensional frame. Using the wall and doorway as structural elements, Valerio divides his picture plane geometrically into three vertical units. The organic form of the dancer's body is superimposed in front of the panelled structure of the darkened door. The trim molding on the wall provides a horizontal motif, which is continued through the door panels and echoed in the lines of the threshold, table, and upper door frame. The gridded tile pattern on the floor provides both horizontal lines and lines that project our view far into the interior space of the drawing. The effects of linear perspective in the tile, door, and table are enhanced by the use of atmospheric perspective created through the rendering of light. It defines not only the form of the body and the discarded robe on the table but also a spatial progression from the foreground into the deep interior of the next room, whose content is shrouded by darkness. The doorway is a good example of how Valerio gets the two-dimensional

**9.22**
James Valerio. *Dancer.* 1988.
Pencil on paper, 49 x 33".
Frumkin/Adams Gallery,
New York. Photo by Bobby Hanson.

and the three-dimensional reality of his drawing to work together. For although the darkness of the doorway implies a deep, indefinable space, it also has a formal integrity as a two-dimensional design element. Valerio may use a camera and consult a photograph while drawing, but unlike a photograph, the drawing portrays no depth of field that is out of focus, as a camera would, and the artist's awareness of human anatomy allows him to give the body a solidity that a photograph could not impart. Notice that the form of the body is defined by deep shadow, but it is never lost in it, whereas the objects of the next room are never defined because, to the artist, the significant content of that space is the shadow. Although he is classified as a Photorealist, Valerio's reality, like Lundin's, is not defined by the photograph but, rather, it is extended by his own personal vision.

## Toward Expression

The figurative-formalist approach, we have noted, is "relationship-minded" rather than "subject-minded." Although these artists use visually recognizable subjects in their work, such as the human figure, they attempt to see within the subject matter its abstract beauty and compositional potential. They generally do not suggest a meaning beyond the perimeters of the work itself, and even the identity of the individual posing for the work is often obscured by having the model look away or by cropping out part of the face. This emphasis on

**9.23**
Edouard Vuillard. *The Artist's Mother*. Pencil on paper, 16.6 x 10.2 cm (6 1/2 x 4″). Metropolitan Museum of Art, New York. Robert Lehman Collection, 1975 (1975.1.762).

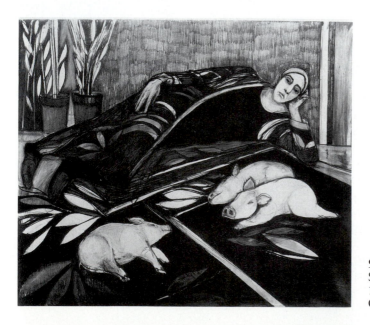

**9.24**
Selina Trieff. *Reclining With Pigs.* 1982. Charcoal on Arches paper, 60 x 72″. Graham Modern, New York.

composition instead of likeness is apparent in a little sketch by Edouard Vuillard, Figure 9.23. A quick gestural drawing of compositional relationships, its line is free and lyrical and could be considered expressive, but Vuillard uses line to express texture rather than subject, as a substitute for the vibrancy of color. He prioritizes what is of interest to him, essentially ignoring the face of his mother. Vuillard's drawing, while quick and sketchy, illustrates his bias in the way he defines space and linear relationships within the two-dimensional picture plane. The term "formalist," rather than "realist," more effectively encompasses those artists who see structural relationships prior to subject matter. If you could ask Vuillard what he was sketching, he would most likely have replied, "a composition."

Another artist whose work is a curious blend of formal and expressive concerns in its representation of the figure is Selina Trieff. Her large self-portrait, *Reclining with Pigs*, Figure 9.24, combines realism with abstraction. In spite of the unusual juxtaposition of pigs within the sedate environment, her drawing formally divides the space with lines and balances the rich patterns of lights and darks throughout the composition. Although the diagonal lines in the lower half of the drawing suggest a recession in space, that space is tight and compressed as if on a small stage. Notice that Trieff's use of value does not in any way attempt to render the play of light, but rather gives the separate areas within the drawing an aura equivalent to color as a design element.

The distinction between relationship-minded and subject-minded blurs further in Dinnerstein's formal portrait of *Arnold*, Figure 9.25. Dinnerstein arranges a perfectly symmetrical composition that gives his subject a quasi-regal quality despite his working man's attire and his timeworn surroundings. The artist laboriously attends to every detail, from the broken floor tiles to the hair

**9.25**
Simon Dinnerstein. *Arnold*. 1972. Charcoal, conté crayon, lithographic pencil, 84 x 36″. Staempfli Gallery, New York.
Photo by Bruce C. Jones.

**9.26**
Simon Dinnerstein. *Arnold (Detail)*. 1972. Charcoal, conté crayon, lithographic pencil. Staempfli Gallery, New York.
Photo by Steven Tucker.

on Arnold's arms (see the detail of the clasped hands, Figure 9.26)—but only after he has carefully planned his composition. He uses the linear elements of the wall panelling and the floor to create a scaffolding that structures the space and contains the heightened rendering of textures. He also consciously works out the interplay between the two-dimensional design of the format and the dramatic effect of perspective on the body's proportions to create the illusion of depth. Notice how the panelling on the wall forms a cross pattern that is reminiscent of a religious icon and how the central dividing line behind the head visually continues to the floor through the face, shirt, hands, and legs. The strength of this drawing derives from a conscious effort to maximize its every aspect, from its structure to the description of the wood grain to the intent face of the subject. It is this heightening, or intensifying, that pushes Dinnerstein's work toward Expressionism.

# In the Studio

## Composition in Line

**Pose** - 30 minutes
**Media** - Charcoal, graphite, or conté on regular white drawing paper, 18″ x 24″ or larger

Pose the model in the midst of a large setup, such as in a chair by a window or on a model stand covered with different pieces of fabric, or in combination with plants and furniture. The main subject is the model, but as part of a larger environment. The purpose is to use the lines of the body in combination with those of surrounding objects. These lines are tools by which to define structural relationships and arrive at your composition. Take lines out to the edge of your paper, as in Figure 9.27. Consider carefully how to frame and crop your subject matter, and don't hesitate to make changes for the sake of your design, even if they do not conform entirely with what you see.

## Composition in Value

**Pose** - 45 minutes
**Media** - Charcoal stick, conté, black and white chalk, or black ink or tempera on regular white drawing paper, 18″ x 24″ or larger

The model should again be posed as part of a larger setting or environment. The light should be regulated with spots or by turning down the lights in the studio. Daylight coming through a window could also be effective. The objective is to illuminate the subject matter to create strong contrasting value areas. Although this drawing may begin

**9.27**
Lance Morrison. *Student drawing, Oregon State University. Composition using line to define assymetrical division of format.* Charcoal.

with a linear breakup of the space, the final composition is to be determined through the description of light patterns and the distribution of value, as in Figures 9.28 and 9.29.

9.28
Kathryn Lee Burton. *Student drawing, Oregon State University. Composition with value.* Watercolor wash.

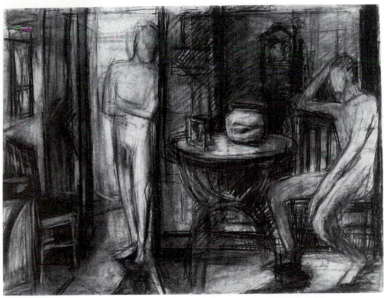

9.29
Shannon Kennedy.
*Student drawing, University of Iowa. Composition with value, using figures in an interior space as structural elements.* Charcoal and chalk.

## Composition in Pattern

**Pose** - 1 hour
**Media** - Charcoal, conté, graphite, or ink on regular drawing paper

Pose the model within an environment of variously patterned fabric and objects. Again, the subject is the model, but your drawing should cover the full dimension of your drawing format, and your use of line and value should describe not only the model's pose but the richness of the surrounding patterns. You need not render objects exactly as they appear or orchestrate your media so that it creates a satisfactory substitute. Figure 9.30 suggests some of the ways line and value can both describe and invent pattern as part of a composition.

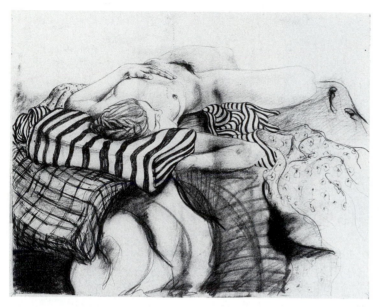

**9.30**
Jeffrey Schoonover. *Student drawing,
Oregon State University. Composition
combining figure with patterns
and textures.* Charcoal.

## Quick Compositional Sketches

**Pose** - 30 to 60 minutes; drawing 5″ x 7″ sketches
　　　(5 minutes each)
**Media** - Dark graphite, charcoal, or conté on
　　　newsprint, 18″ x 24″

This exercise offers a way to explore composition possibilities with quick sketches. The object of this experience is to develop the ability to be "relationship-minded," to see lines and shapes, value and textures, which are created both by the model and by his or her surroundings. Before you begin, draw six to eight rectangles, about 5″ x 7″ each, on several sheets of paper. Some of these rectangles may have a vertical orientation and others may be horizontal. Leave at least two inches between each rectangle. Each small rectangle represents a different picture plane in which a new composition will be sketched.

Although the scene in which you pose the model will remain unchanged, each of your sketches should differ in composition. This may be achieved by simply changing your focus or the arrangement of visual elements within the format. You can also change the value patterns, make light objects dark, shift objects around, add lines where there are none, remove a line in order to balance the composition, or invent your own texture or patterns for greater contrast. The essential ingredient in the study of composition is change, to explore myriad possibilities, as in Figure 9.31.

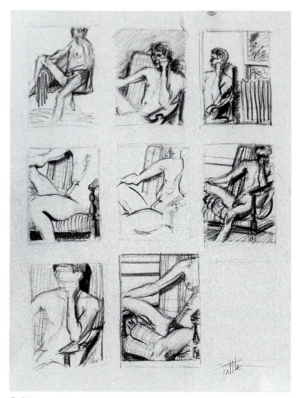

**9.31**
Susie Tuttle. *Student drawing, Oregon State
University. Compositional sketches.* Charcoal.

## Composition Development

**Pose** - 2 to 3 hours
**Media** - Graphite, charcoal, or conté on regular
       drawing paper, 18″ x 24″

Ideally, this drawing exercise should follow the previous quick compositional sketches and use the same set-up and pose. Building on the exploration done with your sketching, take one of those smaller sketches and develop it into a larger, more detailed drawing. Select a sketch that you feel would be worth spending more time on. The larger drawing should not be considered simply a blowup of the smaller sketch but a fuller development of the visual ideas it presents. You will now have the opportunity to make subtle modifications and clarify the forms, increase its appearance or power of expression, or magnify its scale. Figure 9.32 takes the lower right composition from Figure 9.31.

To become relationship-minded and truly sensitive to the organization of the composition is, for most students, a quantum leap when drawing from life. With this drawing, keep reminding yourself that you are not drawing the figure; rather, you are creating a whole composition. Every part of the drawing, and even areas that are left untouched (the white of the paper), should contain a feeling of completion, of having been considered in relationship to the whole.

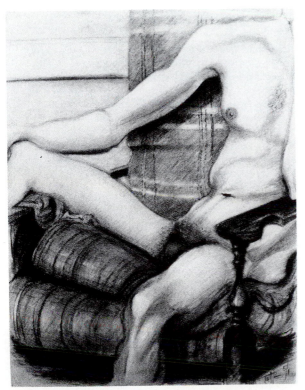

**9.32**
Susie Tuttle. *Student drawing, Oregon State University. Extended sketch derived from small small study with the figure used as a compositional element.*

## Synthesized Composition

**Pose** - 2 hours; standing or sitting
**Media** - Graphite on regular white drawing paper,
       18″ x 24″

This is called a synthesized composition because the purpose is to synthesize elements from what you see in front of you with graphic elements you have added for the purpose of design. An additional purpose is to integrate a two-dimensional linear breakup of the surface design with sections of your drawing that are descriptive of volume and space.

Begin by using a straight edge to lightly draw lines that break up your picture frame into several large shapes. The lines may run across the page or may create self-contained shapes within the edges of your paper. You will find that those lines that are kept parallel to the edge and to one another will be more readily integrated into a total design than will lines that run diagonally or are out of alignment with any other element. These lines are to be kept light, so they can easily be changed, if desired, as the drawing progresses.

Next, lightly add figurative elements derived from your model, inscribing them over the top of your lines. During this process, you may wish to draw several images of the model—fracturing the image, shifting its position, changing its scale. At this stage, your editorial decisions are made for the purpose of synthesizing elements of the three-dimensional figure with the two-dimensional linear structure of your drawing. To achieve this, you may wish to erase lines or add new ones or distinguish some areas with texture or value, as illustrated in Figure 9.33. Line unifies as it moves from the descriptive to the abstract. Your finished drawing will mix two-dimensional and three-dimensional images, combining abstract compositional elements for the sake of design with what you see before you in the model's pose.

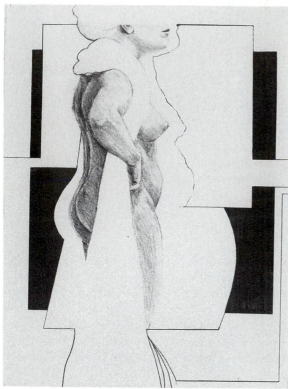

**9.33**
Carol Powers. *Student drawing, Oregon State University. Combination of three-dimensional and two-dimensional elements to form synthesized composition.* Graphite pencil.

### Independent Study:

1. Discover ready-made compositional material that includes the figure in real-life situations. Take a sketch pad and draw people in their surroundings. Use small formats, about 5″ x 7″, allowing for some room around the outside of the picture plane, and do ten quick sketches of what you find. The library, restaurants, train depots, airports, parks, and every kind of work place offer drawing opportunities. 2. Use slides or 35mm negatives placed in a slide mount and project them, one or several at a time, to suggest a compositional arrangement for your drawing that is, again, a synthesis of several different photographic images.

### Endnotes

1 Wayne Thiebaud, *The Sacramento Bee*, 3 October 1965: L-9.

2 Henri Matisse, quoted in *Henri Matisse*, ed. Alfred H. Barr (New York: Museum of Modern Art, 1931), 29.

3 James Abbott McNeill Whistler, quoted in Robert Goldwater, *Artists on Art* (New York: Pantheon Books, 1945), 347.

4 Ibid.

5 Edgar Degas, quoted in Claude Marks, *From the Sketchbooks of the Great Artists* (New York: Thomas Y. Crowell Co., 1972), 283.

6 Edward Hopper, quoted in *The Artist's Voice: Talks with Seventeen Artists* (New York: Harper and Row, 1963), 135.

7 John Elderfield, *The Drawings of Richard Diebenkorn* (Houston: Fine Arts Press, 1988), 22.

8 Ibid., p. 25.

9 Suzanne Langer, *Philosophy in a New Key* (Cambridge, MA: Harvard University Press, 1942), 61

10 Philip Pearlstein, "Why I Paint the Way I Do," *New York Times*, 22 Aug. 1971; 17.

11 Philip Pearlstein, "A Statement," Berlin-Dahlem: Staatliche Museen Preussischer Kulturbesitz Kupferstichkabinett, 1972, museum catalogue, 14.

12 Philip Pearlstein, *A Realist Artist in an Abstract World,* Milwaukee Art Museum, exhibition catalog, 1983, 15.

13 Philip Pearlstein, "Why I Paint the Way I Do," op. cit., 22.

14 See Van Deren Coke's *The Painter and the Photographer* (Albuquerque: University of New Mexico Press, 1972).

# Chapter 10

## Expression and the Figurative Humanist

An Expressionist, yes. . . . It's been suggested that it's a cross we have to bear in our century. I don't think so. I consider my natural inclination toward Expressionism a great virtue.

—*Jim Dine*

A humanist, by definition, is concerned with human nature and human affairs. Artists who see the human figure as a vehicle through which their work can express human emotions or some measure of the human condition could be defined as humanists. Whether figurative humanists use the figure to convey a particular subject, to represent humanity at large, or as a medium through which to disclose their own psyche, they share a desire to "express" or make known their sensibilities or emotions, even if only to themselves. In this regard, "expression" takes precedence over composition because the figurative humanists seek to communicate meaning beyond pure aesthetic concerns of composition. They strive to engage us in a poignant experience even at the risk of offending our aesthetic sensibilities. Where the figurative formalist approaches the human form in a dispassionate, objective way, concerned with its role as a formal aesthetic element, the humanist approaches the figure as an object of content, using the figure symbolically or metaphorically to convey a meaning beyond its form, even beyond the frame or context of the drawing.

## Expressing Empathy

The notion that personal emotions should be the central source and content of art did not come into vogue until the latter half of the eighteenth century and the advent of Romanticism, a movement among artists and writers that emphasized personal content and feeling. They asserted the validity of subjective experience as a moving force in human creativity and expression. Vincent van Gogh articulated the notion that art should be expressive of personal concern for the human condition: "What is a drawing? It is working oneself through an invisible iron wall that seems to stand between what one feels and what one can do."[1] His drawing of a grave digger, Figure 10.1, gives tangible form to his analogy that drawing represents the artist's struggle to make inner emotions visible. From this runt of a man, whose occupation places him near the bottom of the social ladder, van Gogh hacks out a monument, more willfully than skillfully fashioned, out of a need to voice his concerns for society's underlings. Although his

241

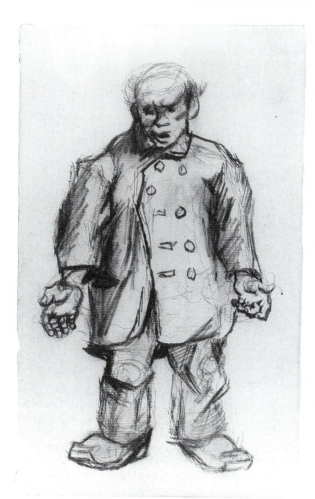

**10.1**
Vincent van Gogh. *Short-legged old man*. 1885.
Chalk, 13 1/2 x 8 1/4".
Collection Rijksmuseum Vincent van Gogh,
Noord Holland; reproduced by courtesy
of the Vincent van Gogh
Foundation/National Museum
Vincent van Gogh, Amsterdam.

to give the figure more presence, more confrontational power. He seems almost to curse us, even as he begs for sympathy. We are not allowed to remain aloof and emotionally unattached.

Another artist considered a pioneer of the modern expressionist view in art is Käthe Kollwitz. For her, the figure was always a symbolic metaphor through which to record her views of a struggling humanity and bear witness to what she saw and felt. Kollwitz was a pacifist with profound compassion for the suffering of others. "I am content that my art should have purposes outside itself. I would like to exert influence in these times when human beings are so perplexed and in need of help."[2] Figure 10.2 projects Kollwitz's view, common among figurative humanists, that art should be about life. The figures are not necessarily drawn directly from life, but inevitably, they are an expression of life. In this respect, humanists often dramatize their subjects, fictionalizing them as in literature or theater. Kollwitz's mood is often reflected in the striking effect of light and dark,

subject is coarse and his expression visceral and crude by societal and aesthetic standards of the day, van Gogh had the audacity to confront us with this disheveled figure, standing empty handed, needing someone to die in order that he might make his living. Van Gogh's compassionate rendering seeks to arouse our empathy.

One aspect of this drawing that is typically characteristic of a figurative humanist approach is the vigorous use of media as an unrestrained record of the artist's process. Notice that van Gogh restates his lines many times, altering the proportions of the grave digger, not to make the figure more attractive or more accurately rendered, but

**10.2**
Käthe Kollwitz. *Woman Leading Two Children
Toward Death*. 1924. Charcoal.
Galerie St. Etienne, New York.

which she uses in Figure 10.2 to convey a sense of gloom and sadness. Her work shares with van Gogh's a desire to reach out and communicate with the viewers, to marshal their compassion and support for social change.

Similarly, Georges Rouault's drawing, *Prostitute in Front of a Mirror*, Figure 10.3, is not just about a nude but about a disenfranchised member of society. It is a particularly loaded subject, making it difficult for the viewer to maintain neutrality. This drawing could be analyzed in terms of its composition, which certainly exists with its division of space and the mirrored reflection, but that is not the thrust of this work. Rouault was more interested in confronting us with a controversial social topic, taking us behind the doors of the brothel. Like van Gogh's drawing, the subject here is not genteel, and Rouault presents it with force rather than refinement. Although Rouault's exact sentiments remain ambiguous in reference to prostitution, he portrays his subject with drama, creating a somber mood. The unglamorous

presentation does not prevent us from being sympathetic, though we are embarrassed, perhaps, at the prostitute's acknowledgment of our voyeurism in her mirror image. Here lies one of the dynamic aspects of much of the figurative humanist's work: There often exists a conflict of approach-avoidance. The subject can both attract and repel the viewer.

Rico Lebrun's drawing, Figure 10.4, carries with it aspects of both van Gogh and Kollwitz. The figure is drawn loosely, with calligraphic line augmented by subtle washes of value. The subject of the drawing, the figure hobbling on crutches, elicits our interest and empathy. As an inspiring teacher, Lebrun believed that, in addition to developing technical skills, students should let their passions have reign in their drawings. Lebrun encapsulates his attitude about drawing in this advice to both student and teacher: "The fundamentals of drawing are the fundamentals of active passion. In teaching we neglect to sponsor passion as a discipline. The only discipline we teach is that

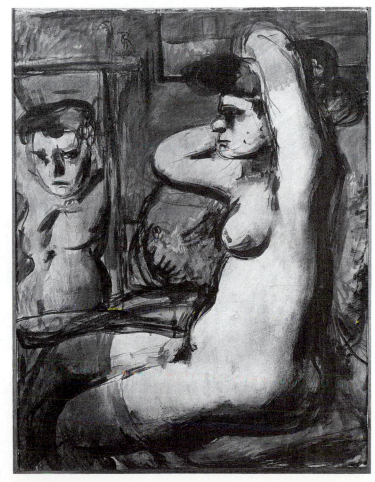

10.3
Georges Rouault.
*Prostitute in Front of a Mirror*. 1906.
Watercolor, 28 1/2 x 21 3/4″.
Musées Nationaux d'Art Moderne,
Centre National d'Art et de Culture, Paris.

of deadly diagrams supposedly to be fertilized later by personal experience. Later is too late."[3]

## Expressing Social Concerns

Many artists express their active passion by using their work as a collective social conscience, revealing for society the truth of its existence—capturing, in poignant visual expression, the heart of a historic event or political issue. Picasso, an outspoken advocate of working from both the imagination and from life, expressed his personal outrage in Figure 10.5, one of numerous works created in reaction to the Nazi bombing of the Spanish village of Guernica. Here, Picasso fictionalizes his subject to more effectively convey the feeling of anguish. "Art," he once said, "is a lie that makes us realize the truth."[4] Picasso did not personally witness the bombing, but this didn't prevent him from expressing his condemnation of the act and his compassion for its victims.

Although the figure may not be realistically rendered, a humanist drawing maintains its authenticity and is accepted as truth if the viewer feels its subject is a matter of importance and is expressed with force and sincerity. Along with feeling little obligation to present the figure as it visually appears, humanists often share a desire to alter the social or political order as well. For many artists, this concern for valid expression extends to personal convictions about the society in which they live and work. Some are overtly critical or disdain-

**10.6**
Max Beckmann. *Martyrdom (Das Martyrium)*. 1919.
Black crayon on transfer paper, 24 1/4 x 33 1/2″ (61.5 x 85 cm).
Sophie M. Friedman Fund, Courtesy, Museum of Fine Arts, Boston.

ful of human behavior, which they hope to change; others try more subtle or subversive approaches. Whereas the formalist would consider this element in art as "propaganda"—or in Whistler's words, "clap trap"—and therefore a contaminant, the humanist might consider it an expression of conscience and an artist's moral duty.

Aesthetic risk-taking can involve political risk-taking. The tragic conflict of the two world wars and the toll in human suffering roused many artists during the first half of the twentieth century to express their concerns in their work.

*Martyrdom,* Figure 10.6, by the German Expressionist Max Beckmann, contains a disdainful, biting satire of the political climate in Germany after World War I. By and large, Beckmann's works are allegorical pictographs comprised of the artist's personal symbols, which are not precisely understood but are perceived on a subconscious level. Beckmann's art was subversive, but it was nonspecific enough for him to survive the Nazi repression by losing only his teaching position. This particular drawing, a sketch on transfer paper to be used as a lithograph, displays the body of a woman, perhaps symbolizing Germany, being mauled and torn apart by the men around her, who may represent the various political factions striving for power in a defeated Germany. The woman's body, stretched out as if it were nailed to a diagonal cross, fractures the picture plane like a broken mirror. Beckmann deliberately confuses us with this helter-skelter arrangement. His figures exist within a compressed space, as if the action were an allegory enacted on stage at a cabaret.

George Grosz also believed that content in art should be derived from one's social and political environment. His drawings expressed his bitter and often caustic view of humanity. *Dinner Party,* Figure 10.7, is typical of his drawing style, with his

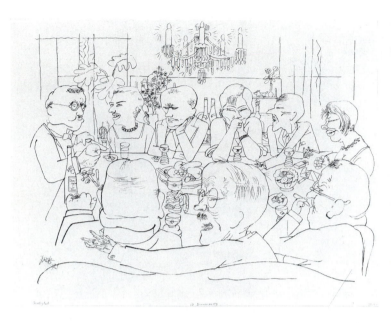

**10.7**
George Grosz. *Dinner Party*. 1929.
Pen and black ink, 16 3/8 x 21 5/8″.
Oregon Art Institute, Portland,
Ella Hirsch Fund.

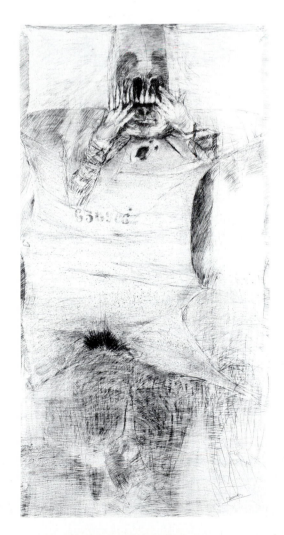

preference for the crisp line of the ink pen. Here, Grosz uses his pen like a knife to create a trenchant characterization of every guest, turning the dining room into a den of the disdained.

Mauricio Lasansky responded to World War II experiences with a graphic indictment of the Nazis in a group of drawings, each of which seem to cry out against the horror. In Figure 10.8, the composition is dominated by a human hide stretched across it, the original owner identified only by a tattooed number, the face twisted in anguish beneath that of a howling head of death. Lasansky lays down graphite aggressively, then combines that with reddish-brown ink. He erodes and smears the graphite with an eraser. Like many other artists represented in this chapter, Lasansky draws not from a model but from his imagination and the powerful life experiences etched in his memory. His drawings are authentic symbols that both externalize and give tangible presence to his subjectivity. Although the images may not have a specific match in the "real" world, they are not less real. The authenticity of his drawings comes not from truthful rendering but from within, from the core of his humanity.

**10.8**
Mauricio Lasansky. *Nazi Drawing No. 21*.
76 x 35″. Collection of
the Richard Levitt Foundation.
Photograph courtesy of the artist.

Some social evils are more pervasive and insidious than a finite event like war. In response to racism and escalating incidents of social injustice in the United States, Paul Cadmus created *To the Lynching!*, Figure 10.9, which reels with action and drama. The composition is tightly packed with the men of a lynch mob that you, the viewer, have somehow become part of. The action swirls about you at a feverish pace. The rippling patterns of value suggest a light that flickers from a torch in your hand, and the man on horseback calls out to you to hurry along. The whole composition is like a vortex that pulls you into the center of the action toward the victim. Even the anatomical forms are arranged to suggest the force and strain of the action. In short, every component within the drawing is called upon to heighten the experience and to involve us in this dehumanizing act with the hope that it will elicit a humane reflex. Cadmus's drawing strives to be a cultural force that moves us emotionally and motivates us politically.

Racial injustice in the famous 1948 trial of the Trenton Six spurred Charles White's drawing, Figure 10.10. The six men had been accused of murder and found guilty, but the verdict was overturned because the judge had improperly sentenced them to death. The case became a *cause célèbre* among civil rights organizations and labor unions who demanded that the black men receive

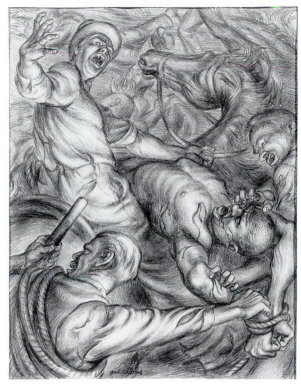

**10.9**
Paul Cadmus. *To the Lynching!* 1935. Pencil and watercolor, 20 1/2 x 15 3/4" (52.07 x 40.01 cm). Collection of Whitney Museum of American Art, New York, Purchase 36.32; Geoffrey Clements Photography.

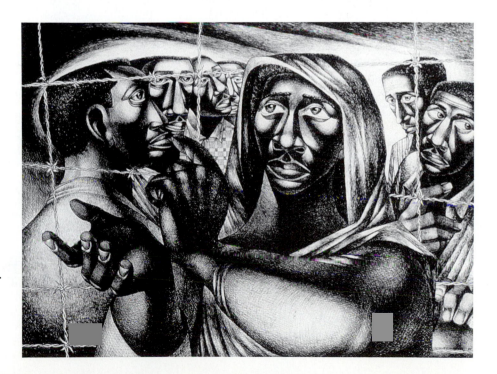

**10.10**
Charles White.
*The Trenton Six.* 1949.
Pen and ink,
28 x 36".
Private collection.
Photograph courtesy
Terry Dintenfass,
Inc., New York.

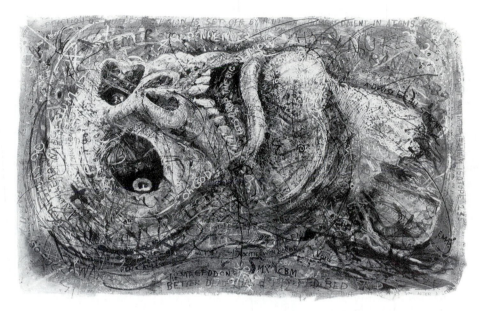

**10.11**
Robert Arneson.
*Gotcha.* 1983.
Acrylic oil stick
and alkyd on paper.
Hirshhorn Museum
and Sculpture
Garden, Washington.

a fair trial, a demand that is echoed visually in White's drawing. He uses a cross-hatching application of value to sculpt these monumental figures. The men behind the barbed wire fencing display a variety of emotions: hope, fear, despair, resignation. The allegorical figure in front beckons to the heavens, one hand open, pleading for justice, and the other hand drawing attention to the men waiting beyond.

The threat of nuclear war inspired Arneson's highly expressive *Gotcha,* Figure 10.11, which exploits an approach-avoidance conflict as part of its dynamic. On an abstract level, the marks create an aesthetic tapestry, but the contradictory graphic image in this mask of death somehow negates the beauty of the marks, and the closer we look, the more horrifying the image becomes. Arneson's use of the written word in the form of graffiti adds momentum to our anxiety, involving the spectator in the reading of his many inscriptions. Through his drawing, Arneson not only expresses his fear but, to some extent, excises it. In this respect, his drawing is both autobiographical and cathartic. His drawing is obviously not a description of reality but, rather, his creation of a myth intended to counteract the acceptance of the "technological myth." In this respect, the act of drawing involves ritual and a kind of magic in its attempt to alter history and to impel social awareness of the need for change. The relationship between art and magic goes as far back in history as prehistoric cave drawings, created to give the

**10.12**
Ralph Woehrman. *Ecology Series—Hines on Pittsburgh.* Pencil and ink, 44 1/2 x 28 1/2″. Photograph courtesy Minnesota Museum of Art, St. Paul.

hunters magic power over the beasts they depicted. In a similar way, Arneson invokes a kind of magic by personifying the threat that hangs over us all.

Figure 10.12 from Ralph Woehrman's *Ecology Series* also responds to a hostile and dehumanizing environment, but in a more formal arrangement of imagery. His thin pencil lines drawn with straight edges furnish a scaffolding to hold the three separate images together in the absence of a unifying aspect of perspective space. The separate bits of information—heads, a bird sounding an alarm, and a breathing machine—are synthesized conceptually by the viewer around what is assumed to be the drawing's theme: a clash between modern technology and the natural environment.

In contrast, Schneider uses a refined realistic style and a revised Biblical theme to create a rich

and powerful dramatic narrative, Figure 10.13. With this drawing, Schneider pays homage both to the Old Testament heroine Judith, who saved her people by slaying the Assyrian general Holofernes, and to the illustrious seventeenth-century artist, Artemisia Gentileschi (1593–1652), whose paintings on this theme influenced Schneider's composition. The Judith theme, for both Schneider and Gentileschi, has historical credibility, but it is also politically relevant today as a feminist statement, a modern allegory for a strong, politically active woman.

## Self-Expression

For many artists, expression is a process more internal than external, more personal than social or political. In addition to expressing empathy or

10.13
Julie Schneider. *Judith, Scene 4 from Heros*. 1989. Graphite on paper, 29 x 23″. From the collection of Renee Stoutjesdyk, Washington, D.C.; Photograph courtesy of the artist. Arlington, Virginia.

compassion for others, the drawn figure can be a means by which to proclaim and verify one's own individuality. "In a world which is forever trying to make you be somebody else, to be nobody but yourself is to fight the hardest battle a man is called upon to fight," wrote Arturo B. Fallico in *Art and Existentialism*.[5] In the Romantic view of the late eighteenth and early nineteenth centuries, and more recently among the Abstract Expressionists of the 1950s, art was viewed as springing forth from strong emotions, as a kind of catharsis. Spontaneity and self-expression were central tenets manifest in an energetic use of media and dramatic and emotive subject matter.

Willem de Kooning is an artist who bridged the gap between Abstract Expressionism and an expressive use of figurative images. Because he continued to use "woman" as a referential symbol after the burgeoning of Abstract Expressionism, de Kooning was viewed by some of his associates and hard liners within the movement as something of a turncoat, an artistic revisionist. But de Koon-

ing kept the visual vocabulary of the new expressionists and combined it with his old-world need for the human figure (Figure 10.14). Some have criticized his work as being hostile toward women, but whatever his intent, his images are both created and obliterated by the kinetic manipulation of his drawing media. The force and energy of his drawing process is, through association, transferred to his women and led one critic to write, "You could name a hurricane after any one of them."[6] This quality is also present in Color Plate V. His haphazard approach to composition, with his passionate bravado and disregard for the details of physical appearance and the formal aspects of composition, makes his drawing the romantic antithesis of the more restrained formalist work discussed in the previous chapter. The women in de Kooning's drawings are surreal, the product of his imagination. The drawings take on aspects of a ritualistic performance, in which the artist verifies himself through the creative process. They are defiant acts that express his own individuality much

**10.14**
Willem de Kooning. *Standing Woman.* 1952.
Pastel and pencil on cut and
pasted paper, 12 x 9 1/2".
Museum of Modern Art, New York,
The Lauder Foundation Fund.

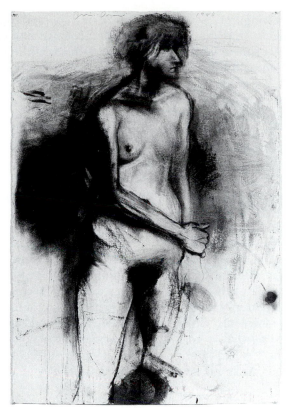

**10.15**
Jim Dine. *Jessie among the Marks*. 1980.
Charcoal, pastel, and enamel on paper,
60 x 40 3/4". Pace Gallery, New York.

side are the more classical and rational works we visually *admire* because of the wholesomeness of the body and the thoughtful way it is composed. Toward the other extreme, we find the expressive, romantic works we are asked to *experience,* in which the aggressive manipulation of the drawing media and the figure itself are agents through which artists transmit their feelings and beliefs.

Although Dine's drawings are vigorously worked, his figures are conceived solidly and based on what he calls the "romance of anatomy."[9] In this respect, his drawing style is quite different from that of de Kooning. For Dine, the anatomy of the body is too interesting and emotionally appealing to be neglected. Dine recognizes the innate tension created by the presence of a figure, especially the nude, which other subjects simply cannot eclipse. "The figure is still the only thing I have faith in in terms of how much emotion it's charged with and how much subject matter is there."[10]

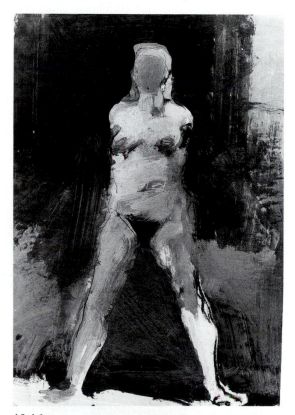

**10.16**
Manuel Neri. *Mary Julia*. 1973/75. Dry pigments, water, charcoal, conté, and pencil,
41 3/4 x 30 1/4" to 28 3/4" (irregular).
John Berggruen Gallery, San Francisco.

more than they convey any extraneous subject. Each one proclaims, "I, Willem de Kooning, made this."

Expressionism often is characterized by the vigorous manipulation of the media, as in Dine's Figure 10.15 and Color Plate XI. When describing his drawing process, Dine said: "I begin with charcoal, and then I often rub it out almost completely. . . . I know where to go from there and I start to work on an area and just keep working until finally I have to fix it. Then I take an electric sander or sanding blocks and take out parts of it—arbitrarily sometimes,"[7]

Dine, who is an admirer of de Kooning's work, places himself firmly among the Expressionists. "I am almost embarrassed by realism. I think it's quite beautiful, but somehow its depiction of the emotionally impoverished life is a cramped Yankee vision."[8] Dine not only expresses his biases but also points out two characteristics that define the opposite poles of figurative drawing. On one

The scrawling, scribbling, hacking action typical of de Kooning's passion-oriented drawings is also intrinsic in the works on paper by Neri, Figure 10.16 and Color Plate VII. Neri's drawing process creates an ambiguity in which the figures seem to exist midway between creation and destruction. Like de Kooning and Dine, he both builds up the figure with pigment and tears it apart through erasure and reworking the drawing surface. The figures in Neri's work result from an ongoing metamorphosis, the product of an art that views change and uncertainty as a virtue over the stability and clarity typical of the formalist approach. His figures seem to hang in the twilight zone between being and nothingness, as unmistakable human bodies without identities.

## Expressing Sensuality

Every drawing presents imagery perceivable through our senses; therefore, any drawing that is aesthetically pleasing might be considered sensuous. However, while the formalist approaches

drawing the figure in a disciplined pursuit of purely aesthetic components, the humanist has a more liberal code of propriety and often develops a sensuality within the content as well as through the use of abstract elements. Within the context of the formalist approach and the desire to appeal to the intellect rather than the emotions, the undraped figure is always distinguished as a "nude" and would rarely be described as "naked." The figurative humanists, on the other hand, often share a desire to involve us in all aspects of life's experiences, including human sexuality and all the fervent emotions of love, hate, jealousy, joy, or anxiety.

Contemporary artist Eric Fischl addressed the metaphoric potential inherent in a naked body: "I'm interested in the way a naked body can be made to reveal a social reality and thus become disruptive for reasons other than its nakedness. I'm interested in the way the body can be coded to reveal what is socially unconscious yet omnipotent."[11] His untitled drawing, Figure 10.17, reveals the subtle narrative of his work and presents

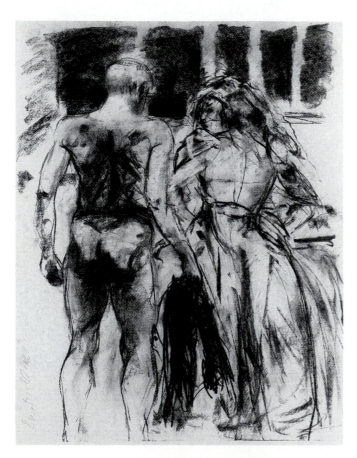

**10.17**
Eric Fischl. *Untitled.* 1986.
Charcoal on paper, 24 x 18″.
Mary Boone Gallery, New York.
Photo by Zindman/Fremont.

a welcome turnabout from the traditional in that the female figure is clothed while the male is naked.

It is significant that Fischl uses the term *naked body* rather than *nude*. According to Kenneth Clark, author of *The Nude*, "To be naked is to be deprived of our clothes, and the word implies some of the embarrassment most of us feel in that condition. The word *nude*, on the other hand, carries, in educated usage, no uncomfortable overtone."[12] The distinction is, of course, a question of attitude, but this nuance affects the presentation of the figure in a drawing. Nakedness carries with it a self-consciousness that nudity does not admit to, and in Fischl's drawing, the interaction is ambiguous, wavering between neutralizing the power of the naked male and making him seem more threatening.

Madden Harkness's figures interact with the viewer rather than each other. They seem to stare out of their obscure environment, confronting us with their expression as well as their nakedness.

*Everything Has Been Forgiven*, Figure 10.18, has a suggestive, narrative quality similar to Fischl's, but Harkness's narrative seems less firmly attached to everyday reality. She begins with fairly traditional drawings on drafting film, often on a monumental scale, then works back into them with erasure and turpentine washes that slightly dissolve her images, leaving them floating in a shadowy world like the twilight realm of the subconscious.

Edvard Munch, who has often been referred to as the father of modern Expressionism, developed a very personal mythology around the themes of sex and death, which reflected both his rather maudlin personality and his sexual anxiety. "Disease, insanity and death were the angels which attended my cradle, and since then have followed me throughout my life,"[13] he once said. Munch believed that woman was the temptress, the "femme fatale," who drew men to her and eventually to destruction. Although he feared women and his involvement with them, human sexuality was a

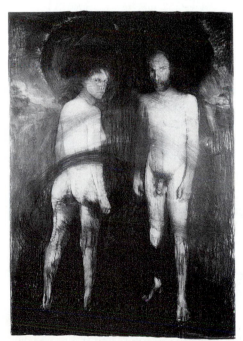

**10.18**
Madden Harkness. *Everything Has Been Forgiven*. Mixed media on drafting film. 6 feet x 3 1/2 feet. Photo courtesy of Contemporary Artists' Services, Culver City, California.

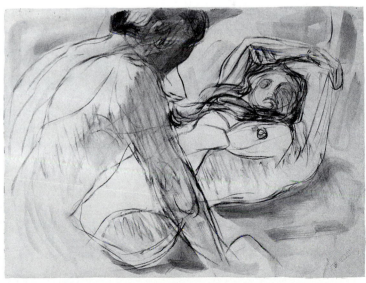

**10.19**
Edvard Munch. *Man and Woman*. 1912–15. Watercolor and charcoal, 25 5/8 x 31 3/8". Munch Museum, Oslo.

**10.20**
Leonel Góngora. *Prisoners of Their Passions.*
1973. Line drawing, 14 x 11".
Courtesy of the artist,
Pelham, Massachusetts.

**10.21**
Thomas Hart Benton, *Dancer.* 1930.
Pencil and crayon on paper,
20 x 11 3/4" (50.8 x 29.85 cm). Collection
of Whitney Museum of American Art,
New York, 30.489;
Geoffrey Clements Photography.

persistent theme in his art. Figure 10.19, like many of his other works, expresses this personal conflict. His line is fidgety, punctuated with starts and stops; it seems to flow from a need to release his tension and anxiety. The sensuality expressed in Munch's drawing is not cosmetic or intended to be aesthetically pleasing. In fact, the drawing hauntingly divulges conflicting messages.

The Latin American artist Léonel Góngora's *Prisoners of Their Passions*, Figure 10.20, is also expressive of physical sexuality, but it levels a mocking, satirical commentary about sex. The subjects acknowledge the presence of the viewer, but they appear undaunted, which is disturbing because it changes our status from viewer to voyeur. Góngora's drawing contains a universal message about passion and pleasure-seeking. The line

has a hard, brittle quality to it, especially noticeable in the hair, but detected as well in the clothes and the figures' contours. There is also enough distortion in the figures themselves—the wide-set eyes, the curvature of her back, the breast, her tangled fingers—to give a sense of abnormality to the lovers and their activity.

American Social Realist Thomas Hart Benton deliberately endows a physical sensuousness to *The Dancer*, Figure 10.21. A fictional character invented for one of Benton's paintings, she becomes a universal symbol. It matters not if she is a big city burlesque or a country barn dancer; her sexual vitality is expressed through her gesture, the anatomy revealed beneath her clothing, and her provocative stance. Although Benton has been labeled a Social Realist, he was not a realist at all.

His figures were always larger than life, with features and actions exaggerated into the realm of metaphor. His art created a visualization of our American mythology.

## Expressing Subconscious Reality

For many artists, the figure's external appearance becomes a metaphor for expressing an interior world of the human psyche. The mind can be a sanctuary from the technological world, or it can be a cauldron where anxieties and paranoias brew. As Goya once said, "The dream of reason produces monsters,"[14] a sentiment he visually depicts in *The Nightmare*, Figure 10.22. The subconscious offers a source of highly imaginative drawings when the artist blends the rational with the irrational in a form derived from free associations within the mind.

Where both the New Realist and figurative-formalist approaches generally accept or attempt to find order in the environment, contemporary humanists are more likely to suggest that what we see as the "real" world may be only one among many possible worlds. The world of myth, dream, and the subconscious might all be expressed through the way the human figure is presented. Salvador Dali, in Figure 10.23, combines the body with elements of furniture to give us a glimpse of another world, the surreal world of dreams and the supernatural. In this work, Dali's chest of drawers contradicts our previous experience with such objects, therefore leaving us disoriented and bemused.

**10.22**
Francisco de Goya y Lucientes. *The Nightmare (Pesadilla)*. Brush and wash, black ink on white paper, 9 3/16 x 5 11/16″.
The Metropolitan Museum of Art, New York, Rogers Fund, 1919. (19.27).

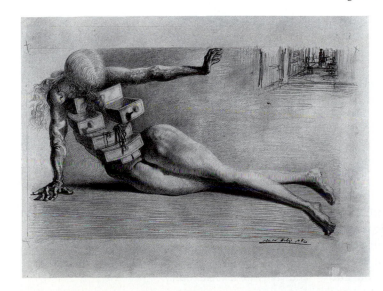

**10.23**
Salvador Dali, *City of Drawers*.
1936. Pencil on paper,
13 5/16 x 20 5/8″ (35.2 x 52.2 cm).
Gift of Frank B. Hubachek, 1963.3.
© 1990 The Art Institute of Chicago.

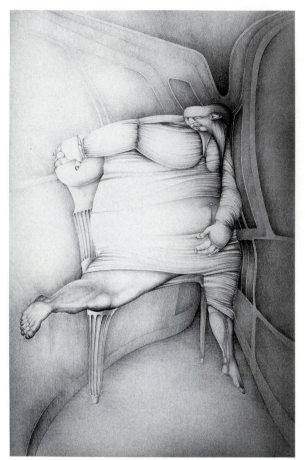

**10.24**
Felix de Recondo. *Femme et Mur Deformé*. 1981.
Pencil on paper, 26 x 40 1/2″ (66 x 103 cm).
Harcourts Gallery, San Francisco.

Felix de Recondo's drawing, Figure 10.24, pulls us into another world of disorientation and instability. He deliberately distorts his figure, elongating some parts of the body and compressing others. The walls, too, are warped and undulating, yet de Recondo's distortion is rendered with a convincing precision that accomplishes a haunting reality. In a drawing where everything is illusion, fantasy is substantiated and reality becomes suspect.

One of the expressive tools of artists' drawing from their own imaginations is their ability to present convincing details that imbue their drawings with all the elements of truth. Nancy Grossman's skillful application of the media works to manipulate reality within her drawing, Figure 10.25, but unlike de Recondo's, her drawing style is documentary and exact, so that we are lead to believe that this figure does, in fact, exist outside

the artist's mind. She presents her image in detail, which makes it all the more convincing and frightening. This image creates a deliberate frustration, a suggestion of restrained power, a modern Prometheus bound, physically powerful but rendered powerless. Another interpretation can also be that her drawings reflect contemporary society's obsession with sex and power, which, in turn, leads to exploitation and the loss of our freedom and identity. The work is deliberately ambiguous, and our inability to discern its ultimate meaning or intent is disorienting and disconcerting. The expression of the surreal often makes us feel uncertain, questioning our own perceptions of reality.

Distortion and exaggeration of natural features are expressive devices used traditionally by artists such as Hieronymus Bosch, Francisco de Goya, and Honoré Daumier to satirize human folly and more effectively draw attention to what they perceived as society's ills. Rather than faithfully re-

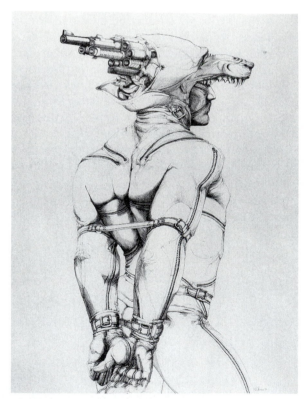

**10.25**
Nancy Grossman. *Figure 1970*. 1970.
Pen and ink on white paper, 117.0 x 87.5 cm.
The Art Museum, Princeton University.
Museum purchase, John Maclean Magie
and Gertrude Magie Fund.

cording only what they saw before them, these artists combined what they had experienced from direct observation with their imaginations to dramatically express their concerns through what might be thought of as pictorial fiction. For the figurative humanist, the imagination often blends with experiential learning. The fictionalization of a subject is not only considered legitimate but is often valued more than an artist's technical skills. Creativity for the humanist is primarily a process of image making and story telling, and the measure of quality is, to a great extent, the degree to which a work engages the viewer's imagination.

## Summary

Although "artistic expression" is broad enough to apply to the work of any artist, you can see from the examples in this chapter that for some artists it has a more specific meaning and perhaps an added dimension. When a drawing communicates something more than the visual appearance of the external world, when the figure becomes a metaphor or symbol through which to vent passions and opinions, the figure loses its neutrality and takes on an emotional charge or personal bias.

For the artist, the drawing becomes a forum where the dialogue is often heated and flamboyant. It is the expression of subjective views rather than objective facts that gives particular significance to the term "artistic expression."

It should also be pointed out that one risk of message-oriented art work is that it is often evaluated on the basis of whether the audience agrees or disagrees with the views expressed, rather than on its artistic merit. What makes a drawing good is very different from what might make it socially relevant or morally right. Also, an artist who lets the content dictate the direction of his or her work to the exclusion of aesthetic concerns runs the serious risk of producing propaganda rather than good art. The artists themselves must take care that their enthusiasm for the ideas they want to convey in their drawings does not prevent them from evaluating their own work honestly on the basis of its aesthetic expression and presentation.

Obviously, it would be impossible to marshal all drawings into one of the two categories established in this section: formalist versus humanist. The groups are not mutually exclusive. Kent Bellows's drawing, *Four Figure Set Piece*, Figure 10.26, represents a very formal composition laden with connotative meaning. A *set piece*, according

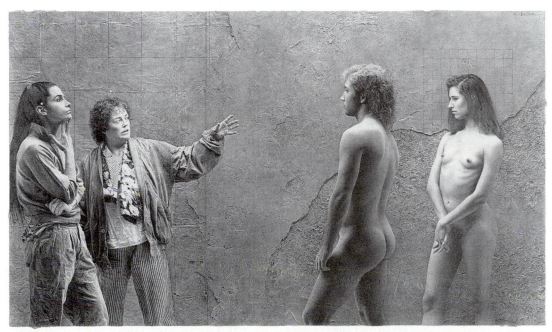

**10.26**
Kent Bellows. *Four Figure Set Piece*. 1988. Graphite pencil on paper, 17 3/4 x 30 1/2″.
The Arkansas Arts Center Foundation Collection: Purchased with a gift from
Virginia Bailey, Curtis and Jackye Finch and Director's Collectors, 1989.

to Webster's dictionary, is "a composition (as in literature or music) executed in a fixed or ideal form often with studied artistry and brilliant effect." Bellows seems to combine this definition of *set piece* with another related to theater arts: "a realistic piece of stage scenery standing by itself." The setting has a number of possible interpretations centered on the interaction of the clothed figures and the nudes. The artist establishes a formal composition, a set piece, then imbues it with ambiguous content, leaving the viewer to determine its meaning.

One drawing that almost completely erases the boundaries between formalist and expressionist biases is Magdalena Abakanowicz's *Body 81F,* Figure 10.27. The central component of this drawing is composition, the stark contrast of form against background: The vertical of the figure is broken by the horizontal of the extended arms, and both vertical and horizontal forms are accentuated by repeated straight lines. The figure is faceless, leaving the viewer distanced from this figure as an individual subject, a recognizable person. But the artist has also imbued the work with subjective content: the action of the mark making, the imagery of the crucifix, the internal organs hinted at beneath the skin. The result is an emotionally charged though somewhat abstract representation of the human form that gains much of its expressive power from the austere compositional arrangement of line and value.

Whether you find yourself more appreciative of formal aesthetic concerns or of the humanistic temperament—or of some middle ground that combines elements of both—it should be apparent

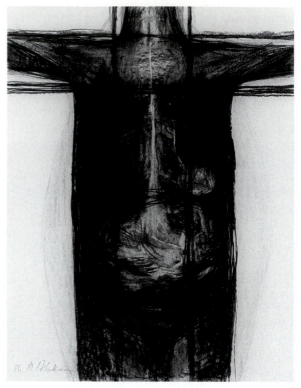

**10.27**
Magdalena Abakanowicz. *Body 81F* 1982. Charcoal on paper, 39 3/8 x 29 5/8" (100.1 x 75.25 cm). Marlborough Gallery, New York.

that for most representational artists, composition and expression hold paramount importance. For these artists, the figure is not an end in itself but the source through which to delve into broader aesthetic issues, into what they wish to make others see.

## In the Studio

Some people believe you cannot teach creativity and artistic expression, or they believe that it should be encouraged only after a student has acquired all of the academic skills of realistically drawing the figure. It certainly could be argued that anyone who has not acquired the basic vocabulary of a language would find it extremely difficult to communicate. Many artists have also pointed out that self-discipline is as essential to creative expression as the desire to be expressive. At the same time, a great deal of evidence suggests

that creativity is a process that can and must be practiced, and that it is not an innate quality that one simply inherits. As Rico Lebrun suggested, "We need to sponsor passion as a discipline." We learn how to become more creative and expressive through practice and by defining these as our goals.

Expression does not mean that "anything goes." Rather, expressiveness suggests a driving desire to push a drawing as far as possible toward its conclusion, toward making its intent clear and

its existence more potent. Just as one learns with practice the skills that relate to rendering a realistic likeness, one also learns with practice to recognize that conclusion when it comes. The exercises that follow are intended to encourage your experimentation into aspects of creativity and expressive problem-solving. They offer only a place from which to begin.

### Expressive Accentuation of Media and Process

**Pose** - 30 minutes; drawing may be developed further without the model
**Media** - Artist's choice on regular drawing paper, 24″ x 36″, at standing easel

Any pose, with or without props, may be used for this exercise. What is important is that you recognize that you have to bring yourself to your work in order to develop it beyond what you see. Drawing from the model is only the first stage of the drawing, which you should develop later. While drawing from the model, look for aspects of the pose or the model's attitude that you could dramatize. Allow for changes as you progress and continually rework the media, erasing or adding multiple layers, as in Figure 10.28. As you work, attempt to transmit a particular attitude of your own into your drawing by making the gestural action of the drawing process a visible part of the drawing, as in Figure 10.29. Direct the work toward a more potently charged statement, following intuitive hunches but also stepping back and objectively evaluating what you have drawn. The final drawing should be as much about you and your presence as it is about the model's pose.

### Expressing Empathy

**Pose** - 60 minutes; to be developed further without the model
**Media** - Artist's choice on regular drawing paper, 24″ x 36″, at standing easel

This drawing exercise will most likely require that you develop your ability to fictionalize as well as empathize. Take your clues from the model and develop the drawing further, like a good fiction writer, into a metaphoric dramatization. The model should be asked to play a role, assuming a

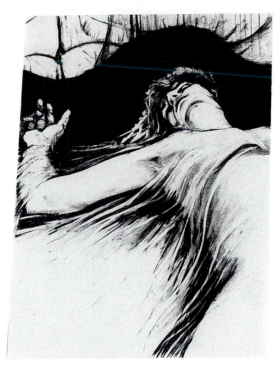

**10.28**
Mark Hogansen. *Student drawing, Oregon State University. Expressive manipulation of the media.* Charcoal.

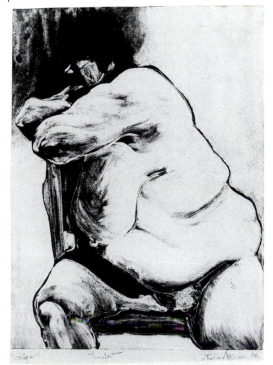

**10.29**
Catherine Wilding Atkinson. *Student drawing, Sonoma State University. Expressive use of media.* Monoprint.

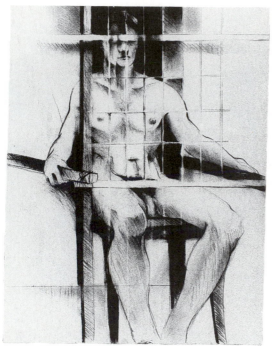

**10.30**
Sandra Butler. *Student drawing, Oregon State University. Expressive study of figure confined in a cage.* Charcoal.

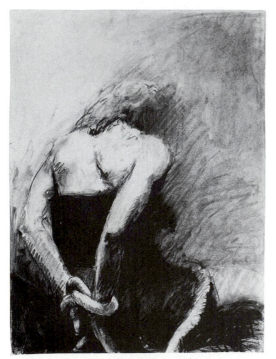

**10.31**
David Opdyke. *Student drawing, University of Cincinnati. Expressive drawing of a bound figure.* Charcoal.

pose suggestive of someone who would ordinarily draw our sympathy, such as a tragic victim of social and political circumstances, a physical laborer, a murder victim, or an imprisoned or caged individual (see Figures 10.30 and 10.31). These roles can be acted out with a few simple props and a little imagination on the part of the model. The success of the drawing, however, will depend on how well you can project yourself into the situation and enhance the drawing with your own empathy and imagination. One's compassion and imagination do not always require first-hand experience. Consider all of the artists who have used the crucifixion and the pietà as the subjects of their art yet who obviously never witnessed the actual events. The test of your drawing will be whether it involves the viewer or promotes an empathetic response.

### Deliberate Distortion

**Pose** - 60 minutes; to be developed further without the model
**Media** - Artist's choice on regular drawing paper, 18″ x 24″ or larger

By deliberately distorting forms, you can amplify or diminish various aspects of the figure, thereby expressing what you feel is of greater or lesser importance. In this way, you can distort reality and create a surreal image that combines the visual clues presented by the model and alters them through the improvisational forces of your imagination. You may choose to distort existing features of the model's gesture or physical form, as in Figure 10.32, or you could develop a composite image using fragments of the model combined with invented shapes into a synthesis that has no basis in reality, as in Figure 10.33. The authenticity of your drawing will not be based on the fact that it looks exactly like an existing situation but, rather, that it has been drawn with such conviction and authority that the viewers find themselves participating in the reality of the visual clues you create.

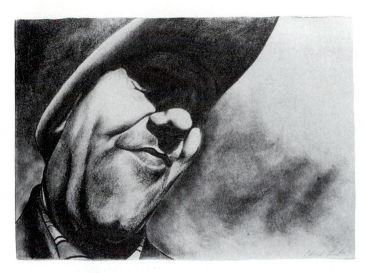

**10.32**
Christopher Forrest. *Student drawing,*
*Oregon State University.*
*Expressive drawing.* Mixed media.

### *Juxtaposing Organic and Inorganic Forms*

**Pose** - 2 hours; to be developed further without the
model
**Media** - Artist's choice on regular drawing paper,
18″ x 24″ or larger

Combine the organic forms of the figure with
inorganic elements to create a metaphoric image,
as in Figure 10.34. The drawing should be a syn-
thesis of the model with forms and shapes sugges-
tive of mechanical or electronic elements or some
other imagery at odds with the human, organic
form of the life model. The nonorganic compo-
nents can be derived from imagination or supple-
mented with visual aids from magazines, books,
machine parts, and so forth. These elements may

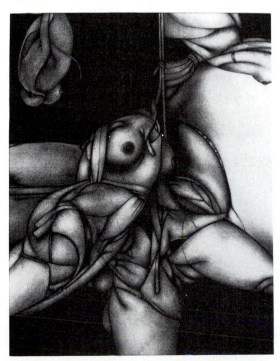

**10.33**
Antonia Egan. *Student drawing, Memphis*
*State University. Example of surrealistic*
*distortion, using elements of human figure.*
Charcoal.

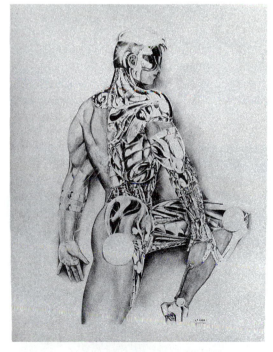

**10.34**
John Choi. *Student drawing, Oregon State*
*University. Surrealistic juxtaposition of*
*organic and inorganic forms.*
Graphite pencil.

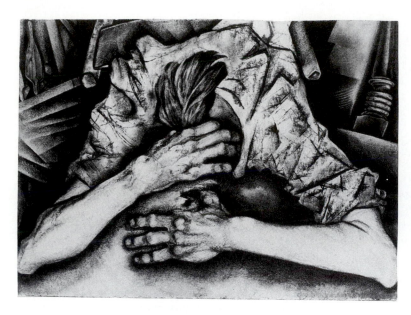

**10.35**
Sheila Flinchpaugh.
*Student drawing, University of Idaho. Example of expressive use of distortion to create surrealistic drawing.*
Pencil and charcoal.

be made part of the body or integrated into the composition as a whole. Mechanical drawing tools, such as a compass and straightedge, are useful for developing graphic qualities that contrast with the gestural qualities of freehand drawing.

### Independent Study:

1. Draw a self-portrait in which your depiction of yourself is atypical, more expressive than realistic. Devices such as aggressive application of the media, distortion, setting, fictional narration, and juxtaposition of unusual objects can add power to your drawing. 2. Create a drawing of an individual on the fringe of society or in some other way a part of a counterculture. This drawing could be based on someone you know or have observed, or on someone you have only read about or imagined (Figure 10.35). 3. Create a drawing that uses the human figure as a metaphor to comment on a current or historical event that you find particularly disturbing in terms of its effect on humans (Figure 10.36).

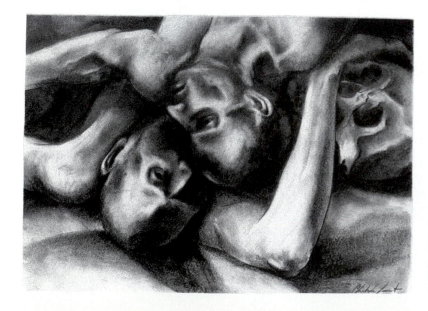

**10.36**
Christopher Forrest.
*Student drawing, Oregon State University. Drawing created as an expressive reaction to an historical event of inhumanity.*
Charcoal.

## Endnotes

[1] Vincent van Gogh, quoted in Robert Wallace, *The World of Vincent van Gogh* (New York: Time-Life Books, 1969), 148.

[2] Käthe Kollwitz, 1922, "On All Souls Day," Victor Meisel, *Voices of German Expressionism* (Englewood Cliffs, NJ: Prentice-Hall), 1970.

[3] Rico Lebrun, *Rico Lebrun Drawings* (Berkeley: University of California Press, 1961).

[4] Pablo Picasso, *Quote,* Sept. 21, 1958.

[5] Arturo B. Fallico, *Art and Existentialism* (Englewood Cliffs, NJ: Prentice-Hall, 1962), 44.

[6] Thomas B. Hess, *Willem de Kooning,* Museum of Modern Art, New York, 1968, exhibition catalogue, 79.

[7] Jim Dine, "Conversation with the Artist," *Jim Dine Figure Drawing 1975–1979,* exhibition catalogue by Constance W. Glenn (Long Beach, CA: The Art Museum and Galleries of California State University), Oct. 1979.

[8] Ibid.

[9] Ibid.

[10] Ibid.

[11] Donald Kuspit, *Fischl* (New York: Vintage Books, 1987), 57.

[12] Kenneth Clark, *The Nude: A Study in Ideal Form* (Garden City, NY: Doubleday Anchor Books), 1956, 23.

[13] Edvard Munch, quoted in Schreiner, *Edvard Munch* (Somvikjente Ham: Venene Forteller, 1940).

[14] Francisco de Goya y Lucientes, quoted in Ian Crofton, *A Dictionary of Art Quotations* (New York: Schirmer Books, 1988).

# Becoming Your Own Best Critic

> Discipline is not a restriction but an aid to freedom. It prepares an artist to choose his own limitations. . . . An artist needs the best studio instructors, the most rigorous demands, and the toughest criticism in order to turn up his sensibilities.
>
> —*Wayne Thiebaud*

In addition to the disciplines, demands, and criticism that you may receive from an instructor in the drawing studio, the personal goal of every art student should be to become self-motivated, self-disciplined, and self-directed. These qualities, along with the acquisition of skills and knowledge of the history of your craft, will enable you to be truly autonomous, free to follow your own path. But beyond gaining these qualities, you also need to develop your ability to be self-critical, to be your own best critic. You need to be able to step back from your work, out of the persona of the artist as maker and into that of artist as critical observer.

During the drawing process, the artist is continuously involved in evaluative judgment calls: Should the line be here or there, a form larger or smaller, a value darker or lighter? Even the most spontaneous impulses are followed by the artist's assessment of their merit. In this regard, drawing is a rapidly alternating continuum between action and evaluation. The artist evaluates the drawing as a whole, in terms of how well it has fulfilled its potential. It is at this point that the artist must become the honest critic, one whose foremost interest is quality.

Your ability to recognize quality work is determined to a great extent by the breadth of your experience, knowledge, and exposure to superlative works, all of which increase your understanding and ability to make value judgments. In your own drawing, you may have noticed emerging

characteristics that are unique to your way of working and are an expression of your aesthetic tastes. Being your own best critic, however, involves more than developing a personal style or a preference for a particular media or type of work. Making true value judgments is not as easy as classifying a drawing stylistically, nor is it as simple as expressing a prejudicial statement of personal taste. Quality is more demanding and requires greater sophistication and discernment.

Quality, in itself, is difficult to define in an absolute sense. But no matter what the artist's media, temperament, or method of working, quality does exist and can be recognized. Quality—that elusive element—is what makes one drawing better than another or, after refinement, better than it was in a previous stage of its development. Quality is something we experience in a comparative sense, and although we may be unable to define it absolutely, it is possible to define some general traits that contribute to the quality of a drawing: *authenticity, presence, enhancement, economy,* and *creative insight.* These five characteristics can serve as guides for assessing the merits of your own work. Although they will not exist to the same degree in every drawing, and it is even possible that one may be developed to the exclusion of others, each contributes to the overall quality of your drawing.

*Authenticity* is what makes your drawing convincing. It is the feeling that the artist knows the subject and is speaking with authority. Authenticity is present when the drawing is so fully described, so skillfully rendered, that the viewer feels drawn into its reality and accepts its logic. Authenticity can also be achieved because the content is poignant and expressed with such force and conviction that the drawing's emotional charge presents a genuine expression of the artist's feelings, or an expression that the viewer accepts as authentic.

*Presence* is that aspect of a drawing that makes us take notice, that demands our attention or invites our consideration. This may be a result of scale, the way a figure fills and activates the space; or it may be the placement that makes the figure the dominant compositional element; or the angle from which it is viewed that makes the subject more interesting and engaging. Presence might be achieved by describing the subject with such undeniable clarity, revealing one minute detail after another, that it lures us into the drawing. Or it might be that the drawing has such tenacity and

force that it seemingly rushes forward to overwhelm us with its intensity.

*Enhancement* involves defining the intent of your drawing and then refining and sharpening its focus, adding richness and embellishment. To enhance means to make greater, to amplify, to heighten or expand, to intensify or elevate, to advance or exalt, to maximize or bring to fruition. Exactly how a drawing should be developed, or "pushed," beyond the initial and often timid starting point, is determined by your intent. Your intent establishes the criteria by which to evaluate the drawing's further development, determining whether you have brought the drawing closer to your goal. It is the refinement of a drawing that gives the impression that it has realized its potential and is fully resolved. For some artists, this may be achieved by giving the subject the greatest degree of realism possible; for others it might depend on a more forceful, energetic execution of the media or on a restructuring of the composition.

*Economy* relates to the efficiency with which information is conveyed. With a quick sketch, it is the way an artist economically distills and expresses the essence of a subject with limited time and effort. In a more time-consuming drawing, however, economy may be the artist's ability to create a single image capable of conveying a complex message on several levels at once. The economy of a drawing may also be demonstrated in its being simultaneously satisfying on both a conceptual and an abstract level, both highly informative and aesthetically pleasing. Economy is not simply an abbreviation, for less is not always more; it is the compacting of information into a more potent visual statement.

*Creative insight* refers to the degree to which a drawing makes known or realizes that which was previously unknown. Every drawing states to some extent what we know, but, ideally, a drawing should also be a revelation. A truly creative and insightful drawing makes new discoveries that are manifest in the act of drawing itself. These discoveries are often as much a surprise to the artist as they are to the viewer. Drawing involves a great deal of craft, but creativity comes through thinking of drawing as an exploration, an investigative process of image-conjuring. At its best, a drawing probes and reveals unknown territory, making revelations to the artist. It illuminates that which was obscure. It gives substance and form, making

tangible the ideas and feelings that began as unfocused or vague concepts. It makes the ordinary appear new and extraordinary.

How do you do all this within the realm of a life drawing? By playing with all the possibilities, by striving for what lies beyond, by not being satisfied with work that you know you can make better or stronger, and by keeping your eyes and your mind open. Quality is not preexistent. It is arrived at—developed, or coaxed—into being. For the artist, quality is a consistent goal, a self-imposed lifelong challenge.

# Glossary

**abstract** Nonrepresentational; having little or no relationship to the appearance of actual or imaginary objects. (See also *representational*.)

**achromatic** Possessing no *color* or *hue*; involving only black, gray, or white. (Contrast with *chromatic*.)

**acid-free paper** A higher-quality paper with greater durability and longevity; usually made from rag fiber.

**action pose** An energetic or gestural pose suggesting a frozen moment or action.

**additive method** The technique of drawing by adding media to the surface or ground. (Contrast with *subtractive method*.)

**analytic approach** A systematic and rational approach to drawing the figure; often dividing the whole into parts and observing their interrelationships.

**anatomy** The study of the form and structure of the parts of an organism.

**angle of recession** The angle at which the subject or parts of the subject recede or tip back in space away from the viewer, thus altering the perception of the subject's *proportions*.

**anterior view** Front view.

**architectonic** Having structural or design characteristics that have qualities reminiscent of the principles of architecture.

**articulation** The state of being joined or interrelated; a movable joint between bones or cartilage.

**atmospheric perspective** A *perspective* device based on the observation that as objects recede in space, light fades, colors dull, and details become obscured.

**background** The more recessive portions of a pictorial *composition* within which objects in the *foreground* are placed.

**blend** To apply media uniformly, with imperceptible tonal transitions. (See also *continuous tone*.)

**blind contour drawing** Describing in a slow, careful manner the outer *contour* of the body without looking at the drawing surface.

**blind gesture drawing** Describing in rapid and energetic fashion the gestural movement and thrust of a pose without looking at the drawing surface.

**broken outline** An *outline* of form that consists of a series of noncontinuous, separate *line phrases* rather than an uninterrupted, *continuous line*.

**calligraphic line** Free-flowing *line* that varies in weight and application and is presented in graceful, rhythmic phrases that share the aesthetic intent of calligraphic writing: to produce lines of elegance or beauty. (See also *modulated line*.)

**cartoon** A preliminary but full-scale drawing that may be transferred to establish the same design on another surface.

**cast shadow** The tonal *value* created when an object blocks light; a dark area cast upon a surface by a body intercepting the light from its source.

**chiaroscuro** A pictorial depiction of *light* and *shadow*, generally associated with a dramatic contrasting arrangement of light and dark. (See also *sfumato*.)

**chromatic** Relating to or having *color*. (Contrast with *achromatic*.)

**circumscribe** The use of line to enclose a form

and define its outer limits as a discrete *config-uration*.

**collage** A *composition* created by adding various materials, such as newspaper, cloth, or wood, to the drawing surface.

**color** The visual perception of the quality of light reflected from the surface of objects. Pigmented colors absorb certain light wavelengths while reflecting those that define their hues.

**composition** The arrangement of elements within a drawing in relationship to each other and to the whole.

**compositional sketch** A quick drawing that delineates the essential elements of a *composition*; concerned with the division of the *picture plane* and the relationship of objects within the *format*.

**configuration** The *form* of a figure as determined by its pose and the arrangement of overlapping body parts.

**conté crayon** Drawing media originally made in a limited range of earth tones from pigment and gum binder compressed into small rectangular drawing sticks; commercially made drawing sticks available in a wide array of colors.

**content** The subject matter of a drawing, including narrative, symbolic, or thematic connotations that imbue the work of art with perceivable meaning.

**continuous line** A line that expresses the subject matter in a long, unbroken line. (See *line phrasing*.)

**continuous tone** The application of media in blended gradations of *value*; having no obvious *vector* or notable directional significance. (Compare with *hatching* and *cross-hatching*.)

**contour line** *Line* that represents the *contour* of an object, both the interior contours and the outer edge. In figure drawing, line that represents the fullness of the human form, its dimensional contours.

**cross-contour line** *Line* that describes an object's surface topography, emphasizing the volumetric shape of an object. (See also *contour line*.)

**cross-hatching** A technique by which *value* areas are created by building up areas of crossing linear strokes known as *hatch marks*. (See also *hatching*.)

**deckle edge** The uneven edge of drawing paper that indicates a mold-made papermaking process.

**diagrammatic** A drawing having primarily a utilitarian and informative function, devoid of embellishment or extraneous elements.

**directional line** Line that implies movement or *vector*.

**double-ply** Paper with thickness equivalent to two *single-ply* sheets.

**elements of design** The principal graphic devices available to the artist for composing a work of art: *line, value, space, form, texture, pattern,* and *color*.

**expressive** Dealing with feelings and emotions and the artist's inner vision, as opposed to objective observation of external phenomena.

**extended gesture** A drawing that begins with a quick gesture sketch but that is expanded upon over an extended period of time.

**extensors** Muscles that straighten and extend various parts of the body. (See *flexors*.)

**eye level** Refers to the physical eye level of the artist, which in turn determines the position of the *horizon line* and the *angle of perception*.

**figurative** Art that represents the human figure or other recognizable objects as visual symbols in contrast with *abstract* art. (See *representational* and *naturalism*.)

**figure-frame relationship** See *figure-ground*.

**figure-ground** The relationship of the positive object or form within its *background* or sur-

rounding space. (See also *foreground, background,* and *ground*.)

**flexors** Muscles that bend various parts of the body. (See *extensors*.)

**foreground** A position of prominence; the part of a scene or representation nearest to the viewer; correlating to the lower portion of a pictorial representation. (See also *background*.)

**foreshortened** A form that is viewed in such a way that its normal proportions visually appear shortened or compressed; also said to be seen in *perspective*.

**form** One of the *elements of design,* form refers to the three-dimensional volume and structure of the figure, as opposed to *shape,* which refers to *two-dimensional* planes. In a broader sense, the manner in which a visual *symbol* of the figure is presented as a visual idea or concept.

**formalist** In art, one who is primarily concerned with the structural *composition* and pure aesthetic elements within a work. (See also *humanist*.)

**format** The proportion, configuration, and scale of the drawing area. (See *picture plane*.)

**geometric shape** *Shape* relating to or in accordance with the principles of geometry, as in circles, squares, rectangles, and so forth.

**gesso** A preparatory coating that can be applied to the surface of a drawing *support* such as paper, wood panel, or canvas. (See also *ground*.)

**gestural approach** A quick graphic representation of form in which the hand (holding a mark-making tool) follows the movement of the eye over the subject's *configuration*.

**gestural contour** Expressing volume and surface contours through lines drawn in an intuitive, free-hand manner. (See *gestural sketch*.)

**gestural sketch** In figure drawing, a quick, energetic drawing that attempts to capture the essential *gesture* or element of a model's pose.

**gesture** The pose or stance of a figure; the movement of the body as a means of expression.

**graphite** A crystallized form of carbon used as the main ingredient in lead pencils and graphite sticks.

**ground** The surface on which the artist works; often a preparatory coating applied prior to drawing, which would be referred to as a "prepared ground." (See also *gesso* and *background*.)

**hatch marks** Short parallel, adjacent lines that, when combined on the drawing surface, are perceived as *value*. (See also *hatching* and *cross-hatching*.)

**hatching** Building areas of *value* using adjacent, parallel linear strokes known as *hatch marks*. (See also *cross-hatching*.)

**head length** A unit of measurement, using the head of an individual to compare proportional relationships. (See *proportion*.)

**highlight** The lightest spots or areas in a drawing or painting; the areas receiving the most illumination; the application of light-colored media over a darker medium or *ground*.

**horizon line** An imaginary line in the distance where earth and sky appear to meet and toward which receding forms appear to diminish in size. (See also *eye level, vanishing point,* and *linear perspective*.)

**hue** The attribute of *colors* that permit them to be distinguished as red, blue, yellow, or some intermediary colors.

**humanist** In art, one who is concerned with expressing subjective feeling and using the figure as a symbolic statement about humanity or the human condition. (Compare with *formalist*.)

**icon** A pictorial representation; an object of veneration; a religious *symbol* or image.

**illusionistic space** The pictorial representation of *three-dimensional space* on a *two-dimensional* surface.

**illusionistic texture** Created when the artist accurately represents the appearance and surface quality of an object. (See also *simulated texture, physical texture,* and *invented texture.*)

**implied line** A suggested or invisible line. A line whose direction or *vector* continues beyond where the line stops; line that relies on the viewer to conceptually complete the movement the line suggests.

**intent** An artist's objective or purpose; an aim that guides the artist's action and establishes the criteria for evaluating the work of art.

**invented texture** An optical phenomenon whereby the artist's manipulation of media creates the visual impression of *texture,* which is not intended to be descriptive of an object's actual texture. (Contrast with *physical texture* and *illusionistic texture.*)

**kinetic energy** Energy associated with motion, which is often recorded by the marks in a drawing.

**lateral view** Side view.

**light** In drawing, those tones nearest to white on the *value scale* from black to white; those areas of a drawing that reflect the most illumination from a light source. (See also *highlight* and *value.*)

**line** A mark made by a tool as it moves across a surface or *ground;* distinguished from its background because of the shift in *value.*

**line phrase** A single, uninterrupted movement of a line from beginning to end.

**line phrasing** The manner in which the artist applies line; a collection of line phrases. (See also *outline, broken outline, overlapping line, modulated line, multiple phrase line* and *contour line.*)

**linear perspective** A drawing technique that relies on the optical impression that parallel lines converge toward distant *vanishing points* and that, as our distance from an object increases, the size of its image on the retina decreases. (See also *perspective* and *visual angle.*)

**mass** In drawing, the representation or illusion of an object's weight, *volume,* and density.

**media** The physical materials and tools through which the visual artist communicates; the categories or techniques of application of physical media (i.e., drawing, painting, sculpting).

**metalpoint** A metal-tipped drawing tool; a drawing technique using a metal stylus, usually silver, on a prepared *ground.* Also called silverpoint.

**modeling** The use of value to create the illusion of *three-dimensional form* and *space.* (Contrast with *rendering.*)

**modulated line** Line that varies in weight and thickness to accentuate or de-emphasize form. (See also *calligraphic line.*)

**multiple phrase line** A composite line that consists of several adjacent or overlapping lines that together define the *form.*

**multiple-point perspective** Employed when compound forms or complex arrangements have parallel lines receding in different directions toward different *vanishing points.* (See also *perspective.*)

**naturalism** In art, a conformity to nature; not stylized. (See also *representational* and *figurative.*)

**negative space** The space surrounding a positive *shape* or solid; that which is not occupied or filled with an object. (See also *background.*)

**newsprint** An inexpensive paper made from wood pulp; used for printing newspapers and by art students for practice drawings.

**objective** Dealing with factual representation as perceived without distortion by personal feelings or interpretations. (Compare *subjective* and *expressive.*)

**oblique angle/oblique view** Observing the figure from a view other than front, back, or profile that results in the visual skewing of the body's normal symmetry or proportional relationships.

**one-point perspective** A system of drawing dependent on the illusion that all parallel lines converge as they recede in space toward a single *vanishing point*. (See also *perspective, horizon line,* and *linear perspective.*)

**organic shape** Relating to nature; having free-flowing or biomorphic, rather that *geometric, shape.*

**outline** A line functioning as a tool of demarcation by tracing the outer edge of and thus enclosing shapes and separating the figure from its surroundings. (See *circumscribe.*)

**overlapping** A *perspective* device whereby spatial relationships are shown by lines and shapes blocking out others, thus implying that one form is behind another.

**overlapping line** Line that extends over or covers another line to suggest the spatial position of forms.

**pattern** The sequential arrangement of *shapes, values,* and *textures* over a broad area.

**pentimenti** A still visible remnant or *underdrawing* that indicates a change made between an earlier stage of drawing and the finished composition. (Italian for "change of mind".)

**perspective** A means by which the artist suggests *three-dimensional space* and depth in drawing. (See also *linear perspective, atmospheric perspective, overlapping, vertical positioning,* and *size differentiation.*)

**physical texture** The actual tactile quality of a surface, including both drawing surface and media application. (See also *invented texture* and *illusionistic texture.*)

**pictorial space** The created illusion of depth on a *two-dimensional* surface. (See also *picture plane.*)

**picture plane** The *two-dimensional* surface on which the artist works; also, the imaginary plane between the artist and the subject.

**pigment** The substance responsible for *color* in *media.*

**planar analysis** A drawing process that reduces volumetric *forms* to their basic geometric structure. (See also *schematic* and *schematic line.*)

**plane** A flat, *two-dimensional,* continuous surface. (See also *form* and *picture plane.*)

**plotting** Systematically creating a plot plane with points of reference and lightly drawn lines to suggest the position and proportional relationships of a model's pose. A *schematic* preliminary sketch usually based on *sight measuring* and comparative analysis.

**point of view** The *eye level* and general position from which the artist sees the subject being drawn.

**portrait** A representational drawing or painting of an individual, focusing primarily on the face and head.

**positive image** An object that serves as the subject of the drawing, as distinguished from the *background* or *negative space.*

**posterior view** Back view.

**preperception** Stored visual concepts that facilitate recognition of objects but often prevent accurate perception of familiar subjects.

**primary colors** The set of colors from which all other colors may be derived; in pigment: red, yellow, and blue. Colors that cannot be derived from mixtures of other colors.

**profile view** The figure seen from the side; particularly the head. (See *lateral view.*)

**proportion** In figure drawing, the comparative relationship between parts of the body and the whole and between one part and another.

**rag paper** Paper made from rag fiber; more durable than *student-grade drawing paper* or *newsprint.*

**reflected light** Light that is not from a direct source, such as the sun or a lamp, but an indirect one, reflected from one surface onto another. (See also *light* and *cast shadow.*)

**rendering** The use of value to visually depict the patterns of light and shadow. (Contrast with *modeling*.)

**repeating line** See *multiple phrase line*.

**representational** A realistic graphic depiction of recognizable objects. (See *figurative*.)

**scale** The size of a form in relationship to the viewer or to other dimensions. (See also *proportion*.)

**schematic** A systematic drawing procedure generally concerned with structure and the delineation of a form's essential features, executed in an orderly and rational manner. (See *diagrammatic*.)

**schematic line** Line used in a *diagrammatic* way, symmetrically drawn; *geometric* in nature rather than *organic*; usually reflective of essential structural features as in an architectural blueprint or mechanical drawing.

**sfumato** The blending of light and dark by almost imperceptible stages, which eliminates edges and the use of line to enclose form; from the Italian word for "smoke." (See also *chiaroscuro*.)

**shading** Using drawing tools to create variation in tone when *rendering* light patterns or *modeling* three-dimensional forms.

**shadow** Tonal areas created by the blocking of the light falling on a surface. (See also *cast shadow*.)

**shape** The configuration of an object. As a visual element, shape usually refers to the *two-dimensional* area of the figure within the picture plane, as opposed to *form*, which implies *three-dimensional volume*, as well as surface area. (See also *organic shape* and *geometric shape*.)

**sight measuring** A technique by which the artist can visually determine proportional relationships from a distance.

**silverpoint** A technique by which the artist draws with a silver-tipped stylus on a *ground* prepared with a coating of *gesso*. (See also *metalpoint*.)

**simulated texture** Created when the artist suggests or accurately represents the tactile appearance and surface quality of an object. (See also *illusionistic texture*, *physical texture*, and *invented texture*.)

**single-ply** Paper with a single-sheet thickness. (See also *double-ply*.)

**size differentiation** A perspective device of regulating the size of an object in drawing to suggest distance from the viewer. (See also *perspective*.)

**sketch** A quickly executed exploratory drawing often done as a form of notation or as a means of initiating a visual idea for later reference; a drawing made quickly to capture the essential elements of a pose or scene or concept. (See *gesture sketch*.)

**solid** A form that has density and weight. (See also *positive image* and *mass*.)

**space** In drawing, the representation of *three-dimensional volume* or volumetric dimension characterized by height, width, and depth.

**spatial plane** The position of a *shape* or *form* in space.

**structural analysis** See *planar analysis*.

**student-grade paper** Inexpensive drawing paper made from bleached wood pulp; whiter and more durable than *newsprint*.

**stylus** See *metalpoint*.

**subjective** Dealing with the opinions and artistic expression derived primarily from within the individual rather than from objective examination of the external world. (See also *expressive*.)

**subtractive method** A drawing technique whereby pigment is removed from the surface or ground. (Contrast with *additive method*.)

**support** The backing, or foundation, on which media are applied; i.e., the paper, canvas, drawing board. (See also *ground*.)

**surface terrain** The surface relief; its *three-dimensional* raises and recesses. (See also *contour line* and *topographical*.)

**symbol** An image that represents something beyond its intrinsic *shape* or *form* by reason of relationship, association, or pictorial resemblance.

**tactile** Relating to the sense of touch.

**texture** The *tactile* quality of a surface. The representation of tactile appearance. (See *physical texture, illusionistic texture, simulated texture,* and *invented texture*.)

**three-dimensional** Having three dimensions: height, width, and depth. In drawing, giving the illusion of depth.

**three-quarter view** Observing or presenting a subject in a position between frontal and profile. (See *oblique angle*.)

**tone** The many value gradations in the *value scale* between black and white.

**toned paper** Paper having a *value* other than white; either hand-toned or produced commercially.

**tooth** The *physical texture* of the drawing surface. The paper is said to have a coarse, medium, or fine-grain tooth.

**topographical** A graphic or pictorial representation of the surface terrain and *contours* of the figure as determined by its anatomical structure.

**topographical contour line** Line that expresses the *contour* of the form, as topographical lines in a contour map indicate shifting topography of the land.

**transverse** Lines that travel across forms, going back and forth, such as *cross-contour lines, topographical lines,* or *cross-hatching strokes.*

**two-dimensional** Having only two dimensions; lacking depth.

**underdrawing** A preliminary drawing used to establish the primary structural and proportional relationships over which progressive finishing layers of refinement are added. (See *pentimenti*.)

**value** The range of *tones* from light to dark or from white to black; all the shades of gray in between. (See also *light*.)

**value scale** The graduated steps in tonal range from white through gray to black.

**vanishing point** In perspective drawing, the imaginary point toward which parallel lines of a form appear to converge or vanish. (See also *perspective* and *linear perspective*.)

**vector** A directional force. In drawing, an implied force of line created as a record of directional movement. The *vector* of a line may also be carried by the line's momentum beyond its extremity. (See also *implied line*.)

**vertical positioning** A *perspective* device that suggests that higher forms are farther back in space. (See also *perspective*.)

**visual angle** The angle at which light rays enter the eye and thus determine the size of the image on the retina.

**visual metaphor** The use of graphic or pictorial *symbols* to convey ideas or concepts beyond their mere physical appearance.

**volume** The expression of form as occupying *three-dimensional space.* (See also *mass, form,* and *space*.)

**wash** A pigmented solution, such as ink or watercolor, that can be applied with a brush to create tonal gradations.

# Index

*References to drawings and diagrams are in italics.*